"Black" British A

"Black" British Aesthetics Today

Edited by

R. Victoria Arana

"Black" British Aesthetics Today, Edited by R. Victoria Arana

This book first published 2007. The present binding first published 2009.

Cambridge Scholars Publishing

12 Back Chapman Street, Newcastle upon Tyne, NE6 2XX, UK

British Library Cataloguing in Publication Data
A catalogue record for this book is available from the British Library

ISBN (10): 1-4438-0601-3, ISBN (13): 978-1-4438-0601-5

TABLE OF CONTENTS

PREFACE

"Black" British Aesthetics Today is a collection of critical essays exploring current thinking about the newest artistic and literary works being produced in Britain. The book is a scholarly outgrowth from observations initially shared at the eponymous international symposium that took place in April 2006 at Howard University. My motive for organizing that symposium came out of my realization as a scholar of contemporary "black" British literature that discussions of contemporary "black" British writing emphasised the social and demographic features of the writing and very infrequently touched on its quality *as* writing, its artistic features and objectives, or its aesthetics. I wondered if the output of artists in other genres was being treated in this more or less anthropological or sociological way, instead of being considered specifically as art and examined for aesthetic and artistic qualities and execution. The symposium was designed to fill the gap.

I have found it useful to define the term *aesthetics* as "the deliberate design of the appeal to an audience"—rather than attempt to provide an ontological definition. *Deliberate design* is one of the most important aspects of the work of an artist, surely, but it may not be obvious—and especially not if critics and reviewers (interested mostly in themes) are concerned principally with such matters as *who* is producing the work and *what* it may be about, and not in its implicit idiom or equivalent nonverbal communicative strategies.

In my own research, I soon discovered that artistic manifestos were not to be found in abundance to help reviewers and critics to see what might be "new" or "brilliant" or essentially "different" about the artistry of contemporary "black" British writers. Publications anthologizing works by new "black" British writers, for instance, promoted new voices and left it to readers to determine their relative artistic merits and accomplishments. Often these introductions mentioned the socio-political emergence of the voices, but drew little or no attention to what the voices were saying and no attention whatsoever to *how* they were crafting their messages.

The artists themselves, of course, do indeed manifest their aesthetics, if we can learn to discern these traces. But without attention to aesthetics and craft, we cannot *fully* appreciate the emergent artistic productions—mostly because they *are* new.

Looking around for help from scholars and critics writing about the new aesthetics, the post-post-colonial aesthetics, the new millennial aesthetics, I

found very few really helpful books and articles: those which I did find are included in the comprehensive bibliography found at the back of this book.

"Black" British Aesthetics Today offers readers a more comprehensive and more insightful treatment of the newest "black" British aesthetics than anything available to date. It shows how current thinking and practice confirm the existence of a vibrant and engaged population of witty and creative talents passionately engaged in the work of transforming the very idea of what it means to be a British artist and citizen today.

"Black" British Aesthetics Today contains twenty-three chapters set into four sections. The first section relates current "black" British aesthetic practices to traditional aesthetics from various quarters, including the ancestral African arts, the Black Arts Movement of the United States, and the more recently developed postcolonial expressive modalities. The second section amplifies the theoretical exploration of current trends and movements in a full spectrum of the arts: literature, the various graphic and media categories, architecture and design, drama, and the performance arts. The third section offers focused studies of individual works or sets of works exemplary of the new "black" British aesthetics. The fourth section recognises the careers of two exemplary "black" British literary activists, women whose considerable energies and exuberant intellectual efforts in behalf of "black" British literature and the arts have inspired many others to follow suit.

Many of the essays are written by the new and avant-garde writers and artists themselves and, as such, amount to the manifestos I had searched for but not found (in print) before their contributions were solicited for this particular publication. The volume includes as well a useful, comprehensive bibliography to help readers ground further work in this field.

In this volume, the terms *black*, *"black"* and *Black* all appear, and it has been my decision, as editor, to allow each contributor to treat the word in his or her own way. For the most part, though, I should clarify that, for many of us sensitive to the current state of cultural affairs in Britain, all of these terms have been challenged. For the title of the book, I use "black" to call attention to the historical reality of a group so called. The word *Black* as a category for human beings was recently been labeled "offensive" by some Britons of African parentage, and it is fast becoming politically incorrect to use it in the United Kingdom. According to British journalist Toyin Agbetu, progressive Britons and others should use the term *African British* to designate British citizens of African heritage or racial backgrounds. Agbetu explained: *"African British* is the name now used to describe the community previously mislabeled as Afro-Caribbean, Black British, U.K. Black, Negro, Nigger, Coloured and Black. It embraces all British nationals with antecedents originating directly from Africa or indirectly via African diasporic communities, such as those in the Caribbean

and South America" (see Agbetu's Ligali webpage at www.ligali.org). In his essay titled "Say It Loud: I'm African and Proud" (*New Nation*, 12 July 2004), Joseph Harker explained "why the time has come to ditch the word *Black*." Writers with cultural and racial roots in India, the Middle East, and other places have also been critical of the label for themselves. I have discussed the matter at length in my introduction to *Contemporary "Black" British Writers*, a volume of the *Dictionary of Literary Biography*, and in my essay "The 1980s: Retheorising and Refashioning British Identity" in *Write Black, Write British: From Post Colonial to Black British Literature*, edited by Kadija Sesay (2005). When all is said and done, many of the writers and artists referred to in the present volume find the label "African British" neither appealing nor even accurate and use other terms to describe their identities and ethnicities. Andrea Levy, for example, calls herself simply English, Michael McMillan calls himself an Englishman of Vincentian parentage, Kobena Mercer calls himself a Londoner of Ghanaian-British descent, Kadija Sesay calls herself an Englishwoman of Sierra Leonean heritage, Roshini Kempadoo calls herself a British-born artist of Indian Caribbean descent based in London, and so on. While the culture is trending that way, no neutral term that could serve as an *omnium gatherum* yet exists that would help readers and librarians identify the focus of this book, which is why I use the expression "*black*" advisedly—surgically even—and within the forceps of quotation marks.

R. Victoria Arana, Editor
Howard University, Washington, D.C.

IN MEMORY OF
WINSTON ANTHONY NAPIER (1953-2008)

ACKNOWLEDGEMENTS

The conference from which this collection has developed was made possible by support from the Office of the Provost of Howard University through its Fund for Academic Excellence. We are grateful to the British Council-U.S.A. (in particular Andy Mackay, then-Director; Sarah Frankland, Arts Officer, and Molly Michal, Arts Coordinator) for subvention of travel for several of the writers who presented at the BBAT Symposium in April 2006. Many others at Howard University and elsewhere, at various stages, helped to make this project a success: Dr. Joan Anim-Addo (Goldsmiths College, University of London), Dr. Thomas C. Battle (Director, Moorland-Spingarn Research Center, H.U.), Rashida Bumbray (The Studio Museum in Harlem), Prof. Floyd Coleman (Art History, H.U.), Ali Evans (The Studio Museum in Harlem), Helon Habila, Tia Powell Harris (Smithsonian National Portrait Gallery), Prof. Maria-Helena Lima (SUNY-Geneseo), Tony Medina (Poet in Residence, H.U.), Deonne Minto (University of Maryland-College Park), Prof. James Miller (George Washington University), Dr. Darrell Newton (Salisbury University, Maryland), Prof. Sandra Shannon (Department of English, H.U.), Dr. Tracyann Williams (The New School, NYC), Prof. Deborah Willis (New York University), Prof. Michelle Wright (University of Minnesota). Our thanks also to Tanya Hardy and Sally McCoy of the English Office, H.U., to Cheryl Roberson of the Howard University Bookstore, and to the following graduate students for their assistance: Leah Blue, Jean Church, Kimberly Collins, Tuere Marshall, Tyechia Thompson, and Daria Winter. For permission to quote from *The Chronicle: Internet Magazine on Changing Black Britain* (http://www.thechronicle.demon.co.uk/archive/7_8_31fo.htm) in the contributor's note on George Kelly-Fowokan, we are most grateful to Professor Thomas L. Blair, editor and publisher of www.chronicleworld.org. For permission to reproduce the photograph of Mr. Kelly-Fowokan's sculpture on our cover, we are grateful to Mr. Kelly-Fowokan and to Mia Morrow of the Well Placed Consultancy (London). For permission to use stills of Martina Attille's 1988 film *Dreaming Rivers* (Christine Parry, photographer), we are extremely grateful to Ms. Attille and to Maureen Blackwood of Sankofa Film and Video, Ltd. For the design of our cover, credit goes to Brandon R. Robinson. Prof. Eleanor W. Traylor, Chairman of the Department of English at Howard University, and Amanda Millar, at Cambridge Scholars Press, gave the editor very valuable support as this book was coming together.

INTRODUCTION

AESTHETICS AS DELIBERATE DESIGN: GIVING FORM TO *TIGRITUDE* AND *NOMMO*

R. VICTORIA ARANA
HOWARD UNIVERSITY, WASHINGTON, D.C.

In a recent online conversation between African novelist Helon Habila and "Black" British writer Courttia Newland, these two young writers explored their thoughts about the vocation of writing. Segueing to the purposes of their artistic endeavours (as happens so frequently when writers from the African continent engage writers of African heritage living elsewhere), Habila and Newland began to try to define the major differences in their points of view concerning aesthetics. A point they pondered related to the place of identity-formation in their respective creative works—how their characters developed maturity, how that maturity related to a strong sense of selfhood, and what self might mean in different cultural contexts. Newland commented:

> I long ago realized that to the African community outside the United Kingdom, our ["black" British artists'] quest to define who and what we are must seem perplexing at the very least—as Wole Soyinka has said, "Why must we boast of our negritude? A tiger does not boast of its tigritude." While I agree that this is true of a tiger that finds itself in its normal environment, could the same be said for one that is caged and peered at by hundreds of spectators a day, miles away from home? Would it not notice how much it stood out, wonder at what makes it different from those outside the cage?
>
> I recognize that an English [white] author would not feel these things, for the very reasons you do not feel them when in Africa. The fact that you are who you say you are is a given.

If an artist's aesthetic can be construed as a vision or conscious scheme for the representation of an idea and if it is, for that reason, *the deliberate design of an appeal* to one or more audiences, real or imagined, no discussion of an artist's aesthetic can ignore the artist's local (read: *residential*) situation, nor can it ignore the artist's perception of himself within his or her cultural context.

Courttia Newland's comment has broadly ramifying implications for our subject matter in this volume.

Every original artist must at some point or another feel the need to boast of his or her tigritude, especially if *tigritude* is to be construed as the artist's indispensable identity, the distinguishing marks of that identity. The artist may not consciously ask, What is my tigritude, my truest self? But surely —Giorgio Agamben's melancholic musings aside[1]—the artist *does* wonder, How do *I* want to relate to and attract the attention of real and potential spectators ambling around? The essays in this volume—particularly those by Diran Adebayo, Anthony Joseph, Valerie Mason-John, Koye Oyedeji, Lauri Ramey, SuAndi, Andrene Taylor, and Samera Owusu Tutu—engage aspects of this crucial conversation. And SuAndi and Valerie Mason-John, especially, posit that certain aesthetic features and artistic strengths in the works of "black" British artists derive from their having to deal candidly with bizarre experiences of cultural dissonance or dislocation, whether or not they are armed from birth with knowledge of a rich African or other heritage.

For some artists, the metaphorical cage to which Courttia Newland alluded exists as the artist's persona, the way the artist feels (or fears) that he or she is perceived by others. The artist's persona is, of course, only a symbolic enclosure or constraint or condition surrounding the possibility of speech and expression. In other times and other places, silenced or alienated from their surround, some afflicted artists, we know, became the spectators and recorders of their defeated careers. Their artworks, designed in solitude—for some god, an imagined audience, or the self alone—remained confidential messages, and spectators coming upon them later have sympathized or appreciated those artists' messages designed in solitude, quiet joy, or self-torment.

In contrast, the "black" British artists coming into the lime lights *today* are concerned to reach out, and the artistic programmes emerging from their considerations of identity and of relation to community embody not merely *a politics of identity*, but *an aesthetics of identity* as well. Theirs is *the deliberate design of an appeal*, of an invitation to consider an idea—something like a call, a summons, a prayer, or even a growl. In the light of that challenge, Valerie

[1] See Agamben's treatise on the status of art in the modern era, *The Man without Content,* tr. Georgia Albert (Stanford UP, 1999). In discussing the aesthetics of G.W.F. Hegel, Friedrich Nietzsche, Martin Heidegger, Walter Benjamin, Franz Kafka, and Charles Baudelaire, Agamben concludes that aesthetics "is unable to think of art according to its proper statute, and so long as man is prisoner of an aesthetic perspective, the essence of art remains closed to him" (102). It should be noted, however, that Agamben is mostly concerned with aesthetics as a philosophical enterprise, not with the artist's *aesthetic*, the self-conscious premise of his or her artistic principles and aims.

Mason-John, for instance, argues in her chapter that the *trans-raised* "black" British writer (at times against the grain of both "blacks" and "whites") takes perhaps the greatest aesthetic risks in an effort to communicate biting truths about social realities in the U.K. today. Others whose writings are included in this volume pronounce their own artistic trajectories as moving toward larger aesthetic freedoms, acquired through greater knowledge of and pleasure in the world's radiant traditions.

In this volume, we have collected a rich discussion on an array of thoughts, statements, and products of "black" artists at work in Britain today. These British citizens seek to have their say and to express their creative ideas in a wide variety of genres. Of course, today being what it is—an era of ever-present global mass media and of communications at the speed of light, a period also, some say, of colossal collisions between contending cultures—Britain stands at an interesting junction in regards to the world and its peoples. It has offered itself not merely as a *pied à terre* for travellers from its former dominions, but as a place of permanent residence for individuals from around the world seeking political asylum at its shores. Since the end of World War II, waves of migrants from Britain's former colonies have joined the descendants of the historical Angles, Saxons, Normans, and other tribal influxes to the Albion Isles, and they are now all contributing willy-nilly to the creation of a new cosmopolitan nation.

The descendants of the most recent arrivants have been participating formally and enthusiastically since 1997 in the lively project of "Re-inventing Britain"—and doing so, it seems, with the Establishment's blessing. But to re-invent Britain will require, all are agreed, more than a series of constitutional reforms: it will take (as it always has in the past) brilliant and accessible works of the creative imagination. Never more than in the present day have artists been challenged to produce works that appeal to more than their solitary selves—works that convey something more than an image of their inner *tigritude* pacing in circles within the confines of their isolation. Re-inventing Britain will take something like a fresh aesthetic disposition. W. H. Auden may have been colossally off-beam in asserting that "poetry makes nothing happen." Nelson Mandela added a gloomy post-note to Auden's observation: "Poetry cannot block a bullet or still a sjambok, but it can bear witness to brutality—thereby cultivating a flower in a graveyard." With all due respect to Auden's ghost and Mr. Mandela, the arts—the works of the creative imagination—can do a good deal more than merely participate in the mournful horticulture of burial-ground flowers, as the essays in this book emphatically demonstrate.

One major feature of the aesthetic of many current "black" British artists is a decided emphasis on a firm and purposeful (if not always cheerful) civility. As I have argued elsewhere, many of the writers publishing in the

United Kingdom today affirm *in no uncertain terms*[2] their fundamental commitment to advancing the cause of an egalitarian civil society in Britain, where most of them were born. Their basic dedication to this socio-political end underlies their aesthetics. It gives their creative work a certain amount of *gravitas*, even when their works are meant to be light-hearted, entertaining, or just plain funny. Indeed, theirs might be thought a difficult artistic tone to maintain while the West's zealous "war on terrorism" is going on and inter-ethnic paranoia (or fanatical mistrust of "others") is escalating in some quarters. Valerie Kaneko Lucas's chapter on "verbatim drama" shows what aesthetic strategies contemporary "black" playwrights are using to draw attention to *mainstream* lapses of civility and justice—Lucas's point being that the tenor of the plays is not so much *anger* over the unfairness of British systems of justice as insightful, compassionate *analysis* of how things go wrong.

In the light of these current realities, it is worthwhile to analyse how contemporary "black" British writers manage to reconcile their politics and their art, without compromising either. In general, the prevalent aesthetic—it seems to me—can be codified (roughly) this way: (1) Artworks must be socially engaged and sympathetically alert to contemporary ways of life. (2) They need to be psychologically rich and plainly representative of real social and moral dilemmas. (3) They should maintain and offer moral compasses that point to wise conduct, even when (fictional) characters may seem to be losing their way. (4) They should devise ways to demonstrate a healthy attitude toward change as well as respect for *valuable traditions*, whatever their provenance. (5) The brightest-lit moments in each work should bring into focus the artist's best thoughts and deepest feelings on these matters. (6) One of the best ways to accomplish these artistic ends is through a friendly sort of satire. The authors whose writing today glows most brightly with all six of these attributes are (according to critics and reviewers) Diran Adebayo, Monica Ali, Bernardine Evaristo, Anthony Joseph, Andrea Levy, Zadie Smith, and Benjamin Zephaniah. While they are not, by a long shot, clownish buffoons, they are the "comic hotshots" among today's "black" British writers. Patience Agbabi, Biyi Bandele, Diana Evans, Martin Glynn, Jackie Kay, S.I. Martin, Valerie Mason-John, Courttia Newland, Helen Oyeyemi, SuAndi, Meera Syal, and Alex Wheatle also create works attentive to contemporary states of mind and full of subtle wit and good humour. Their works may not be out-and-out riotous like those of the "hotshots," but, in adopting the essentially optimistic modalities of wit and social satire, they, too, manage their cultural critiques artfully and with a

[2] See my "Black American Bodies in the Neo-Millennial Avant-Garde Black British Poetry" in *Literature and Psychology* 40, 4 (2002): 47-80, esp. 52-53, 77; and "'Black' British Writing: An Introduction" in *Contemporary 'Black' British Writers / Dictionary of Literary Biography* (Sumter, SC: Bruccoli, Clark, Layman, in press).

smile. Among photographers, Joy Gregory in her *Cinderella Tours Europe* (2001) and Roshini Kempadoo in her *ECU-European Currency Unfolds* (1992)—to cite just two examples—register equivalent aesthetic qualities.

Jude Okpala's chapter in this volume addresses the differences between texts written by authors who focus on Africa and those who focus on Britain. In centring his discussion on such writers as Ben Okri, Biyi Bandele, and Chris Abani, Okpala makes the important point that the lenses of postcolonial critique, especially as these have been fashioned to examine works by expatriate Asians living in Britain, do not help us materially to clarify the aesthetics nor the historical realities that concern this band of (Nigerian-born) British writers interested in current affairs outside of Britain proper. Okpala's caveat strikes me as vital to our volume's purposes. His further point that what may appear fantastic or preposterous to one living within the relatively safe enclave of Britain may indeed be realistic (a shameful reality) and should be checked against facts before it is hastily relegated to this or that aesthetic or generic category (gothic crime, sci-fi, or fantasmagoria). Okpala's argument suggests to me that one seriously misreads the works of these writers if one does not recognize how much their aesthetics are confluent with the paradigmatic one sketched above, especially the part about representing *real* social dilemmas.

On the other hand, in a recent dialogue with London poet Dorothea Smartt (whose heritage is Barbadian), Jackie Kay (the "black" Glaswegian poet, novelist, and dramatist) said, "In our society right now, we are obsessed with fact and memoir, biography and autobiography, and what gets lost in all of that is the imagination itself."[3] In short, it is the artist's imagination, as Jackie Kay so appositely reminds us, which deliberately designs the appeal of the artwork; so, it is the artists' imaginations, rather than the particulars of their lives or the connections between their lives and their themes, on which we readers and scholars of the *artistic* productivity of our age should (most gainfully) be focusing. Jackie Kay, in that same interview, noted, "...it isn't really my job, in a way, to analyse my own themes or try to work out what I am doing, because then [an artist] can end up thinking, 'Oh, I am the kind of person who does this and then does it again" (10). Point well taken. It is *our* job as readers, critics, and scholars to pay attention to the part that imagination plays in the works created by "black" British artists and writers today—and this, precisely, is the objective of *"Black" British Aesthetics Today.*[4]

[3] "Jackie of All Trades, Mistress of Many" (interview of Jackie Kay by Dorothea Smartt) in *Sable: The LitMag for New Writing*, issue 9 (Autumn 2006), p. 9.
[4] Much has been written and debated, especially in the abstract, about the validity of aesthetics as a topic of inquiry today. For the best current scholarship on the topic, I strongly recommend the excellent collection of essays *Aesthetics in a Multicultural Age*, edited by Emory Elliott, Louis Freitas Caton, & Jeffrey Rhyne (Oxford: Oxford UP,

It is not an easy territory to negotiate, however—especially not *today*, as I have said. In addition, we are often reminded that distinct differences exist between *imaginative works of art* and their close cousins: those well-crafted artefacts associated with versions of clan ritual or with the straightforward conservation of established hegemonic traditions. While we should be mindful of such distinctions, I certainly do not mean to suggest that *imaginative art works* cannot exist to express political ideas or religious sentiment; they can, of course, and often do, as Koye Oyedeji, Magdalena Maczynska, Lauri Ramey, and Andrene Taylor take pains to explain in their chapters in this volume. Genuine art works, more often than not, have served extra-aesthetic purposes, including the endorsement of a hegemonic ideology or the exaltation of some purported spiritual quintessence. When they convey, respectively, political or religious intentions, those messages can be so ingeniously incorporated into the *design* of the creative work that the political or religious *ennoncé* becomes equal if not subordinate to the aesthetic experience offered to readers, listeners, or spectators. In such cases, it becomes necessary for art critics and literary critics to distinguish the particularities of the aesthetic expression from the work's social and religious functions. This need complicates our study of "black" British aesthetics today, given the overt and undeniable socio-political and ethnic orientation (or scope) of so much that is being produced. We need to know something of Nigerian belief systems to understand fully Helen Oyeyemi's, Valerie Mason-John's, David Nwokedi's, or Biyi Bandele's fiction about British youth of African heritage—as Koye Oyedeji and Jude Okpala point out. Samera Owusu Tutu discusses the politics that are inseparable from what, in her chapter, she calls the "resounding underground" of performance poetry in the U.K. Anthony Joseph sees avant-garde poetic experimentalism as a profoundly political statement in itself, especially when the literary establishment seems to recognize and to reward only poetry that sounds the "black" identity themes in acceptable, if not predictable, ways.

Some comparisons seem in order here, to clarify the issues. Who would argue that the initial experience one has, for instance, of the basilica of St. Peter's Cathedral in the Vatican is *not* (even for a Roman Catholic) an aesthetic one, sparked by a response (whether positive or negative) to the lofty and gilded architecture, the lighting of statuary, the staging of the religious paraphernalia? The same can be said for the ruins of Sacsahuamán outside Cuzco or the colourful painted villages of the Ndebele in Zimbabwe. Just so. These places were designed aesthetically, to appeal to more than the artists involved, whatever purpose besides an aesthetic one they may serve or have served.

2002). Of special note are Emory Elliott's "Introduction" to the volume; Winfried Fluck's "Aesthetics and Cultural Studies" (79-104); & Louis Freitas Caton's "Afterword" (279-293).

Similarly, Tolstoy's *War and Peace* and Chinua Achebe's *Things Fall Apart* are about the tugs of power and affiliation on a personal, a national, even an imperial level; yet, one would not call these novels primarily political tracts. The deliberate invention of character and situation and the attention to subtle traits of individual human conditions and aspirations lift the literary inventions out of the banal and self-serving category of mere clan ritual designed for the purpose of reanimating political solidarity. The works of novelists have, in short, very little in common with partisan political gatherings. The same may be said for the fiction of Diran Adebayo, Monica Ali, Biyi Bandele, Judith Bryan, David Dabydeen, Bernardine Evaristo, Victor Headley, Peter Kalu, Jackie Kay, Andrea Levy, Courttia Newland, Mike Phillips, Joan Riley, Ravinder Randhawa, Leone Ross, Zadie Smith, Meera Syal, Joanna Traynor, and Alex Wheatle—as well as for the plays being written and produced today by, for instance, debbie tucker green, Tanika Gupta, Kwame Kwei-Armah, Winsome Pinnock, Roy Williams or the raft of new "black" British playwrights: Rhashan Stone, Mark Norfolk, Pat Cumper, Maya Chowdhry, Valerie Mason-John, Gurpreet Kaur Bhatti, Dolly Dhingra, and Sol B. River. No matter what happens in a story, its audience often perceives in the "conflicts" of plot (whether in the theatre or on the page) various fundamentally social and political messages. The scholarship in our field has addressed the matter of social themes with verve and enthusiasm. Among the best recent work along these lines are John Clement Ball's *Imagining London: Postcolonial Fiction and the Transnational Metropolis* (2004), Gabriele Griffin's *Contemporary Black and Asian Women Playwrights in Britain* (2003), C. L. Innes's *A History of Black and Asian Writing in Britain, 1700-2000,* Bruce King's survey *The Internationalization of English Literature* (2004), John MacLeod's *Postcolonial London: Rewriting the Metropolis* (2004), James Proctor's *Dwelling Places: Postwar Black British Writing* (2003), Sukhdev Sandhu's *London Calling: How Black and Asian Writrs Imagined a City* (2003), Kadija Sesay's edited volume *Write Black, Write British: From Post Colonial to Black British Literature* (2005), Mark Stein's *Black British Literature: Novels of Transformation* (2004), and Michelle Wright's *Becoming Black: Creating Identity in the African Diaspora* (2004).

Published discussion of the aesthetic properties of the artworks of today's "black" British artists—and most especially of "black" British writers whatever the genre—is a much scarcer commodity. Samera Owusu Tutu's chapter in this volume breaks new ground by detailing the aesthetics of that most political of poetic genres, the black British performance poetry scene, and exploring the aesthetic connections between the U.K.'s poetry underground and the new "black" British mainstream. The essays of Tracey Walters, Magdalena Maczynska, and Roy Sommer provide useful mappings and the groundworks for future, serious study of today's "black" British fiction.

What were their creators thinking when they designed their artworks? What particular objectives had they in mind? Are today's "black" British architects, artists, composers, dramaturges, filmmakers, hip hop artists, multimedia artists, novelists, poets, photographers, playwrights, sculptors, and writers of works in new hybrid genres enunciating their tigritude or taking it for granted—and how do their diverse imaginative stances affect their deliberate designs? Such are the questions about British arts today that are raised and answered in the essays that follow. We have direct answers to many of these questions in the artistic manifestos included in this volume—the chapters by Diran Adebayo, Anthony Joseph, Roshini Kempadoo, Sheree Mack, Michael McMillan, and SuAndi. Yet, these writers and artists also raise wide-ranging questions about aesthetics today. We are most interested, in this book, in exploring the dimension of imagination as it is invested in "black" British artworks of our own day—and in discovering ways of appreciating what motivates the artists who are producing this particular body of aesthetic objects.

"Black" British Aesthetics Today answers two important questions: *What precisely is "artistic" about current black British art?* and *Why is this question so important?* To answer those questions, it is imperative—at the outset—to approach the subject from the standpoint of the artist. So far, there are no competing publications that I know of, although there are many to which this particular collection serves as a sequel (see this book's Bibliography).

This book contests and rebuts the idea that the whole subject of aesthetics is an effete one, best not engaged in literary study today, and counters Giorgio Agamben's thesis that humanity (he, in fact, used the term *"man"*/ *"uomo"*) can no longer relate to tradition. In contrast to the affirmations of the scholars included in this introductory unit of our book, Agamben's thesis, though gaining recognition in academic circles, sounds an irrelevant chord, quite dissonant in our framework and completely at odds with the tenor of what Andrene Taylor, SuAndi, and Jude Okpala have to say in their chapters about the vitality of the links between today's "black" British artists and writers and their antecedents. Because the breach between Agamben's popular thesis and the aesthetics of contemporary "black" Britons is so marked, it would be unwise to pass over his claims without comment. In his provocative chapter "The Melancholy Angel," Agamben wrote:

> The interruption of tradition, which is for us now a *fait accompli*, opens an era in which no link is possible between old and new, if not the infinite accumulation of the old in a sort of monstrous archive or the alienation effected by the very means that is supposed to help with the transmission of the old.... Suspended in the void between old and new, past and future, man is projected into time as into something alien that incessantly eludes him and still drags him forward, but without allowing him to find his ground in it. (*The Man without Content,* 108)

In *Outside Literature* (1990), Tony Bennett, the British cultural critic, is far less phlegmatic about the position of the arts in contemporary life than his near age-mate, the Italian philosopher. In his anti-elitist, materialist critique of the whole trajectory of philosophical disquisitions on aesthetics, Bennett agrees with Bertolt Brecht, who suggested quite simply that "we should abolish aesthetics." While, like Brecht, Bennett considers the philosophical enterprise of aesthetics a "useless" attempt at describing a universalising system, he does not go so far as to deny "the political utility of discourses of value"—and, instead, warns against "class-specific aesthetic norms" and bourgeois hegemonic projects that are essentially attempts "which serve as a blockage to both political analysis and cultural policy formation" (*Outside Literature*, p. 166). While he does not call it an aesthetic, as such, Bennett nevertheless subscribes to the notion that an artist does *indeed* formulate his or her own local and specific *discourse of value* within an economy of competing political force fields. It is a useful postulate, which, I find, echoes in diverse ranges and registers through the chapters that follow. I think that what Bennett's calls "discourse of value" is the antecedent to the aesthetic afflatus, which then inspires the artist to imagine a design for the work of art. We cannot "abolish aesthetics" and think seriously about art as such.

This collection of essays on "black" British aesthetics today is divided into four sections. Unit I (*The Sankofa Tradition: Looking Back to Move Forward*) takes up the topic of earlier aesthetic positions and practices out of which the artists and writers living and working in Britain today have emerged and to which they are still connected in important ways. Without explicitly contending with Giorgio Agamben's seductive argument (that the crisis for the artist today is that humanity has been severed from tradition), Andrene Taylor, SuAndi, and Jude Okpala map out the roads that connect current "black" British artists and writers with (or disconnect them from) predecessors, both recent and ancient. Unit I, thus, is foundational. In her chapter "Black British Writing: In the Tradition of Revolutionary Poetics," Taylor relates the writing of new "black" British novelists to the tenets of the African American Black Arts Movement. SuAndi, in her panoramic investigation "Cultural Memory and Today's Black British Poets and Live Artists," surveys "the existence of cultural memory" from the personal perspective of a British-born individual and writes of her one-on-one exchanges on this topic with a broad array of fellow artists who live and work in Britain. Bristling with references to the web-pages of fellow artists and studded with *à propos* comments in the form of personal anecdotes and her own poems, SuAndi's essay amounts to an aesthetic manifesto announcing the incalculable and irreplaceable value of cultural memory to the contemporary "black" British poet. To round off the unit, Okpala points to the stubborn affinities between postcolonial and "black" British

aesthetics, even in the face of strenuous efforts by literary activists, including Kadija Sesay, to distinguish the two; and, at the same time, he warns against too glib an application of the postcolonial critical apparatus to the works of today's writers of African backgrounds. In sum, Unit I takes up American, diasporan British, and postcolonial "residuals" in the works of today's "black" British arts practitioners, to show the many ways that traditions of various sorts play crucial roles in contemporary "black" British aesthetics.

Unit II (*Critical Theories and Aesthetic Movements*) offers eight stimulating chapters that look at our topic from an array of differing points of view. In "'Diaspora Wasn't Made in a Day': Reflections on Aesthetics and Time," Kobena Mercer traces a genealogy for "black" British aesthetics and names some of the specific cultural challenges confronting artists working in a range of media today, from architecture to arts curatorship. In "Situating a 'Black' British Poetic Avant-Garde," Lauri Ramey analyses various ways that poets have availed of both diaspora and avant-gardism to generate innovations either in synchrony with or opposition to recent aesthetic developments in Britain. Tracey Walters explores trends in the new "black" British literary criticism as they emerge from the aesthetics implicit in the works of today's writers. Koye Oyedeji takes up the idea of a "post-black condition" and relates it to currently perceived problems of artistic representation—for the "new" artists as well as the "new" audiences. Magdalena Maczynska investigates the aesthetics of realism in the new "black" fiction and elucidates its attraction. Avant-garde poet Joseph Anthony explains the resistance to avant-gardism among "black" artists and audiences and his own attraction to it. Samera Owusu Tutu brings to the discussion insights from the "poetry underground" flourishing in the United Kingdom. In his manifesto "'Pretty is the New Black: New Directions in Black British Aesthetics," Diran Adebayo, a "new" novelist himself, challenges artists and audiences to pay much closer attention to the writer's deliberate choices of poetic imagery, literary forms, and artistic devices that produce pleasure while highlighting the truth of a work's spin on reality.

Unit III (*Embodied Aesthetics*) takes our investigations a few steps closer to the individual art works and the creative imaginations of individual artists. In his chapter, Roy Sommer surveys the field of contemporary "black" fiction to indicate the richness of the stylistic choices evident there—and to suggest ways that an "intercultural narratology" would help to explain the aesthetic effects of the many formal strategies deployed by new "black" cosmopolitan writers. His point is that critics must be alert because the writers are, more and more, availing themselves of intercultural signifying systems and exploiting an incredible array of narrative strategies culled by writers with multicultural and multi-ethnic interests from the communicative strategies of artists and writers from all epochs and from around the world. Courtney Martin

centres her discussion on the cultural challenges of new media and explores the way one multi-media artist (Yinka Shonibare) imaginatively exploits a new, non-standard, public venue for the display of thought-provoking aesthetic objects. Meenakshi Ponnuswami concentrates her analysis of new aesthetic orientations in "black" British theatre by discussing the treatment of alienation and transnationalism in the plays of Winsome Pinnock. Deirdre Osborne unpacks for us the aesthetically motivated provocations implicit in the theatrical works of debbie tucker green and Dona Daley. Amna Malik concentrates on a film by Martine Attille to demonstrate aspects of a creolised "black" British aesthetics with roots in all quarters of the former British Empire. Valerie Kaneko Lucas explains the aesthetics of verbatim drama, using a set of current theatrical works that draw directly from the public record to elicit civic sentiment as well as aesthetically conditioned responses from theatre audiences. Roshini Kempadoo discusses her own aesthetic ideas and practices, the concepts and methods that have inspired her highly hybrid photographic artworks. Michael McMillan unpacks the aesthetics of West Indian domesticity and, further, explains the aesthetic appeal of an installation he curated in the U.K., which (in distancing and reifying aspects of the West Indian "front room") linked British history to current "black" British artworks in a whole spectrum of genres. Sheree Mack's chapter—in surveying specific cases of "black" women's authorship and authority—draws the conversation around to an aspect of our subject that she fears always suffers suspicious neglect: the volatile critical discourses surrounding "black" British women's aesthetics today.

Unit IV (*Activists in the Vanguard of "Black" British Aesthetics*) sets in motion, I anticipate, an on-going effort to recognize and to celebrate the work of a new generation of arts activists who, plainly, have devoted their intellectual energies to enlarging awareness of "black" British arts and aesthetics and who have sterling records of success in bringing worldwide recognition to what is new and special about artworks emerging from the U.K today. In this section, for starters, we highlight the lives and careers of Susheila Nasta and Kadija Sesay, whose critical insights and entrepreneurial work are integral parts of the overall representation of "black" British aesthetics today.

* * * * *

In chapter after chapter of this volume, it will be noted, a common, underlying aesthetic informs the productions of "black" British artists and writers today. The similarities (and some of the differences) in the topics and themes of this developing canon have already been explained socially and historically. The contributors to this volume want the world to pay attention to

the aesthetic idioms, the new shapes, the brilliant creative imaginations implicit in the artworks.

It is not beside the point to note that, about a group of twentieth-century African American writers, Johnella Butler, a distinguished American academic, wrote:

> The[ir] quest for wholeness suggests more than a revision of the way we view racism, slavery, and their legacies in everyday lives. It involves a change of world-view, and a struggle ensues in either consciously attempting to realize that change or, for African Americans, in living in accord with and utilizing the sustaining aspects of African-American culture.... That struggle is fuelled by the binaries of materialism and spirituality, the masculine and the feminine, good and evil, black and white—binaries that perpetuate the inhumanity of racism, sexism, hetero-sexism, classism, neo-colonialism, and the dominance over and the destructtion of the environment. ...their writing expresses the loss of something vital to the affirmation of humankind's frustrated need to understand and live through connections to one another and to the world. (180)

Butler contrasts the Western sense of reality ("*Logos*" and a binary approach to it) with the African sense of reality ("*Nommo*"). She summarizes the system of values resident in *Nommo*:

> connection to a usable but not a defining past; connection to other human beings; recognition of the connection and overlapping of discourse if not in content, purpose, or process, then in time or place, or even connected through opposition... all things negotiated as relative to the common good of humanity. (180)

There are salient and particular differences, of course, between the immediate concerns and aspirations of the American writers Johnella Butler discusses (Paule Marshall, Alice Walker, Toni Cade Bambara, Gloria Naylor, Julie Dash, Jean Toomer, and Ishmael Reed) and the concerns and aspirations of the writers and artists included and/or discussed in this book. But Butler's injunctions not to forget about *Nommo* are apposite. It is impossible not to recognize a family resemblance between (a) Butler's distillation of the aesthetics of some of today's African American writers and (b) the powerful, embedded discourse of inclusive and communitarian values which—whether we call it *Nommo* or something else—conditions the artistic manifestos and creative productions of this newest generation of "black" British artists.

Works Cited

Agamben, Giorgio. *The Man without Content*. Translated by Georgia Albert. Stanford: Stanford U P, 1999.

Bennett, Tony. *Outside Literature*. London and New York: Routledge, 1990.
Butler, Johnella E. "*Mumbo Jumbo*, Theory, and the Aesthetics of Wholeness." In *Aesthetics in a Multicultural Age*, edited by Emory Elliott, Louis Freitas Caton and Jeffrey Rhyne. Oxford: Oxford University Press, 2002. 175-193.

UNIT I

THE SANKOFA TRADITION: LOOKING BACK TO MOVE FORWARD

The role of the African artists today is to begin the process of developing a language that enables us to communicate across ethnic, tribal, national and geographical boundaries; however, it should use the elements of the various ethnic, tribal, and national groups to achieve this end. But, before we can begin that process, it is necessary for us to acquire a greater understanding of our traditional art forms and culture, specifically its purpose within our ancestral societies. Within most traditional African societies, there was no such thing as "art for art's sake." Art was an integral part of the life of the community; it was not separate nor was it solely the artist's prerogative to express his personal desires and inclinations. Art was the means by which sacred history served the function of revealing those invisible dimensions that gave support to transcendent ideals. For without sacred history, self would have no relationship to family, family would have no relationship to community; community no relationship to world, and world no relationship to Creation. Those traditions are not dead, buried, and inert, unchanging things waiting to be rediscovered. They are living entities which must be constantly renewed, to enable us to make ourselves anew—new Africans in a contemporary, post-modernist world.

In today's African artist's work, we must see the eyes and hands of the contemporary artist, looking anew, not at, but through, the prism of an African aesthetic speaking in a new world with the voices of the ancestors; voices for so long silenced; in doing so, their art will offer new generations the opportunity to look again with fresh eyes, to see themselves in new ways.

—George Kelly Fowokan, SPS, Sculptor

CHAPTER ONE

BLACK BRITISH WRITING: "HITTING UP AGAINST" A TRADITION OF REVOLUTIONARY POETICS[1]

ANDRENE M. TAYLOR
HOWARD UNIVERSITY

> Tradition ... cannot be inherited, and if you want it you must obtain it by great labour.
> —T.S. Eliot, "Tradition and the Individual Talent" (1919)

> The grace with which we embrace life, in spite of the pain, the sorrows, is always a measure of what has gone before.
> —Alice Walker, "Fundamental Difference" (1970)

> Implicit in the writer's situation is the cumulative effect on that tradition upon the culture of his times. One could say that the writer is essentially a creation of the books he has read.
> —Larry Neal, "The Writer as Activist?" (1976)

As critic Michelle Joan Wilkinson suggests, "A concern for tradition represents not the failure to relinquish the past, but the responsibility to remember it. Tradition is itself a politic of cultural memory—to adopt the subtitle of Kary Nelson's *Repression and Recovery*. A tradition of revolution is one that reverses the rotation: such a tradition swings, pendulum-like, up against the past with each stride it makes into the future." Today, I situate my conversation about Black British writing as "hitting up against" the tradition of revolutionary poetics of the Black Diaspora. The tradition is marked by the

[1] Title inspired by Michelle Joan Wilkinson's "In the Tradition of Revolution: The Socio-Aesthetics of Black and Puerto Rican Arts Movements, 1962-1982."

presence of ancestors, real or imagined, and it is always implicitly or explicitly political.

Kadija Sesay, in her introduction to *Write Black, Write British: From Postcolonial to Black British Literature*, argues that the current generation of Black British writers is pushing beyond the category of postcolonial. In Sesay's view, this generation has a different "take" on Britain because they are writers born and educated in Britain (16). Nonetheless, the writings of these authors reflect an aesthetic of literary resistance that expands beyond the geographical plane of England. Authors such as Patience Agbabi, Courttia Newland, Chris Abani, Lorraine Griffiths, Bernardine Evaristo, Diran Adebayo, Jackie Kay, Dorothea Smartt, and others are a part of a tradition which extends to the shores of Africa, America, and the Caribbean.

While I am aware that young Black Britons are strongly connected to the English literary tradition, it is my argument that their new movement is an extension of a larger African diasporic tradition that includes but is not limited to the Negritude Movement, the Harlem Renaissance, and Black British writing's most immediate predecessor, the Black Arts Movement. My particular interest in this essay is to trace the African American connections in the writings of today's Black British writers. As Lauri Ramey points out in "Contemporary Black British Poetry," "African American poets are often cited as having served as role models and voices of permission for many contemporary Black British poets" (116). Instead of suggesting that these writers are performing a radical break from their literary predecessors, I argue that this generation is in the process of innovating many of the themes, re-shaping, re-vitalizing, and expanding many of the aesthetic features present in the work of their literary predecessors.

Black British writing is, thus, created within a framework of multiple relationships. The tensions among the relationships of race, identity, culture, and history converge and create a series of thematic and structural continuities and discontinuities that work within and against a tradition of revolutionary poetics. The tradition is defined by common themes while manifesting technical transformations. The tradition is also defined by the function of the poetry, which is to raise individual consciousness in order to create social and political change.

The tension among the various relationships in the literature can be best understood in the poets' use of the "ancestor." In "The Ancestor as Foundation," Toni Morrison argues that it is "interesting to evaluate Black literature on what the writer does with the presence of the ancestor" (201). Morrison describes the ancestors as a "timeless people whose relationships to the characters are benevolent, instructive, and protective, and they provide a certain kind of wisdom" (201). While Morrison references the ancestor in terms

of the novel, the ancestor is manifested in poetry as well. Farah Jasmine Griffin's use of the concept in *Who Set You Flowin': The African-American Migration Narrative* is in line with my assertion. In her text, Griffin extends Morrison's concept of the ancestor in terms of "ritual, religion, music, food, and performance," and she adds: "His or her legacy is evident in discursive formations like the oral tradition. The ancestor might be a literal ancestor; he or she also has earthly representatives we may call elders" (426). In terms of theme and structure, the ancestor is clearly present in Black British writing.

Take for example, Dorothea Smartt's Medusa poems from her collection *Connecting Medium*. In that series, Smartt constructs Medusa as everyday women—mothers, grandmothers, and godmothers—and revolutionary women. In the poem "Medusa: Cuts Both Ways," Smartt writes,

> Medusa is Nanny
> Medusa is Assata Shakur
> Medusa is Cherry Groce
> Is Eleanor Bumpers is Audre Lorde
> Is Queen Nzinga Sarraounia…. (60)

The poem appropriates the image of Medusa to include women, who in their own ways, serve as examples of resistance to a patriarchal order. According to critic Laura Griggs, Smartt uses the myth of Medusa to challenge patriarchal myths and effectively unlearn gender submission (191).

While Griggs's assertion is no doubt correct, Smartt is doing more than merely re-writing the Medusa myth: she is following a black storytelling tradition. In his study of Harlem Renaissance poetry, Sterling Brown states that one of the five areas of the new poetics was the use of the black heroes and events. According to Brown, the poetry of the Harlem period reflects an expression of historical and racial pride. The result of such a shift of attitude is articulated in the five major concerns:

> (1) a discovery of Africa as a source of race pride (2) a use of Negro heroes and heroic episodes from American history (3) propaganda of protest (4) a treatment of the Negro masses (frequently of the folk, and less often the workers) with more understanding and less apology and (5) franker and deeper self revelation. (61)

Brown notes that it was not until the Harlem Renaissance that black poets of the diaspora began to use heroic figures as symbols and as part of their developing a mythology from within black culture.

Black Arts critic Stephen Henderson, in *Understanding the New Black Poetry*, reiterates Brown's assertion, doing so in the critical framework he provides to understand the poetry of the Black Arts Movement. According to

Henderson, the poets of the Black Arts Movement, similar to the poets of the Harlem Renaissance, utilize heroic figures and events. To illustrate his point, Henderson references Black Arts poets Don Lee's (aka Haki Madhubuti) and Sonia Sanchez's use of John Coltrane, and Mari Evans's use of Margaret Danner. While Henderson makes it clear that the poets of the Black Arts Movement are writing within the tradition, he claims that their emphasis is different. Namely, the writers of the Black Arts Movement are writing directly to a black audience with a more informed understanding of black history and identity. Indeed, according to Larry Neal in "The Black Arts Movement," the poetry of this movement has a "concrete function, an action" (125). The tradition of revolutionary poetics calls for a transformation of cultural symbols, an unsilencing of history, and a (re)construction of black identity in its various modes of interpretation.

In light of Henderson's and Brown's analysis of black poetics, Smartt's poems both follow and depart from the tradition. For example, Smartt uses a "classical" archetype in Medusa, who is not typically a symbol in the African diasporic literature. At the same time, the poem announces a part of Medusa's history that has been erased, namely "Medusa is Black!" Not only is Medusa black in the sense of racial identity, but she shares in the collective experience of black women's resistance. Nanny and Assata Shakur are maroons; Nanny ascended into the hills of Jamaica in an effort to escape slavery; Assata Shakur escaped America's penal system and was marooned in Cuba. Smartt is certainly referencing ancestors.

The calling of the names and invocation of personal histories is an earmark of the story-telling tradition. The calling of names is of significance because it is a way of acknowledging the history and acknowledging the gifts and sacrifices of one's ancestors. Smartt's technique of calling the names of Nanny, Assata Shakur, Audre Lorde, and so on, signals an "expression that has grown directly out of traditional people's belief in the strong relationship between name and personal essence and the corresponding [black diasporic] preoccupation" with naming and identity (Williams 186). So, when Smartt traces her Medusa "motherlines," she is not merely creating a distinct voice for herself as a poet and an identity for herself as a Black British woman, she is writing herself into the Black Diasporic tradition. Smartt's invocation of heroic figures is in line with previous generations of black poets' preoccupation with acknowledging a history that may otherwise be erased. The continuity of the technique is present in the poems of Robert Hayden, Margaret Walker, Amiri Baraka, Ted Jones, Reginald Butler, Kamau Brathwaite, and Rita Dove. And, while Smartt works within the continuity of the story-telling and poetic expressive tradition, she reshapes it.

To best understand how Smartt reinvigorates the tradition, it is necessary to examine the orality of the text. Stephen Henderson, Sherley A. Williams, Henry Louis Gates, Jr., Kamau Brathwaite, and George Lamming are among the many critics and theorists who argue that much of the writing by people of African descent operates on both an oral and a written level. Smartt's Medusa poems are aligned with this assertion. The repetitive "Medusa is" in "medusa: cuts both ways" adds a rhythmic quality to the poem illuminating the verbal strength of the piece:

```
Medusa is Nanny
Medusa is Assata Shakur
Medusa is Cherry Groce
is Eleanor Bumpers                              is Audre Lorde
is Queen Nzinga                 Sarraounia
QueenMother                     is godmother
                                our mother
Medusa is our mother's mothers

                                myself all coiled into one
Medusa is spirit
Medusa in you is you in me
                                is me in you
Medusa is my shield.... (60)
```

If read silently, the poem could remain "inert on the page," and its rhythmic effects would be lost (Henderson 35). The narrative voice announces who "Medusa is" through a series of comparisons. Although the references appear simple, they create a polyphonic effect, implying that the voices of history and time people the text. By the time the speaker gets to the fourth line, the "Medusa is" refrain disappears and "is" becomes the dominant sign in the poem. Without the word *Medusa* preceding the linking verb *is*, the poem's language transforms from the literary (with its device of comparison) to a mathematical mode, in which *is* stands for the prime number *one* and as an equals sign. By the end of the poem, the phrase "Medusa is" returns and establishes a sense of closure. By inserting "is" between Medusa and heroic Black women, Smartt enables the history of the women to exist on the same level. The technique allows Smartt to collapse the hierarchies of history and to connect women's resistance across racial, historical, cultural, and geographical boundaries.

The linguistic technique Smartt employs brings together the written and the oral, the real and the imaginative, in what Stephen Henderson calls "mascon images"—i.e., "a massive concentration of Black experiential energy which powerfully affects the meaning of Black speech, Black song, and Black poetry" (44, my emphasis). According to Henderson, mascon images derive

from mascon words, which are words that have "complex associations" and that "carry an inordinate charge of emotional and psychological weight" (44). Sherley A. Williams succinctly defines Henderson's concept: mascons are "not really images in the literal sense of the word, rather they are verbal expressions which evoke a powerful response in the listener because of their direct relationship to the concepts and events in the collective experience" (186). Henderson uses the word *roll* to explain mascon images. According to Henderson, the word *roll* is used in the following context: "'Rock and Roll,' 'Rollin' with My Making,' 'I'm Rollin' through an Unfriendly World,' and 'Let the Good Times Roll'" (Henderson 44). Whether being used in the days of the Black Arts and Black Power Movements or in the speech and song references of today, the complex "meanings connote work, struggle, sexual congress, dancing, having a good time," and movement (Henderson 44). As Henderson illustrates, mascons are dynamic signifiers.

Mascons not only "cut across areas of experience," they avoid "being clichés because their meanings are deeply rooted in a constantly renewed and thus living reality" (Williams 187). The Medusa persona that Smartt creates brings together a collective history of Black women's oppression and resistance. At the same time, the poems evoke a sense of personal resistance and transformation. According to Laura Griggs, Smartt's revision of the Medusa myth began when she was labelled Medusa because she decided to let her hair grow natural and lock-up her hair. According to Lauri Ramey, in "Contemporary Black British Poetry," Black British poets use their "art as a site for reclaiming the powers of identity and belonging that reinforce self and culture, past and present" (120).

Smartt's experience echoes that of generations of Black women who were made to feel less than beautiful if they did not chemically process their hair. In "Medusa? Medusa Black!" the narrator uses references that speak to the rituals of hair maintenance that millions of Black women go through in order to fit into narrow boxes of acceptable beauty:

> Scrub it bleach it operate on it powder it
> Straighten it fry it dye it perm it
> Turn it back on itself
> Make it go away make it go away. (57)

The ironic twist of the poem resides in the refrain, "Make it go away." Despite the repeated attempts to make the hair "go away," it keeps coming back. In light of this, Medusa's hair becomes the literal embodiment of distorted beauty mythology and the metaphoric terrain to do a collective self-critique. Words like "nappihead," "wildwoman," and "dread" are deeply rooted in the everyday speech of some Black people. The words and images reinforce the notion that

"[Black women's] hair as it comes / is just not good enough" (Smartt 58). And, while there is no denying that Smartt's poems are directly aimed at white patriarchal societies, they are also aimed at Black audiences.

The use of mascon images is an important strategy for young Black British writers because it allows them to transform worn words and ascribe new meanings to them. Moreover, it provides a means for this generation of writers to connect with artists across the diaspora. Take for instance Smartt's use of the term "nappiheaded nastiness" (58). The term was once meant to degrade Black people, men and women. However, Smartt makes the term a sign of valor, one that redefines beauty. And, in doing so, Smartt makes "nappiheaded nastiness," a mascon of immediate force, and an emblem of resistance. Thus, "nappiheaded nastiness" becomes a powerful sign of individual acceptance and collective redefinition of beauty. The "massive concentration of Black experiential energy" which Smartt's poetry creates is also apparent in Jackie Kay's *Trumpet*.

Like Smartt, Kay inserts aspects of her biography—a mixed race heritage, queer identity—in order to create a distinct voice about a particular Black British experience. The novel tells the story of Joss Moody, a half Scottish-half Nigerian transgendered jazz musician. The fact that Joss is transgendered—i.e., an individual who manifests characteristics and behaviours commonly associated with the other gender, e.g., male/female, female/male, and mixed race—deepens and complicates Henderson's ideas about Black experiential energy.

On the surface, it appears that Joss Moody's story does not register with the historical experience of black people across the diaspora. However, a deeper reading of Joss's performance and of the narrative techniques Kay employs to tell his story not only places *Trumpet* squarely in the tradition of revolutionary poetics, but also at the point of expanding the parameters that define it. Still, it is true that Kay was inspired to write *Trumpet* after learning about the white American musician Billy Tipton. Tipton was a saxophone and piano player who was assigned the gender of female at birth but lived her life as man. Tipton dressed in men's clothing, married several times, and adopted three sons. Upon his death, it was discovered that Tipton had female anatomy. Although Kay pulls from Tipton's biography, her novel invokes the spirit of African American jazz legends. From his mode of dress to his walk, Joss Moody embodies and transforms the jazz musician's aesthetic.

In "A Blues Way of Life: Literature and the Blues Vision," Eleanor W. Traylor explains that a jam session begins with musicians playing the same melodic line. For a time, the group plays in harmony, and then, each musician assumes the voice. In other words, each musician performs a solo. According to Traylor, the musician's solo becomes his improvisation of the melodic line: "The 'improv' or riff examines every aspect of the melody that the musician's

instrument is capable of, as well as every aspect of the musician's own feelings of the melody" (287). The riff is the musician's personal voice; it signifies his contribution to the composition. What makes the performance significant is that each musician offers a riff on the experience.

Kay's construction of Joss Moody begins the first of a series of riffs on the traditional jazz composition. The first site of the riff comes in the construction and placement of Joss. Unlike the fictional jazz figures in the works of Langston Hughes, Amiri Baraka, or the real jazz figures alluded to in the poetry of Nikki Giovanni, Sterling Brown, Haki Madhubuti, or Sonia Sanchez, the jazz icon that Kay creates does not exist in Harlem, he is not a part of the Chicago scene, or of the United States proper. Instead, Joss is a product of Scotland and England. Yet, Joss fits in the aesthetic representation of the jazz tradition. Kay's construction is innovative because it suggests that Joss can exist in what Max Roach calls the "royal family of jazz" (115). Everything about Joss's dress and style is reminiscent of some of the early jazz greats: Jelly Roll Morton, Charlie Parker, Louis Armstrong, Duke Ellington, Count Basie, Lester King, and Nat King Cole. Considering this, Joss's performance destabilizes past and current discourses of normative black identity. Kay's narrative use of Joss posits a way to re-imagine the discourses on authentic black identity through a transgendered, mixed-raced woman.

Like his contemporaries, Joss Moody was a man who had style: "He wore unusual shirts that had five cufflinks, specially ordered. Beautifully stitched. He never looked like he'd just got of bed. His trousers were always creased" (172). Colman, Joss's son, admires his father because his hair was always shining and his black skin always glowed. Another speaker admires how Joss Moody "never looked like he got of bed." By transposing the iconic jazz figure to a different place, yet suggesting that Joss Moody could exist at the same time as the legendary jazz musicians (the story begins in the 1950s), Kay not only makes Joss's identity visible; by creating a jazz musician in line with the characteristics of the real and imagined personas of the time, Kay also asserts her mastery of traditional African American literary conventions and cultural forms while maintaining her sense of narrative and stylistic individuality. Ralph Ellison, in "Living with Music," argues that the jazz musician develops his personal identity in the background of tradition. According to Ellison, the jazz musician "must learn the best of the past, and add to it his personal vision" (190). The riff that Kay creates becomes a way of injecting another voice into the tradition.

So, while Joss's dress is an "embodiment of masculinity," as Patrick Williams suggests in his article, "Significant Corporeality: Bodies and Identities in Jackie Kay's Fiction," it is Joss's rendering of black masculinity that makes his performance significant (43). However, Joss is not simply "performing

gender," to reference Judith Butler. In Butler's view, "gender is an identity tenuously constituted in time, instituted in an exterior space through a *stylized repetition of acts*" (179). For Butler, gender is a "performative accomplishment which the mundane social audience, including the actors themselves, come to believe and to perform in the mode of belief" (179). Butler goes on to suggest that the performance of a gendered identity is a political act, one that destabilizes essentialist notions of femininity and masculinity. Instead, Joss is in the process of creating something new, that is, a new way to engage the mixed-race character that is not tragic, but transformative.

The fact that Joss makes the decision to take on the persona of an American-style Black man, at a time when discrimination against Black men was prevalent, is a sign of defiance. Moreover, Joss's transgendered identity interrupts discourses of mulatta characters deployed in early African American fiction, such as *Clotelle, or the Colored Heroine, A Tale of Southern States* (William Wells Brown, 1867), *Iola Leroy, or Shadows Uplifted* (Frances Ellen Watkins Harper. 1892), or the characters associated with the Harlem Renaissance writers: Nella Larsen's *Quicksand* (1928) and *Passing* (1929) and Jessie Fauset's *There is Confusion* (1924). A character like Joss Moody goes beyond Alice Walker's assertion that early African American novels' representation of mixed-raced characters symbolize a "fatal social vision" or Barbara Christian's argument that mulatta figures gave Black women claim to "the cult of true womanhood" (a dominant discourse of the nineteenth and early-twentieth centuries). As Joss is not deployed to contend with the same historical, political, and social baggage as those mixed-race counterparts, he has the ability to transform notions about race, gender, culture, and identity. It is my contention here that the transformative possibilities of the jazz motif enable such a creation.

The voice that Kay introduces into the tradition shares the collective history of Black people's struggle and resistance across the diaspora; it is not burdened by the past. For example, when Joss's son, Colman, asks him about his grandfather, Joss makes up a series of stories about men across the diaspora. He begins with the story of an African man marooned in Glasgow, Scotland; then he goes on to tell the story of a Black American man who left the States because of the racism; Joss ends with the story of a rootless Caribbean man with no name or claim to any particular island. He finally tells Colman, "you make up your own bloodline" (58). Joss's suggestion likens identity, and by extension history, to an imaginative process. Joss's declaration to Colman is part of the jam session performance of the book as a whole.

Bernard Bell in *The Afro-American Novel and Its Tradition* notes "the initiation rites ... [that] challenge the individual musician to define himself through improvisational solo flights upon traditional materials" (205). Such a challenge is significant for Colman. In the aftermath of discovering that his

father was born a biological woman, Colman is charged with the task of deciphering his own identity. For Colman, everything about his coming into manhood—going through puberty and learning to shave—appears false. After Colman goes back over his "whole life with a fine-tooth comb," he comes to realize that, despite the fact that he was unaware that Joss was a woman, Joss was his father and their relationship was real. Colman's catharsis is an extension of Henderson's concept of experimental energy.

In theorizing about the ancestry of African American literature, Eleanor W. Traylor argues that the "blues-jazz experience of African-American sensibility is not merely an occurrence in music; it is also an occurrence in language" (288). Among the examples Traylor cites to illustrate her point are Jean Toomer's *Cane*, Ralph Ellison's *Invisible Man*, and Toni Morrison's *Song of Solomon*. As Traylor explains each author's nuanced way of writing—from Toomer's amalgam of prose, song, and poems; to Ellison's improvisational use of language through representations of ritualistic jive talk and double edged satire; to Morrison's use of folktale and narrative digressions—the blues-jazz experience allows the language to become a site of a collective mood of expression that is rife with diversity. And, thus, in *Trumpet* it is in the poetic use of language that the reader is able to experience Henderson's concept of massive concentration of experiential energy.

Henderson's concept is further evidenced in the narrative style of *Trumpet*. The vocalization of the text echoes the jazz structure. The narrative of Joss's triumphant and tragic tale is told in a series of riffs, departures, digressions, repetitions, and spontaneous acts of narration that resembles a jam session. Kay's narrative is peopled with voices. The primary voices that tell Joss story are those of his wife, Millie, his son Colman, and the overzealous reporter Sophie. At different intervals in the narrative, secondary voices—those of the registrar Mohammad Nassar Sharif, the funeral director Albert Holding, the cleaner Maggie, Joss's drummer Big Red McCall, and Joss's mother Edith Moore—break into the narrative to tell part of Joss's tale. Each voice is a carrier of a part of Joss's story. Kay's narrative strategy echoes that of a jam session in which each solo performance becomes an integral part of the whole composition.

The narrative's voices go through a series of riffs and improvisations. The novel opens with the section "House and Home." Here, readers are introduced to Millie, Joss's wife. Millie's narrative is consistently told in first person. Millie's narrative frames the mode of storytelling: digressions, flashbacks, breaks, and departures from the storyline. Each of Millie's riffs takes the reader through a journey of time and space. For example, there are glimpses into Millie's present predicament as the paparazzi-stalked widow of the famed jazz trumpeter, Joss Moody; then, there are snapshots of her as a

"fearless girl" climbing rocks and scaling hills; and finally, there is the picture Millie paints of her relationship with Joss. While Millie's story pulls together an image of Joss as a husband and lover, Colman's story brings together the picture of Joss Moody as a man and father.

Colman's narrative fluctuates between first and third person. The movement between narrative voices occurs because part of Colman's story is framed in an interview format. The first person narratives occur when Colman is revealing the life he shared with his father to Sophie Stone, the reporter assigned the task of exposing Joss's story. Through a retrospective narrative charged with irony between the formerly innocent and currently knowledgeable Colman, we learn to question what is real or imagined. At one point in the narrative, Colman believes that he could possibly be "living in some weird Freudian dream, some fucked-up dream" where he did not know his father, his mother, or himself (60).

Underlying Colman's quest for wholeness is the musical technique of improvisation. For Colman, the coherent narrative of his life as "'Joss Moody's son'" begins to fall apart when he learns that his father inhabited a woman's body (45). Though he remembers playing with his father's trumpet, being placed on his father's shoulders, and fishing with his father, none of it seems real. As the novel progresses, Colman begins to realize that his identity is not completely dependent on that of Joss Moody. For example, Colman's "longest memory" is of Millie chastising a man on the bus for calling a Black man an ape. Though he was embarrassed by his mother's raging reaction, the moment forced Colman to see himself. He confesses to the reporter Sophie, "I was scared people were staring at me. It made me look at my own colour of skin when I got home. Maybe that was the first time I really noticed it. And I was sort of surprised by it" (54). Colman's recollection of this event is significant because it does not involve his father. By recalling this moment, Colman creates an important departure from his father's story in the same way the musician in his solo performance departs from the established melody. Here, the theme—"you make up your own bloodline"—is textured through the structure of the story telling.

While the specifics of Joss's story are not quite akin to the tradition of revolutionary poetics of the diaspora, there is a sense of continuity and familiarity in Kay's style. On one level, the text is similar to Jean Toomer's *Cane*. Like *Cane*, *Trumpet* is an amalgam of narrative forms: prose vignettes, interviews, letters, and song lyrics. At the same time, the text is reminiscent of Ralph Ellison's *Invisible Man*. Like Ellison, Kay uses the jazz motif to tell the story of individuals learning to become more human, just as Ellison's nameless narrator does. Though there are similarities among the texts, there are evident differences. Unlike Toomer and Ellison, Kay does not have access to African American folklore.

However, Kay does have access to the collective folk culture of the diaspora. Evidence of this occurs with the introduction of Joss's voice. In an attempt to answer Colman's questions about his "bloodlines," Joss writes that his story—that is, Joss's, his father's, and Colman's—is the story of the diaspora. Using the image of water, Joss explains, "Every story runs into the same river and the same river runs into the sea" (271). The metaphor suggests that the different histories of people's lives eventually collapse into the same time and place. In other words, the stories Joss had once offered Colman about Black men from Africa, America, and the Caribbean are as much a part of their lives as any story Joss could offer him about his true bloodlines. What becomes clear in Joss's assertion is the need to (re)create and (re)define history and tradition so as to make it one's own.

As fascinating and ambitious as Joss's assertion is, it does not forsake what binds Black people together across the diaspora: the music. The music is part of Joss's identity and Kay's own narrative bloodlines. Kay devotes a whole chapter ("Music") to a description of Joss's experience of playing his trumpet. Joss's performance echoes the beauty and horror of his people in history. The pain and agony of his experience is what mirrors their experience. At the same time, there is triumph and joy. Kay takes all of this and puts it into a rhythmic language.

> ... he gets down ... he loses his sex, his race, his memory. He strips himself bare, takes everything off, till he's barely human. Then he brings himself back, out of this world. Back, from way. Getting there is painful. He has to get to the centre of the whirlwind, screwballing in musical circles until he is nearly out of his mind. The journey is so whacky, so wild that he sometimes fears he'll never return sane. ... [131] There is music in his blood. [134] ... All of his self collapses—his idiosyncrasies, his personality, his ego, his sexuality, even, finally, his memory. All of it falls away like layers of skin unwrapping. He unwraps himself with his trumpet. Down at the bottom, face to face with the fact that he is nobody. The more he can be nobody the more he can play the horn. Playing the horn is not about being somebody coming from something. It is about being nobody coming from nothing. The horn ruthlessly strips him bare till he ends up with no body, no past, nothing. (135)

The description of Joss comes to the reader from the narrator in the section titled "Music." The passage alludes to how music (and art for that matter) allows an artist to unmask and journey toward a sense of self. Here, the reader gets the sense of the double-voice in Kay's text. The narrator expresses the tension between culture and identity. While Kay alludes to an iconic African American figure, there is also a sense of a rejection of that identity. Yet, the rejection of identity the text posits is filled with tension. The music, then, becomes a way to (dis)connect and (dis)engage as a way to show bloodlines and cultural ties.

According to Eleanor Traylor, the language of literature becomes a way to preserve the memories and contributions of the ancestors. A central feature of the tradition of revolutionary poetics is the working within an established form and then "hitting up against the tradition."

In light of this feature, I suggest that ancestral traditions extend to the shores of Britain, arise in the works of Patience Agbabi, Courttia Newland, Chris Abani, Bernardine Evaristo, Lorraine Griffiths, Diran Adebayo, Dorothea Smartt, and climax again in the writing of Jackie Kay. As Kadija Sesay points out in "Transformation in the Black British Novel," the character of the most recent Black British literature can be identified by changes in regard to the themes of identity, imagery, and language (101). The shifts that Sesay mentions are evident in Smartt's poetry and Kay's novel.

However, more than transforming the Black British novel, this generation of writers is expanding the meaning of revolutionary writing. They are doing so by re-imagining and re-appropriating diasporic traditions and mythology and clearing a way for the new writing being produced as "talking texts"—to reference Henry Louis Gates's discussion of signifyin' in the black literary tradition. According to Gates, the phrase "talking texts" denotes the way black texts "talk" to other black texts. Gates asserts, "Black texts signify upon other black texts in the tradition by engaging in what Ellison had defined as implicit formal critiques of language use, of rhetorical strategy" (xxvii). The literary echoes in black texts constitute a way of revising and extending the literary tradition.

The phenomenon is visible in Bernardine Evaristo's *The Emperor's Babe*, the politically and emotionally charged poetry of Chris Abani, and the mysticism of Diran Adebayo's *My Once Upon A Time*. Adebayo transforms the traditional Western fairy tale by adding elements of African mysticism. At the same time, adept readers will find Adebayo's digression about cricket to be an intertextual link to Caribbean writer and theorist C.L.R. James.

Today, Black British writing does not reflect the same level of political and social urgency as past revolutionary movements. Perhaps, what is revolutionary about Black British writing today is that young writers are not just writing to "confront the contradictions arising out of the Black man's experience in the racist West," which Larry Neal asserted was one of the goals of the Black Arts Movement (257); but, instead, they are writing to expand the meaning of revolutionary black writing. In the past, the lack of identity violates and brings violence to the identity politics of the revolutionary poetics of the 1960s and 1970s. Today, Black British writers are not only challenging identity politics, but also illustrating the multiple ways in which identity, and the expression of identity are manifested and can be articulated. And, in doing so, this current

generation is illustrating the multiple modalities of their literary and cultural repertoire.

In referring to the role of the Black artist in America, Amiri Baraka has argued that the role of the artist is to "report and reflect so precisely the nature of the society, and of himself in that society, that other men will be moved by the exactness of his rendering ..." (169). In Black British writing today, the idea is to create art that is reflective of the writers' cultural, social, and political understanding of the world. In light of this, what is revolutionary about the writing being produced today by Black writers in Britain is that they are taking from black traditions across the diaspora and creating a *massive concentration of black experiential energy* that reflects the British landscape and communities to which they belong. And, in so doing, these writers are at the beginning of creating a new tradition built on previous traditions of black literature.

Works Cited

Baraka, Amiri. "State/meant." in *The Leroi Jones/Amiri Baraka Reader*. William Harris, Jr., ed. NY: Thunder Mouth Press, 1991. 169-170.

Brown, Sterling. *Negro Poetry and Drama*. Ny: Arno Press, 1969.

Gates, Henry Louis, Jr. *The Signifying Monkey: A Theory of African-American Literary* Criticism. New York: Oxford UP, 1989.

Griffin, Farah Jasmine. *"Introduction in 'Who Set You Flowin'? The African American Migration Narrative."* *African American Literary Criticism: 1773-2000.* Hazel Arnett Ervin, ed.. NY: Twayne Publishers, 1999. 423-432.

Griggs, Laura. "Medusa? Medusa Black! Revisionist Mythology in the Poetry of Dorothea Smartt." In *Write Black Write British: From Post Colonial to Black British Literature*. Kadija Sesay, ed. London: Hansib, 2005: 179-92.

Henderson, Stephen. *Understanding the New Black Poetry: Black Speech and Black Music As Poetic References.* New York: Morrow, 1973.

Kay, Jackie. *Trumpet*. New York: Vintage Books, 1998.

Morrison, Toni. "Rootedness: The Ancestor as Foundation." In *African American LiteraryCriticism: 1773-2000.* Hazel Arnett Ervin, ed. NY: Twayne Publishers, 1999. 198-202.

Neal, Larry. "The Black Arts Movement." In *The Black Aesthetic.* Addison Gayle, Jr., ed. NY: Anchor Books, 1972. 257-274.

Ramey, Lauri. "Contemporary Black British Poetry." In *Black British Writing*. R. Victoria Arana and Laura Ramey, eds. NY: Palgrave Macmillan, 2004. 109-136.

Roach, Max. "Jazz." In *African American Literary Criticism: 1773-2000.* Hazel
 Arnett Ervin, ed. NY: Twayne Publishers, 1999. 113-16.
Sesay, Kadija. "Introduction" to *Write Black Write British: From Post Colonial
 to Black British Literature.* London: Hansib Publications, 2005.
—. "Transformations within the Black British Novel." In *Black British Writing.*
 R. Victoria Arana and Laura Ramey, eds. NY: Palgrave Macmillian,
 2004. 99-107.
Smartt, Dorthea. *Connecting Medium.* Leeds: Peepal Tree Press, 2001.
Traylor, Eleanor W. "A Blues View of Life: Literature and the Blues Vision." In
 African American Literary Criticism: 1773-2000. Hazel Arnett Ervin,
 ed. NY: Twayne Publishers, 1999. 285-289.
Wilkinson, Michelle Joan. "In the Tradition of Revolution: The Socio
 Aesthetics of Black and Puerto Rican Arts Movement, 1962-1982."
 Diss., Emory University, 2001.
Williams, Patrick. "Significant Corporeality: Bodies and Identities in Jackie
 Kay's Fiction." In *Write Black, Write British: From Post Colonial to
 Black British Literature.* Kadija Sesay, ed. London: Hansib, 2005. 41-
 55.
Williams, Sherley A. "The Blues Roots of Contemporary Afro-American
 Poetry." In *African American Literary Criticism: 1773-2000.* Hazel
 Arnett Ervin, ed. NY: Twayne Publishers, 1999. 179-191.

CHAPTER TWO

CULTURAL MEMORY AND TODAY'S BLACK BRITISH POETS AND LIVE ARTISTS

SUANDI. O.B.E.
POET, U.K.

The last night at the proms or, rather, Proms in the Park, the Manchester contribution to The BBC's Last Night at the Proms, is a wonderful tradition in the cultural calendar of the United Kingdom. And I do mean the *United* Kingdom because Welsh, Scottish, and Irish orchestras and audiences join the English locations via technology for an evening of classical music and song. I enjoy the Manchester gathering, hosted by the Lord Mayor in Heaton Park, the largest civic park in Europe; the light banter, the music, all of it, all of it until the final songs.

> Rule Britannia!
> Britannia rules the waves.
> Britons never, never, never shall be slaves.[1]

The flag waving is all well and good, but when tradition cuts raw, the ancestral memory makes it always the time for me to leave, and inevitably I find myself humming the following:

> John Brown's body lies a-mouldering (sic) in the grave,
> John Brown's body lies a-mouldering in the grave,
> John Brown's body lies a-mouldering in the grave,
> But his soul goes marching on.
> Glory, glory, hallelujah,
> Glory, glory, hallelujah,

[1] The poem "Rule Britannia" by James Thomson (1700-48) was put to music by Thomas Augustine Arne (around 1740) and is sung as an unofficial national anthem. Full text available online at http://britannia.com/rulebrit.html.

Glory, glory, hallelujah
His soul goes marching on [2]

...though I am pretty certain that, as a kid, I sang that it was his *boots* that kept marching on, even though his body was a-mouldering in that grave— somewhere between fighting the cowboys and Indians, as seen on TV.

It was many years later that I learnt of another John Brown. Not the young Scotsman who had lost his life in trying to free those slaves that the British were never to become (but who, instead, simply became slave traders). This other John Brown was a slave who was forced by Dr. Thomas Hamilton of Clinton, Georgia, U.S.A., to sit repeatedly in a heated pit until he fainted, as a test for remedies for heatstroke.[3]

Where (and how) do the rules of morality come into play when tradition and historical atrocities come into conflict with the awareness of some member sections of modern society?

I wasn't even standing on the edges of the arts world when my then- "Love of My Life" introduced me to African-American writers. He was studying American literature and had turned his full attention to Black writing and, thus, opened my knowledge, mind, and imagination to the same. Each book I read not only amazed me and hurt my heart, but often left me questioning my own family and its position within a Black community, which seemed, by comparison with America, absent of ritual, social cohesion, and networking with Black Movers and Shakers. Indeed, compared to the U.S.A., I was totally unaware of any British-based Black Cultural Leaders.

In America there were people who seemed to live out their lives on stoops, de-stringing green beans as all those magnificent heroes of the Black Power and Civil Rights Movement popped by to chat—*words that only grown- ups got a right to listen to.* (I am not quoting here simply being creative.)

It was not until I was in the same room with one of these writers.... Not a big, famous, gob-smacking-making-me-envious-of-her/his-creative-ability writer, but an African-American who had run, skipped, and giggled on the sidewalks outside the brownstones of Harlem as Jesse Jackson, John Coltrane, Malcolm X, Charles Mingus, Dr. King, and name drop, name drop, name drop had passed by to get a piece of granny's mouth-watering sweet potato pie.

It was this night that made me realise that I knew I had no shame of which to be embarrassed just because my growing-up days had only seen my mother stooped over a kitchen sink trying to make boiled potatoes interesting. I discovered that evening in the Studio Museum of Harlem that there was a hell of a difference between cultural memory and cultural fantasy.

[2] http://ingeb.org/songs/johnbrow.html.
[3] Source: Harriet Washington, medical journalist.

No wonder that, when I finally became comfortable with the professional title of Poet/Writer, I realised that I wanted to break the myth that there was only one definition of Black—a definition based on historical (ignorant) anthropological research on peoples whose differences are as vast as the continent of Africa herself; and that I also wanted to invest creative time into identifying similar experiences—from youth to womanhood of family and professional achievements and obstacles, and from generation to generation—of what it was to be Black *and* British.

But let me return for a moment longer to my pre-writing days—days as a consumer of literature, not a producer: years of living in a place where there was no one to share a memory that told of Black lives, Black achievers, and Black sorrow. My reading appetite as youngster, and into young-womanhood, was no different from anyone else's, I expect. I had never heard of Black literature, so I didn't try to find it. *Ebony Magazine* was the only publication I remember, and as it was full of images of clear-skinned folk with straight jet black hair sitting in sun-filled settings. It didn't really keep my attention. These images were as tantalising and impossible as anything else I presumed had come out of the Hollywood, which was where I thought all of America lived.

Astonishingly, move forward to 2000/1/2/3/4/5/6, and search the Internet for Black British writers. With the exception of friend and colleague Lemn Sissay, [4] Benjamin Zephaniah,[5] and, in recent times, the so-called newly-established writers, like Courttia Newland, [6] the majority of the names you will find do not identify as Black British: for instance, Jean "Binta" Breeze,[7] John Agard,[8] Valerie Bloom,[9] and, of course, the wonderful master of lyrical poetry Linton Kwesi Johnson[10]; simply because they were not born and raised in the U.K., their stories and their living cultural memories have a different starting point. Though we all in time "begin the begine" in an African or South Asian tradition (Indian, Pakistani, and further into the continent), the tradition we inherit travels out to where we are raised, and that location has a massive effect not only on what we write, but also on how we write (or record) it.

I am well aware that I am here slightly confusing the novelist with the poet. But, for me, we are all the orators of our time.

[4] http://www.lemnsissay.com/.
[5] http://www.benjaminzephaniah.com/.
[6] http://www.myvillage.co.uk/urbanfactor/courttianewland.htm.
[7] http://www.lkjrecords.com/jeanbintabreeze.htm.
[8] http://www.contemporarywriters.com/authors/profile/?p=auth162.
[9] http://www.valbloom.co.uk/.
[10] http://lister.ultrakohl.com/homepage/Lkj/lkj.htm.

I was too young to appreciate Sam Selvon [11] and was quickly disappointed with Salman Rushdie[12] and Hanif Kureishi,[13] mainly because they were not born on this spit of land called England. Their stories (for me) followed the tradition of high literature, as in English style. So, small wonder that I would become so grateful for the knowledge and rise of Fred D'Aguiar,[14] Bernardine Evaristo ,[15] and, coming in fast behind, Andrea Levy,[16] Valerie Mason-John,[17] and so many others that I dare not list them for fear of forgetting someone. The one thing I do know is that, had the media attention that focused on Zadie Smith indulged its reading time more widely, then a lot more Black writers, prior to her publication and since, would be on the bookshelves of the bigger retailers.

Where am I in all of this? There's a fact that you, the reader, need to know before continuing or discarding my opinion as lacking a sound starting point.

Well, I grew up half caste, spent my teens as "coloured," and matured as Black, and though I have been Black as a political identity ever since, in the arts my ID has suffered from several layers of imposed labels and pigeonholing that have sometimes taken me to the verge of madness (which, as you will know, is a recognised clinical ailment that "my people suffer from along with aggression"[18]).

I am the Nigerian daughter of a Liverpool mother, and identify myself Black! One of the earliest poems I wrote went as follows:

> I long to be thin but I'm fat
> A sexy kitten but I'm fat
> A long willowy wisp of feminism
> But I am a fat that's a fact I am fat.
> But honey before you take leave of me
> Step up close let me wrap you in the whole of me
> When you discover the length and the breadth of me
> You'll be glad that I'm fat that's a fact [19]

[11] http://www.eng.fju.edu.tw/worldlit/caribbean/Selvon.htm.

[12] http://en.wikipedia.org/wiki/Salman_Rushdie.

[13] http://www.hanifkureishi.com/.

[14] http://www.humboldt.edu/~me2/engl240b/student_projects/daguiar/daguiartoc.htm.

[15] http://www.contemporarywriters.com/authors/?p=auth179.

[16] http://www.andrealevy.co.uk/.

[17] http://www.valeriemason-john.co.uk/.

[18] SuAndi, with my tongue stuck in my cheek, as I elaborate a quote from the media and medical departments.

[19] BLACKSCRIBE – Blackscribe/GMVC 0-614168-44-5.

At the time I wasn't fat, but felt sure that I was destined to follow the 44D cup of my buxom mother, though I knew that the ivory skin and rosy cheeks were simply out of the question and impossible. Like most girl-children, I favoured my mother in most things. I was a chatterer who loved a good story alongside laughter. A good laugh was a cure for all the racism that faced our daily lives, whereas my father was far more sombre: far more intent on the ethics of work and place. He seemed to occupy a space I couldn't get into: a space private to him, a place in his memory.

I was to lose not only my father, but also my mother before I established myself in the arts. My brother's passing was within a few years of my gaining a reputation/following. Now that everything was reliant on memory, there was no one-to-one inspiration. It would take me a few years to understand that, as a Black writer, I was to draw on a source that went beyond immediate family.

A Black writer—that, in itself, opens a whole chapter of debate. In 2001, I wrote:

> Not ~~ethnic arts,~~
> ~~minority arts,~~
> ~~multicultural arts~~
> Or ~~Cultural Diversity;~~
> Simply Black and therefore political [20]

I had had it with the definitions. What I didn't know was that there were more to come. I entered the arts as a "percentage" though I can never remember if that was 4% or 14%. I then became an "ethnic," or at least, they thought I had, but seeing as the original meaning of *ethnic* is "a minority of heathens being of neither the Christian or Jewish belief," then you will know how wrong this label was. I mean, look how many of "we" are moving into areas of housing and the professions. I had a rather exotic period in Multiculturalism, and this progressed into an AEMS: Arts and Education in a Multicultural Society. From there I gravitated into Cultural Diversity; and just when I had gotten kind of comfortable, they gave me a decibel and decided I was a BME.[21]

For some of you readers, the way we in the U.K. define Black might seem a mite confusing. So I am going to take a pause here to explain it. For the founders of Black Arts Alliance [22] (the artist-led members' organisation that I

[20] Acts of Achievement Colloquium ISBN 0-9542766-1-2.
[21] www.artscouncil.org.uk/publications/publication_detail.php?rid=0&sid=&browse=recent&id=479.
[22] http://www.blackartists.org.uk/.

coordinate as its freelance Cultural Director), Black has always been a political umbrella term.

> Black Arts Alliance is 21 years old. Formed in 1985 it is the longest surviving network of Black artists representing the arts and culture drawn from ancestral heritages of South Asia, Africa, South America, and the Caribbean and, in more recent times, due to global conflict, our newly arrived compatriots known collectively as refugees.

Though we have updated the definition of *Black*, its essence has never changed. I am not qualified to write on the Asian voice and experience, so I would never attempt to do so, although overall I hope that much of this chapter has a pertinence of similarity.

When I received my O.B.E.[23] in the Queen's 1999 Honours list, the Black community celebrated, whilst a surprisingly large number of my white colleagues exposed a cynicism by asking me if this meant I was no longer African. This was my only possible reply:

> I speak in English.
> Think in English.
> Read in English.
> Live beside the English.
> Survive the English.
> Appear English.
> But my soul is African. [24]

I had written it three years earlier. I am nothing if not prepared.

Anyone looking at my CV would probably assume that it tells of a reasonably successful career as a poet, live artist, and cultural activist. Indeed, the O.B.E. after my name is considered by some to signify my *"having made it."* One English friend sent me a card addressed to an *Outstanding Black Example.* I thank her for that. Another friend, who is Kenyan Asian and far more *"say it as it is,"* prefers to call it *Other Buggers Efforts,* a definition that sits more comfortably with me. (*And giving it back might well have jeopardised any future funding for BAA, so I accepted it. OK?*) In my private thoughts, I prefer to use it as an acronym for *Only Blacks Endure.* Why else are there resplendent grey shoots in the growth of my very funky black head?

On my first trip to New York, I was struck in awe by the number of Black women proudly revealing their grey hair. I came to the conclusion that this signifier was about survival—the survival of the Black race within a human

[23] Officer of the Order of the British Empire.
[24] In *There Will Be No Tears* (Manchester: Pankhurst Press, 1995) ISBN 1 90016 00 1.

race with an aggressive section set on our annihilation. In the U.K., we still reach for the hair dye in an attempt to disguise the pressure of our days. This is a country obsessed with age. Ageism permeates all aspects of life, not just in fashion, but in the professions, whether it is banking or the arts. The arts investment concentrates on the young and emerging. Even though, as Keith Antar Mason has always said, *"If you are Black you are always emerging."*[25] Yet, out there an audience exists that salivates on the edge of their seats for traditional art of which they have very little understanding. They see this work in a halo of quaintness—a rosy vision of the native's creative skills, in a time warp compared to contemporary concepts. Arts funding promotes and propagates youth with the hunger of a vampire. Urbanites, contemporary-ists, and modernists run amok with ideas, each more outlandish and "out there" than the one before, simply to enforce their belief that they are "the new."

There seems to be no place of honour for the cultural memoirists. Is it that we/they are seen as purely reflective on yesterday, that we wallow in the past instead of understanding that it is a main artery pumping vitality into our lives? Have they all forgotten that tomorrow will soon be history, and if we do not note the errors and value the achievements of the past, then time will simply rush ahead and forget everything?

I am surprised my hair did not flash-change to sliver when I received the AHRB's (the Arts and Humanities Research Board's) response to my fellowship application. I have misquoted this many times to conference delegations. My reasoning, one might think, was simply to extend and exploit the shock element with dramatic comedy. Maybe so. But, in my heart, I know it is the only way I am able to handle a comment that questions my political soul as a Black woman and makes the assumption that my father was absent from my life. Though my parents divorced when I was young (and my mother's celebration party was quite a shindig), my father remained a constant in my life. Indeed, he sat beside me at my mother's funeral. I cannot deny that being born in the U.K. is a marked difference to being born anywhere else not under white majority rule. But, still and all, I reject violently the assumption that to be mixed race makes it impossible to have either a cultural memory or day-to-day contact with both parents and their immediate extended family. The AHRB's response to my application was

> The meaning of oral history for mixed-race performance artists born in Britain and brought up by white families is somewhat different from that for first-generation migrants from Nigeria, for example.[26]

[25] http://www.artistsnetwork.org/artists/keithantarmason.html.
[26] AHRB Assessor, 2005.

The fact that the AHRB assessor (whom we suspect to be female) gives Nigerians as her example says to me that she was not unfamiliar with my work. Based on her expertise (I make the assumption that she isn't a *Black* woman), I need to advise you that from here on you might well consider that I have no foundation or knowledge of the points I am going to cover. For it is her assumption that all mixed-raced children were either abandoned by their Black parents or given up for fostering and adoption—and are, in the cruel word of the streets, "*coconuts.*"

This Is My Story

I sit in the audience of Chinua Achebe's *Things Fall Apart*[27] at the Library Theatre, Manchester. My man is African-American, and he is slightly envious that, unlike himself, for whom the ravages of slavery have breached and broken the umbilical cord that would link his ancestral line to Africa, I know where my people come from. He has a few Nigerian friends, although they are mostly adopting smoother lifestyles in the Black neighbourhoods of Minneapolis. They also have a place called home and can point to it on the map.

I am startled by this production, this play. I am moved. I am comfortable. I see the turn of my head in the (some might say) arrogance of the main character. I recognise hand movements, gestures, the rise and fall of the voice. I respond to the situations.

In front of me is a stage full of actors, but my eyes see only my father, even though the actors are Ibos[28] and my family Ijaw.[29] We are the same people. My father's passing is a date only visible in my heart. I thought I had forgotten the rituals of being a Nigerian daughter. I had not. They were being played out in front of me in just the same way that I recreate them each day that I wake up and go out. I went to this play once and have carried it with me every since.

Brosun goes two, three times. After the first night, my arm reveals the bruising from his elbow nudging, meaning "*You do that. That is just like you. Ouch, that look! and your looks are just as disdainful.*"

The power of theatre! The power of the written word to reawaken, to refresh, to invigorate and to feed the mind and nourish the soul! How to make such an experience understandable to the academic mind? And should we even bother to try? Playwright Anita Franklin observes:

[27] http://en.wikipedia.org/wiki/Chinua_Achebe.

[28] http://www.africaguide.com/culture/tribes/ibo.htm.

[29] In many ways the African American absorption with the Yoruba people has wiped the Ijaw out of the reference book, and it took some time to find this link: http://www.ijaw-naa.org/ijaw/home.htm.

...One of the things I've seen over and over in Black theatre is the way in which, when talking about our pleasures and heartaches, we frequently are reminding someone out there of our accomplishments as a people. We, as writers and performers, sneak in history lessons, reminders and clues of who we are beneath the mask. Writing out of histories, that, whilst oppressive, also give us strength, and telling stories of our achievements against the odds, weave stories of the past into the present. The 'keeping' of community blends the old and the new. We look backwards to look forwards. You can see this sometimes in our actions when, without even knowing it is happening, we replicate the actions of our grandmothers. We repeat, tell over, similar stories, but in and for different times and places. We have knowledge passed on to us, handed down, that we may not have understood and yet are making ready to hand down and pass on again. Ancestral pasts circulating in a living present, rooting and routing futures.[30]

There is a weird contradiction in the English academics who seem to have no awareness of the ridiculousness of their self-appointed right to investigate (OK, *research*) Black culture, then draw conclusions based on their unseeing, unconsciously inherited colonial mindsets, and then go ahead and deny, disgrace, and ridicule the work that the Black mind/hand places onto the page/stage/agenda. This is done unless, of course, that Black "presentation" has been educated to a standard that the academy regards as acceptable. So, *that* wipes out the majority of Black artists as well as the many scholars who have received only a basic secondary education, even if it has led to university appointments, leaving just those few who graduated from the higher echelons of Oxford and Cambridge as "up to standard." *These* graduates are fine because— the establishment believes (I think un-rightly so, in many cases)—that it moulded them into "acceptable" writers. It is not for me to berate the education received behind walls festooned with history (and debauchery). But, even for these graduate students, the establishment is trying (I believe) to enforce assimilation in an attempt to wipe out their cultural memory.

This emphasis on assimilation comes from every quarter and agenda. I cannot tell you the many times I have been asked if I am feminist with the tone of "Well? *are* you?" Now, which feminist movement would that be? Because in its beginning I saw no moves to embrace cleaners and non-professional women, nor that particular majority of Black women, coming in post-*Windrush*,[31] who were scrubbing the floors of the very wards that they were *over*qualified to nurse in. Whom did I have then to look up to and second my membership?

[30] Extract from my chapter "Africa Lives On in We: Histories and Futures of Black Women Directors" in *Feminist Futures?: Theatre, Performance, Theory*, eds. Geraldine Harris and Elaine Aston (New York: Palgrave Macmillan, 2006).
[31] http://www.icons.org.uk/theicons/collection/ss-windrush.

In truth, the attention that Maya Angelou's writing brought to her—and the resulting showcasing of her as an exotic (Black) woman of exceptional talent—finally made the feminist movement turn, not sideways (we have never waited patiently on the sidelines), but full circle, and realise that Black women were also striving forward, and that a strength is more powerful when it is unites with another force.

But back to this enforced assimilation. We have never been the partner or the victim of such duplicity, for we have not embraced assimilation, nor have we rejected our heritage, our roots. Instead, we have mixed them up, reinvented them to suit our purpose, to suit our wake-up days and sometimes sleepless nights. We are speaking out in tongues as numerous as the languages of our respective homelands and then translating it all back to English.

How clever this cultural memory is, for it allows for the possibility of remembering and forgetting, so that there is a fusion in the representation of the present with the past. And, in some cases, it even works for some writers who indeed have no first-generation inkling of their ancestral home. Then the form of their art practice, the style of their work, particularly in stage format, will reveal itself without their necessarily calling on it. It will simply be there, a part of them just like their genetic make-up. Their cultural memory will simply one day wake up and begin to revive, regenerate, and inspire them. So like myself, that youthful silly female obsession with size and weight is replaced, not by a politicised chanting voice of dissent from all things English and British, but with a deeper understanding of self-positioning on a global stage where so many are still waiting at the back door. Not the stage door! The back door! Down the dark alleyway, still waiting to get in.

PRESENCE.

I feel my presence
And in my being
Know there is no greater might
Than my own

I stand like a child
On the precipice of knowledge
Nodding with the wisdom of grandmothers
I feel my presence

I linger for moments in a past
So bloodied
That ghosts turn to carrions of human flesh
To block my progress in the present

My arms have embraced generations
Hung from crosses of missionaries
Impaled by civilisation
And still my soul has remained true
I feel my presence.

See my reflection
In many eyes turned blind to me
And know I am beautiful
Know I am Black
And rejoice that Africa lives on in me. [32]

This is why storytelling, the telling of our stories, is such an important intergenerational element of our lives.

Storytelling is largely regarded as fiction, and this is mainly the case. But, for the Black writer, we capture a moment in time: a myth drawn from an actuality by bringing the past and sitting it right next to the present. "It's the way I tell them"—that's the catch phrase of comedian Frank Carson .[33] Indeed, it is, Frank; for Irish tradition has skilled itself in taking hardship and human degradation and mixing it up so that is comes out as a love song tinged with melancholy and humour. For Africa this extends into a proverb that has adapted into general use as:

Until the lion is his own historian
History will always glorify the hunter
History will always glorify the hunter
Until the lioness is her own historian

My Lioness

Only Caesar went to his death believing that he could master history. Oh, and he died a mad man, by the way.

History is the coming together of numerous parts, incidents, relationships. Not all harmonious, but not necessarily violent.

My Lioness was my mother.

I feel it is important to tell you this because some readers might be assuming that, in identifying myself as Black, I have rejected one half of my makeup. (I

do so love the Liberals. They are so swift to finger point. I am not a Liberal; this is an experience-speak.) *The Story of M* places my mother right where she belongs in the centre of my living. I still use the term *Mixed-Raced* (for me) because she is not visible on me. My mother gave me the sprit that embodies my by-word: *SUSSEDBLACKWOMANCELEBRATINGLIFE.*[34]

A Contradiction

This is not the first time I have written about Cultural Memory, although the terminology hasn't always been in my mouth, and I still prefer to think of "we artists" as The Keepers, signified by the Adinkra[35] symbol Sankofa[36] ("return and get it"): "looking backwards in order to move forward," marking the importance of learning from the past. We reach understanding by exploring what has gone before in order to assist the future to be smoother.

Not all Black writers are in agreement with this, and why should they be?—for we each follow our own creative path. Julie Ellis is of such an opinion.[37] Though she is not professionally regarded as a writer, but as an actor, still she does write her own performance pieces; and, even if initially she didn't agree with the theory of Cultural Memory, it is what she deals with.

The work tells those audiences with the imagination and the 'eyes to see' that Juliet's present self is also trapped in the industrial past of England's great city of steel, Sheffield. She doesn't dwell on racism. She doesn't want racism to be the focus of her work in an issue-based way, even though this is very much a part of her experience. Rather, The Meeting Place tells how it was for this particular Black woman, wandering the streets of a city (Sheffield, U.K.) whose pulse was tempered by the factories that soared above it.[38]

The exploration of where we come from, leading naturally to why we are here, comes unbidden to our work.

I keep thinking I don't write from a Caribbean/British perspective, my work just is. But time and again it keeps biting me on the arse. I have stories to tell and the stories come from whom I am and what I know and what I'm trying to find out

[34] http://www.blackartists.org.uk/suandi/storyofm.htm; my biographical play *The Story of M* is published in *Four for More*, ed. SuAndi (Manchester: Black Arts Alliance, 2002) ISBN 0-9542766-0-4.
[35] http://www.welltempered.net/adinkra/.
[36] http://www.welltempered.net/adinkra/htmls/adinkra/sank.htm.
[37] http: //www. artscouncil.org. uk/documents/publications/phpD0UYPj.pdf#search=%22 Juliet%20Ellis%22.
[38] http://www.palgrave.com/products/Catalogue.aspx?is=140394532.

about who I am and what I know. I try to illuminate the silences we have between ourselves. I do write from a Caribbean/British perspective, I was just scared to acknowledge it in case it was thought of as folksy, community – not art. But it is. [39]

That was said, I must point out, by Black British playwright and director Sonia Hughes, author of *Weeding Cane*, who believes art should be "beautiful, scary, and honest."[40]

Even when we write love poetry, no matter the racial ID or gender of our lovers, the voices we speak in and our terminology expose us as Black:

> Translation
>
> Thought is outside
> Perceived without the perceiver
> Thought is fragmented
> Geography divided
> Is it possible?
> To look without measuring
> Comparing
> Thought must be controlled
> Don't confuse me if I don't compare
> Can I still be loved? [41]

It's the loneliness of the long distance writer (with apologies to Sillitoe).[42]

For those of us who live far away from "home" in cold climates and societies that resist our existence, that have made "wars" disguised as policies to sever our cultural links and traditions in their attempt to force us into assimilation, cultural memory is our sanity saver.

In 2005, I was awarded a NESTA Dreamtime Fellowship[43] to fund research for a potential publication, which I pre-titled "Rooted in the U.K.: A 21st-Century Account of Black British Artists." On the website for that project, I have quoted the following cryptic statement: *We may not know where we are but we are not lost (Stolen)*. Black folks—we know where we should be, simply

[39] Extract from my chapter "Africa Lives On in We: Histories and Futures of Black Women Directors" in *Feminist Futures?: Theatre, Performance, Theory*, eds. Geraldine Harris and Elaine Aston (New York: Palgrave Macmillan, 2006).
[40] http ://www.artscouncil.org.uk/documents/publications/phpMmWlpZ.pdf#search=%22 Sonia%20Hughes%22.
[41] Unpublished – "Brosun" (Minneapolis, U.S.A.)
[42] Reference is to Alan Sillitoe's acclaimed work *The Loneliness of the Long-Distance Runner* (Alfred A. Knopf, 1959).
[43] http://www.suandi.org.uk/surveys/index.php?sid=1.

because we know that this place (wherever this place is for the individual) is the place we were brought to after we were stolen. I believe as well that what totally confuses us is that most thieves steal out of desire to have "it" for themselves. They covet that which belongs to someone/somewhere else. Gangsters steal for profit. We are the chattels of profiteers still, which is why very little value is placed on our skills outside the entrepreneurial market. In fact, even today, there are publishers who claim that there are very few capable manuscripts being penned by Black writers and that, for those which do exist, the audience is limited.

As part of my NESTA research, I have met with a number of writers whose voices you need to hear. Because I believe that most artists—and Black artists, in particular—are multi-skilled, I invited as many artists as were interested to complete a questionnaire. I also met with artists in small groups, using the rituals of food to have more personal, delightful, funny conversations. These, I am not sharing here right now, but keeping them for the book. I would, nevertheless, like to acknowledge and thank in particular Faith Bebbington ,[44] Nina Edge,[45] and Jacqueline Roy.[46] I have decided to allow some of the statements made in response to the questionnaire to appear here as anonymous, simply because of each person's willingness to trust that I would treat them all in a confidential and sensitive manner. I strongly believe that their words provide insight into our literary voices and the struggle to be heard.

How long have you been a practising artist?
(The range is from two years to twenty-plus.)

To what extent does each of the following descriptions apply to your artistic career? Established. Recognised. Successful.
(Readers, you will have to wait for the book! There were so many differing answers to this three-part question, and yet underlying them were such similarities that they deserve a chapter to cover and analyse them all.)

What other terms would you use to describe your position?
"I have a unique and authentic voice which is rendered silent based on market forces and fear of challenging the status quo."

Please tell me what it means to be an 'Established Artist'; and how do you know you have achieved this?

[44] http://www.faithbebbington.co.uk/.
[45] http://www.artscouncil.org.uk/documents/publications/phpMmWlpZ.pdf#search=%22nina%20edge%22.
[46] http://www.annettegreenagency.co.uk/jacquelineroy_195691.html.

"I feel established through the amount of commissions I now get, and just making a living from being an artist. I feel like I'm on a journey and I'm about half way! I set new goals each year and meet them, although sometimes it takes longer than I thought."

... what a 'Recognised Artist' is.
"Name known in mainstream for their work; judged as quality, people can be known for the noises that they make, they can shake and move but it's their work, the writing or performances that they should be recognised for, not how big their mouth is! Reviewed in the mainstream, people waiting for the next book or performance or piece of work."

... how you would define being 'Successful' in the Arts?
"True to the self, true to expressing the self in all its guises and not selling out, losing that inner integrity just to get the breaks or the exposure, rose tinted spectacles yes but still very important and to hold fast to."

... what has been your Greatest Success.
...any obstacles or hurdles in your artistic career?
"Money, time, suitability, work not fit into the mainstream, too black, too loud, too unknown, too hyper, the list goes on, in this game if your face fits you're in, or who you know not what you know."

What follows are some comments made by individual respondents who didn't mind revealing their names.

T. RASUL MURRAY. "Poetry is not an easy career. Most poets teach. Black poetry has even fewer teaching positions! : >) It has been, for me, not a career, but a vocation."

BROSUN. "Trying to understand the 'black male experience' and its relation to the world and the art world."

On the Adinkra symbol *Sankofa* and its relevance to their work:

BROSUN. "Because of the cultural significance of Africans in the Diaspora, we always have to stay connected to our heritage as we are displaced in all parts of the world now."

SHEREE MACK. "We carry the baggage of the past whether we want to or not; we enter life at a certain time of history; in order to understand that position, we must look to what has gone before, to learn and move forward; it's about getting to know yourself and the world around you; you can learn from the past but also find out who you are in the present and future: it gives you the tools to

understand the present, why do people behave towards me in a certain way and they don't even know me, etc."[47]

MARTIN GLYNN. "The past roots us in traditions that we inherit but sometimes don't understand. Wrestling with notions of past is an indicator and a recognition of how we are and why we are." [48]

ISHA MCKENZIE-MAVINGA. "Of course our history informs our identity and research as artists." [49]

T.S. RAUL. "We build on the shoulders of our ancestors, creative as well as familial. Our strength is in our history and its lessons of survival. We write from an aesthetic sense, a sense rooted in our collective past."

JULIE TITUS. "As I have great interest in believing that you have to know your family history and cultural history before you can know yourself, the above statement rings true because I can only write what I know or have experienced and this comes from finding out who I am (globally and locally)."[50]

FAITH BEBBINGTON. "It's in my blood. It's not conscious; it just happens when I make art."

And because there really isn't a full stop after Black, we are not always in full agreement:

MYRNA LOY. "Mulling over the past can be a hindrance sometimes—looking to the future with no idea what it can bring or what is out there gets the creative juices flowing and makes the creative mind more imaginative." [51]

Telling Secrets

Ponder for a moment the difference, possibly, between Cultural Memory production and Verbatim Theatre. For the "mainstream," Verbatim Theatre has become increasingly popular. This is particularly interesting for Black practitioners, for whom this staged opportunity of telling our stories has been invaluable to counterbalance our exclusion alongside the mainstream stories of the working classes. Our real issue with VT is that we are a people who take care never to reveal the whole of ourselves. We keep something back,

[47] http://www.shereemack.com/.
[48] http://www.pih.org.uk/events/martinglynn_info.html.
[49] http://www.applesandsnakes.org/artists.php?contact_ref=38836.
[50] www.Juliatitus.com.
[51] http://fineline.hypermart.net/artsowngallery/.

we do not wash our laundry in public, put the baby out with the bath water, or hang out our underwear on the washing line in view of all the neighbours. We take care to keep secret that which we feel might be used against us, as historically it always has been. We chastise our own children harshly so that others might not find the need to. We have walked naked, not because our lands are in the southern hemisphere, but because we failed to protect ourselves; so when the thieves came to steal us, we were visible and vulnerable. Now there exists an inherent desire (a need) not to expose ourselves again.

But some of us ignore these unspoken rules. Some of us choose not to hear the whispering disapproval. Some of us speak out, not simply or loudly, but with knowledge and authority. Some of us take what is, and mix it with what should be, and smack this reality with total ridicule. For this latter, I have to hail the work of Ronald Fraser Munroe,[52] who has a wicked (as in Black speak *wicked*) skill in exposing the demons of racism for who they are and takes no captives.

But no one could have prepared me for my reaction to Lynette Goddard's[53] conference paper[54] on Debbie Tucker Green.[55] I wrote the following around the edges of the conference programme:

> She Telling Secrets.
>
> She telling secrets.
> Secrets
> Who told she is right
> To wash dirty clothes outside
> Full view of people
> Not of our blood, our skin, our colour.
>
> No one tell she
> Smut feeds hungry minds eager for scandal
> Fingers extending in accusation
> That we no good
> Never have been
> Never will.
>
> Better tell Anansi fact and fiction
> Relating relations
> Right to the root of Mother Africa
> With all her branches extended full of leaves

[52] http://www.thecentreofattention.org/exhibitions/roney.html.

[53] http://www.rhul.ac.uk/Drama/staff/goddard_lynette/index.html.

[54] http://www.lancs.ac.uk/depts/theatre/womenwriting/pages/symposiumprogramme.htm.

[55] http://doollee.com/PlaywrightsG/green-debbie-tucker.html.

And those leaves are we

Better tell history
Of great, great, great long time grand ancestor
Sold and cargoed
Whipped and raped till black as cherry
Birth itself in smooth brown
Tell this story
So they can never forget
How far we come
How far we travel
How great our endurance

Don't tell about ghetto style breeding
Laying down with any
Skirt raised high
And leaving too many faces with the same
Tooth gap and droop eye
And Prince Charlie hugemongous ears

Tell about the church
A belief in the trinity
'Rice and Peas' keeping warm
Or fou-fou ready in the pot

Tell about white gloves
White hat
And shoes…
'Lord have mercy how me feet a fire'
And elegant men in small trilby
And knife sharp creases
Descending to mirror glaze shine of leather

Don't foul the air
With strange women in khaki jeans
Arm muscle solid
Reaching out publicly to bring close
Another just like herself

Don't tell about sweet looking men
Sweet smelling
Sweet talking
With not one word of interest in any Sistah
Just infecting us all with his nastiness
So now even love risks infection

> Gal me know she no stupid
> See she uniformed to school
> Cheeky to college
> So why she never learn
> No speak our business in public
> White people be listening
> And best we tell them nothing

A contradiction to all that I have written here? No! Far from it. It was my giggling, toes curling, delighted response to hearing words that even I, some days, dare not speak out loud; to hearing opinions, thoughts, ideas, and ideals coming right at me instead of flying round in my head. Hearing with clarity things said that, some days, others have used to question *my* sanity. All of this went through me as Lynette read from Green's script.

Heavens! if we keep it all to ourselves how will our experiences and "their" experiences really interrelate? We are not alone. In truth we never were, and quite obviously we never can be, because no matter what we remember, we can never go back. Yesterday *is* done.

But, by not forgetting, by telling our children, and the children of our neighbours, all of our neighbours, maybe we can stop the bloodletting, the hatred, the abuse both physical and verbal, especially the misunderstandings—white to Black, and Black to Black—that come ahead of sharp blades and randomly-targeted flying bullets.

And when the ancestors look down upon us, they will smile and know us—no matter where we live, no matter what our cultural make up is now. And, as is the case with my NESTA fellow artists, this rich heritage includes Welsh, Irish, South Asian, European, Jewish, English, Jamaican, African-American, and the sadness of the unknowns; so they, too, must be Africans. Or, as Martin Glynn puts it, basically we have a "multi-identification": the absorbing of our different heritages without rejecting one over the other, the ways of a truth. When today's Black British poets and live artists celebrate our various cultural memories, our forefathers and foremothers will be pleased to see that we still remember to live as Africans.

CHAPTER THREE

POSTCOLONIAL AESTHETICS AND BLACK BRITISH AESTHETICS: KINDRED SPIRITS IN ERROR

JUDE CHUDI OKPALA
HOWARD COMMUNITY COLLEGE

A discussion of postcolonial and Black British aesthetics as kindred spirits may seem out of place and redundant. I feel justified, though, to raise the issue here for the following reasons: 1) Black British literature is an offspring of the excesses of postcolonialism; 2) colonialism has had an impact on Britain, especially through the immigration of the formerly colonized; 3) Britain is forging a surreptitious claim on the postcolonial, especially because of the nature of its citizenry as both hybrid and carnivalesque; 4) the surreptitious claim thrives on the redundant notion of centre and periphery within postcolonialism. I argue that postcolonial and Black British aesthetics share the same mode of representation, which could be deemed "a new way of seeing" and be better articulated in Gilles Deleuze's and Felix Guattari's paradigm, according to which both postcolonial and Black British aesthetics deterritorialise the assumption of the dominant group and, in so doing, redefine and extend its boundaries; they proceed with a political necessity, and rest upon a "collective and communal expression" (16-27). Mark Stein warns against such a comparison, though; he avers that since "black British literature overlaps with British literature, it cannot be compared to the post-colonial literature" (10). This sort of warning functions as a means to celebrate Black British aesthetics and as an embargo on any critical examination of the aesthetics involved. Rosemary George has quite an appropriate rejoinder to Stein. She argues: "...all locations, all writers, all subjects are postcolonial" (172). Stein's unwillingness to accept the comparison or (even) the identity, or his oblivion of the fact, is suspicious. Black British aesthetics, like postcolonial aesthetics, as such, operates with a sense of forgetfulness, which imbricates with its desire to exclude and marginalize. This forgetfulness is at the crux of my discussion; this forgetfulness extends the reach of postcolonialism and altogether re-inscribes

the logic of imperialist epistemology. This forgetfulness can be demonstrated clearly in the works of Nigerian writers who are now baptized Black British writers.

Nigerian writers in Britain could be classified into two groups: the British born writers and those who migrated to Britain. The latter group spans several generations and is noted, partly, for what has been called Nigerian literature. As such, their imagination details their consciousness of Nigeria, and they are interested both in Nigeria's material and political culture. It is interesting to note, also, that this group of writers produced what has become the literature of affirmation and in no way sought the fluidity and fusion of worldviews, a technique that is now more prevalent among the younger generation of émigrés, specifically Ben Okri and Biyi Bandele, to name just two. The British-born writers, on the other hand, novelize the British experiences and romanticize a Nigeria that is not available to them or, at times, available through the imagination of their parents. To use Stein's words,

> The homelands left behind by their parents are less 'available' to this group of writers. Most importantly, there are no direct memories, excepting those of journeys to these countries. The parents' homeland may be present through the parents' accounts and memories; these places may be visited, and these places may in fact be represented within Britain in neighbourhood, venues, cultural products, through teachers, political initiatives, and the like. But the connection with such an 'origin' can be quite tenuous. Yet the attachment to Britain may also not be unbroken. (7)

In this connection, the two groups of writer do not share the same concepts of home and home-country. I am using the term *home* the same way Henry Giroux does. According to Giroux, *home* "refers to the cultural, social, and political boundaries that demarcate varying spaces of comfort, suffering, abuse, and security that define an individual's or group's location and positionality…. 'Home' is about those cultural spaces and social formations which work hegemonically and as sites of resistance." Home, in that sense, maps out not only places of origin, but also boundaries and extents of existence. The place of origin for Nigerian-born black British writers is not the same as for the British-born Nigerian British writers; the two sets do not share the same experiences. While in England, "home" looms large for the Nigerian-born black British writers; it looks like a past and object of memory. Yet, I should note that the conditions of emigration for the first group create scars on their minds, scars that exist as a result of their exile or of the political, social, and economic malaise that led to their emigration; and the fatigue of that condition does not allow them to negate their past and join the dominant order; they visit their past in the form of narration—and often as a form of critique. Put simply, what is home for the Nigerian-born black British writers is in shambles. What is home

for Nigerian-British born writers is a location or "elsewhere" and object of a rigorous education. These two groups of writers warrant scrutiny, especially in the context of postcolonial and Black British aesthetics. For writing alongside other black British writers, Nigerian-born black British writers assert a subject position that draws it energy from an examination of socio-political Nigeria and the capitulation of her decayed polity. As such, this group engages the postcolonial and British landscape in a critical manner and suggests different forms of reading.

To clarify this different form of reading, I will pave the way with what you already know. By its very nature, postcolonialism is a phenomenological project; it examines how the postcolonial subject lives in his everydayness.[1] My objective is not to deny that definition, but to introduce a different form of analysis, which is necessary because postcolonial theory has been found suspicious and "bankrupt" as a theory of reading and as a means or method of salvaging and uplifting the imagination and the "being" of the colonized. I have used the word *being* not as a mere synonym for *life*, but to ratify the philosophical nature of the existence of the colonized after the end of colonialism. That existence can be divided into two categories: *being-with-self* and *being-with-the-other*. The first form of "being" relates to the existence of the postcolonial within his own world—within his native horizon; how he lives in the post-independent world; how he uses his post-independent and post-colonial "emacipatory potentials" (Lazarus 50); the second describes his engagement with the coloniser in all fashions. This form of being is well articulated in what Bill Ashcroft *et al.* describe as "writing back" and in what has emerged as an effect of globalization. As such, this second form of being is not essentially a physical but a phenomenological one: it is a relationship of consciousnesses that is, rather, enacted through language and representations. To be succinct, any authentic discussion of the postcolonial—aesthetics included—must align these two forms of being.

Although the cadence of what I will say here is not new, I will introduce and recognize representations that postcolonial critics for the most part have chosen to ignore. I will expose the neglected and the invariably silenced aspects of the postcolonial as being-with-self. It would not be unreasonable to note that the limitation may have arisen because of the collision between postcolonialism and postmodernism, especially with regard to these fashionable, associated terms: *hybridity, in-between, mimicry,* and *boundary.* Analysis of hybridity, as such, limits postcolonial theory to the interface of the colonizer/colonized and the practice of postcolonial criticism to the examination

[1] I am using the term *postcolonial* in this chapter to refer to both the Nigerian group of black British writers and to people of colonized countries. The term *post-colonial* (hyphenated) designates the time after colonialism.

of postcolonial as being-with-the-other. And, as such, both theory and critics foreclose the discussion of postcolonial as being-with-self.

One may note within my discussion the tenor of Arif Dirlik's and Chudi Okonkwo's critique[2]; yet, I would like to maintain some specific positions: the actual analysis of postcolonial literature entrenches the critic's agenda to the exclusion of specific cultural products that emanate from the marginalized people (Okonkwo 2); the postcolonial formula and analyses preclude texts that gain their authority by novelizing their local cultures—texts that recall the postcolonial landscape and raise the question of its being; postcolonialism has fallen into the hands of the avatars of neocolonialism; postcolonial critics do not even "recognize" or "respect" postcolonial authors who engage representations that do not fit so-called postcolonial principles. In so avoiding or disparaging, they do not address crucial questions: What has become of the postcolonial nations? How do writers of the colony address the contemporary forms of imperialism and instability in their nations? How do postcolonial writers represent their postcolonial nation?

[2] Postcolonialism has been found inadequate, and, at best, anachronistic. Several critics maintain that position. According to Kalpana Seshadri-Crooks, it "is beset with a melancholia" (3-4). The melancholia occurs because postcolonialism functions as "First-World" response to the marginal world. Abiola Irele has a position I would like to share here in its entirety because it exposes clearly the errors in postcolonialism: "The problem with postcolonial studies is that it does not know what it is. The theoretical underpinnings are vague—and I say this with apologies to my good friend Ato Quayson. Even the textual representation of postcolonial studies is very uncertain. To put Africans together with Canadians and Australians in the same postcolonial bag seems to me very odd. I have, therefore, preferred to just stick with the label African literature: with that, despite the problems of definition we discussed earlier on, you basically know where you are, what you are talking about. This leads me to another problem I have with postcolonial studies today, because at the moment its focus is Southwest Asia[:] it has shifted attention to Indian literature. African literature more or less plays second fiddle to this other field within the general area of postcolonial studies, but my strongest objection is that it forces us to define ourselves exclusively in terms of the colonial experience and our relation with the west. It is easier for me to say that this literature is African literature, and that some of it deals with the colonial experience or the post-independence experience and other areas deal with an experience that has nothing to do with the colonial, for example, the oral literature, the folk tales and the poetry. But if you call the literature postcolonial, you have only one broad historical perspective, which has to do with that one particular relationship and that is something I feel we should discard. There is also the problem of the language in which postcolonial studies is carried on. All the jargon. That language has crept into the writing of our younger people, and when you read their writings you are reading pages and pages and you are unsure of what they are saying, so you have this Homi Bhabha kind of language that is now spreading all over the place" (Na'Allah).

My critique is different from Dirlik's and Okonkwo's because it introduces a new form of analysis that exposes and illuminates what postcolonial critics neglect. This form must not be expected to be clear immediately or be regarded as insurgent, and it is founded on the principle that *postcolonialism* is the explanatory principle for the nature of the colonised after the end of colonialism—and this means that any writing after colonialism, including post-independence, could be classified as postcolonial writing; literature of the postcolonised addresses the state of affairs in the postcolonial world and examines the ideology that makes it possible. Accordingly, I am paying more attention to the forgotten question—that is, how the colonized looks at himself: What has become of the postcolonial nations? How do writers from the colony address the contemporary forms of imperialism and instability in their nations? How can we discuss postcolonial writing without reproducing the exclusionary gestures of imperialism? Another question that is important is the one posed by Julie Wuthnow: "…how might … postcolonial discourse be defined differently in order to enhance rather than disappear indigenous 'ways of knowing and … current concerns'?" (193).

Critics who engage black British literature have not done anything differently, nor has their engagement with black British literature produced a more even discussion, especially in looking at black British literature produced by Nigerians. The critics are still largely concerned with hybridity and so limit themselves to defining black Britain as a homogenous group and thereby thwart the *differance* that underlies the respective ethnicities. As Chris Mullard claims, no matter what, a black Briton "will not be white" (145). This claim resonates with other definitions of Black Britain as a "witness to subaltern lives and fortunes of those rendered other or marginal…" (McLeod 4). The impetus of these definitions is articulated by Ian Chambers, who sees English culture as founded on two rather opposing modes: "One is Anglo-centric, frequently conservative, backward-looking, and increasingly located in a frozen and largely stereotyped idea of the national, that is English, culture. The other is ex-centric, open ended and multi-ethnic" (27). Mullard would disagree with Chambers's classifications; Mullard does not exclude the ex-centric English from the centre. He believes that the multi-ethnic English is "English Completely." The definition, however, is suspect and ambiguous because to be "British completely" has no specific signification. Often, a Black Briton speaks a language different from English, or has another language available to him or her. Also, a Black Briton may have a different country or an alternative homeland. As such, the nature of Black British and Black British literature "cannot be represented without a reference to … ethnicity (Hall 167), and this ethnicity is constructed in and out of England. Hanif Kureshi warns that we need to look at the polyglot of races and consciousnesses "to understand Black

Britain today" (cited in Hall 171). His designation of England as "international" is most appropriate (More-Gilbert 9). Accordingly, a discussion of Black Britain or Black British literature should focus on the international valence of the representations and projects and jettison the tendencies to uneven discussion of writers.

Stein's study of Black British literature is crucial here. He outlines specific modes of representation that are essentially Black British. They include the "performative function of the novel" that reveals a concomitant transformation of the protagonist and the British landscape; the issue of cultural conflict that arises from generational shift and dislocation; finally, the aesthetics "post-colonial intertextuality"—a technique that allows the narrator "to inquire what it may mean to write a 'post-colonial' narrative" (xvii).[3] Stein's study of Diran Adebayo extends Stein's argument. He reads Adebayo's work as merely a *bildungsroman*, highlighting vividly aspects of the novel that underscore what he describes as a Black British aesthetics (Stein 18-19).

Such an aesthetics is obviously selective. It does not seem to address completely the textual properties of Black British writing, especially not of the Nigerian group of writers. Stein's aesthetics, as such, commits several sins: it dilutes the connection of some writers to their native culture, a connection that is necessary because of the immigrant nature of the writing; it looks at the native culture as a distant recollection or a burden that affects the present existence; it appropriates the business of criticism in a way that dispenses with its investment in ethnic difference; it homogenizes; it precludes examination of postcolonial and post-independent nations; it manoeuvres around the sensitive issue to celebrate identity as "new ethnicities" (to use Hall's phrase); it undermines the international nature of the writer and, thereby, privileges England as the central place/space. This is evident even in the use of the term "*black*."[4] Stein's analysis, to use Karen Kaplan's phrase, seems to "appropriate and raid other spaces" (Cited in Jay 41).

[3] It is interesting to note that these characteristics are the same Rosemary George outlines for what she calls "Immigrant genre," which she argues is distinct from but related to both postcolonial literature and literature of exile. See *Politics of Home*, 171-197. Cesar and Sharon Marez, speaking of black British literature produced by West Indies, provide other dominant themes of such literature, namely, "Childhood," "Old Age," "History," and "negation of post independence West Indies."

[4] R. Victoria Arana in this volume's Preface points out the inadequacy of the term; she cites writers and artists who define themselves differently: "…Michael McMillan calls himself an Englishman of Vincentian parentage, Kobena Mercer calls himself a Londoner of Ghanaian-British descent, Kadija Sesay calls herself an Englishwoman of Sierra Leonean heritage, Roshini Kempadoo calls herself a British-born artist of Indian Caribbean descent based in London, and so on."

Why do Nigerian-born Black British writers still write about Nigeria? What do critics discuss when they critique Black British writing produced by Nigerians? What should they discuss? Which of the Nigerian groups of Black British writers are represented? Is the study of that group privileging British landscape or the writer's complete *weltanschauung*? These questions point to the postmodern trappings of Black British aesthetics, especially in its negation, exclusion, or silencing of issues that detail the project of the writer. These questions also point to the lacunae in the discussions of Black British writing and call for an ethics of interpretation, one that warrants not only intelligibility and truthfulness of criticism, but also preservation of the purpose of the text. Such lacunae in the critical literature testify to how a politics of location works to the disadvantage of the specificity of the "Other." A critic cannot just speak of hybridity when people are suffering and, more so, when writers discuss such suffering. Critics need to develop what Hans-Georg Gadamer calls a "fusion of horizon": "Thus a person who wants to understand must question what lies *behind* what is said. He must understand it as an answer to a question. If we go back behind what is said, then we inevitably ask questions *beyond* what is said. We understand the sense of the text only by acquiring the horizon of the question..." (370). Gadamer, wisely, warns against arbitrariness in criticism; he describes the judicious and dialectic nature of interpretation, where truth lies in the proper investigation of what is said. Critics should be aware of the potential of an enterprise called Black British aesthetics to exclude or to silence in the name of multiculturalism and resistance or in its redefinition of the centre.

I contend that, so far, literary critics who have studied the Nigerian group of Black British writers have been remiss in what they have chosen to discuss. Like postcolonial critics, they preclude the writers' imaginative return and the horizon against which these writers engage their native landscape. These critics seem unconcerned with the writer as *being-with-self*. In this manner, critics have neglected some techniques in Black British writing that are relevant to the political and international ramifications of such writing. They have neglected as well what F. Abiola Irele calls the "new realism" in African fiction. He asserts:

> The particular meaning I attach to the term *realism* relates therefore essentially to a new attitude toward the African experience in the more recent literature, a new apprehension of events, social forces, and human character as they interact to create the sense of the moral universe impinging upon the writer's consciousness. The term translates not merely a particular mode of formal presentation of the contemporary African situation but also, and principally, the awareness induced by the writer's new relationship to that situation and a corresponding urge to reinsert the African imagination within the total fabric of historical experience. This new realism of the African writer, which stands in contrast to the earlier Romanticism, reflects the mood of disillusionment that has

invaded African minds as the hopes and expectations inspired by the general euphoria of political independence, taken as the signal for a new and positive phase of African development, began to fade. This mood has determined the manner and attitude characteristic of what I have termed the new realism. (214)

In the presence of this realism, it would not be unreasonable to say again that critics who discuss the Nigerian group of Black British writers do not look at the political structures in the post-colonial and post-independent Nigeria, where governments and leaderships, at best, are criminal; they do not look at the writers' imagination as it impinges upon events and social forces in Nigeria.

Put simply, Nigeria is in shambles and exists today under corruption, instability, and the tutelage of the West. Life in Nigeria, to use Hobbes's words, is "short and brutish." Chinweizu detailed this life, speaking of Nigeria in his lecture "Lugardism, UN Imperialism and the Prospect of African Power." He argued that Nigeria is "a society of inward antagonism, one held together by mutual internal antagonism, one which could not carry on if its members had no fellow member to hate." He asserted further that "Nigeria has been reduced to an amoral land where greedy people think of kidnapping their neighbours' children and selling them to be killed for fresh body parts to be sold abroad for organ transplant." The significant phrase in that quotation is "has been reduced." Chinweizu does not trace the reduction beyond those Nigerians whose mentality profusely forges greed, "acute individualism and deep insecurity."

In considering this issue, one can see that the Nigerian group of Black British writers are not merely postcolonial in their concern about *being-with-the-other*; many are deeply committed to reflecting what I call *being-with-self*. In being-with-self, the writer forges two epistemic fields: one represents the devastating destructive nature of the Nigerian landscape, and the other foments a kind of universal human principle: self-preservation. The first field can be charted as an ethos of instability and suffering, while the second manifests through the trope of survival and hope. Examination of these fields is what is missing from both postcolonial criticism and discussions of the Nigerian group of Black British writers. The omission signifies (*prima facie*) "First-World response," the problem of knowledge construction, and the imperative to kowtow the Nigerian group of Black British writers into an interpretive system that undermines their discourse; equally, the omission truncates the process of the emerging expression. My point, in line with Bishnupriya Ghosh's, is that a complete and fair examination of the Nigerian group of Black British writers will "imbue ... the First World with a political responsibility not only to their own national public sphere, but to the greater circuits which determine and are determined by their actions" (Ghosh, "The Postcolonial Bazaar").

Biyi Bandele, Ben Okri, Chris Abani, Buchi Emecheta—Nigerian writers who are also now labelled Black British writers—engage these epistemic

fields in their narrative imaginations.[5] Novels of such integrity include Okri's *Famished Road* and "Stars of the New Curfew," Bandele's *The Man Who Came in from Back of Beyond* and *The Sympathetic Undertaker*, Abani's *Kalakuta Republic*, *Graceland*, and *Becoming Abig*ail, and Buchi Emecheta's *The New Tribe*, to name just a handful. An ethos of suffering stands out, and the writers use it to recapitulate the Hobbesian nature of the postcolonial landscape.

There is to date no serious critical discussion of the Nigerian group of Black British writers in the light of their representation of the Nigerian landscape or in the light of the postcolonial nature of a writer's imagination as he or she presents an ethos of suffering—that is, detailing the postcolonial as being-with-self. Abani captures this ethos in *Kalakuta Republic,* which, in particular, is a volume of poetry about his prison experiences in Kalakuta—Kiri Kiri Maximum Security Prison in Nigeria. The fact that the book is published in London magnifies the representation; it suggests that such a book could not have been published in Nigeria. The location of the publication equally provides the avenue for the eradication of all possible censorship.[6] Such a gesture is critical, for it shows that writers have to purchase the safety for telling the truth about Nigeria in a foreign land. In the book, Abani presents the government with utter condemnation and without sacrificing his art. In his own words, "This initial brush with the government was not deliberate on my part, but having once been brushed by the wings of the demon, I became the demon hunter." Here is an excerpt from the book about his experience in Kalakuta and, and it exposes inhumanity, yet with a poet's kaleidoscopic vision:

> Sergeant Adam Barkin Zawa
> *Rammed the barrel*
> *Of a rifle—Lee Enfield—up my rectum*

[5] My focus is on Abani and Okri. In selecting them, I wanted mainly to represent a broad time span for the publication of the texts I study. Okri's story "Stars of the Curfew" was published in 1989 and Abani's *Kalakuta* and *Graceland* were published in 2000 and 2004 respectively. The presence of the ethos of suffering across these time periods shows the continuity of and preoccupation of the writers with the ethos; it shows also that to engage that ethos is a prevailing mannerism in Nigeria. One can equally study Emecheta's *The New Tribe* and Bandele's novels in that light. Other writers engage this sort of imagination: Ike Oguine in *A Squatter's Tale*, Helon Habila in *Waiting for an Angel*, Chimamanda Adichie in *Purple Hibiscus*. Achebe has celebrated that imagination in *A Man of the People*. The imagination is not new, but has been foreclosed as a topic because of postcolonialism's preoccupation with "writing back."

[6] In an essay on Abani published in the *Dictionary of Literary Biography*, I explain the context of Abani's publication of the book. He was, in brief, unjustly incarcerated for challenging the government's indiscriminate services of injustice.

Maintaining casual banter
"How is your mother? How is she finding
our lovely country?" interrupted only
by the *blood spraying from my backside,*
baptizing his *heavily scarified face,*
empty ancient mask.
Breath heavy with local gin—ogogoro—used
To scare demons, guilt, into lonely
Dark corners. (Italics mine)

He uses imagery to elevate the idea of inhumanity meted out by the government and to expose the government as agent of pain. Sergeant Zawa, a supposed agent of law and order, inflicts irrational and sadistic pain. The hyperbole "blood spraying from my backside" suggests the magnitude of his injury; at the same time, he seemingly dehumanizes the Sergeant for causing such injury, refusing to attach any significance to him and his ancestry as he refers to his "empty ancient mask." This dehumanization is Abani's response and retaliation for the wantonness of the suffering inflicted. And Abani is not imaginative, but factual, in this connection.[7]

A graduated exposition is present in the *Graceland*. Although the title and the name of the main character signify on the American pop icon Elvis Presley, the novel recapitulates the postcolonial as being-with-self. *Graceland* is set in Afikpo, in eastern Nigeria, between 1972 and 1981 and in Lagos in 1983—with excursions to Abeokuta and Ijebu. It is the story of Elvis Oke and his family, beginning when he was five years old. Generally and based on the main character, Elvis, the novel has been described as a *bildungsroman*. Put simply, the novel is replete with paradox. John Hawley has noted some of these contradictions:

Graceland is the story of an adolescent, Elvis Oke, who lives with his father and stepmother in Moroko, a notorious slum on stilts over a fetid swampland in Lagos. Throughout the story Abani plays on the traditional use of names as talismans, generally inverting their surface meaning. Thus, the stepmother's name is Comfort, but she is cold. His dead mother's name is Beatrice, but she is no longer present to guide him through this hell. His father is Sunday, but he has no access to rest or transcendence. Elvis himself cannot sing or dance, and his hopeless impersonation of his namesake for white tourists is painful to imagine. He is pulled in two directions: the revolutionary King of Beggars wishes him to stand up against the corrupt regime, with predictable results; the pragmatic and corrupt Redemption, on the other hand, is a character much like Dickens's Artful

[7] Other artists in Nigeria had had such experiences: Wole Soyinka, Fela Kuti, and Ken Saro-Wiwa. Soyinka devoted *The Man Died* to his brush with such inhumanity, and he repeated that in his recent memoir, *You Must Set Forth at Dawn.*

Dodger, who introduces Elvis to drugs and to the kidnapping of children for export to Saudi Arabia and the sale of their internal organs to rich Americans.

Elvis's fluctuation between contraries is representative of the difficult existence in Nigeria and of the subtle way to manoeuvre around it. All of his friends engage in corruption as a means of survival and to elude the gaze of the "corrupt regime." Accordingly, Abani uses paradox to forge realism, to detail the truth and the social forces that affect daily existence, and not really to suggest aporetic judgment.

Abani further focuses on government figures and exposes the evils they engage in, both in their inability to govern and in their disposition to corruption. Among their projects is Operation Clean the Nation, through which the government demolishes cities; government agents traffic in human body parts; they practice false imprisonment and fatuous torture. Using these facts, Abani emphasizes the moral decay in Nigeria. *Graceland* is Abani's voice against tyranny, and it is his lamentation of the hopelessness the government "doles" to everyone; in addition, it is his interrogation of the moral will of the people and an invitation to see the post-colonial and post-independent Nigeria clearly.

Okri is another author whose examination of the postcolonial considers being-with-self—that is, as the Nigerian person exists in his or her own world and is neglected. His works are, for the most part, classified (oddly) as magic realism and as a montage of heterogeneous stylistic unities.[8] Take, for instance, "Stars of the New Curfew." This story is mainly about a character who seeks for modernity, but through all of the possible foul means available in his country. To escape the thraldom of homelessness, destitution, and madness, he dabbles in salesmanship, which is a platform for duping and deceiving people. In this trade, his modus operandi is "succeed by all means." That presupposes, of course, an absence of ethical understanding and an acceptance of laissez-faire economics, trickery, and shenanigans mentality. Okri uses this character as the pivot of all other similar dispositions, especially the rivalry between the Odeh and Assi families that borders on obvious ignorance and false probity. But the point Okri seems to make is really the nature of the dependence of these families on their fans and on the blindness of their fans. He orchestrates the blindness as a result of the search for the beauties of life, of hardship, that can only be satisfied by money. In this regard, the fans recapitulate the narrator's consciousness – dubious, untrustworthy, and parasitic. Accordingly, Okri highlights the hardship that ravages people's mind and turn them into irrational

[8] See, however, Luke Strongman, "Post-Colonialism or Post-Imperialism." *Deep South* 2. 3 (Spring 1996). Strongman cites Okri's *The Famished Road* as an exemplary voice in "opposition to the imperial process and which articulates a counter discursive stance to the presence of settler-invader."

beasts; the market scene where the narrator sells his product is a good illustration:

> We got to a bus-stop and the clamor increased as people fought to get off and as other struggled to get on. Eventually the bus began to move, and the traffic eased on over the bridge. We passed some traffic policemen, who looked a little sickly in their yellow uniform tops.... The bus sped on. Voices rose. We heard protestations of the engine as the vehicle changed gear. We also heard the driver singing. It was only when we noticed that another molue [bus] was speeding alongside us, with both drivers challenging each other, that we realized we were engaged in an absurd war of wills. The conductor joined in the contest, spurring his driver on, urging him not to allow the other molue driver – 'a bushman from Abeokuta'—to overtake us. (105-106)

Okri puts it adroitly: it was "absurd war of wills" energized by apparent lawlessness; the policemen could not and would not do anything, so the passengers are at the mercy of the driver whose "demented euphoria" is perilous.

Neither Okri nor Abani, it must be said, is excessively imaginative in his representation, both presenting realistic stories loaded with verisimilitude. No one who is informed about Nigeria would challenge the veracity of their representations, especially with regard to suffering, lawlessness, and deception. Fela Anikulapo Kuti, before them, devoted his music to such situations. I contend that this ethos of suffering, which turns human beings into beasts, should be addressed to engage the historical and social conditions of the postcolonial and thereby underscore the postcolonial nature of the country. The ethos of suffering should be recognized, equally, as a theme in Black British literature and should be addressed—especially because of the freedom, habitable landscape, and market success England provides for such publication. In this connection, to discuss Black British literature or postcolonial literature, at least as these relate to the Nigerian group of Black British writers, is to discuss evenly the materials—situations, experiences, events, social forces—that impinge on the writers' imagination.

Postcolonial criticism and the study of Black British literature, as they are currently practiced, without a doubt, have their merits, and it would be unreasonable to deny that. I would say categorically, though, that hybridity, in-betweenness, mimicry, and writing-back are not the only lenses for postcolonial criticism, nor are they the only ways to look at Black British literature. Being-with-the other is not the only form of existence for the postcolonial and should not be the only grounds for criticism. We should not just gravitate towards writers who dwell on that mode of being, nor interpret texts to bend them to emphasise such traits. What I hope I have achieved here is to show that critics who engage such approaches and employ that jargon in examining the Nigerian

group of Black British writers should, instead, study them in their truer contexts. Failing that, critics seemingly shut out insights into both the writers' imaginative and their literal explorations of their own worlds. Yet, the writers themselves deny that foreclosure and invite us to look at their narratives as phenomenological projects—as examinations of the postcolonial subject as he *is*, not as he is seen *in* or *by* the West. When we fail to attend to realities, even in literature, we only risk bringing to the world and perpetrating the suffering that devastates a people. The project of criticism—and a truer approach to Black British aesthetics today—would reveal that postcolonialism and Black British writing are not just about opposition and new ethnicities, but also about the true life and reality of the postcolonial inside his or her native horizon.

Works Cited

Abani, Chris. *Becoming Abigail*. New York: Akashic, 2006.

—. *Graceland*. New York: Farrar, Straus, and Giroux/Picador, 2004

—. *Kalakuta Republic*. London: Saqi Books, 2000.

Achebe, Chinua. *A Man of the People*. New York: Anchor Books, 1966.

Afzal-Khan, Fawzia and Kalpana Seshadri-Crooks,eds. *The Pre-Occupation of Postcolonial Studies*. Durham: Duke UP, 2000.

Ashcroft, Bill, et al. *Empire Writes Back*. 2ed Edition. London: Routledge, 2002.

Baker, Houston, Jr., et al., eds. *Black British Cultural Studies: A Reader*. Chicago: The University of Chicago Press, 1996.

Bandele, Biyi. *The Man Who Came in from the Back of Beyond*. London: Heinemann, 1992.

—. The Sympathetic Undertaker and Other Stories. London: Heinemann, 1993.

Bernard-Donals, Michael. "Forgetful Memory and Images of the Holocaust." *College English* 66 . 4 (2004): 380-402.

Chamber, Ian. *Border Dialogues: Journeys in Postmodernity*. London: Routledge, 1990.

Chinweizu. "Lugardism, UN Imperialism and the Prospect of African Power." A Public Lecture Delivered at Agip Recital Hall, Onikan, Lagos. 18 Feb. 2006. Available online August 15, 2006 atA http://www.assatashakur.org/forum/showthread.php?t=16309.

Deleuze. Gilles and Felix Guattari. *Kafka: Toward a Minor Literature*. Trans. Dana Polan. Minneapolis: University of Minnesoata Press, 1986.

Dirlik, Arif. "The Postcolonial Aura: Third World Criticism in the Age of Global Capitalism." *Critical Inquiry* 20 (Winter 1994): 328-356.

Elleke, Boehmer. *Colonial and Postcolonial Literature: Migrant Metaphors*. 2nd Edition. Oxford: Oxford University Press, 2005.

Emecheta, Buchi. *The New Tribe*. Oxford: Heinemann, 2000.

Gadamer, Hans-Georg. *Truth and Method*. New York: Continuum, 1998.

George, Rosemary M. *The Politics of Home*. Cambridge: Cambridge University Press, 1996.

Ghosh, Bishnupriya. "The Postcolonial Bazaar: Thoughts on Teaching the Market in Postcolonial Objects." *Postmodern Culture* 9.1 (1998). Muse.jhu.edu/journals/postmodern_culture/v009/9.1ghosh

Giroux, Henry A. "Paulo Freire and the Politics of Postcolonialism." *JAC* 12.1 (1992): http://jac.gsu.edu/jac/12.1/Articles/2.htm Available August 2006.

Hall, Stuart. "New Ethnicities." Baker et al. 163-172.

Hawley, John. "Oke's Odyssey." Review of *GraceLand*, by Chris Abani. 2 August 2004: http://goliath.ecnext.com/coms2/gi_0199-275340/Oke-s-Odyssey-GraceLand-A.html (Available 23 Aug. 2006).

Irele, Abiola F. *The African Imagination*. Oxford: Oxford University Press, 2001.

Jay, Paul. "Beyond Discipline? Globalization and the Future of English." *PMLA* 116.1)2001): 32-47.

Lazarus, Niel. "Great Expectations and After: The Politics of Postcolonialism in African Fiction." *Social Text* 13-14 (1986): 49-63.

McLeod, John. *Postcolonial London: Rewriting the Metropolis*. NNew York: Routledge, 2004.

Mullard, Chris. *On Being Black in Britain*. Washington D. C.: Inscape, 1975.

Na'Allah, Abdul-Rasheed. "Literature, Culture, and Thought in Africa: A Conversation with Abiola Irele." *West Africa Review* 7 (2005): http://westafricareview.com/issue7/naallah1.html

Okonkwo, Chudi. *Decolonization Agonistics in Postcolonial Ficiton*. New York: St. Martin's Press, 1999

Okri, Ben. *The Stars of the New Curfew*. New York: Viking, 1989.

Seshadri-Crooks, Kalpana. "At the Margins of Postcolonial Studies: Part 1. Afzal-Khan and Seshadri-Crooks. 3-23.

Soyinka, Wole. *The Man Died*. New York: Harper and Rowe, 1972

—. *You Must Set Forth at Dawn*. New York: Random House, 2006

Stein, Mark. *Black British Literature: Novels of Transformation*. Columbus: Ohio State University Press, 2004.

Strongman, Luke. "Post-Colonialism or Post-Imperialism." *Deep South* 2. 3 (Spring 1996). http://www.otago.ac.nz/DeepSouth/vol2no3/postcol.html. Available August 15, 2006.

Wuthnow, Julie. "Deleuze in the Postcolonial." *Feminist Theory* 3.2 (2002):183-200.

Unit II

Critical Theories
and Aesthetic Movements

What makes the current moment especially interesting is that, as well as the up-front visibility of the artists and practitioners, there is now also a critical mass of arts professionals working behind the scenes in both established institutions and emerging arts spaces. Black arts professionals are among decision-makers in "British" institutions of art and culture in a way they certainly were not twenty or thirty years ago....

The key phrase that now demands attention is institution-building; but what exactly are the challenges of "institution building" and what vocabulary can best help to name them and debate them? Should we be talking in terms of inclusion, mainstreaming, cultural visibility, or internationalism, diaspora, and universality? What makes black Britishness and British blackness locally distinctive and yet globally connected not just to North America and Western Europe, but to all sorts of "other" spaces around the world?

—Kobena Mercer (from Ch. 4)

CHAPTER FOUR

'DIASPORA DIDN'T HAPPEN IN A DAY': REFLECTIONS ON AESTHETICS AND TIME

KOBENA MERCER
MIDDLESEX UNIVERSITY

The architect David Adjaye recently held an exhibition at London's Whitechapel Gallery. Highlighting his public commissions, the display featured maquettes of ten major projects that Adjaye Associates have produced since 2000, including the British pavilion for the 2003 Venice Biennale, the Nobel Peace Centre in Oslo, Norway, and the Ideas Store in East London. Walking through the exhibition, I realised that Adjaye is actually producing three of the four new arts centres that will provide permanent "homes" for the black British art scene: the Stephen Lawrence Centre in Deptford, the Bernie Grant Arts Centre in Tottenham, Rivington Place (Fig.1) in Shoreditch, and Rich Mix in Whitechapel. This is a considerable achievement for an individual talent not yet in his forties, and it also reveals something about the future possibilities for "black Britain" in the visual arts.[1]

Across the country, black artists from African, Caribbean, South Asian, and other backgrounds are everywhere involved in the contemporary cultural life of the nation. Cities such as Bristol, Liverpool, Manchester, and Birmingham each have institutions with a long-standing track record in exhibiting black British artists, and indeed in most any large town in England, Scotland, and Wales you would be able to access "culturally diverse" visual arts in one form or another. But why stop with the cities? In May 2006, the Artsway Gallery, located in the New Forest in Hampshire, hosted an exhibition of "White Paintings" by the Guyana-born abstract painter Frank Bowling, who was recently elected as the first black British artist to join the Royal Academy in

[1] Peter Allison, ed. *David Adjaye: Making Public Buildings* (London and New York: Thames & Hudson, 2006).

London. England's green and pleasant land, one might observe, is now inflected by many shades of "black."

Visitors to Britain who take London as their main port of call tend to miss out on the local character of the country's distinctive regions, although the cosmopolitan nature of London's identity as an international city underlines the social mix that makes it very different from other European cities such as Paris, Amsterdam, or Berlin. In point of fact, Britain's national culture is actually quite London-centric in terms of the historical evolution of artistic infrastructure that is concentrated in the capital city: its art schools, museums, galleries, and public spaces have been the principal focus for successive generations of artists whose practices over the past twenty years and more have come to define "black Britain" as a distinct cultural space on the world map of contemporary art.

Artists such as Steve McQueen, Yinka Shonibare, Zarina Bhimji, and Isaac Julien have attracted the attentions of curators, critics, and collectors throughout the world, and each has been featured in Documenta XI, the critical survey of international art held every five years in Germany and curated in 2002 by Okwui Enwezor. The global dimension of the process whereby international recognition has been conferred upon "black British artists" has been a crucial aspect of the evolution of the black arts scene during the 1980s and 1990s, and the trans-Atlantic component of this has been especially important. As well as being the subject of dedicated exhibitions such as *Transforming the Crown* (1997) in New York, "black British art" has become a recognisable strand in contemporary art, not only as a result of intra-national factors, but also on account of the trans-national forces of contemporary globalisation: the painter Chris Ofili, who won the 2002 Turner Prize, was already an international art star before Mayor Giuliani helped him further on his way with the political panic that was stirred up in 1999 when the "controversial" *Sensation* exhibition from the Saatchi collection travelled to the Brooklyn Museum.

What makes the current moment especially interesting is that, as well as the up-front visibility of the artists and practitioners, there is now also a critical mass of arts professionals working behind the scenes in both established institutions and emerging arts spaces. Black arts professionals are among decision-makers in "British" institutions of art and culture in a way they certainly were not twenty or thirty years ago. A quick snapshot: writer and broadcaster Ekow Eshun is Director of the Institute of Contemporary Arts; curator Carol Tulloch is at the Victoria and Albert Museum, Mike Phillips is at Tate Britain, and Gus Casely-Hayford, artistic director of the Africa 05 season and formerly a curator at the British Musuem, is now the Director of InIVA, (Institute of International Visual Arts). The black British arts scene has long involved "animateurs"—that is, individuals taking on multiple roles as artists, activists, educators, and archivists—but the current "professionalisation" of the

sector points towards an emphasis on executive roles: former film scholar
Baroness Lola Young, O.B.E, has served on boards for the Greater London
Authority, the Arts Council of England and English Heritage, and the
performance artist Keith Khan, founder of the Moti Roti live arts ensemble, is
now Artistic Director of Rich Mix, whose programme highlights South Asian
cultural forms.

Fig.1: David Adjaye, *Concept Sketch* (2003)

The opportunities are exhilarating, which is to say that fresh anxieties inevitably accompany such an unprecedented moment. The key phrase that now demands attention is *institution-building*; but what exactly are the challenges of "institution building" and what vocabulary can best help to name them and debate them? Should we be talking in terms of inclusion, mainstreaming, cultural visibility, or internationalism, diaspora, and universality? What makes black Britishness and British blackness locally distinctive and yet globally connected not just to North America and Western Europe, but to all sorts of "other" spaces around the world? Reflecting on Adjaye's exhibition in light of these questions, I feel assured that the challenge of institution-building is in a safe pair of hands, that is, as far as the bricks and mortar are concerned. The light touch with which cross-cultural aesthetics are embedded in Adjaye's take on late-modernist design principles, and the tactile ways in which his chosen forms and materials address the social location of those who will be using these buildings, underline a highly distinctive approach to an architecture of public space in the twenty-first century. Standing back, however, and viewing contemporary developments in a broader historical narrative—for the black British arts scene extends back across the twentieth century as a whole—I found one or two doubts entering my mind, for, dear reader, am I alone in wondering *who exactly is going to go into these buildings and what exactly is going to come out of them?*

To raise such doubts is observe that the current black British art scene has reached something of a plateau in the period between 2000 and 2005. The driving energies of its creative ambitions actually began to level off, in my view, some time ago, at some point in the late 1990s. Against this backdrop, the complex question of institution-building is underlined by the double-sided connotations of its cognate term: *institutionalisation*. On the one hand, without museums, collections, and institutions to preserve the materials of shared cultural history, the past is vulnerable to selective erasure—a symbolic threat that the cultures of the Black Atlantic diaspora have had to contend with from their inception. On the other hand, however, there is the equally appalling dystopian risk that Adjaye's beautiful buildings might someway end up "empty" if there is insufficient passion for genuine public dialogue, debate, and disagreement about the overall "direction"—or rather "directions" in the plural—that the black British arts scene is taking as a whole.

It may well be the case that the black British arts scene is flourishing and floundering in equal measure; at what point does the consolidation of past achievement give way to complacency? Would it be too much of an exaggeration to say that we are dealing with a "crisis" with a lower case 'c' that has been mostly hidden from view by shop window displays of multicultural celebrationism? When put in such terms, the plateau-like condition of the black

British arts sector was laid bare by the "decibel" campaign launched by the Arts Council of England in 2003. With a marketing tag-line—"raising the voice of culturally diverse arts in Britain"—that sought to stimulate public debate, by way of an international conference and a colour supplement in *The Guardian* newspaper,[2] the muted outcome actually ended up lowering the volume into silence.

A couple of recent interventions, however, suggest an element of unease with the institutionalisation of the sector under the banner heading of "cultural diversity"—which is the preferred term in the official discourse of public policy. In March 2006, curator Richard Hylton of London Metropolitan University put together a panel discussion called "What is Cultural Diversity?" Chaired by art historian Sarat Maharaj and featuring curator Eddie Chambers, the panel asked whether such policies may "be acting as a constrainer rather than a facilitator of artistic and societal development," in the words of the flyer for the event. Debating "why certain people are regarded as being more 'ethnic' than others," the panel was highly critical of the bureaucratic "tick-box" culture encouraged by the Arts Council, which requires funding applicants to categorise their identities as Black, Asian, Chinese, or Other so that funding agencies can reach equal opportunity "targets." In April 2006, I chaired a day conference at the Walsall Art Gallery in the West Midlands entitled "Should Black Art Still Be Beautiful?" that gave voice to related concerns.

Held in memory of artist Donald Rodney (1962-1998), who was one of the founder members of the BLK Art Group formed in 1982 with Eddie Chambers and Keith Piper, this regional conference added a historical dimension to the critical reckoning. Asking what actually happened to the utopian and futuristic energies of the 1980s Black Arts Movement, the conference agreed that a new consensus around issues of identity had dismantled the political definition of blackness as a sign of solidarities among Afro-Asian communities. A trade-off had arisen whereby post-colonial perspectives had placed the categories of Britishness and blackness into mutual dialogue, such that identities are now widely understood in post-essentialist terms as always multiple, partial, and incomplete: but the flip side to this lies in the diminishing significance of "community" in discourse on identity, and a mood of disenchantment that could be described as the gradual loss of aura surrounding the political definition of "blackness" as a signifier of radical difference.

Taking stock of the shifts brought about by globalisation, the art historian Amna Malik stated that "essentially we live in a global economy that

[2] See *The Guardian* supplement, *Reinventing Britain* (edited by Naseem Khan), 16 August 2003.

has become adept at mining ethnicity as a marketing tool to transform us into genuine citizens, i.e., consumers, that aims at eradicating difference as a site of resistance," to quote from her unpublished abstract. Equally important were the views expressed by Afro-German gallerist Bea de Souza, director of the Cabinet Gallery in Shoreditch, who suggested that since art-world globalisation had opened access to alternative sources of funding, patronage, and support, black artists could now transcend the limits of "the national" and opt for an international biennale career, thereby freeing themselves from dependence on public funding. The question of beauty in our conference title also led to the view that it was precisely our own relative neglect of the aesthetic dimension that has contributed to the current state of play whereby black artists in Britain may be recognised, acknowledged, and tolerated in the art world, but the work itself often seems to be taken less seriously as a enriching site of aesthetic experience. This last area of concern struck a particularly resonant chord for me as my main preoccupations in recent years have revolved around efforts to clarify the methods and concepts best suited to art writing that addresses the phenomenon of "diaspora aesthetics" in the history of modern art. While I return to this below, briefly discussing the Annotating Art's Histories series that is currently in progress, I want to see if it is possible to make a provisional mapping of the plateau period between 2000 and 2005 in terms of a juxtaposition between two events that, between them, encapsulate some of the anxious uncertainties surrounding the challenges of "institution-building."

Looking forward, looking back

In spring 2001, the freshly refurbished Studio Museum in Harlem hosted the exhibition, *Freestyle*, curated by Thelma Golden and Christine Y. Kim, who selected twenty-eight artists, mostly in their early thirties, as indicative of the directions being pursued by a new generation of contemporary African American artists. While several of the artists—John Bankston, Laylah Ali, Kori Newkirk—had already been widely exhibited, *Freestyle* won considerable acclaim for highlighting the critical individuality of current practices. My focus, however, is on the fortunes of the descriptive term that Golden employed in framing the show—"*post-black*." Recounting to Greg Tate how the phrase emerged in her informal conversations with artist Glenn Ligon, Golden pointed out that it was merely one of a succession of adjectives that were employed to convey her perception of the *Freestyle* generation as "post-multicultural, post-identity, post-conceptual, post-black."[3] Once taken out of

[3] Greg Tate, 'The Golden Age: Interview with Thelma Golden,' *Village Voice* 21 May 2001. www.villagevoice.com. Accessed March 2006.

context, however, "post-black" entered circulation as a journalistic buzzword. Whereas, in its initial context, it acted *descriptively* as a diagnostic attempt to name the symptoms of a generational shift away from the politics of representation associated with artists from the early 1990s, such as Gary Simmons or Lorna Simpson, or Kara Walker in the mid-1990s, once "post-black" was seized upon as an *evaluative* term, supposedly announcing the total abolition of "blackness" as a socially meaningful distinction, it became more or less synonymous with a "post-political" outlook.

Golden's curatorial practice is embedded in a sharp awareness of the ways in which mainstream institutions have taken on board the critiques launched by African American artists of the 1990s—thus transforming the relationships between art and politics for the contemporary generation—and she has revitalised the cultural profile of the Studio Museum in Harlem (along with Director, Lowery Stokes Sims) by making a grounded assessment of the far-reaching artistic transformations that have occurred since the SMH was founded in the late 1960s. Situated in this context, "post-black" might be fruitfully explored for its analytical potential as a diagnostic tool, although just as "post-modernism" was initially seized upon by neo-conservative agendas that saw a clear-cut break with modernism and the avant-garde, before being qualified by historical studies that presented a long-range view of the crisis of modernism, I wonder whether the free-floating currency of "post-black" appeals to a contemporary tendency in which the term mostly expresses a wish that "blackness" would become semantically detached from the sheer heaviness of "race" as a historical, cultural, and political signifier.

Another event that took place in spring 2001 also gave voice to similar doubts about the meaning of blackness in the contemporary moment. Revisiting the 1980s "breakthrough" of the black British art scene, *Shades of Black: Assembling Black Arts in 1980s Britain* (2004) was organised by David A. Bailey, Sonia Boyce, and Ian Baucom as an important opportunity to historicise the cultural and artistic shifts of the last twenty years. Whereas the journalistic currency of "post-black" could be seen as registering the loss of aura surrounding "blackness" in the short-term timespan of the fashion-cycle, *Shades of Black* documented the more difficult and prickly process of coming to terms with the more complex issues that arise when the contemporary becomes historical—when living artists reflect on their place in art history. Moreover, in a context where the political definition of blackness has been de-centred by the presence of asylum seekers, economic migrants, and global Islam, what light is shed on the crisis of "blackness" when viewed from the British side of the Atlantic diaspora?

For artist Lubaina Himid the story of the past two decades is a bitter tale to be told in the past tense: "We created something, named it, and then

allowed it to be un-named and thus de-funded. It certainly does not exist now. All of us destroyed it. We cannot revisit it except as a dead thing to worship or be nostalgic about."[4] For Keith Piper, on the other hand, the predicament of the present was approached differently:

> Let's come at this from another angle. I am sitting in my apartment in Pittsburgh watching Fox Network News. On the screen the devil and all his works are on full display. George W. Bush, ultra-conservative leader of the twenty-first-century Republican Party, is onstage ... To his right stands U.S. National Security Advisor, Dr. Condoleeza Rice. To his left stands Secretary of State Colin Powell. No doubt skulking somewhere in the background is Supreme Court Justice Clarence Thomas. Here are three negroes who, through the embrace of the political right, have been ushered to the very core of national and therefore global power. Question: Are these the three most powerful black people on the planet? Perhaps. Another question: Is this what Huey P. Newton meant when he called for "black power"? Hell no![5]

Drawing attention to long-term changes that have installed neo-conservative blackness as a mainstream tendency, these comments show how Piper acts as a "clinician" of the social body, identifying symptoms "of certain tendencies in society of which it was as yet unaware," as writer Jean Fisher puts it in her introductory overview.[6] Where Himid decries the way in which blackness came to be un-named by "cultural diversity," her viewpoint marks a strong contrast with Piper's, who identifies key vicissitudes of the broader post-1960s conjuncture to show that contradictory outcomes have dis-articulated political "blackness" out of the discursive chain of equivalences that in earlier periods made it synonymous with worldwide struggles for social justice.

There is a sense in which the "1980s" are in danger of becoming our "1960s"—a key moment of historical transformation that is constantly battled over by competing and antagonistic interpretations. To draw up a balance sheet of losses and gains around criteria established in the past is to ignore the paradoxical ways in which the "success" of black British artists has impacted upon the international institutions of art and culture. We cannot overlook the equally paradoxical ways in which success (rather than failure) inevitably brings disappointment. If it is a truism to assert that there are only so many times that

[4] Lubaina Himid, "Inside the Invisible: For/Getting Strategy," in David A. Bailey, Ian Baucom, and Sonia Boyce, eds. *Shades of Black: Assembling Black Arts in 1980s Britain* (Durham: Duke University Press, 2004), 41.
[5] Keith Piper, "Wait, Did I Miss Something? Some Personal Musings on the 1980s and Beyond" in *Shades of Black: Assembling Black Arts in 1980s Britain,* Ibid., 38.
[6] Jean Fisher, "Dialogues" in *Shades of Black: Assembling Black Arts in 1980s Britain*, Ibid., 182.

you can have a breakthrough moment, then it is also the case that our contemporary criteria for "success" and "failure" have been shot through with ambiguity as a result of the mainstreaming of cultural diversity. Addressing the regressive aspects of the 1990s "young British artist" phenomenon as a local reaction to globalisation, I have argued that British blackness has been modified by "multicultural normalisation" such that previous relations between art and politics have been gradually de-coupled from one another.[7] In my contribution to *Shades of Black*, I suggested that part of the current dilemma is that a certain fixation on being in the "contemporary" section of the fashion-cycle seems to always take precedence over the slower time of historiography, which is heightened by the paucity of historical studies that would be able to place the 1980s period into the bigger picture of diaspora aesthetics in twentieth-century art as a whole.[8]

What makes post-1945 British blackness distinctive is the overlapping of three ex-colonial diasporas—from the Caribbean, the Indian subcontinent, and West Africa—for as art historian Judith Wilson commented in her contribution to *Shades of Black*:

> The triangle, for me as an Afro-U.S. person, has always been the most striking feature of black British identity. It embodies its fundamental and revelatory difference from blackness organised around a simple black/white binary, as we habitually conceive it in the United States. Instead, the prevailing concept of blackness in the British context involves a minimum of three ethno-cultural spheres: African, Asian, British, with the latter, of course, seen metonymically as Europeans.[9]

Whichever way the triangle is sliced—by demography or by disciplinarity—it points to "black Britain" as a boundaried formation that emerged as a late-twentieth-century site of multiple and overlapping diasporas. Viewed through a triangular rather than binarist lens, British and North American models of blackness can never be treated as equivalent, for the task of producing a historical account of their interaction—which Paul Gilroy initiated with *The Black Atlantic* (1993)—is, in my view, a scholarly objective that is only recently underway. When asked to differentiate the discourse of blackness in the U.K. and the U.S., film-maker John Akomfrah once said "the community here in

[7] Kobena Mercer, "Ethnicity and Internationalism: New British Art and Diaspora-based Blackness,' *Third Text* n49, Winter 1999-2000, 51-62.

[8] Kobena Mercer, "Iconography After Identity," in Bailey, Baucom, and Boyce, eds., op cit. 49-58.

[9] Judith Wilson, "Triangular Trades: Late-Twentieth Century "Black" Art and Transatlantic Cultural Commerce," Ibid., 168.

Britain is younger, smaller,"[10] and indeed such demographic factors mean that even if there is no political equivalence, disparate ex-colonial communities nonetheless find themselves in constant proximity. The very evolution of the black British art scene would not have been possible without the agency and involvement of such figures as Rasheed Araeen, Naseem Khan, or Partha Mitter, and other artists and writers from numerous South Asian backgrounds.

Afro-Asian equivalences were politically obsolete by the late 1980s, and today it is global Islam that occupies the centre of attention; but at a local level, the emergence of British Chinese artists and writers during the last decade —including Mayling To, Diana Yeh, and Susan Pui San Lock—points to the further overlay of the Chinese diaspora as a fourth aspect of comparative differentiation. In her contribution to *Shades of Black*, Lok observed that the bureaucratic subsumption of "British Chinese" under the umbrella term of blackness was initially resented as an imposition, even though (once British-Chinese identity became a separate category) it was defined mostly in relation to the broader Afro-Asian dialogues that have shaped the politics of "race" and ethnicity in post-war Britain.

Stuart Hall has led the way in terms of providing a theoretical framework that triangulates the artistic and cultural production of black Britain in terms of the three overlapping perspectives of post-colonialism, post-modernism, and post-structuralism. First configured in "New Ethnicities" (1988) and "Cultural Identity and Diaspora" (1989), this model is brought forward in his contribution to *Shades of Black* to underscore the importance of the archive and the necessity of developing a critical historical account of U.K. Afro-Asian artists in light of the challenges of institution-building. What was most revealing about the 2001 conference was Rasheed Araeen's disagreement with Hall's method of approach. Writing in summary, Fisher states that, in Araeen's view,

> an opportunity was lost to develop a new aesthetic theory around the early years of the Black Arts Movement because 'instead of art historians and theorists who would develop a discourse in support of black art as the new avant-garde, we had sociologists whose cultural theories of ethnicity removed black art from its historical context.' [11]

Pointing out that Araeen's critique is contradictory, for it was precisely the modernist faith in the one true 'avant-garde' that was called into question by post-modernism—a term that originated in Leo Steinberg's art criticism in the

[10] John Akomfrah in Thomas Allen Harris, 'Searching the Diaspora: An Interview with John Akomfrah," *Afterimage*, April 1992, 13.
[11] Fisher in Bailey, Baucom, and Boyce, eds., op cit., 178.

late 1960s—Fisher's critical distance (she was not a participant in the event, but was commissioned by the editors to provide an overview) brings into focus an unresolved discrepancy between the language of cultural studies and the logic of art theory. Even as his complaint mis-recognises the epistemological revolution that was led by cultural studies, Araeen's following remarks are symptoms of frustration at the relative lack of attention to the specificity of art's aesthetic dimension. Describing the impact of the BLK Art Group generation, he says:

> what differentiated these artists from the mainstream was not the invocation or enunciation of their race or ethnicity—nor a desire to go back to African or Asian roots or cultures or reconstruct them in light of what some black academics call diasporic experiences—but their uncompromising modernity: a modernity that was given a new role as the avant-garde.[12]

While substantively concurring with the principal thrust of Hall's insights, Araeen's remarks are couched in an anachronistic vocabulary. Read symptomatically, however, we can discern a faultline between the contextualist orientation of cultural studies methods—as developed in the field of visual culture—and the largely "internalist" discourse of art criticism and art theory whose emphasis on the autonomy of the art object has mostly underpinned the hegemony of formalist methods in the historiography of modern art.

The Shades of Black conference was, at times, uncomfortably emotive: I believe the frustrations stem from a double-bind in the relations of "race" and representation that has haunted discourse on the black art object from the very start. Artists, art-worlds, and art works are three very distinct ontological categories; and yet in black art discourse at various moments in twentieth-century art history—from the Harlem Renaissance of the 1920s, the Negritude era of the 1940s, and the U.S. Black Arts Movement of the 1960s—there seems to be a strong emphasis on the first and the second elements—the social identity of the artists and the cultural policies of art-world institutions—that always overshadows the attention given to questions of aesthetics in the actual experience of individual works of art. It is this third element in the circuit of artists, art-worlds, and art objects that now requires our duty of care. Indeed, it was this very diagnosis that led me to the editorial platform for Annotating Art's Histories as a series of thematic and topic-based historical studies that can open up the restricted spaces to which numerous formations of "minority modernisms" or "other modernisms" have been confined in the discipline of art history.

Where Araeen's artistic output as a minimalist sculptor has been overshadowed by his leadership role as an arts activist and animateur, perhaps

[12] Ibid.

the frustration is also a product of the "compaction" of roles characteristic of minority formations. In the current moment of "specialisation," there is the danger that the black British arts scene will conform to a New Labour fantasy of model minority behaviour, but there is also the possibility that the analytical tools provided by Hall, Gilroy, and others can lead the way to alternative understandings of modernism and modernity. As a material signifier, the multi-accentual properties of blackness can be pushed and pulled into many antagonistic and competing discourses: while this means that debates on the definition of "black art" often tend to be circular and repetitive, the polysemic qualities of blackness constantly implicate art in the social relations of "race" and representation. While this makes the analytical separation of text and context especially fraught with complexity, it may well be the case that a certain kind of contextual reductionism in discourse on the black British art scene has given priority to issues of funding and state policy that blocks our ability to understand how works of art survive time and communicate with one another across empirical boundaries of origin and belonging.

To talk of the relative autonomy of the art work as an object of attention "in its own right" is to detach the material artifact from the person who brought it into being. This is something one is brought up against most sharply when the artist is not there to make the object speak. Around about the time of Donald Rodney's death in 1998, when I was researching and writing on the photographs of Rotimi Fani-Kayode (who died in 1989), I realised that in the moment of separation between the artist and the work of art, the latter may acquire a life of its own when it continues to elicit our aesthetic response. If the material condition of art's objecthood becomes an issue after the artist has gone, could we not say that it is the work "itself" that is acting as an agent when it continues to move us and touch us, when it disturbs and surprises our habits of thought and feeling?

Up to now, such aesthetic questions have been held back and delayed by various tendencies that focus on contextual matters of identities and institutions in an activist agenda that often ends up "using" works of art in the manner of political expediency. The exciting thing about the ambiguities of "institution-building" is that the future is up for grabs. Rather than the terminal *finito* implied by "post-black," the agonies of the current transition can be grasped as a measure of the *long-duree* of "the end of the notion of the essential black subject," as Stuart Hall once put it.[13] In the quarter-century since the post-colonial turn was inaugurated in the arts and humanities, it may sometimes seem as though the very "success" of post-colonial theory has become part of the

[13] Stuart Hall, 'New Ethnicities' in Kobena Mercer, ed., *Black Film/British Cinema* (ICA Documents 7) (London: Institute for Contemporary Arts, 1988), 28.

problem: author names are used like brand names. Making their own critical assessment of the subsequent shifts since the 1990 *Out There* anthology, Gerardo Mosquera and Jean Fisher introduce their 2004 *Over Here* anthology with the following observation:

> whereas if the exile was the figure of early modernity, the diasporean or immigrant was the figure of post-modernity, with its de-centred or deterritorialized subject. With few exceptions, the 'new cultural politics of difference' foregrounded marginalized, First World, diasporan agents, but quickly segued into the institutional reification and commodification of expressions of 'cultural hybridity.'[14]

But is "institutionalisation" equivalent to "commodification"? The question itself is an index of unexplored aspects of the gap between "he world" and "the work." In my view, the need to differentiate among the disparate time cycles that characterise the cultural life of diaspora leads towards the model that Raymond Williams put forward in his study of the "formations" of modern art and culture.[15] In a Janus-like double movement that simultaneously looks forward as it looks back, such a culturally materialist approach means that the process of writing up the late-twentieth-century formation of the black British diaspora will inevitably entail a kind of *trauerarbeit*; or, as Wilson Harris put it when describing the poetics of Kamau Brathwaite, there is a process whereby art "appoints losses" and finds a place for them in a more encompassing vision of becoming.[16] The art history of the black diaspora is still an "undiscovered" country. Reaching into the deep historical past to track the aesthetic agency of black art objects, even as we contemplate the futural beauty of what blackness is yet to become, we would do well to bear in mind the words of James Baldwin's narrator in *Just Above My Head* (1978), whose friend has just come back from Africa in a mood of temporal dislocation: "'Well, I'm trying to get it together, brother. The diaspora didn't happen in a day'. We both laughed."[17]

[14] Gerardo Mosquera and Jean Fisher, eds., *Over Here: International Perspectives on Art and Culture* (Documentary Sources in Contemporary Art series) (New York and Cambridge, Massachusetts: New Museum and MIT, 2004), 3.
[15] Raymond Williams, *Culture* (London: Fontana, 1981).
[16] Wilson Harris, Caribbean Artists Movement conference, April 1968, quoted in Ann Walmsley, *The Caribbean Artists Movement, 1966-1972: A Literary and Cultural History* (London: New Beacon, 1992), 174.
[17] James Baldwin, *Just Above My Head* (New York: Dell, 1978).

CHAPTER FIVE

SITUATING A "BLACK" BRITISH POETIC AVANT-GARDE

LAURI RAMEY
CALIFORNIA STATE UNIVERSITY, LOS ANGELES

There is, even today, a range of conventional notions limiting what "black" British poetry should look like, sound like, and be about. Those preconceived ideas reinforce racial stereotypes, create a distorted view of "black" poets as not being engaged in all areas of literary dialogue and influence, and deprive some of the more experimental "black" British poets of recognition, if not, in fact, of creative agency. It is in relation to these cultural constraints that an avant-garde initiates its procedures for simultaneously breaking away from conventional expectations and assuming a frontline position with relation to artistic self-expression. A poetic avant-garde engages quite deliberately in an aesthetic project that transmits to present audiences a new sense of cultural possibility and a new direction for art.

While a body has been produced of recognizably "black" British poetry, much of which could be called "original," very little of that writing would be associated with the practices of the (historical) avant-garde—that is, an assertively and strategically antithetical response to conventional modes of aesthetic expression, the exploitation of formal properties such as unstable lyric subject positions, anti-narrative strategies to problematise imagery of wholeness and closure in the art object, exploratory use of open-field poetics, non-referential employment of language, collage and fragmentation, and other commonly defining traits.

Certainly, there are fine "black" British poets who have put a unique stamp on British poetry, but few would be considered canonical even today, much less avant-garde. Among these, Derek Walcott alone tends to show up in virtually all major anthologies of contemporary British poetry. Technically, however, his poems cleave close to traditions established in the twentieth century by W. H. Auden and others; and of that small group making its way into

anthologies with increased frequency—typically Grace Nichols, John Agard, Jackie Kay, and E.A. Markham—none would be considered avant-garde, nor do they evince any such aspiration.

Yet, based on a wealth of theory that connects non-totalising formal impulses with a "fragmentary" sociological history in "black" diasporic populations, it might seem reasonable to expect that "black" British poets would be producing avant-garde writing. In order to demonstrate how innovative aesthetic assumptions and techniques have played out in a specific context that inherently foregrounds issues of race, gender, class, and culture, in this essay I propose a theoretical cross-mapping of diasporic and avant-garde techniques, themes, and motives in contemporary "black" British poetry.

* * * * *

The growth of alternative or oppositional poetries in Britain became especially widespread in the 1970s, 1980s, and 1990s. A wide range of the poetry of "others" began to appear—not necessarily of racial "others". In their anthology *Other: British and Irish Poetry Since 1970* (Hanover and London: Wesleyan U P, 1999), editors Richard Caddel and Peter Quartermain included an excellent introduction, presenting multiple kinds of poetry alternatives and discussing a spate of exclusions, some due to sex, class, ethnicity, nationality, or style. As they explained,

> ...in many cases, this "neglect" is hardly surprising, since the writers concerned would not seek—or have indeed formally rejected—inclusion into existing hierarchies, which they see as increasingly lifeless and irrelevant. (xvi)

Out of Everywhere: Linguistically Innovative Poetry by Women in North America and the UK, edited by Maggie O'Sullivan (London: Reality Street Editions, 1996) is another illuminating compilation. Both anthologies contain poets who challenged the idea of a "standard" English expression. The development of oppositional poetry was, some literary historians have contended, due in part to the presence and artistic influence of the second generation of migrant children of the African diaspora.

According to Kwame Dawes, "Nobody talked much about black British writing until the early 1970s. Prior to that period, black people wrote in Britain but their work was not conceived as speaking to the British experience *per se*" (Dawes, 19). Although "black" writers had long been in Britain, their numbers were small, and they commonly had primary attachments to other geographical and cultural locations. With Sam Selvon's *The Lonely Londoners* (Longman, 1956) as the classic example, earlier texts were seen (by the writers themselves as well as British audiences) as perspectives on how Britain and the

British were perceived and experienced by outsiders—not the voices of writers who were part of the culture and happened to be "black". Their words and ideas were permeated by a sense of an imminent return to their places of origin, and these works reflected conflicted, alienated, and authentically colonial and postcolonial attitudes towards the United Kingdom as the motherland—and source of culture and education, if not of sustenance and belonging.

James Procter identifies "a tangible shift away from the more prose-based narratives of the 1950s and early 1960s to a more poetry-based cultural production in the 1970s and early 1980s." He attributes this shift to "an increasingly self-conscious experimentation with 'vernacular', 'dialect'" or the linguistic forms that Kamau Brathwaite termed "nation language," a development which strongly influenced Linton Kwesi Johnson among other major contemporary "black" British poets (Proctor, 97). In the opening Comment to his 1970s selected poems, *Fractured Circles,* James Berry explains that this increasing intermingling of dictions took place because "Political independence in the Caribbean brought respectability to the people's language." According to Berry, the use of vernacular also produced a generational divide: its use was frowned on by the older generation because of their attachment to "pre-independence entrenchment, based on the old lessons—those of the single validity of the European prototype." Their attitude was "Black Prime Ministers an' professors and all top people don' get whe' them is talkin' bad talk like we" (Berry, 9).

As for the younger generation, their using indigenous diction and diasporic references was a way of extending respect towards their ancestors and traditions, and it was a way of articulating the value of the foundations of their core identities. At the same time, these younger poets—notably Linton Kwesi Johnson, but also Grace Nichols, John Agard, and Berry—showed progressive signs of appropriating British culture, identities, and rights, and of claiming a present and future where their adopted home would be an actual home for them, too, not just a place of temporary residence. The shift was due to the coming of age of a substantial group of young "black" poets who knew no home other than Britain, or who had come to Britain to stay. This great wave of poetic output included Linton Kwesi Johnson's *Dread Beat an' Blood* (Bogle L'Ouverture, 1975), Berry's *Bluefoot Traveller: An Anthology of West Indian Poets in Britain* (Limestone, 1976) and *Fractured Circles* (New Beacon Books, 1979), Jean "Binta" Breeze's *Riddym Ravings and Other Poems* (Race Today Publications, 1988), Agard's *Mangoes and Bullets: Selected and New Poems* (Pluto Press, 1985), E.A. Markham's *Human Rites: Selected Poems 1970-1982* (Anvil Press, 1984), and Nichols's *The Fat Black Woman's Poems* (Virago, 1984). This groundswell also reflected the emergence of publishers committed to what was now being thought of as writing by "black" Britons.

Berry's case makes a good focal point for the discussion of a "black" British avant-garde. As the title of Berry's selected poems, *Fractured Circles*, announces, the formerly self-circumscribed, closed circles—of Great Britain, of its former colonies—had been cracked open. The generation coming of age in the 1970s and 1980s naturally joined the language of an ancestral "elsewhere" and the speech of their parents to the experience of a new homeland, resulting in what Procter identifies in the writing of Wilson Harris and others as an exploration of "the aesthetic possibilities of a synthetic, diasporean landscape" (Procter, 97)—in other words, no longer a contribution to descriptions of a hegemonic Britain, demarcating insiders and outsiders, but disclosing and representing somewhere entirely new where the young "black" British poets belonged.

The development of Berry's writing exemplifies the changing patterns in "black" British poetry from the 1950s to the 1970s. Bruce King observes that the audiences implicit in Berry's poetry of these two eras are different. The poetry of the 1970s switches away from being directed primarily towards Jamaican readers; it is intended to communicate Berry's evolving identity as a British poet addressing a British and a wider, international audience (King, 109). That new rhetorical posture also signals the presence of double consciousness: in addition to Jamaican readers, Berry engages British readers, imagining how they are seen and described through Jamaican eyes to other Jamaicans, reflecting with self-satisfaction how grand, impressive, busy, and overwhelming London must be to displaced "aliens" from Caribbean sands, a subtextual point of view which Berry cleverly insinuates.

In contrast, Berry's earlier poem "Migrant in London," written in the 1950s, uses sufficient vernacular diction to identify the speaker as Caribbean. The opening stanza conveys, by means of irony, both the speaker's awareness of how he is externally perceived and the British posture of self-aggrandisement. He achieves this rhetorical dualism by describing himself as transforming into one of the "stragglers" for whom the sea divides when they arrive in "the Mecca." The imagery blends Old Testament and Muslim (i.e., non-Christian) references, while explicitly conjuring the Exodus ("sea divided for we"), demonstrating the "black" speaker's identification (as in the African American spirituals) with the enslaved Exilic Jews as the original population referred to as "diasporic":

> Sand under we feet long time.
> Sea divided for we, you know,
> how we turn stragglers to the Mecca.

We (as an adjective in stanza one, above) and *man* (as an emphatic noun of address, in stanza two, below) clarify the identity of the addressee, a fellow

Jamaican, as the speaker describes his arrival on a street which is "worl'
centre"—the heart of the Empire, where sand has been replaced by loud traffic:

> An' in mi hangin' drape style
> I cross worl' centre street, man.
> An' busy traffic hoot horns.

This "town"—not a capital city, reflecting the speaker's "provincial" frame of
reference—is filled with landmarks and belongs to the subject's king, not to the
subject himself (actually still a visitor from the Commonwealth). These factors
add up to reinforce each other as signifiers of class as well as race. The speaker
compares his humble stature (pigeons roost on the pinnacle of his shoulders)
with the feet of "great Nelson" in stanza three:

> I see Big Ben strike
> the mark of my king town.
> Pigeons come perch on mi shoulder,
> Roun' great Nelson feet....

In the fifth and final stanza, the turn arrives with the self-evident reality of the
speaker's situation: there is no welcome or place for this immigrant in great
London, pinnacle of civilisation, and any thoughts to the contrary are only
momentary self-delusions, which the speaker acknowledges to himself:

> I whisper, man, you mek it.
> You arrive.
> Then sudden like, quite loud I say,
> "Then whey you goin' sleep tonight?"

 Two decades later, with the concentric circles of centre and margin
"fractured," and Berry having been a resident of England for twenty years, his
1970s poem "Black Immigrant" depicts quite a different situation. The
vernacular has been replaced by the post-Eliotic elevated diction of arch high
Modernism in the poem's powerful opening stanza: "I have not danced to drum
beats / of Independence, it is their / echoes that animate me." But this is not
Eliot reanimated: this is a new voice, one which announces dominion over the
future of British culture and its dead and dying myths, through reclaiming and
regenerating diasporic myths and achievements reset in the present.
 In this poem, Berry maps his diasporic identity over rigidified and
conventional imagery of British culture for a purpose that is avant-garde—if we
use the term in the sense of leading or pushing the arts and society ahead into
unfamiliar terrain. His poems from this period represent an avant-garde
expression of a counter-cultural agenda, even in the absence of technical

features associated with avant-garde practice. Here, it becomes necessary to separate avant-garde *form* from avant-garde aesthetic *function*. If we understand the two as different from one another, we are able selectively to activate aspects of our definitions of both "avant-garde" and "diasporic" to accommodate a wider range of British poets in understanding the complexities and rewards of the intersection of these two concepts—how they may relate in ways that are not immediately self-evident, and how this dynamic enables us to open up our conceptions of both diasporic and avant-garde features and practices.

* * * * *

Berry was not in the former colonies when he experienced this aesthetic liberation. He was now firmly situated in England, but he perpetuated a residual rootedness in the diaspora, hearing not the drumbeats themselves but their reverberations (as in his reference to the echoes of the drumbeats but not the drumbeats themselves in "Black Immigrant"). Vernacular expression continues to appear in other poems by Berry after the 1970s, but a wider range of styles becomes normative. For Berry, the use of Caribbean vernacular as a political statement—in contrast, notably, to L. K. Johnson, whose poetry never abandons it—has become only one of many meaningful options by this time. The diasporic drumbeats representing the history of Africa continue to energize the speaker in Berry's "Black Immigrant," but now from a removed perspective, as a more distant reminder of provenance, rather than as a native, first-hand presence. The memory of winning Independence, with all that it signifies, has not been forgotten by choice; rather, that memory has become purely an inheritance. "I clash with myths," we read (in an interesting echo of Adrienne Rich's feminist anthem "Diving into the Wreck"), as the speaker takes control over who inscribes him and how, in the transition from oral to written testimony. Berry uses "myth" with double meaning, echoing Du Boisian double consciousness as well as Mircea Eliade's idea that perpetuating past myth is a means of regenerating time, and extending moments of first beginnings by connecting past with present:

> The past is but a prefiguration of the future. No event is irreversible and no transformation is final. In a certain sense, it is even possible to say that nothing happens in the world, for everything is but the repetition of the same primordial archetypes; this repetition, by actualizing the mythic moment when the archetypal gesture was revealed, constantly maintains the world in the same auroral instant of the beginnings. Time but makes possible the appearance and existence of things. It has no final influence upon their existence, since it is itself constantly regenerated. (Eliade, 89-90)

Stanza three continues: "My presence tames minds with touch. / I educate the civilized." The poet's presence is depicted as sensory, and the senses are given primacy over the rationality of "the other" in their ability both to tame and to domesticate the formerly empowered. "I understate my self" continues the poem, in its Eliotic erasure of personality while the persona searches for an "objective" self-determined truth about experience. A new myth (which is actually the originary diasporic myth revived) is supplanted over the received myths of Empire, regenerating the foundational diasporic myths as sources of power. This repetition makes the present an endlessly "auroral" beginning, in Eliade's terms. If Modernist tradition is the only available interpretive framework, it is easy to overlook the fact that triads dominate this poem, one of the key structural African survivals, forming a correspondence between these two sets of influence. The line "I bring earthy reflexes / to refined cadences" encapsulates the blending of an authentically diasporic identity with British literary traditions and achievements. There, the speaker enters into—and even lays claim to—the power to control the future aesthetic direction of Britain, revealing a perspective that melds diasporic references with avant-garde intentions. As if speaking back in history to an earlier self—contrasting the previously overwhelming experience of Big Ben and Nelson's statue—this formerly Caribbean-Arts-Movement voice now announces that "treasures now do not / signal me instantly / an alien visitor."

Though confessing "my new roots are downy" (because they have been recently replanted), the poem's final stanza looks towards a future which is an immediate extension of the present (a gesture that is one of the central survivals of African religion and philosophy). The future is now depicted as resting in the hands of the next generation (also representing African survivals, by connecting past and present generations and emphasizing the importance of community for each individual). The poem invokes "my son," who "scans the park of snow / knowing every landscape his / footway. To him arrows are / buried, not superseded." The sands of the past are replaced by the now-familiar snows of the present. The mechanisms of injury are no longer avoided—they are dead. The diasporic myths and concepts have been the powerful weapons that have destroyed them.

* * * * *

There appear to be ample theoretical grounds for expecting formally innovative poetry by writers from the African diaspora and for expecting that a diverse array of their creative designs, formed once on the margins, would transfer in our own day to the progressive centre of British aesthetic culture. In 1948, with the passage of the Nationality Act and the arrival of the *S.S. Empire*

Windrush in Tilbury with its 492 passengers from Jamaica, Britain opened its doors for the first time to substantial numbers of "black" immigrants, leading to what Mike Phillips and Trevor Phillips have described as the "irresistible rise of multi-racial Britain" (this phrase is the subtitle of their landmark study, *Windrush: The Irresistible Rise of Multi-Racial Britain* [London: HarperCollins, 1998]). Surely, one might expect an explosion of avant-garde poetry from these diasporic arrivants, blasting British literature into its new, eclectic multicultural future, joining race, nation, identity, and aesthetics into one propulsive fuel. At the present moment in history, one might expect the existence of a substantial body of startlingly fresh "black" British poetry that reflects the ability of "black" Britons to meld a fluid, adaptable, and synthesizing practice with multi-layered commentaries on current times and locations rooted by African survivals. The reality is somewhat disappointing, if one is looking only to be startled by this or that particular sort of innovation, but more than consoling, if one takes the time to discover what is happening in this field and to note the sparkling qualities of "black" British poetry being produced today.

That said, although the presence of diasporic references in contemporary "black" British poetry may have enhanced a sense of racial identification and presence, there is not a considerable body of *formally* challenging poetry being produced. The little that exists has not been perceived as legibly British, nor is it widely available as a result. Jackie Kay, John Agard, Grace Nichols and Benjamin Zephaniah may be relatively well-known cultural figures who have an occasional (usually more explicitly autobiographical) poem taught as part of the national curriculum—but poetry by "black" Britons is not much easier to obtain today than it was in the 1970s, and it is inscribed in cultural spaces mainly designated as ethnic. It has not been long since Zephaniah turned down his offer of an OBE with a "no thank you, Mrs. Queen" and a scathing attack in *The Guardian* for the Crown's continuing references to the British Empire. The story, "Rasta Poet Publicly Rejects His OBE", made the front page of *The Guardian* on 27 November 2003. These poets' experiments with avant-garde poetics remain, for the most part, invisible to the general British public—and even to those "black" literary activists committed to the dissemination of "black" British art. One might hypothesise that avant-garde poetry is not being created simply because poets know that it will be ignored—and viewed widely as "tangential" to "black" British experience. My contention here, however, is that we need to reconsider our definitions of the avant-garde and the diasporic as these concepts interrelate. The fact is that, in line with the general marginalised treatment of "black" poets, no group of "black" artists is more consistently or systematically excluded than those whose practice is *thoroughly* avant-garde, in the sense of *formally* innovative, which suggests a sad and self-fulfilling prophecy.

* * * * *

Two exceptions of note are poets Patience Agbabi and Anthony Joseph. Joseph's poetry does indeed toss Caribbean references of various sorts into his postmodern, quasi-apocalyptic, avant-garde poetic mélange. And Agbabi's avant-gardism is just as edgy as Joseph's—but her cultural touchstones, clear of Caribbean influences, are located as much in the canonical English tradition that includes Chaucer as in British hip hop, rap poetics, wry references to Nigerian cultural behaviours, and cyberculture. Each of these two poets is doing something new deliberately, and each is aware of the reasons for technical experiments and innovative aesthetic designs. They both want very calculatingly to show the way forward—away from the well-worn poetic paths of (*even*, if not *especially*) their "black" British antecedents and contemporaries.

Joseph and Agbabi make important contributions to contemporary poetry in English, but, as closer examination will demonstrate, it is difficult to consider both of them as avant-garde poets without rethinking the conventional parameters of the category. In spite of perceptions that Joseph and Agbabi are both cutting-edge culturally and aesthetically speaking, and deeply concerned with issues of race, their oeuvres are radically different from one another's, and their critical and popular receptions have reflected those differences. Each of them marks an important path of inheritance and a new aesthetic direction for "black" British poetry as diasporic expression—and for moving British poetry forward into an energized future.

In the reaction to Anthony Joseph's postmodern linguistic experimentation, which exemplifies many of the practices associated with radical twentieth-century avant-garde movements, we see double marginalization (not only is it "black", but it is the wrong kind of "black").[1] Joseph's poetry imaginatively extends, in a diasporic context, a trajectory of experimentalist influences (including Dada, Russian Formalism, Negritude, the Beats, L=A=N=G=U=A=G=E Poetry, and surrealism, not to mention connections to various contemporary African American and diasporic innovators, including Kamau Brathwaite, Ted Joans, Amiri Baraka, and Wilson Harris). But Joseph is not well known in the United Kingdom. His challenging, non-mimetic, anti-narrative, and fragmentary poetry is absent from sites such as

[1] The most extended academic treatment to date of Joseph appears on pp.121-125 in my essay "Contemporary Black British Poetry" in *Black British Writing*, ed. Arana and Ramey, which I hope serves as an invitation to others to look into Joseph's work. I also discuss Agbabi's work at length in that essay. My lengthier critical and biographical studies of Joseph and Agbabi will appear in 2006 in *Dictionary of Literary Biography: Black British Writers*, ed. R. Victoria Arana (Bruccoli, Clark and Layman Publishers).

respected British literary magazines (for example, *Stand, Wasafiri*, and *Poetry London*) and anthologies that have published "black" British poets of his generation (such as *IC3, The Fire People, Step into a World*, and the *New Writing* series). These oversights have occurred despite his having published two stunningly original poetry collections that garnered sufficient international acclaim for him to be invited by California State University at Los Angeles as the first West Coast (U.S.A.) British Council Poet-in-Residence (in April 2005). Joseph's publisher, London-based Poison Engine Press, is a collective providing a limited run of editions. It identifies itself as "a black independent imprint founded in 1994 and specialising in experimental/neo-contemporary texts." Joseph's writing has been locked out of critical consideration from an aesthetic point of view, but I believe that other factors, beyond aesthetics, explain why Joseph's work is not better known and appreciated. These factors include race, class and gender. His situation invites further interdisciplinary study of the interconnectedness of aesthetics and sociology in explaining why certain "black" British poets have become invisible.

Joseph's own radical statements support a claim that aesthetics is inextricably connected to non-aesthetic factors in the style of his writing. In the introduction to *teragaton*, Joseph explains that he writes as he does "because we are experiencing a crisis of representation—**conceptual colonialism**" (Joseph, *teragaton*, 16). This exilic imagery echoes Berry's, with the term "conceptual colonialism" functionally replacing the earlier term "postcolonialism" as we start to see a developing sense of exile from within—British, but the wrong kind of British; "black", but the wrong kind of "black"; poet, but the wrong kind of poet *for who you are.*

Escape from that sort of linguistic repression is central to Joseph's poetics, which interrogates social, intellectual, national, and cultural institutions whose idea of self-preservation is to lock out voices of diversity. Joseph's work has been largely ignored in the United Kingdom—not because of its diasporic identification, but because an avant-garde agenda is not recognizably "British." He is not seen as a "black" poet because his work is experimental. I have seen only one other critic who has written about Joseph (James Oscar, in the Preface to *teragaton*), and this brief piece describes Joseph's poetry not as avant-garde, not as "black", not as British—but as "European." Joseph's exclusionary treatment brings up associated expectations for "acceptable" "black" British poetry. Expectations dictate that it should be performative with a linear narrative, that it call for class- and race-based social interventions, and that it employ techniques and imagery directly discussing dual identities and cultural tensions. In clear contrast to these stereotypes, much of Joseph's poetry operates as aural and visual collage. He is not interested in directly calling for social change, but in the implicit power politics of exploring his identity as a language

user. Double consciousness is not reflected in naturalized characterizations, but through voices which are decentered, unidentified, multiple, and distributed. Instead of addressing disempowerment as a theme in his poetry, he represents it through semantic rupture, with syntactic fragmentation, and by breaking down communicative frames and patterns:

> I wrote *teragaton* during a year long period of experimentation with the language of the unconscious. I was searching for some true text, some hidden, profound and honest text, at the same time I was conscious of rhythm and form when poems were assembled on the page, respectful of poetry. Most importantly was my first life in Trinidad, coming to England at 22, the cadence and motion of our speech, memory. My influences—some cubist poetry, William Carlos Williams, Pound, the Beats, Ginsberg, Black Mountain, Wilson Harris, Monk, Bukowski, Baraka, Dorothea Brande, Negritude, and then I discovered surrealism. And it is this that shapes that text.[2]

Regarding a hospitable aesthetic context for his specifically avant-garde practice (as opposed to his less problematical association with the African diaspora), Joseph states:

> I've always felt like I write in a vacuum, I'm still waiting to meet other black experimental poets. There's a shortage of 'em in London. I guess like everyone else, in my work I've tried to construct a self-sufficient universe of text to fill this vacuum. I mean, as James says, "the metaphysics of another world," a body of work with a sense of continuity and cohesion, a method, a science. Now, I feel it necessary to experiment even further with poetry. I like the idea of resonance, minimalism, something. We'll see. It's not often I get to talk text.[3]

Colonialism, diaspora, postmodernism, and the avant-garde intersect in Joseph's oeuvre, and the interdependence of these themes sheds important light on the restrictions that still obtain in spite of some of the cultural and critical openings that have been achieved by "black" British writers in recent times. Joseph's poetics is, of course, normative for avant-garde practice. He is a contemporary poet interested in decentering and reconceptualizing identity, examining literary connections across metaphysical boundaries with others who have engaged in exploratory practices, and interrogating language as a system of discourse. But as a "black" British poet, his practice essentially renders him faceless, although he has assiduously searched for literary affiliations, lineage, and influences that speak to his poetics.

In trying to find past and present exemplars, Joseph has sought out poets associated with an avant-garde outlook, and, in some cases, he found some

[2] Ibid., Joseph interview, December 2003.
[3] Ibid, Joseph interview, December 2003.

who happened to be "black". But where influences may be discernible, Joseph's poetry clearly indicates that the experimental stances of specific role models have been dominant, not their racial identities. Joseph has been much more interested in white poets who are innovative and counter-cultural than in "black" poets who are stylistically and ideologically conservative. The spiritual impact on him of his discovering the work of innovators Amiri Baraka, Ted Joans, Kamau Brathwaite, Wilson Harris, Leopold Senghor, and Aimé Césaire, poets similarly committed to being artists both "black" and avant-garde, was extraordinary:

> I sent Wilson Harris a manuscript of *teragaton* for his 76th birthday. I thanked him for being such an inspiration to me, wished him happy birthday, told him a bit about my background, what the manuscript was and that was it. He replied some weeks after, thanking me for sending it, apologising for not replying earlier, he said that he'd read and enjoyed it, and he wished me luck with it and my work in the future. Short & sweet. I think he mentioned a poem he especially liked. I was so happy, just that he'd actually responded to me, that he'd actually read my work.

> When I met Kamau Brathwaite, one of the profound things he said was "You don't become a Caribbean person until you leave the Caribbean." You need distance to scope the scene, Trinidad and the Caribbean itself are so complex. I remember years ago, I was reading Madan Sarup, Kristeva, Lacan, Baudrillard, thought I was hip, thought I knew postmodernism (this was mid 90s when postmodernism was the byword). I went to Trini and tried to explain its concepts to my brother, wild island poet, the river down the hill is his bathroom. His response was something similar to 'nigga please, i doh want hear dat sheeet'. I laughed then, but years later, I realised that he was the most postmodern all along, all this time, his life in that village was so postmodern he didn't even have a name for it (kinda like a fish shouldn't notice water). It was me that was running forwards facing backwards, trying to catch up. [4]

Joseph's state of expatriation from Trinidad—a place to which he feels he can never fully belong again, but which remains for him an important source of creative material—appears to be the foundation of his identity as a "black" British artist. Connections with others from the Caribbean (including Wilson and Brathwaite) have had a profound impact on his sensibility, and those aesthetic links have helped compensate for the critical disregard he has experienced in England. Through their example, Joseph has learned to see himself as part of a scattered avant-garde community and praxis, rather than as an individual working in isolation from movements of greater apparent popularity. His avant-garde network epitomises a diaspora within a diaspora.

[4] Email from Anthony Joseph dated 12 June 2005.

As such, Joseph views himself as a future role model for younger "black" experimentalists, in the way that elders have served for him, to mitigate the next generation's imagined sense of isolation. Joseph does not expect things to change for avant-garde artists, who will always be in the minority:

> One of the reasons I seek these poets out is because I feel I need to honour them for staying on the path they chose; they've gone through the same doubts and agonies I go through, and they stuck to it. One day young experimental poets will come to me and ponder my grey beard, I hope. So in a way too, I seek contact with them so they will know that the work they inspired continues, we/they did not write in a vacuum. Meeting someone like Kamau Brathwaite teaches me a lot about myself and where I stand in Caribbean poetics, maybe even where I'm going. He's a role model, been on this road from time.
>
> When I began to catch my voice as a poet, I searched for kindred spirits, most weren't black, their colour was secondary. I was interested in the way they broke cages textually, how they constructed sculpture with words, the magic of their text, and most importantly their search for a true text, a core. That's why the beats and later the surrealists were so important to me. Because to me avant garde work is like a sharp point searching, searching, leaving the house and going outside. And while I love & respect the classics, I had no desire to re-write them, I wanted to create new classic forms. I wasn't interested in poets, black or white, who had nothing new to say, no new way of tackling the crisis of representation.
>
> When I began to discover black writers who were experimental (and funky too), it did blow my mind, like free jazz! Baraka! Preface to a 20 Volume Suicide Note, Palace of the Peacock, even Ted Joans, Césaire, Harris, Brathwaite, Henry Dumas! The whole negritude movement, Fanon, politically, Last Poets! And then saints like Coltrane.... [5]

Joseph's poetry also contains many features associated with the African diaspora—sustained contact with deceased elders as spirit guides, emphasis on family and cultural inheritance, dispossession and the effort to create one's own functional world in the face of migration, the integration of the individual with community, and cultural, psychological and linguistic alienation. *The African Origins of UFOs*, Joseph's most recent book, works across boundaries of genre to form a multi-strand, poetic, science-fiction "novel" set in a world where Darwinian processes have enabled only the darkest-skinned people to survive, with melanin as the contraband drug of the day. Joseph explains the genesis and central premise of *The African Origins of UFOs*:

[5] Ibid., Joseph email dated 12 June 2005.

The origin was a tourist guide book to Trinidad. There was a section on history and it mentioned something that happened in 1837: a slave called Daaga (actually he was never a slave, he was captured by the British from the Portuguese, so the story goes), anyway he was put into the Brit army stationed at St. Joseph, Trinidad, but he was always saying he'd make it back to Africa, and take his people. So one day he shot up the barracks, gathered his men and 'they set off to walk back to Africa', that line haunted me, it was the genesis. I imagined them getting into a spacecraft, *I then saw their journey as a metaphor for black people trying to find their roots, to find a mythical Africa* [my emphasis]. It became a sci fi story. As the idea took shape, I began to include myself in the text, in a metafictive way. I was looking now for a structure, something mathematical, about dna/rna. I found [Timothy] Leary. So the idea of past present future took hold. I researched extensively on planet construction, on genetics, on Trini folklore, etc.[6]

The African Origins of UFOs is the extraordinary culmination to date of all that has come before in Joseph's writing—a true melding of the diasporic and the experimental into something genuinely new, so fully infused by race that it need not be "racial". Joseph comments on the role of race as a theme in this book and as it relates to the style that he developed:

I considered the antiessentialist/essentialist debate for a long time. I found humour in it. I remember hearing a speech by Eldridge Cleaver saying how 'niggers' in the ghetto had no time for high-fa-lutin language. I thought of creating a characters so 'black', so gut bucket funky that they were over the top, there's a lot of humour here. I was playing with the idea of 'blaknuss', its in the language, read 'Secret Underlung' for a better explanation.[7]

Accordingly, we read the irony (including self-irony and self-allusion in a reference to Joseph's own poem "Blackdadamasonsong" from *teragaton*) and meta-literary/meta-cultural commentary in this excerpt from "Secret Underlung" which describes the arrival of Joe Sam, the melanin drug pusher:

His modus upset some post earth negroes who believed inner:disembodied blacknuss and they bemoaned Joe for his blackdada retrograde. They claimed Black as a concept of being was only ever relevant on Earth, and even then was suspected as the mindset of a con that afros down and kept negroes terra bound to suffer (when we coulda been interplanetary from way back). they said black was dead. Black as in the tones of Nuyorican niggerpoets ranting militant in ancient days, earth long, livin' in cold water Brooklyn warehouse space, no food but Fanon, no cash but Jackson, back then them rhetoric was hip and

[6] Ibid., Joseph email dated 12 June 2005.
[7] Email from Anthony Joseph dated 13 June 2005.

OnTheOne 'cause subversive boots and dreader guerillas were needed on the urban battlefields and word was sword, shield and dagger, even ancient Iere had gun in Dashiki and afro intellects bust plenty police head with oratorical gas but not now we swimming in heaven.

In *The African Origins of UFOs*, Joseph moves to the future to reconcile the wrongs of the past that resulted in migration in the first place. By starting with the myths of African origins and regenerating them, Joseph echoes Eliade and uses myth-making to create new meaning in the present. Consistent with African cultural survivals, the future in this work is depicted as a reachable extension of the present. In the popular imaginary, diaspora is conceived of as a moment—a static event (or series of related events) that took place in particular locations in the past and whose reverberations are felt today. Joseph fully exploits and explores that conception by imagining a diasporic wave extending into the future, but whose purpose is to reverse migration—to affect a return to Africa. By these means, he reconnects the diasporic present with originary myths and reactivates them as something new, using techniques now conventionally associated with the avant-garde. In other words, Joseph uses the means and goals of diasporic and avant-garde writing in order to achieve the mutual aims of both. In the terms of Mark Turner, Joseph has created a metaphorical, blended space (a concept that Turner explores exhaustively in various important works, including *The Literary Mind*) through which former slaves have travelled to the future to arrive home in a new time and place.

Joseph employs a syncretic, diasporic, and highly innovative blend of genres and styles. It is his way of providing an example of how diaspora becomes subject, inspiration, and rationale for the innovative use of form. These experimental measures enable him to show the diaspora in a fresh light. The formal (and narrative) purpose of *The African Origins of UFOs* is to permit significant insight into the history of the African diaspora by foregrounding the fundamental longing and search for home among people who have distinctively preserved their culture when removed from it. At the same time, it is a poet's way—regardless of race—of discovering a path through language and experience.

Part of Joseph's aesthetic challenge springs in general from his wish to work in a poetic genre and, at the same time, to generate an exploratory narrative. It has been for him, all along, a technical issue, not a racial matter:

With *African Origins of UFOs*, my struggle was how to write fiction as a poet, how to write narrative. I had to train myself to write in paragraphs and not verse, many long nights, eventually I developed my own way of doing fiction, and still keeping my poetic sensibilities intact. I could not escape the poet in me. I ended up with poetic prose. There are many systems within it, wheels within wheels, like the mathematical structure of 24 chapters was inspired by Timothy Leary's

24 stage evolutionary theory, 3 time zones/holy/trinity/synapse cell/past present future/ water land space. So 8x3=24.The three sections are 'Joe Sambucus Nigra', 'Journal of a return to a floating island' and 'The genetic memory of ancient iere', and they interweave, like plaits in my grandmother's hair. [8]

As his description intimates, it would be impossible (maybe even for Joseph) to extricate his systematic exploration of the avant-garde as counter-cultural practice (with Timothy Leary providing the central structure) from its diasporic unfolding (seen, remarkably, as the braided hair of his grandmother). In short, Joseph has elaborated a spirited experimental poetics and an avant-garde aesthetics generated out of his intellectual response to cultural displacements and the hegemonic residuals "blacks" encounter in the art world. While the diasporan sensibility has served to intensify his isolation as a British poet, it has also made possible his entire creative output.

* * * * *

Patience Agbabi's use of traditional poetic forms within a recognizably British poetic tradition—but inserting African diasporic references—has earned her, unsurprisingly, a far more central place in contemporary British culture than Joseph's use of diasporic references and his faith in avant-garde forms have earned him. Yet Agbabi is often called avant-garde and viewed as cutting edge—which in some ways she is, though not at the same obvious level of form and structure as Joseph. She is a self-described performance poet who writes almost entirely in metrical verse, with sonnets and sestinas that incorporate references to hip hop culture, Northern Soul, urban alienation, the effects of migration on communities and individuals, and the "black" female body. Her "avant-gardism" is legible while Anthony Joseph's—in all probability more identifiably part of the practice of experimental poetics—is not.

Agbabi's poetry, for instance, veers from the urban inflections of rap poems towards extravagant meta-linguistic play in a mock-London-Nigerian updating of Chaucer's "Wife of Bath's Tale" ("The Wife of Bafa" from *Transformatrix*). Elsewhere, she has taken on the daunting formal and conceptual challenge of writing a corona of sonnets, which she embroidered on a skirt that appeared in American *Vogue Magazine*. In some ways, Agbabi's poetics could be taken as conservative in her use of conventional form—but the matter of her race shifts the critical conversation.

Like Joseph's, Agbabi's poetry triggers preconceptions about what "black" British poetry is meant to be, and hers in some ways conforms to these conceptions (in terms, that is, of *content*), while in other ways it does not (in

[8] Joseph email dated 12 June 2005.

terms of *form*). This Nigerian-British "avant-garde poet" cites Robert Frost's "The Road Not Taken" as her favourite poem. As major influences, she credits Chaucer, Browning, and Wordsworth. She names as some of her favourite recent poets R. S. Thomas, Paul Muldoon, Carol Ann Duffy, Michael Donaghy, Roger McGough, Jackie Kay, and Roddy Lumsden—primarily white males, closer to the centre than the margins of culture, and more closely associated with confessionalism and neo-formalism than avant-gardism. She is aware of how her influences appear and properly unapologetic. Her stance is reminiscent of the situation of a number of African American poets whose work did not seem "black" enough or political enough in the context of the Black Arts Movement.

The alternating depictions of her objectification, "exotic" status, and absorption as "black", British, female, and alien (she is the stranger within) also emerge in the conflicted reception of her poetry and performances. She is widely esteemed and just as widely published. Still, Agbabi's cultural position among younger "black" poets is singular. On the one hand, she is far more fully inscribed than Joseph's challenging formal experimentation, but her poetry nevertheless is relegated to a category of one. It appears provocative, but it can be naturalized. It is "black" and edgy on the surface, but ultimately recoupable and legible. Indeed, it is culturally rewarded and recognized for the British breeding it manifests—a civility that can be counted on, finally, to prevail over potentially threatening manifestations of sexual transgression or other forms of counter-cultural challenge.

Some of this critical equivocation arises from the tension between Agbabi's use of conventional forms and her interest in exuberant live performance. "Black" poetry in Britain is often associated with performance poetry, sometimes along with dismissive remarks pronouncing performance poetry inferior to "print poetry". Because she is well-known for the quality of her live readings, Agbabi believes that even her "print poetry" is sometimes underestimated, not acknowledged for its formalist emphasis on skilful versification and its relationship to the English poetic tradition—misperceptions which, she recognizes, are fundamentally race-based.

Performance, for Agbabi, is as closely related to the oral roots of the West's lyrical poetic tradition as to African diasporic traditions. She addressed the problem in her M.A. thesis, discussing the sonnets and sestinas that predominate in her volume *Transformatrix*, which she links directly to the medieval troubadour tradition: "When I perform [poems] they are labeled 'performance poems' because I am known as a performance poet" (Agbabi, "Word of Mouth," 6). She warns readers and critics, "*Don't judge a poem by its author*"; and she asks critics to avoid reviewing "poetry from a prejudiced perspective..." (Agbabi, "Word of Mouth," 28). In writing sonnets and sestinas

that unexpectedly draw on diction and imagery of popular culture, Agbabi's
intent is to create something new—to "challenge fixed views about so-called
high and so-called popular art" (Agbabi, "Word of Mouth," 6). The desire to
produce unexpected juxtapositions to create new meaning, combine "high" and
"popular" references in the work of art, and be empowered as a black poet to
enter into historically white and male literary traditions define Agbabi's
intentions as avant-garde—intentions which become perceptible once we avoid
judging racially, and are able to look beyond manifestations of form, style, and
technique alone.

In desiring to reintegrate "performance" with "page" and "poetry" the
p-words), Agbabi's goals are based on a longing to incorporate recent
technological developments with the ancient practices of reciting lyric poetry.
As she put it, "Poetry is one of the oldest forms of artistic expression: the
printed page a relatively recent technology. Each can empower the other for
both possess unassailable strengths.... It is time for open dialogue, critical
debate. It is time for an integrated, holistic 21st century poetics. It is time to
break the silence" (Agbabi, "Word of Mouth," 29). Still, Agbabi's humorous
use of the term *p-words* drenches in irony the imputation of a transgression into
dangerous terrain should a poet approach this delicate topic. In coining the term
p-word, Agbabi acknowledges that any discussion whatsoever of the *page-vs.-
performance* divide marks an entry into highly sensitive territory. Attempts to
distinguish the "serious" arts from those which are merely "popular" have also
proved perilous, with implied racial grounds for what is likely to be canonized
and taken "seriously" (not, of course, the work of the merely popular
"performance poets"). These discursive patterns account, at least in part, for the
continuing marked under-representation of "black" poets in the general
anthologies of British literature. Aware of these prejudices, Agbabi is
determined to return lyric (the poetic genre) to its origins in sound and music,
while maintaining the discipline of structure and technique that comes from
viewing a poem as a stable, reproducible and fixed art object. For Agbabi, there
is no conflict between these goals.

Agbabi cites a number of her most influential precursors, earlier poets
who refused that line of demarcation between "page" and "performance" in
poetry: Chaucer in *The Canterbury Tales*, Browning in *Dramatis Personae*,
Wordsworth in *Lyrical Ballads*, Eliot in *Four Quartets*, and Pound in the
Cantos. This enunciation of her lineage (an interesting contrast with the
forebears and contemporaries named by Joseph) confronts the unspoken
expectation that performance poets—British or American, and especially those
who are "black"—share a tiny cadre of recent influences. Agbabi's example
reframes some frequent stereotypes of the content and techniques used in
"performance poetry" or "spoken word"—i.e., dominance of rhythm and rhyme,

a limited range of current (and mainly political) topics, minimal conceptual or formal complexity, a primary stress on dramatic delivery—to a model more consistent with the illustrious troubadour tradition. This homage includes Agbabi's perpetuation of the sestina, one of the favoured forms employed by the Provençal troubadours of medieval times.

Agbabi's sense of diasporic connection and alienation is further revealed in the poem "Ufo Woman (Pronounced OOFOE)," which forms a useful comparison with Joseph's *African Origins of UFOs*. In "Ufo Woman (Pronounced OOFOE)," the speaker—who describes herself as an unidentified flying object as well as a perceived foe—arrives as an alien in the opening lines: "Mother Earth. Heath Row. Terminal 5. Yo!" In stanza two, the speaker articulates plaintively the desire to fit in, which she has prepared for by going through all the approved motions to be "read." The word *read* is used self-reflexively and in the dual sense of being "read" or understood as a person and having one's words read and understood as a poet. But of course, by definition, an alien does not fit in: "I've learned the language, read the VDU / and watched the video twice. Mother Earth / do *you* read *me*? Why then stamp my passport / ALIEN at Heath Row?" The italic *you* and *me* emphasize that the speaker "reads" Mother Earth but is frustrated that Mother Earth cannot read her back. This attitude contrasts with the black characters of *The African Origins of UFOs* who leave Earth to find their roots elsewhere rather than keep trying to fit in on Earth and who find a planet to which, biologically, they are better suited for survival than those who are white.

Joseph and Agbabi both convey racial identity in extended metaphors of alienation through imagery of futuristic space "aliens." Joseph's work is set in an alien world where black people (the darker the better) are in control while the "Ufo woman" is similar to the ill-suited arrivants found in the earlier poetry of Grace Nichols and Jackie Kay. In Agbabi's poem, as in Nichols's Fat Black Woman poems, the speaker does not fit in for physical reasons that are described in detail.

In examining what constitutes the avant-garde in a diasporic context, the examples of Joseph and Agbabi suggest that we have short-circuited our ability to form fresh judgments about form and intent by pre-determining our own definitions of phenomena that should be allowed to be "new" in a variety of unexpected, unpredictable, and historically specific ways. Preconceptions of "black" British poetry remain fundamentally conservative with only certain kinds of constricted experimentation legible and condoned, with little progress having been made since the 1970s and 1980s. In fact, in reviewing *Transformatrix*, Bev Braune wrote, "I found it quite unsettling that Agbabi's concerns with regard to alienation are not much different from those of African and Caribbean writers living in England twenty to thirty years before her"

(Braune, 79). References to the African diaspora as well as to Africa as the originary culture, the Middle Passage, slavery, and the conditions of migration, alienation, isolation, and relocation—all have been well-represented in "black" British poetry since the 1950s. Some of the best known contemporary "black" British poetry explicitly uses themes associated with Africa, cultural miscommunication, and judgments made according to race, class, gender, or national origin. Critical and cultural theory suggests that references to the African diaspora and the formal features traditionally associated with an avant-garde sensibility and practice *should* go hand-in-hand. Yet, the most popular and respected body of "black" British poetry refers to race and the history of the Commonwealth nations in modes that are formally anodyne. The sociological is automatically entailed in dealing with "black" British poetry, explaining why the juxtaposition of the avant-garde and the diasporic illuminate so clearly some of the central dilemmas facing these poets.

For Agbabi, it is authentic—and possible—to convey new ideas and expressions using British literary traditions. The technical markers associated with the historical (read white Euro-American) avant-garde movements of the twentieth century may not be present in her poetry, but her poetry nonetheless aims to move tradition forward in a new direction so that diversity is incorporated and represented.

If we can look beyond technique (as much as beyond race), avant-garde practice historically emerges from a sense of group identity, where representations of voices from the margins comment on the centre and on their absence from it, fusing art and politics. These traits all apply to Agbabi's poetry, in spite of the marked absence in it of fragmentary depictions of selfhood, anti-narrative strategies, use of collage, and so forth. In fact, this diasporic poetry may be a call to reconsider what have now become predictable and rigidified definitions of avant-garde practice. One would expect the truly avant-garde to refer to something not seen before, rather than to recycle a cliché or set of dead metaphors. In some ways, it seems oxymoronic to attempt any definition of the avant-garde in a working sense, except in discussions of past historical movements. A true avant-garde for the present would have to be something unknown both in form and content—something like the reinvention of Britain.

Does *avant-garde* mean, simply, contrary to the cultural expectations for the person one is? Is a poetics called "avant-garde" if it is used by someone perceived as standing outside the established tradition? Evidence still indicates that "black" consciousness and artistic freedom have yet to be reconciled in the public's eye, even if this binary has been resolved for and by some "black" British poets. The very incongruity of Agbabi and Joseph invites questions about unitary characterizations of poetry of the African diaspora. That

incongruity creates an equal challenge to presumptions about what constitutes an avant-garde poetics, in any time or place. Does an avant-garde have to display homogeneous goals, techniques, or themes? In giving special focus to Agbabi and Joseph, it is not my intent to legitimise or valorise one poet and poetics over the other—the fact that both such unique approaches exist in literary contemporaries is only a testimonial to the rich diversity of contemporary "black" British poetry. It is a welcome development to see realised the intersection of the diasporic and the avant-garde in the context of "black" British poetry. This ostensibly paradoxical space allows us to enrich our understanding of these critical terms, to erase any preconceptions that they cannot form a synthesis, and to appreciate new poetries that we cannot readily categorise as one or the other.

Works Cited

Agbabi, Patience. *R.A.W.* London: Izon Amazon in conjunction with Gecko Press, 1997.

—. *Transformatrix.* Edinburgh: Payback Press, an imprint of Canongate, 2000.

—. "Word of Mouth: Deconstructing the 'p' words: 'performance', 'page' and 'poetry.'" Unpublished MA thesis, University of Sussex, 2002.

Arana, R. Victoria, and Lauri Ramey. *Black British Writing.* NY: Palgrave Macmillan, 2004.

Berry, James. *Fractured Circles.* London and Port of Spain: New Beacon Books, Ltd., 1979.

Braune, Bev. Review of *Transformatrix,* in *Wasafiri* 32 (Queen Mary, University of London, Autumn 2000): 79-80.

Caddell, Richard, and Peter Quartermain, editors. *Other: British and Irish Poetry since 1970.* Hanover & London: Wesleyan University Press, 1999.

Dawes, Kwame. "Negotiating the Ship on the Head: Black British Fiction" in *Wasafiri* 29 (Queen Mary, University of London, Spring 1999): 18-24.

Eliade, Mircea. *Cosmos and History.* NY: Harper & Row, 1954.

Joseph, Anthony. *The African Origins of UFOs.* Cambridge: Salt, 2006.

—. *Excerpts from The African Origins of UFOs.* London: Poison Engine Press, 2005.

—. *Desafinado.* London: Poison Engine P, 1994.

—. *teragaton.* London: Poison Engine P, 1997.

King, Bruce. *The Internationalization of English Literature.* Oxford: Oxford U P, 2004.

O'Sullivan, Maggie, editor. *Out of Everywhere: Linguistically Innovative Poetry by Women in North America and the UK.* London: Reality Street Editions, 1996.

Phillips, Mike and Trevor Phillips. *Windrush: The Irresistible Rise of Multi-Racial Britain.* London: HarperCollins, 1998.

Procter, James, ed. *Writing Black Britain: An Interdisciplinary Anthology* Manchester and NY: Manchester U P, 2000.

Turner, Mark. *The Literary Mind.* NY and Oxford: Oxford U P, 1996. Especially, Chapter 5, 57-85.

Wright, Beth-Sarah. "Dub Poet Lekka Mi". In *Black British Culture and Society: A Text Reader,* ed. Kwesi Owusu. London and NY: Routledge, 2000, 271-288.

CHAPTER SIX

MUSIC AND METAFICTION: AESTHETIC STRATEGIES IN BLACK BRITISH WRITING

TRACEY L. WALTERS STONY BROOK UNIVERSITY

In *"Race," Writing, and Difference* (1992), Henry Louis Gates, Jr., laments that the "focus on the valorization on the social and polemical functions of Black literature" have led to the "structure of the Black text repressed and treated as if it were transparent" (Gates 5-6). While Gates's assertion is directed mainly towards African American literature, his observations are also true for Black British literature. Over the past twenty-five years, much of the scholarship on Black British writing has focused on thematic readings grounded in post-colonial and New Historicist analyses. Recently, though, because contemporary writers like Jackie Kay, Zadie Smith, and Bernardine Evaristo have produced texts that experiment with narrative form and structure, scholars have begun applying formalist readings to the literature. In this chapter, I hope to further the appreciation of the aesthetic choices made by Black British novelists writing today and to set down some notes towards a new Black British literary criticism.

Jackie Kay

"It's liberating to define yourself if you are the one that's doing the defining."
—Jackie Kay

Jackie Kay's use of the jazz aesthetic as a structural device for the novel *Trumpet* (1998) illustrates that for writers like Kay the construction of the narrative is as vital as narrative content. *Trumpet* presents the story of Joss Moody, a famed jazz musician who upon his death shocks the music world as well as close family and friends with the revelation that although he lived his

life as a man he was anatomically female. The story focuses primarily on how Joss's death has an effect on his wife, Millicent, and adopted son, Colman, both of whom struggle to grapple with Joss's absence and evident transvestitism. The complexity of Joss's dual identity as male and female becomes one of the central concerns of the narrative as the characters—as well as readers—grapple to understand Joss within the constraints of our socially constructed notions of male/female identity.

The novel's focus on questions of identity has led most critics to concentrate on issues of gender, thus overlooking Kay's appropriation of the jazz aesthetic. Like other writers who have adopted jazz features in their narratives (Langston Hughes, Ralph Ellison, Toni Morrison), Kay is very much influenced by jazz and the blues. According to Yemisi Jimoh, writers who incorporate jazz aesthetics in their narrative do so because jazz symbolizes

> the value of improvisation, which allows reshaping of set forms; the ability to represent in art the idea of paradox as a condition of life; song as a means of recording one's life experiences; and fragmentation and doubleness as artistic techniques. (5)

In addition to writing *Outlines: Bessie Smith* (1997), a poetic and biographical account of Bessie Smith, Kay has also incorporated jazz and blues motifs into poems, including "Blue Notes for Billie." In an interview, Kay said that, when she was writing *Trumpet*, she "wanted to write a novel whose structure was very close to jazz itself" (Williams 42). With her employment of musical strategies—such as call and response, repetition, improvisation, riffing, and the antiphonal mode—Kay achieves her aim.

In *Trumpet*, jazz functions as an organizing principle and thematic metaphor to thrash out the indeterminacy of gender and identity. Jazz is typically defined by its unpredictability and improvisation: "[Jazz] expands, includes, reshapes, and elaborates. It makes no claims on the permanence of its form, on its purity, or on its originality. Jazz musicians [know] that there are many approaches to a constantly 'changing same'" (Jimoh 29). Like a jazz score, Joss's identity is also in a state of flux, as s/he shifts between genders and races (s/he is biracial). In a jazz-like riff, the narrator explains, "He can't stop himself changing. Running changes. Changes running. He is changing all the time" (135). Later the same sentiment is expressed when Joss tells Colman, "That's the thing with us: we keep changing names. We've all got that in common. We've all changed names, you, me, my father" (276). Joss's actual transformations become apparent to others only after his/her death.

In life, to the music world, his friends, wife, and son, Joss was Joss Moody, trumpet player, band member, husband, and father. Joss's death prompts family and friends to reassess their perception of Joss. The ruthless

tabloid reporter Sophie Stones attempts to write a shocking tell-all book revealing (what she considered to be) Joss's true identity as Josephine Moore. Colman, who is shocked the most by the news that his father was female, does not really know how to come to terms with Joss. Millie, the only person who shared the secret of Joss's cross-dressing, is one of few who are unwilling to perceive Joss as anything but male: "I look at the picture on the album cover, but no matter how hard I try, I can't see him as anything other than him, my Joss, my husband" (35). By looking at the album cover though, Millie indicates that even she begins questioning her perception of Joss. While Joss successfully duped most into believing he/she was male, to others like her elderly mother Joss played a different role; to her mother, Joss always presented herself as Josephine Moore, the devoted daughter.

Although we are never told why Joss chooses a transgendered lifestyle, one can deduce that his/her reasons may relate to the discomfort he felt living as a woman or perhaps the power s/he felt living as a man. In *Gender Trouble*, Judith Butler asserts, "When the constructed status of gender is theorized as radically independent of sex, gender itself becomes a free-floating artifice, with the consequence that man and masculine might just as easily signify a female body as a male one, and woman and feminine a male body as easily as a female one" (6). Joss represents Butler's argument because, although s/he is biologically female, the outward appearance is male. In essence, as Jeannette King maintains, Joss performs gender: "Gender acquisition is a matter of imitation, of learning to perform a role. Sexual identity is not given at birth, but produced through the performance of the cultural conventions of gender" (105). Joss's masculine performance involves donning of men's suits, a shaving ritual, a "slow deliberate walk," and visits to the barbershop. Joss's masculine persona gives "him" license to perform as a jazz musician and play the trumpet, an obvious phallic symbol. Historically, jazz has been a male dominated sphere. Although there have been countless female musicians who have played with male musicians—usually as vocalists—(Ella Fitzgerald, Billie Holiday, and Sarah Vaughan), it has been mostly men who have held the honoured role of band leader.[1] In creating her protagonist as a jazz trumpeter, Kay marries the roles of the male and female jazz musician. Joss's performance is both aesthetic and personal. Patrick Williams observes, "He performs his identity in order to enter a different performative space, where that identity no longer has substance or importance, where the corporeal is in fact no longer significant" (45). For Joss, music becomes an equalizer; when s/he plays his saxophone gender *and* race become inconsequential. Jeanette King's discussion of the relationship

[1]During the 1920s, Thelma Terry a string bassist was a well-known female bandleader.

between music and empowerment further explains the significance of the way Joss's musical performances frees him/her from labelling:

> Music can offer such liberation because it is one of the few forms of artistic communication which does not rely on language, like liberation, or embodiment like drama and dance, and which is therefore potentially gender-free. Jazz in particular, by definition demands improvisation, the abandoning of scripts and precedents, the ability to construct variations on given melodies, rather than being tramlined by agreed roles and forms. (107)

In the section "Music," Kay uses paradoxes and contradictions to illumine the point that when playing the trumpet Joss's race, gender, and nationality merge, resulting in the erasure of a fixed identity. In the following passage, Kay uses binaries to capture the rhythmic cadence and tone of a jazz movement: "He is a girl. A man. Everything, nothing. He is sickness, health. The sun. The moon. Black, white. Nothing weighs him down (136).[2]

Through reinvention, challenging notions of gender, and going "beyond the margin into the unknown in order to change the rules within the existing structure, to present the 'unpresentable,' to say the unsanctioned" (Jimoh 29), Joss lives life like an extended improvisational moment.

In *Trumpet*, jazz serves as a literary motif and a structural device. In a jazz suite, the melody is what gives the song its cohesion. The melody is always kept in view, appearing and disappearing. As the song progresses, the musicians begin improvising and departing from the melody to create a different sound (or narrative), making the master narrative less cohesive. The musicians play off each other and engage in call and response—one musician playing a phrase that is repeated in variation by other musicians, in turn. The improvisation culminates with the musicians returning to the basic melody, having enlarged its resonance and meaning.

The narrative form in *Trumpet* adopts the non-linearity of jazz music. *Trumpet* is divided into sections that move from past to present, but the story is presented from a multitude of narrative perspectives. Dream sequences, italicized flashbacks, editorials, and letters also reflect the fragmented nature of the narrative. One of the most prominent features of jazz is the intertextual

[2] In *Shadow and Act*, Ralph Ellison discusses jazz aesthetics and the artist. His essay clearly illuminates the effectiveness of Kay's use of the jazz motif to explain how, through artistic expression, Joss asserts his individuality. Ellison states: "True jazz is an art of individual assertion within and against the group. Each true jazz moment…springs from a contest in which each artist challenges all the rest; each solo flight, or improvisation, represents (like the successive canvases of a painter) a definition of his identity; as individual, as member of the collectivity and as a link in the chain of tradition" (234).

revision or "signifyin(g)" on pre-existing texts. Henry Louis Gates, Jr., remarks that, in comparison to other musical forms (or texts) where "meaning is fixed," in jazz music "it is the realignment of the signifier [the original text] that is the signal trait of expressive genius. The more mundane the fixed text ... the more dramatic is the Signifyin(g) revision" (64).[3] John Coltrane's more rhythmically inspired rendition of Rodgers and Hammerstein's "My Favorite Things," for example, is revised into a recognizable but altered adaptation. Coltrane's composition is much more up-tempo, and his use of jazz riffs, swift changes in chord progression, innovative harmonic structures, and improvisation alters the song dramatically. Kay's *Trumpet* is also a reworking of a pre-existing narrative. Kay improvises upon the life-story of legendary jazz piano player Billy Tipton. Tipton, whose birth name was Dorothy Lucille Tipton, lived all of his adult life as a man. He had a successful career, producing albums and touring with The Billy Tipton Trio; he was married five times and adopted three children.

 Until his death in 1989, Tipton's sex remained a secret. The news that Tipton was biologically female created a media frenzy that resulted in the publication of several books about his life.[4] In *Trumpet*, Kay vigorously reworks Tipton's narrative into a fictional tale about a famed jazz musician who marries and adopts a son. In a manner similar to the improvisational style of jazz, Kay "signifies" (or riffs) on Tipton's real-life narrative. Tipton, who was a white American, is transformed into Kay's Scottish and biracial protagonist. Kay imaginatively recreates a life of some one like Tipton. She envisions episodes before and after his death; she explores intimate relationships with the woman s/he loved and the media frenzy in the aftermath of the artist's death. In addition to appropriating Tipton's story, Kay also writes *herself* into the narrative. Kay shares a number of similarities with her protagonist. In addition to being a Scot, a lesbian, and an artist, Kay also resembles Joss Moody in other ways. Kay's headshot on the book jacket is remarkably close to how Millie describes Joss: he had "high cheekbones that gave him a sculpted proud look; his eyes darker than any I'd ever seen. Thick black curly hair, the tightest possible curls, sitting on top of his head, like a bed of springy braken" (11). The similarity in appearance, along with the other parallels, suggests that Kay uses her text as medium

[3] See Gates's *Signifying Monkey* for a thorough investigation of how jazz musicians signify on preexisting texts, esp. page 63.

[4] See, for instance, Diane Wood Middlebrook's *Suits Me: The Double Life of Billy Tipton*. London: Virago Press, 1998.

through which to transform her identity from Jackie Kay (Scottish poet) to Joss Moody (jazz artist).

In addition to drawing upon the revisionary elements of jazz, Kay also appropriates a blues aesthetic. Jazz, as Baraka tells us in *Blues People*, is an extension of the blues: "[J]azz should not be thought of as a successor to blues, but as a very original music that developed out of, and was concomitant with, blues and moved off into its own path of development" (71). In *Trumpet*, Kay picks up on this connection between the blues and jazz genres. The opening pages of the narrative convey a blues tone of melancholy and pain. Millie becomes the classic blues singer who sings about the tragedy of love lost and Joss's death: "Every day feels like a week. I am awake for much of the time, staring out into the dark or the day; it doesn't make much difference. ...I don't know what is real and what is not, whether the pain in my side is real or imagined. The terrible thing about pain is that it doesn't matter, it still hurts. It hurts like hell" (4, 5). This blues motif is also extended to Colman, who until the end of the narrative remains burdened by grief and frustration. Colman's despair is the result of feeling that he cannot measure up to Joss. Joss's death leaves him feeling even more confused and lost than he had felt as a youngster.

In addition to borrowing from the blues tradition, Kay fuses her narrative with jazz techniques such as repetition and call and response. In jazz music, oftentimes a musician plays a musical phrase that is answered or responded to by his/her band mate. Throughout *Trumpet*, Kay replicates the central thematic question concerning Joss's identity. Following the structural convention of the call-and-response pattern, Kay's narrative repeatedly "calls" for us to answer the question, "Was Joss Moody male or female?" The polyphonic voices (two or more competing voices) of the characters respond to the call with their own answers. Jurgen Grandt's discussion of the polyphonic voices in Morrison's novel *Jazz* helps to explain how the voices in Kay's novel come together: "In the jazz moment, voices demand recognition, inserting themselves, vibrating with the intensity of emotional fullness; the individual plays against the collective, which forms the larger work, the greater truth" (Grandt 633). In *Trumpet*, as each character gives a personal view of who Joss was, Joss's persona changes. Millie characterizes Joss as a sensitive, loving husband, Colman presents Joss as a fraud who lied to his son, his band mate remembers him as a gentle natured guy who could hold his liquor, and the journalist Sophie Stones labels Joss a freak and pervert. Essentially, these different viewpoints illustrate that Joss was comprehended in a multitude of ways. Moreover, as Alison Lumsden points out, the reader also has difficulty trying to determine Joss's basic identity: "The multiple narrators allow the reader no fixed position by which Joss's constructed identity may be contained;

rather, the at times competing perspectives imply that his/her life and death can never be safely delimited through standard teleological narrative modes" (87).

The technique of overlapping viewpoints and voices is featured in other parts of the narrative. In "Travel" (180-195), for instance, parts of the text take on an aural quality as readers hear the various voices and dialects. Colman, while half asleep on the train to Scotland, becomes irritated by the cacophony of noise around him: "*Shut the fuck up!*" he thinks, as a child says

> ...over and over, 'But I want that one there.' And the mother's voice saying again and again, 'Ewan, I'm not going to tell you again.' A man's voice behind him says, 'I'm telling you. If it wisnae fir me the place wid have been ransacked' ... and a woman somewhere down the train ... shouts into her mobile phone, 'Hello, hello, I'm all on my ownio. Hello? Hello hello hello.'" (193)

The repetition of the woman's "Hello? hello hello hello" is a play on the echoing that occurs in jazz where musicians echo certain phrases. The echoing of recollected phrases in another scene emphasizes Colman's anxiety: "Did he leave them [the Glasgow tickets] by the phone? He can see them by the phone" (185). After finding them he thinks, "thank fuck for that. He says that out loud to himself. Thank fuck for that" and repeats the phrase, thinking about how his "father used to say that all the time and [Coleman] always liked the ring of it" (185).

Jazz riffs (the replaying of a phrase with variation) often "resound and ... reformulate an important concept or key idea found within the narrative" (Jimoh 37). The motif of change becomes a recurrent theme in Kay' novel. While our primary focus is on how Joss's identity changes, both Coleman and his mother reconstruct their identities. Jeanette King observes, "*Trumpet* is not only Joss's story but also one of how Millie and Colman de- and re-construct themselves, finding ways to exist after his death" (89). This idea of change is particularly perplexing for Colman who seems resistant to change; and when he passes a homeless man who asks for change, Colman replies: "'Any change?' Change in what? Change in the weather, change in the government. Change— what do you mean any change?" (184). Really, Colman is reflecting on his own fear of change, because change leads to uncertainty.

In addition to experimenting with the repetition of words and ideas, Kay also replays specific images that serve to remind us that Joss is biologically female. In three different scenes, Kay describes Millie, the medical examiner, and the undertaker binding and unwrapping the bandages that hide Joss's breasts. Each unwrapping and rebinding of the breasts varies. Doctor Krishnamurty, for example, performed the act "as if she was removing skin, each wrapping of bandage that she peeled off felt unmistakably like a layer of skin.... When she first saw the breasts ... she thought that they weren't real

breasts at all.... Also, the doctor was struck by how young these breasts looked" (43, 44). Where Doctor Krishnamurty seems to handle Joss's body delicately, the undertaker, Albert Holding, is less gentle with the body: "Holding pulled a bit of bandage, turned it on the side, rolled the body over to the other side to pull some more. This went on for some time.... Even though Holding was expecting them, he still gave out a gasp when he saw them. There they were. In terribly good condition for someone of his years" (110). The processes of binding and unbinding are experienced as riffs in variant contexts. Even so, as in jazz, with each unwrapping, readers anticipate the surprise and confusion experienced by the unravelling and the unveiling of the secret.

The most obvious references of Kay's allusion to jazz music are presented in sections where Kay describes Joss playing his trumpet. In the following excerpt, Kay uses a halted, rhythmic style, discord, scatting, and repetition to evoke the tone of an improvisational jazz moment:

> And he is bending in the wind, scooping, pitch, growling.... Telling it like it is. Like it is. O-bop-she-bam. Running changes. Changes running faster, quicker, dangerous. A galloping piano behind him. Sweating like a horse. Break it down. Go on, break it down. It is all in the blood. Cooking. Back, from way. When he was something else. Somebody else. Her. That girl. The trumpet screams. He's hot. She's hot. He's hot. The whole room is hot. He plays his false fingers. Chokes his trumpet. He is naked. This is naked jazz. O-bop-she-bam. Never lying. Telling it like it is. (131, 132)

Here readers are able to connect with the frenetic pace of the passage and experience the jazz moment along with Millie.

Kay's final homage to the jazz aesthetic is presented at the end of the narrative. In "Last Word," Kay gives Joss his solo, allowing him finally to respond to the call "Who was Joss Moody?" This chapter presents the text of a letter that Joss had written to his son explaining how his own father, John Moore, influenced his ability to define his own identity. Joss tells Coleman that John Moore travelled from the West Indies to Scotland to work as a servant. John's employers treated him well, but he had desires to move beyond an existence of servitude. Moore empowered himself by moving beyond his expected role as servant and becoming a painter. Joss's father's experience further links *Trumpet* to the jazz tradition because his story represents the traumatic past and unpredictable life experiences of African diasporic people. Literary scholars have aligned the African diasporic experience with jazz to show that African people are constantly exposed to chaos and change. Slavery, for example, was a violent disruption of Black life, which resulted in attempts to erase the identity and culture of the people of the African diaspora but gave them a sensibility of double consciousness. Aesthetically, Kay's novel is also jazz-like because she presents a narrative that defies convention. Kay presents

many of the same topics found in Black British literature: alienation, identity, prejudice, but writes about these issues in a different way. In comparison to most Black British texts, Kay privileges race over gender (which she melds); and, with her discussion of transgendered identities, Kay explores unfamiliar terrain. With *Trumpet*, Kay offers a new reading and a new telling of black British experience—emphasising the aesthetic element.

Zadie Smith

Readers unfamiliar with jazz can easily overlook the significance of the jazz aesthetic in the structural framework of *Trumpet*. Alternatively, in *The Autograph Man* (2002), Zadie Smith's employment of the metafictional mode ensures that readers are forced to acknowledge her more experimental approach to narrative form. *The Autograph Man* recounts the adventures of Alex Li Tandem, a half-Jewish and half-Chinese neurotic, self-absorbed autograph man who is disillusioned with life. Alex's funk is the result of his inability to come to terms with the untimely death of his father, Li-Jin. During one of the most momentous events of his life, attending a wrestling match and securing his first autograph from wrestler Big Daddy, Li-Jin unexpectedly dies of an aneurysm. Alex is unable to reconcile with the death of his father, and he moves from childhood to young adulthood in a perpetual state of mourning, using drugs and alcohol to numb his pain. Childhood friends try encouraging Alex look to his Jewish faith to find solace, but Alex is spiritually bankrupt and rejects their offer and his Judaic heritage. Although Alex's life appears bleak, there is one thing that gives him pleasure. Alex's life goal is to secure the autograph of famed movie star Kitty Alexander. Since he was fourteen, Alex has written to request Kitty's signature. When Alex finally receives a copy of Kitty's autograph, he travels to New York to authenticate the signature and meet his idol. *The Autograph Man* serves as a commentary about how contemporary culture has become so obsessed with celebrities that we have replaced our spiritual quest for the truth with an unhealthy infatuation with the superficial lives of the rich and famous. Smith's highly satirical novel, crammed full of nonsensical details and colourful characters, uses metafiction as a textual strategy to record the mundane and many bizarre adventures of Alex-Li Tandem.

In texts that employ the metafictional mode, form is essential to the narrative. The primary function of metafiction is to draw readers into the construction of the text itself, often using innovative methods to tell the story. According to Patricia Waugh, metafiction is a genre of literature that "self consciously and systematically draws attention to its status as an artifact in order to pose questions about the relationship between fiction and reality" (21). Because metafictional narratives employ metatextual clues to remind readers

that the act of reading must be as playful as the act of creative writing, these narratives rely on unconventional narrative techniques—including direct address from narrator to reader, the use of diagrams, mini-essays, nonsensical information that digresses from the narrative, and stories within stories. This overload of information often makes metafictional narratives appear rambling and incoherent. The superabundance of detail in *The Autograph Man* has been observed by a number of critics. Laurence Phelan of *The Independent Sunday* commented on the "excessive narrative, typographical and design gimmickry" (19). Additionally, a reviewer for *The Atlantic Monthly* noted that the text is "so zany and improvisational that a reader wonders if Smith herself can track its action.... *The Autograph Man* feels not so much busy as empty, like a short story that's been padded beyond reason..." (145). While the assessment of these critics may be accurate, they could be missing the point that this abundance of information is a crucial component of Smith's exploitation of the metafictional mode. Smith's unconventional approach to narrative links her text to Kay's *Trumpet*. Like *Trumpet*, *The Autograph Man* reflects the disorder in the protagonist's life. Alex's constant drugging and drinking leaves him in a continuous state of unconsciousness and confusion. Unsurprisingly, Alex has problems distinguishing truth from fantasy. When Alex secures Kitty Alexander's autograph, for example, he is not sure as to whether he actually received the autograph or just forged the autograph while in a drunken state. Alex (and readers) must navigate through this sort of confusion in order to uncover truth.

　　One of the fundamental characteristics of the metafictional narrative is the inclusion of digressive passages by the narrator that teasingly interrupt the narrative flow. Smith's *Autograph Man* includes no shortage of jokes, trivia, charts, lists, quotes, emails, song titles, line drawings, and pop quizzes. Readers are privy to "The Joke about the Pope and the Chief Rabbi" as well as a series of pop quizzes about inconsequential subjects. For example: "Q. What is the law concerning the man who is very stoned and the man who is not as stoned as he? How shall these two behave towards each other?"(117). And, in case the pop quizzes and jokes are not sufficiently distracting, Smith also engages readers in a continuous game of trivial pursuit. While Alex is on an airplane watching *Casablanca* and reciting sections by heart, the narrative breaks with the following: "Facts. When Bergman and Bogart kiss, what looks like the moon turns out to be a searchlight.... Did you know that Ronald Reagan was seriously considered for the role of Rick? That *Play it again, Sam* is never said? That Bergman though Bogart a bore?" (186). Here, because there are no quotation marks, readers cannot be sure whether these are Alex's observations or the text here represents the narrator's voice. What *is* clear is that this passage bears no relevance to the narrative's plot *per se* and that Smith includes these fun facts

for her own (and our) amusement. In *Fictional Truth*, Michael Riffaterre argues, "Signs of fictionality in a text are not veiled or blunted or compensated for by corrective verisimilitude that suspends disbelief; rather, it is these very signs that point to a truth invulnerable to the deficiencies of mimesis or to the reader's resistance to it. They do so by suspending belief, by radically displacing verisimilitude" (33). Smith's employment of jokes and trivia and the like make obvious the "fictionality" of her narrative.

In metafictional novels, *how* we read is as important as *what* we are reading. Reader-response theorists who agree with Roland Barthes's notion that the author is dead suggest that, rather than the author directing readers' interpretations and acts of reading, it is the reader who controls the outcome of the narrative. Wolfgang Iser, for example, argues that "literary texts are generated in the act of reading; they are the product of a complex interaction between text and reader" (5). In *The Autograph Man*, the self-conscious narrator dictates the reader's reception of the text. Smith's unconventional use of typography and sentence construction impact upon the way that readers respond not only to what they *read* but also to what they *see* on the page. James Phelan maintains that "In reading, we are strikingly both passive and active, as the text acts upon us and we act upon it; the text calls upon—and we respond with—our cognitive, emotive, psychological, social, and ethical selves…" (227). Smith defies the conventions of grammar and linguistic structure and punctuation. For example, she begins some paragraphs with all-capital letters and changes the font size and typeface seemingly arbitrarily: "YOU'RE EITHER FOR ME OR AGAINST ME, THOUGHT *Alex Li Tandem*, REFERring to the daylight, and more generally, to the day" (39). Smith's use here of capital letters and three different font styles prompts readers to pay attention not just to the story but also to the actual words on the page. In another example, Smith creates an almost incomprehensive language to represent Alex's intoxicated speech pattern: "GEJUSTBOLLKT BYIMMIN LIE KEUW" (314). This statement forces reader to slow the pace of reading to decipher the language. In other places, shaded boxes ensure that certain quotes and trivia stand apart from the main narrative.

Imagination is vital to the process of reading. Typically, readers have the responsibility of creating in their own mind images of the characters. In *The Autograph Man* sometimes we are free to use our imaginations and at other times we are not. Our image of Alex, for example, is destroyed as Smith includes several drawings of Alex. She also includes a number of diagrams of Adam's Kabbalah chart. In other instances Smith omits and invites the reader to complete the author's job of describing specifics in the text. When it is mistakenly reported that Kitty Alexander has died, a news report features a story about Kitty's life. The news show features several pictures of Kitty, "Here is a

picture of the actress when young: ...Here is the most famous moment of her most famous film" (293). Instead of providing us with images of Kitty, Smith's text presents line drawings of three blank television screens as if to suggest that readers must project their our own images of Kitty onto the blank television screens provided.

In other cases, Smith directly addresses her readers and cues them to respond and aid in the creation of the world of the narrative. When the characters make non-verbal gestures, such as shrugging shoulders or making faces, she prompts readers to attach the cultural signifier that relates to their action. So, for example, when she writes "Alex makes the International Gesture for vomiting"(7), we are supposed to know that Alex has either cupped his hand over his mouth or placed a finger into his throat and mimed a gagging action. In another instance, when Alex attends his father's Kaddish, a mourning prayer in honour of his father, the narrator translates the Hebrew words that Alex recites to the rabbi: "*Magnified and sanctified* (said Alex-Li, but not in these words)... *Amen* (said the sitting people, but not in these words)" (345-346). As if to preserve the sacred nature of the ritual, Smith omits the Hebrew characters and writes only in English. In other cases, Smith purposely excludes details so that readers can aid in the construction of the narrative: "ALL OF A SUDDEN they run at each other once more and if you have a better phrase than *like thundering elephants* insert it here []" (32). The narrator's direct address to readers once again underscores the artificiality of the text. Metafictional narratives often feature protagonists who create their own stories. These stories within stories often become the self-conscious voice of the writer who inserts his/her own frustrations and observations about the writing process.

In *The Autograph Man*, Alex is writing a book on *Jewishness and Goyishness*. The title and subject matter of his book is a play on comedian Lenny Bruce's routine about the difference between Jewish and gentile behaviours. Jewish office items, for example, are stapler and penholder whereas Goyish office supplies are the paper clip and the mouse pad (77). Smith's narrative shares a number of similarities with Alex's. First, *The Autograph Man*, like Alex's *Jewishness and Goyishness*, is over three hundred pages long and overloaded with too many unnecessary details. Second, like *Jewishness and Goyishness*, some of the chapter headings in the first half of Smith's text use the Tetragrammaton, God's four letter name: Y H W H, or the equivalent Hebrew letters themselves (76). Alex also uses the Tetragrammaton, as the narrator notes, "Occasionally, when the section was particularly contentious, he used its more potent Hebrew incarnation.... As if the invocation of the Holy Name would protect his heresy" (76). And lastly, Smith, like Alex, realizes that this text will not appeal to all readers:

Well, maybe *Jewishness and Goyishness* wasn't for everyone. But didn't everyone get *everything*? Hadn't they had enough yet? Everything on this earth is tailored for this *everyone*.... Who was left to make stuff for no one? Just Alex. Only he. *Jewishness and Goyishness* was for no one. You could call it the beginning of a new art movement if it weren't for the sad fact that no one would recognize a new art movement if it came and kicked them in the face. (77)

We can read this statement as Smith's own views concerning her use of metafiction. Smith's first novel *White Teeth* (2000) was heralded as such a success that she felt the pressure to produce a sophomore effort that would be as good as the first book. Through her use of direct address in passages like the one above, Smith tells readers that this text, like Alex's, is not for everyone, nor for anyone in particular. It is just a novel. It's just art.

Bernardine Evaristo

Bernardine Evaristo is another writer attracted to the innovative and challenging aesthetics of metafiction. Similar to Smith's *The Autograph Man*, Evaristo's *The Emperor's Babe* (2001) includes metafictional devices such as side jokes, direct address, and experimentation with typography. *The Emperor's Babe* is a rags-to-riches story about Zuleika, a working class Sudanese girl who is forced into an arranged marriage to the wealthy Roman senator Lucius Aurelius Felix. Felix, who is thirty years Zuleika's senior, is repeatedly unfaithful and treats Zuleika as his sex slave. Zuleika's loveless marriage leaves her feeling alone and unfulfilled. Poetry becomes the creative outlet that allows Zuleika to express her frustrations and desires. At the urging of her childhood friend Alba, Zuleika engages in an extramarital affair with Septimus Severus, the famed African Roman emperor. Zuleika's romance with Septimus leads her to sexual awakening and self-fulfilment. Tragically, just as Zuleika begins finding her new self, Felix learns of the affair and kills Zuleika with food poisoning.

Versified, this novel consists of a sequence of monologues in diverse prosodic forms. Furthermore, as regards narrative structure, *The Emperor's Babe* adopts a number of epic conventions. In addition to opening *in medias res*, the text is written in esoteric language. Readers encounter the cataloguing of primary characters, a wide world, cultural conflicts, and a heroic protagonist whose journey to the underworld transforms her identity. Since Evaristo's novel is written in verse, readers are forced to take note of the poetic language. Many of the poems are composed in irregular verse rhythms and unrhymed couplets, and, as Lars Ole Sauerberg observes, "there is an overall predilection for a falling trochaic cadence, with dactyls and spondees arresting and countering the rising iambic movement of the traditional blank verse" (458).

The poems are presented from two perspectives: the majority are written in the narrator's voice, but Zuleika's poems are also added to the construction of the narrative. So, while each poem relates to the larger narrative, the poems can also be read independently. Zuleika's poems, most of which read more like prose, address sub-themes of race and identity that are secondary to the text's primary focus on history and self-empowerment. For example, the poem "Identity Crisis: Who is She?" questions Zuleika's nationality and ethnicity: *"Am I a Londinio or a Nubian? / Will my children be Roman or Nubinettes?"* (201). As a poet, Zulieka has her own views about literature. Similar to the self-conscious and in-your-face narrator in the *Autograph Man*, Zuleika desires to create a new kind of art that is different from what was then (or is now) available on the market.

Like figures in other metafictional works, Evaristo's protagonist not only creates art but comments on the artistic process and literary production. In "AB ASINO IANAM (Wool from an Ass)" Zuleika expresses her impatience with the Western literary tradition. She dismisses Homer's *Iliad* as "bloody tedious" and "Just an insty-winsty bit old fashioned?" (83), calls Pliny "B-O-R-I-N-G" (84), and scoffs at her tutor Theodorous's belief that "in two millennia from now" *The Aeneid* will be a classic. Zuleika also rejects Theodorous's notion that "poetry's supposed to be difficult 'cos / it's high art, otherwise any Tom, Dick / or Hortensious would understand it, yeah!" (84). Theodorous tells Zuleika that in order for her to be a poet she must know different metric feet, such as trochee, spondee, dactyl, and cretic. While Zuleika may not know or care about such verse jargon, Evaristo does and challenges readers to recognize prosodic features throughout the text.

Zulieka also challenges Theodorous's argument that to write good poetry one must have experienced war and death. Zuleika tells her father that her goal is to write a different narrative, one that includes stories "about Nubians in Londinium, about men / who dress up as women, about extramarital / peccadilloes, about girls getting married / to older men.... / And I don't care about the past / and I ain't writing for posterity—" (85). Here, it is clear that Evaristo inserts her own voice into the narrative. The text Zuleika wishes to write is, of course, *The Emperor's Babe*. In an interview with Alastair Niven, Evaristo explains that, with *The Emperor's Babe*, she sought to revise history from the Nubian perspective. After reading Peter Fryer's *Staying Power,* learning about the Roman Emperor Septimus Severus and his involvement with the Moors stationed at Hadrian's Wall in Brittania in AD 211, Evaristo realized she had to "create a new version of history" (283). She tells Niven, "I am committed to exploding the myth of Britain as monocultural and 'racially' pure until 1948. There are so many layers of British history to be peeled back" (280). Like Derek Walcott (who revised *The Odyssey* with his *Omeros*), Evaristo fuses the ancient and contemporary societies and creates her own narrative about

European history and identity so as to include the Black experience. As David Gunning explains, "Evaristo's engagement with the idea of history takes place through a conscious interrogation of the cosmopolitan. In this way, she is able to claim the telling of Black British histories as at least partly the job of the imaginative writer, and to challenge any vision of the nation that relies on historical 'truths' to elucidate a philosophy of exclusion" (166).

Evaristo's version of ancient Blacks in Britain re-imagines and rewrites the typical image of enslaved British Blacks featured in travelogues and Hogarth prints; in *The Emperor's Babe*, the Black characters are the slaveholders, rather than the slaves. Moreover, unlike other Black British novelists (e.g., Sam Selvon, Zadie Smith, Monica Ali) whose narratives about Black life in Britain often centre on themes of alienation, Evaristo, like Kay, deals with alienation in a different way. Zuleika's isolation is not the result of her race, but rather the result of her husband's attempt to keep her confined to his household. Evaristo tells Niven, "Zuleika is one of the few black people in my version of Roman London and she is noticed because of her colour but she is not discriminated against because of it. The Romans did not practice anti-black racism" (286). And again, as in *Trumpet*, race is not the driving theme of the narrative. The *Emperor's Babe* is a fusion of fact and fiction. Before writing the book, Evaristo engaged in thorough research of life and culture in ancient Britain around AD 211. Nevertheless, the novel presents a number of purposely anachronistic details—such as the use of powdered mouse brains and fried jellyfish. More importantly, she reminds readers of the important contributions that Blacks made to ancient civilizations. Zuleika's love interest, African Lucius Septimius Severus, for example, is not a fictional character. Septimus was actually a great Roman Emperor who ruled Rome and assisted with the reconstruction of Roman Britain's Hadrian's Wall.

Although Evaristo's narrative is set in ancient London, the description of the city is reflective of contemporary London. In fact, Evaristo says that when she was researching ancient (Roman) Britain, she had the opportunity to see the Roman Galleries and was astonished to note the parallels between both cultures. Evaristo's Londinium is a bustling cosmopolitan city that is as diverse as contemporary, multicultural London. Evaristo uses language and dialect to reflect the diversity of the city. Pidgins, Scots, cockney, Latin, and patois are just some of the languages spoken by the characters. Zuleika's servants, for example, speak with a heavy Scots accent: "Mammy an Faither were chieftens, ye ken.'/ "Oor home was a big room stone hoose. / De hail of oor village could feast inower it" (57). Evaristo told Karen McCarthy that she had infused the narrative with a blend of vernaculars because the "English language itself is a hybrid of several other languages, so I'm just continuing the tradition." Latin, the language of ancient times, is also used (and bastardised) throughout the

narrative. Sometimes Latin phrases are translated, and other times the reader must translate the text: "from the first days of our marriage— / silentium mulieri praestat ornatum" (143); "how to get my amo amas amat right"; and *"Zuleika accepta est. / Zuleika delicata est. / Zuleika bloody goody-two shoes est"* (4, 5). Evaristo, who studied Latin herself, said she did not shy away from using Latin because she tried to use it in a way that would allow readers to understand the language. The comment "I'd tell him to *futuo-off*" (10), for example, is a clear reference to a well-known expletive.

In addition to experimenting with language, Evaristo also plays with rules of typography. In "Post-Coital Consciousness" the margin is on the right side of the page instead of the left side. Evaristo playfully indicates to us that after love making with Septimus, Zuleika is literally and figuratively on the right side of the bed. In other places, words in capital letters divided by dashes, for instance, call attention to unfamiliar vocabulary: "I need a C-O-N-I-U-X! / Whatdoesthatspell? Husband! (44). The metafictional ploy of reminding readers that they are reading a constructed text is also indicated when Zuleika is talking to her father about her poetry and says, "At last I've found a way to express myself. / I know they're not brilliant yet, but you see, / if I keep at it ... Watch ... this ... space!' (85, Evaristo's ellipses). Here, Zuleika addresses the audience directly. Readers take a moment to return to the sentence and take note of the three blank spaces created by the ellipses. In short, Evaristo (like Jackie Kay and Zadie Smith) succeeds in finding new ways to remake literary experience so as to reflect a contemporary Black British vision of reality and to control—through deliberate aesthetic strategies—how readers receive the text.

Works Cited

Anderson, Linda. "Autobiographical Transvestites: The Nostalgic Self in Queer Writing." *Territories of Desire in Queer Culture: Redefining Contemporary Boundaries*. David Alderson and Linda Anderson, editors. Manchester: Manchester University Press, 2000. 68-81.

Anonymous. Review of *The Autograph Man*, by Zadie Smith. *The Atlantic Monthly*, Oct. 2002: 143-7.

Anshaw, Carol. "Gender Pretender." *The Advocate*. 16 March.1999: 63.

Butler, Judith. *Gender Trouble: Feminism and the Subversion of Identity*. London: Routledge, 1990.

Dyer, Richard. "Jackie Kay." *Writing Across Worlds: Contemporary Writers Talk*. Susheila Nasta, editor. London: Routledge, 2004. 237-49.

Ellison, Ralph. *Shadow and Act*. New York: Vintage, 1972.

Gates, Henry Louis, Jr. *The Signifying Monkey: A Theory of African American Literary Criticism*. New York: Oxford University Press, 1988.

—. *"Race," Writing, and Difference.* Chicago: University of Chicago Press, 1992.

Grandt, Jurgen. "Kinds of Blue: Toni Morrison, Hans Janowitz, and the Jazz Aesthetic." *African American Review* 38.2 (2004): 303-322.

Gunning, Dave. "Cosmopolitanism and Marginalisation in Bernardine Evaristo's *The Emperor's Babe*." In *Write Black Write British: From Post Colonial to Black British Literature.* Kadija Sesay, editor. London: Hansib Publications, 2005. 165-178.

Iser, Wolfgang. *Prospecting.* Baltimore: John Hopkins University Press, 1989.

Jones, Leroi. *Blues People: Negro Music in White America.* Rpt. New York: Perennial, 2002.

Kay, Jackie. *Trumpet.* London: Picador, 1998.

—. "Blues Notes for Billie." *Black Women Talk Poetry.* Olivette Da Choong, Cole Wilson, Bernardine Evaristo et al., editors. London: Womantalk Ltd., 1987.

—. *Outlines: Bessie Smith.* London: Absolute Press, 1997.

King, Jeanette. "A Woman's a Man, for a 'That'" *Scottish Studies Review* 2.1 (2001): 101-108.

Lumsden, Alison. "Jackie Kay's Poetry and Prose: Constructing Identity." *Contemporary Scottish Women Writers.* Aileen Christianson and Alison Lumsen, editors. Edinburgh: Edinburgh University Press, 2000. 79-90.

McCarthy, Karen. "Q and A with Bernardine Evaristo" *Valparaiso Poetry Review.* 5.2 (2003): n. pag. Online. Internet. 11 Sept. 2006. Available at http://www.valpo.edu/english/vpr/v4n2.html.

Niven, Alastair. "Bernardine Evaristo." *Writing Across Worlds: Contemporary Writers Talk.* Susheila Nasta, editor. London: Routledge, 2004. 279-291.

Phelan, Laurence. "Paperbacks; Just Your Everyday Druggy Chinese-Jewish Film Fanatic: *The Autograph Man* by Zadie Smith." Rev. of *The Autograph Man* by Zadie Smith. *The Independent Sunday.* 15 June 2003: 19

Phillips, Rowan. Rev. of *The Emperor's Babe. Callaloo* 27.2 (2004): 565-569.

Riffaterre, Michael. *Fictional Truth.* Baltimore: John Hopkins University Press, 1990.

Sauerberg, Lars Ole. "Repositioning Narrative: The Late Twentieth Century Verse Novels of Vikram Seth, Derek Walcott, Craig Raine, Anthony Burgess, and Bernardine Evaristo." *Orbis Litterarum* 59 (2004): 439-464.

Smith, Zadie. *The Autograph Man.* New York: Random House, 2002.

Waugh, Patricia. *Metafiction: The Theory and Practice of Self-Conscious Fiction*. New York: Routledge, 1988.

Williams, Patrick. "Significant Corporeality: Bodies and Identities in Jackie Kay's Fiction." *Write Black Write British: From Post Colonial to Black British Literature*. Kadija Sesay, editor. London: Hansib Publications, 2005. 41-55.

Yemisi, Jimoh, A. *Spiritual, Blues, and Jazz People in African American Fiction: Living in Paradox*. Knoxville: The University of Tennessee Press, 2002.

CHAPTER SEVEN

IN SEARCH OF... (ADEQUATE REPRESENTATIONS OF OUR POST BLACK CONDITION)

KOYE OYEDEJI
SCHOOL OF ORIENTAL & AFRICAN STUDIES (UNIVERSITY OF LONDON)

From the study and criticism of Sam Selvon's *Lonely Londoners* (1956) right through to Buchi Emecheta's *In The Ditch* (1972), black British literature has a thematic fixation on Identity Politics: the notions of essentialism and anti-essentialism, and the idea of home and homelessness, with Africa and the Caribbean often in one corner, Britain in the other. The topical positioning of texts continued throughout the 1990s with abandon, pervading black British literature to a point where the theme developed a dangerous tendency to delimit artistry and artistic merit in scholarly research and critical examination. It is these accusations that fuel my research, the original focus of which was to define how notions of Nigerian identity are depicted in emerging Black British writing of Nigerian descent. My work considered the perspectives of both the author and the character as children of post-independence migrants to the U.K., obliged to re-imagine the borders of cultural space and national identity.

In an earlier essay titled "Prelude to a Brand New Purchase on Black Political Identity"[1] published in the collection *Write Black, Write British* and edited by Kadija Sesay, I more than recognised the issues depicted in Bernardine Evaristo's *Lara*,[2] a novel-in-verse published in 1997 that examines both the desire to conform to culture and the problem of identity explored through the tensions of a Yoruba and Irish couple in an intransigent Britain. Subsequently, the offspring of this union, Omilara and her siblings growing up

[1] "Prelude to a Brand New Purchase on Black Political Identity: A Reading of Bernardine Evaristo's *Lara* and Diran Adebayo's *Some Kind Of Black* in Sesay," *Write Black, Write British*, Kadija Sesay, ed. (London: Hansib, 2005).

[2] Bernardine Evaristo, *Lara* (London: Angela Royal Publishing, 1997).

in 1960s and 1970s London, are to come to terms with a society that does not quite know how to relate to them.

Comparatively, I looked at *Lara* alongside Diran Adebayo's *Some Kind of Black*,[3] a novel that centres on the protagonist Dele, his relationship with his sister Dapo, and the way he attempts to juggle the life of a black student in the white world of Oxford University with that of the fundamentalist expectations of his father's strict doctrine and a black "world" within London. His identity is called into question because it is under constant political and ideological interrogation. His racial integrity is called into question for studying at Oxford. His "Nigerian" integrity is called into question by his father because Dele chooses to wear particular clothes. Both authors have publicly stated that their texts draw heavily from aspects of their own lives,[4] and I, myself of Nigerian parentage, could relate to a great number of the attitudes, emotions, and tensions they expressed.

However, within the texts I could sense a restlessness with a mere interrogation of these issues. Implicit in their narratives were protagonists in search of new ground, new breathing space; and the autobiographical admission of the authors implied that they themselves were using their texts as vehicles in search of the possibilities, the new positions, the new paradigms, and the new perspectives that await them. With this very same reason, I offered up both Evaristo's and Adebayo's texts as "preludes," preludes to a brand new black political identity—*preludes* because they were literary precursors, visible signs that Black British literature was steering itself in a different direction.

In continuing my inquiries, I found a trend emerging from the manner in which the two protagonists in my chosen texts of study expressed their experiences: engaging with Britain in the twenty-first century still required an introverted dialogue with the performative demands of the nation. On the surface, at least, the questions were still being asked: How do I manage two worlds? How does the Nigerian influence of a parent sit with a young person's British experience? In the instances in which the child is of a mixed-heritage background, the British parent is still the rule against which the Nigerian is measured, and the child finds cause to ask: Am I Nigerian? Am I British?

The preponderant tensions displayed in the 1996 and 1997 texts of Adebayo and Evaristo, respectively, are still prevalent in the novels of 2005 (which I examine later in this essay). This persistence poses a number of questions. Does such a regurgitation of these underlying themes account for an identity politics which has up until today been insufficiently tackled? We could

[3] Diran Adebayo, *Some Kind of Black* (London: Abacus 1996).
[4] See "Bernadine Evaristo with Alistair Niven" (p.285) and "Monica Ali with Diran Adebayo" (p.346) in *Writing Across Worlds: Contemporary Writers Talk*, Susheila Nasta, ed. (London: Routledge, 2004).

also consider the idea of a heavy thematic burden on the author to subscribe such issues to their texts—the notion that a black writer cannot detach him- or herself from "black" and simply become "the writer" or an industry emphasis on the analytical quality of a text as opposed to its aesthetics. Equally, we could posit this thematic perpetuity as a bid for social relevance, where these texts simply mirror how regnant the confusion with identity for blacks in Britain remains almost a decade after I began to tackle the issue in my case study of first generation authors of Nigerian descent. These are a number of the questions I considered as I cast a critical eye over post-millennium novels.

* * * * *

David Nwokedi's *Fitzgerald's Wood* was published in 2005.[5] Nwokedi's debut novel, at least on a first reading, very clearly plays on the idea of an essentialised Nigerian identity (if not an African one since the novel speaks of the continent in broad terms). The novel tells the story of Fitzgerald, a mixed-race teenage boy born to a British mother and a father who himself is of mixed heritage, a result of a fling between his own mother and an anonymous Nigerian soldier. Following the death of Fitzgerald's father, the family are left to decide where his ashes should be laid to rest. Fitzgerald's father appears to Fitzgerald in spirit, asking that his ashes be scattered in Africa. In *Fitzgerald's Wood*, the protagonist's father is portrayed as a pensive insular man who feels a sense of loss and alienation, having never experienced Africa or known his own father. In compensation for this painful identity crisis, Fitzgerald's father asserts that he is African though he offers no direct meaningful links to the continent, and he instils in his son the need to be proud of being African:

> As my father sawed into a particularly stubborn piece of wood, he told me that I was African and that I should be proud of it. I was only part African, he told me, but added that there was no reason why I shouldn't be as proud to be African as someone who was wholly African. (50)

Fitzgerald on his part is aware that he is one of a number of a handful of black people in Wistful, a small town south of London, and one of the two persons of colour at his school (8, 10). His teacher, Eugena Braithwaite, is objectified by Fitzgerald; he likes the colour of her skin, describing it as "dark and oily and shiny like the ebony keys on the piano that she played in assembly" (10). When Fitzgerald confides in his father his admiration for Eugena Braithwaite, the only person of ebony skin whom he knows, saying how he likes "her smell," his father replies with an air of romanticism:

[5] Nwokedi, David, *Fitzgerald's Wood* (London: Jonathan Cape, 2005).

'Does it take your fears away, son? Does it make you think of a better place?' I
wasn't sure what my father meant but I nodded all the same. 'Somewhere just
out of reach? Somewhere just over the hill?' (11)

For his father, Eugena Braithwaite, being of African descent, represents an idea
of home, of roots and affinity. His father seeks to forge cultural links actively
where possible. Another example lies in his complaints to his wife that she does
not cook African food, despite the strong possibility that he did not have the
cultural experience of such dishes in childhood:

> My father told my mother that I should eat African food in order to help me to be
> truly aware of where I came from or at least where part of me came from. He
> argued that fish fingers and bubble and squeak were depriving me of my
> heritage. (27)

There is the sense that, quite literally, we are what we eat—that Africa,
according to Fitzgerald's father, can be inferred from one's behaviour or in
one's recognition of the continent, to such an extent that his father seemed
particularly sad that they could "find nothing else about Africa to talk about"
(28); and it is this unbridled desire to have a relationship with the continent that
drove space between him and his family, especially when he would retreat into
himself and remain in bed with the curtains drawn for days (29).

Since he had been instructed that there was something essentially there
regarding his identity, Fitzgerald, as a child of an English mother and a father of
mixed heritage, was left to wonder "which part of him was African and how he
could go about being proud of it" (52). We arrive at a premise that, without
some sort of recognition or dialogue with the continent, those with any trace of
African heritage remain "culturally unfulfilled."

Fitzgerald's father's introspection mirrors that of Jessamy Harrison in
Helen Oyeyemi's *The Icarus Girl*,[6] published in 2005. Jessamy is the troubled
daughter of a Nigerian mother and British father. In a recent interview with
Felicia R. Lee published in *The New York Times*, Oyeyemi described Jess as
representing "this kind of new-breed kid, the immigrant diasporic kid of any
race who is painfully conscious of a need for some name that she can call
herself with some authority."[7] Oyeyemi stated that, like her protagonist Jess,
she "knows well what it feels like to be an outsider, to fight despair, to seek an
authentic self."[8] She described her adolescent environment as having a "default
cultural category [that] was white." A turning point for Oyeyemi, she says, was

[6] Helen Oyeyemi, *The Icarus Girl* (London: Bloomsbury, 2005).
[7] Felicia Lee, "Conjuring an Imaginary Friend in the Search for an Authentic Self," *The New York Times*, 21 June 2005.
[8] Ibid.

her reading of Simi Bedford's *Yoruba Girl Dancing*,[9] a novel that tells the story of a Nigerian girl trying to find a place for herself in London. In Oyeyemi's novel, Jess, upon a visit to Nigeria, comes home with Titiola, whom she considers to be a special "friend." Despite her mixed parentage, Jess cannot escape traditional Nigeria, as Titiola is revealed to be the spirit of her dead twin sister, Fern, an *abiku*[10] bent on possessing Jess. Sarah, Jess's mother, feels that they could have prevented the possession by carving a wooden *ibeji* (165), a tribute to the deity Ibeji, whom she describes to her daughter as the god of twins (282), and the carving would serve to appease the dead twin's spirit.[11] The magnitude of the crisis Jess experiences—that of spiritually colliding with Titiola as the manifestation of her confused identity—is further amplified by the issue-based conflict between Jess's parents, often founded on ideas of cultural commodity, such as her mother's belief that Jess would benefit from a firmer discipline that she inadvertently ascribes to being "Nigerian."[12]

This idea of a Nigerian brand of discipline is further revisited in Valerie Mason-John's *Borrowed Body*,[13] in which Wunmi, the Nigerian mother of the protagonist Pauline, withdraws her daughter from fostering and attempts to refashion her into a "Nigerian" daughter by beating the English out of her, promising her daughter, after clouting her around the head, that she was going to "get rid of [her] fancy English habits" (121). This leitmotif is a reoccurring one as Wunmi asks herself, "What am I going to do with this English child?" before hitting Pauline with her belt (128) and asking her daughter, "How dare you give me that typical English smile" before striking her to the ground (139). Pauline retreats into her own world, often escaping her body and using her mind to distance herself from her physical reality,[14] but at the same time aware of the need to protect her body from the spirits that wish to possess it.

Basically, *Borrowed Body* is in opposition to *Fitzgerald's Wood*. Long before her mother returns to instil "Nigeria" into her, Pauline has rejected it. She does not want to be known as black; she does not want to be known as African. As far as she is concerned, she is British. In her early years at a foster home, she innocently and naively pleads with her foster mother to make her white. Her

[9] Simi Bedford, *Yoruba Girl Dancing* (London: William Heinmann, 1991).

[10] *Abiku* is the term for the Yoruba spiritual belief that the death of an infant before puberty is the result of its possession by an abiku spirit. The word *abiku* comes from *abi*, "that which possesses," and *iku*, "death." The Yoruba term is defined in *A Dictionary of the Yoruba Language* as "a child who is supposed to have come back after death to the mother and [so is] born again" (Ibadan: University Press PLC, 1991).

[11] Oyeyemi, Ibid., pp. 165 & 282.

[12] Ibid., p.188.

[13] Valerie Mason-John, *Borrowed Body* (London: Serpent's Tail, 2005).

[14] Ibid., see p.139, for one such example.

foster mother says it is impossible, but Pauline does not believe her: "I scrub my skin, chalk myself, dip my hands and face in flour. Sally becomes angrier with me, my brothers laugh, and Mummy slaps me" (5).

Mason-John was born in Cambridge and is of Sierra Leonean heritage. Her debut novel, *Borrowed Body*, is a painful tale, loosely based on her own childhood growing up in a children's home, being shuttled between foster homes and detention units. What is most glaring about the novel is just how early the politics of race strikes Pauline. She is not yet five years of age when the "loose golden curls and pink blossom cheeks of her foster sister enchant her" (3). She is not yet a teenager when her mother accuses her of being brainwashed by the white people at her children's home, when she begins to misunderstand why she has to change from being English to being African (128).

The sacristy of twins in Nigerian culture is again addressed in Diana Evans's *26a*,[15] published in 2005. Mixed-race twins Bessi and Georgia, again of Nigerian and English descent, make their first trip to Lagos. They have a magical bond, reinforced by the notion that previously they had experienced a life together as "furry creatures" travelling through undergrowth with no fixed destination, bent on crossing a main road, despite the signals of danger. Reborn together as twin children, they share a vivid memory of the life they lived before, the moment of their death, and their reincarnation (1). Then, in later life re-reinforced by the notion that while in Nigeria they meet each other in their homesick dreams, travelling back across indigo skies to their home, where they made sure their lodgers were keeping their bedrooms in order (54). Together, these trips helped them make the transition to Nigeria. It is with that magical sense of dual identity that Evans illustrates how Bessi and Georgia come to address, regardless of their consciousness, the loose sense of home and nationhood:

> These trips became less and less frequent. For home had a way of shifting, of changing shape and temperature. Home was homeless. It could exist anywhere, because its only substance was familiarity. If it was broken by long journeys or tornadoes it emerged again, reinvented itself with new décor, new idiosyncrasies of morning, noon and dusk, and old routines. (54)

Having gained sufficient sunshine to darken their skin, Bessi asks her mother (Ida) if they are "proper Nigerians," to which Ida replies that Bessi can be as Nigerian as she wants to be (58). However, the twins soon realise how easily their mother's words can be undermined when they enter the village of Aruwa to choruses of "Oyibo," which they realise means "white" (59). Ironically, the bond the twins possess slowly dissipates as they negotiate their adolescence

[15] Diana Evans, *26a* (London: Chatto & Windus, 2005).

upon their return to the Britain, the cultural landscape in which their relationship was originally formed. Bessi and Georgia are children of the new school, anti-essentialists who adopt no particular position in terms of identity; and they appear to be the most comfortable of all the protagonists I have studied specifically in this regard. Inevitably, they cannot avoid the friction of their cultural heritage and the cultural dichotomy that pervades the existence of blacks in Britain. However, in the text, such friction is played out by their parents and the distance that grows between them and their respect lives. Their father, Aubrey, stops Ida from teaching the children her Nigerian dialect of Edo. "We're in England now," he says. "The girls don't need Nigerian here. They'll forget it soon enough" (97). The twins' mother is full of regret for following their father to Britain while their father turns to drink, feeling that he has worked tirelessly and futilely for thirty years. The marriage is broken and perceived to be a sham; and, when the eldest daughter leaves home, she abandons her bedroom to her mother:

> Aubrey was asleep in his chair. The photograph of his parents was lying on the floor next to him. Ida woke him up and bandaged his arm. They didn't look at one another. 'Bel is going,' she said, 'I will take her room.' (108)

* * * * *

Fitzgerald's Wood, The Icarus Girl, Borrowed Body, and *26a* are all post-millennial texts, yet each echoes something about the 1990s texts of Evaristo and Adebayo, written almost a decade ago. The contemporary black British novel's apparent preoccupation with the notion of cultural identification reflects a younger generation still ill at ease in dealing with the issue. Today, the black British novel, as to representation, faces both an assortment of political objectifications created by theorised meta-narratives about Black Britain and the challenge of escaping them. Their efforts to address these political dimensions of life in the U.K. should not be mistaken for attempts at racial flight or to deemphasise the debate surrounding race. The black British novelist will always speak politically from a particular position. As Stuart Hall states, identity is not so much a "rediscovery" but rather "a production."[16] The essentialism/anti-essentialism debate need not be gleaned from texts alone; it is articulated through other artistic genres, saturating the very existence of blacks in Britain, and interwoven throughout our media. Such theorising, at least in this context, has only helped to historicise and to lend an air of verbosity to the questions and

[16] Stuart Hall, "Culture, Identity & Diaspora" in *Colonial Discourse and Post-Colonial Theory: A Reader*, Williams Patrick and Chrisman Laura, eds. New York: Columbia U P, 1994).

inner dialogues that black people have long harboured in Britain. It is a firm part of black British life when dealing with unsettled cohorts, only a generation or two removed from migrancy, and for generations that have a clear example of what it is to be non-British. In Pauline's, Jess's, Georgia's and Bessi's cases, the clear example is the Nigerian mother. For Fitzgerald, in the predominately white town of Wistful, it is the very hue in his skin and the presence of Eugena Braithwaite that exemplify the non-British.

In his preface to *The Political Unconscious,*[17] a seminal work of cultural criticism, Fredrick Jameson recognises the "limits" of interpretation and the fact that no single text can be approached from a position of objectivity:

> The Political Unconscious accordingly turns on the dynamics of the act of interpretation and presupposes, as its organizational fiction, that we never really confront a text immediately, in all its freshness as a thing-in-itself. Rather, texts come before us as the always-already-read; we apprehend them through sedimented layers of previous interpretations, or—if the text is brand new— through the sedimented reading habits and categories developed by those inherited interpretive traditions. (x)

So black Britain's cultural production continues, aware if not (entirely) of those inherited traditions, then of the saturated meta-narratives, which suggest that the cultural identities that "reflect a common history continue to be a very powerful and creative force in emergent forms of representation amongst hitherto marginalised people."[18] The "struggle" to reconcile the black presence in the national identity of Britain with that of migrant ancestry becomes the narrative on which rests any sense of a collectivity; hybridity becomes our collectivity. History has shown that marginalised groups are more effectively formed on the basis of oppression than of liberation, suffering builds cohesiveness, and, in this sense, the dual identity (nationality/ancestry) is seen as something against which one must grapple, rather than as a position of liberation from the fixed idea of nation. In short, we see it as a problem, not as a privilege; we see it as something that needs addressing because the meta-narrative's ideal is to reach a clear and simple utopian resolution.

There can be no simplification, and therein lies the difficulty. Stuart Hall, in his essay *Culture Identity and Diaspora*, got around the problem by describing identity as being not a linear construct riding its course through history, but rather something framed by two axes, or vectors, that operate simultaneously: the vector of similarity and continuity and the vector of difference and rupture. The one gives us some grounding in—some continuity

[17] Frederic Jameson, *The Political Unconscious: Narrative as a Socially Symbolic Act* (New York: Routledge, 1983), pp.ix-x.
[18] Ibid.

with—the past. The second reminds us that what we share is precisely the experience of a profound discontinuity.[19]

For black British literature the liberation lies in the idea, perhaps, that one can embrace this complex and simply "move on," but on a personal level it is taking an intense interrogation of the issues in order to do so. This close and nuanced attention is reflected in the black British texts of Adebayo and Evaristo, Evans and Oyeyemi, Nwokedi and Mason-John—in their pervading instability as they try to address the aforementioned sentiments. A black Britain that on a surface appears as if it is without a strong diasporic history to which to cling deals uncomfortably with this rupture, repelling what is immediately in front of it. Instead, it goes above and beyond. The novel's trajectories are symbolic journeys, the symbolic journeys that "are necessary for us all—and necessarily circular. This is the Africa we must return to—but 'by another route': what Africa has become in the New World, what we have made of Africa: Africa as we retell it through politics, memory and desire."[20]

* * * * *

In drawing on what these new novels have in common, above all that they were debuts, and, as is often the case with first novels, at least partial reflections of the authors' lives, *Fitzgerald's Wood, The Icarus Girl, Borrowed Body*, and *26a,* like *Lara* and *Some Kind of Black*, provide readers a cathartic struggle with the concept of identity and its present meta-narratives. It has often been the case that the debut novel stems from an author's desire to flush this sort of personal interrogation out of his or her system. But the authors do not want the texts merely to reflect their own lives. You can trace this impulse in the creative innovations in the writers' works: each of these post-millennial texts draws on fantasy, African spiritualism, and magical realism. Pauline in *Borrowed Body* stems from a spirit who is in a rush to be reincarnated and is conceived in the flesh on the banks of the river Oshun.[21] Our initial belief is that Pauline's problems with Wunmi stem from the latter's desire to see her daughter display more Nigerian tendencies and from Wunmi's frustration with British ways. However, this assumption is turned on its head when we read that Pauline was betrothed to Wunmi in a former life:

[19] Stuart Hall, Ibid.

[20] Ibid.

[21] The River Oshun, or Osun, runs southwards from southwest Nigeria into the Lagos lagoon. It is named after the Yoruba deity Osun, who is the goddess of fertility. The Osun festival at the river in Osogbo in August draws many people not only from across the country but internationally.

> My heart begins to pound as I realise I chose my wife from a past life to be my mother in this life and bring me back into the world. The voice in my head is Wunmi. It's my wife too. She never forgave me for selling our people, and the rapes of all the village women. (239)

The idea that the tensions come down to a collision of cultures is relocated to another realm—to a narrative of simple revenge, while at the same time Mason-John is able to use the text to overcome what I have termed "the burden of the meta-narrative."

These texts seek to get over the odious questioning and to embrace creative freedom. Therefore, we must seek to bring such interrogations to an arbitrary closure in trying to mediate both a theoretic and an aesthetic rediscovery. The effort is, at least in part, already underway. Mahlete Getachew, for instance, in her essay "Marginalia: Black Literature and the Problem of Recognition," writes that "The challenge Black writers face is to develop a mode of expression, a new language, which resists these pressures, transcends these expectations, and makes Black literature a distinctive and aesthetically valuable enterprise."[22]

I turn to the second novel of Diran Adebayo and the second and third of Bernardine Evaristo. Evaristo's 2001 sophomore effort, *The Emperor's Babe*,[23] is yet another novel-in-verse, this time a comical love story of a young Sudanese girl in the Roman Empire's London of 211 A.D., who courts the attention of the Emperor. It is historical in a light-hearted way, playing on the contemporary and satirising our modern times. It is a fusion of poetry and prose, described as "funny," "funky," and "a triumph of imaginative writing." Her third novel, *Soul Tourists,* is as imaginatively experimental in formal ways. Similarly, I sensed something in that Diran Adebayo had to get the whole issue of identity off his chest in *Some Kind Of Black* before turning to a more lyrical, stylistic aesthetic in the Old-World-meets-New-World detective story *My Once Upon a Time*.[24]

In his 1989 popular essay "New Ethnicities," Stuart Hall spoke of the beginnings of a new conception of ethnicity, a new cultural politics which engages rather than suppresses difference and which depends, in part, on the cultural construction of new ethnic identities. He later added that there was a marked shift in the point of contestation to the notion of ethnicity itself.[25] The

[22] Mahelete-Tsige Getachew, "Marginalia: Black Literature and the Problem of Recognition" in *Write Black, Write British*, Kadija Sesay, ed. (London: Hansib, 2005), p.339.

[23] Evaristo, Bernardine, *The Emperor's Babe* (London: Hamish Hamilton, 2001).

[24] Diran Adebayo, *My Once Upon a Time* (London: Abacus, 2000).

[25] Stuart Hall, *ICA Documents 7: Black Film, British Cinema*, edited by Kobena Mercer, 1989.

problem might be that we contest the contestation and then contest *that* contestation further, and so forth and so forth. The contestation becomes orthodox black British Literature. Fredric Jameson's *The Political Unconscious* does remind us of the relationship between history, the history of a text, and its content. Jameson showed a correlation between the thematic choice of a writer and an "unconscious framework" guiding these choices.[26] The aesthetic becomes historical literary practice. The question I began with was this: Is Black Britain shackled by this continual interrogation of our histories and of the notion that having two unique perspectives is something that has to be perceived as frictional? I had hoped not.

Hope lies in the artful magic, the creative fantasy, and the formally crafted language employed in these texts, signs that the texts are overcoming a cathartic process, helping literature by blacks in Britain to move towards the next phase, the creative experimentation of our future. All the post-millennial texts I have examined here transact in the autobiographical mode, but insert fantasy. The fantasy represents not Africa but a channel through which to escape the pervading interrogations as to identity. It is not the excessive theorisation and meta-narratives of these issues that drive the unsettled mind to resolution, but the immanent critique that arises from within these texts. Such a critique, the critique of black British artists themselves, is important in moving the paradigm forward.

* * * * *

Dizzy, the protagonist in Diran Adebayo's short story extract "P is for Post-Black," comments on a marked change in black behaviour, believing that no one is trying too hard to be anything but themselves. While trotting through central London on his way to a date he observes:

> Further on, and there are more instances of unorthodox black behaviour: a black and white couple, the black lady's arm elegantly, continentally, linked around his, on a stroll, stopping by the odd venue or store window, promenading. A pack of young women on a night, a mixed bunch, all grouped around a bar table, a few clothes bags at their side. Happy with themselves; glugging Barcardi Breezers and enjoying the booming economy. Not posh-black or those slightly freaky Soho types, just regular, neighbourhood-looking girls, being mainstream. Sort of ... post-black.[27]

[26] Jameson, Ibid.
[27] Diran Adebayo, "P is for Post-Black" in *Underwords: The Hidden City*, Maggie Hamand, ed. (London: Maia Press, 2005).

The author's narrative reflects the changes that are being made in literature: that (and I say this with respect) past burdens of responsibility and representation are somewhat outdated. This is not to say that as black people we are no longer burdened, nor that we no longer possess the "double consciousness" that W.E.B. Du Bois coined in *The Souls of Black Folk*,[28] but merely that the manner in which we deal with issues of race is in need of re-evaluation. I was very much interested in the term *Post-Black* in Adebayo's short story. We discussed it in relation to my essay, and I was grateful to him for pointing me towards the work of New York curator Thelma Golden. For several years, Golden has been interested in a post-modern discourse surrounding race—even when race is not at the forefront of the focal (cultural) text itself. Though she comments on visual art, her ideas can be effectively transferred to literature. As deputy director of Exhibitions and Programs for The Studio Museum in Harlem,[29] Golden coined the term *Post-Black* in 2000 in referring to Freestyle, an exhibition of twenty-eight emerging African-American artists who, she felt, did not put the notion of identity at the forefront of their work. In the introduction to the exhibition catalogue, she stated that the category *Post-Black* is "Characterized by artists who were adamant about not being labelled as 'black' artists, though their work was steeped, in fact deeply interested, in redefining complex notions of blackness." She continued that there were no "prevailing themes in the exhibition except perhaps an overwhelming sense of individuality"—adding that the artists were both "post-Basquiat and post-Biggie. They embrace the dichotomies of high and low, inside and outside, tradition and innovation with a great ease and facility."[30]

* * * * *

Golden is articulating something that is communicated in the texts I have mentioned. Though I was initially stumped, almost alarmed, by the pervading similarities in the texts upon further readings, I could feel that the works did not insist on being labelled black or Nigerian or British, but rather sought to redefine these notions and bring them into harmony.

Post-Black is an attempt to shift the paradigm of *black* so that it may be understood as a historically specific social construct. In the *New York Times*'s

[28] DuBois, W.E.B., *The Souls Of Black Folk* (Chicago: A.C. McClurg, 1903).
[29] Thelma Golden became the deputy director of Exhibitions and Programs of The Studio Museum in Harlem in January 2000. Prior to that appointment, Golden was curator at the Whitney Museum of American Art in New York City. She is an adjunct professor at the School of the Arts, Columbia University.
[30] Thelma Golden with Christine Y. Kim, Hamza Walker, et al. *Freestyle* (New York: The Studio Museum in Harlem, 2001), pp.14-15.

review of Freestyle, critic Holland Cotter described such a construct as a "trap" particularly "frustrating to artists born in the 60s and the 70s for whom the Black Pride and Black Power politics of an earlier day are now deep background, historical realities to be remembered, drawn on, referred to, played with, but not re-embodied and reasserted every time out."[31]

In her essay "Post Modern Blackness," bell hooks describes how she engaged in a passionate argument with the only other black person present regarding the significance of postmodernism for the contemporary black experience:

> the idea that there is no meaningful connection between black experience and critical thinking about aesthetics or culture must be continually interrogated.... It has become necessary to find new avenues to transmit the messages of black liberation struggle, new ways to talk about racism and other politics of domination.... The critique of essentialism encouraged by postmodernist thought is useful for African-Americans concerned with reformulating outmoded notions of identity. We have too long had imposed upon us from both the outside and the inside a narrow, constricting notion of blackness.[32]

Radical experimentation and difference in black British aesthetics would denote Post-Modern radicalism; it would be political within itself—new forms of artistic experimentation and modes of distribution to attack the epicentre of the commercial publishing industry, like a virus spreading from within. Though referencing Black-America, bell hooks's ideas are just as relevant to black Britain when she states, "Contemporary African-American resistance struggle must be rooted in a process of decolonization that continually opposes re-inscribing notions of 'authentic' black identity"; and she is aware that this post-blackness is not a running away from black and black history, adding, "This critique should not be made synonymous with a dismissal of the struggle of oppressed and exploited peoples to make ourselves subjects. Nor should it deny that in certain circumstances this experience affords us a privileged critical location from which to speak."[33]

* * * * *

Ironically, the dialogue and the meta-narratives on Black British identity, their inherent failure to reach ideal answers, allow one to draw a line on

[31] Holland Cotter, "Beyond Multiculturalism, Freedom?" *The New York Times* (*Art Review*), 29 July 2001.
[32] bell hooks, "Postmodern Blackness" in *Yearning: Race, Gender, and Cultural Politics* (Boston: South End Press, 1991; London: Turnaround, 1991).
[33] Ibid.

the issue, settle on the fact that one's idea of home and self may lay beyond Nigeria or Britain, to shores one is presently not associated with or indeed beyond borders themselves.

With that in mind, that those issues of identity have been put to bed with the idea that one can never collectively conceptualise them effectively, black British writers today inevitably concern ourselves with the notions of here and now and our instincts for survival. To achieve economic growth, the sense of identity for black people in the arts becomes ever more important to increasing our sustainability.

As Thelma Golden has stated, let it be "blackness as a style but nothing more than style";[34] let a black British writer be black, but do not infer anything from his or her race alone. Do not infer that black British writers are speaking to the West from the position of the Other. Do not infer that they are obliged to address the collective sum of Black Britain. In these trans-national times, we have a responsibility to innovate and find new styles of political address and efficiency. If this means that originality implies post-modernity, then let it be post-modernity. The subject position is inherently political.

As I mentioned above, I offered up a previous essay as a "Prelude to a Brand New Purchase on Black Political Identity." The gesture implies an authorial desire to move on, both racially and socially, but in such a way as not to neglect or to fail to address present power politics around race, identity, and gender. There is a growing need to move on from the issue of identity politics, towards individually favourable, post-modern approaches to self-expression and its communication. The relation between style and the social positioning of black British writing needs to be addressed. It is equally important that we get the right balance between social (or political) criticism and aesthetics, when we are dealing with literature and literary criticism, and not impose the social and ethical mechanics of the arts over aesthetic quality in our judgement of the arts.

There is a stale notion, quite literally, of political correctness attached to black people; and if you do not represent this "buddy politic," then you are something else, some anomalous kind of black, to borrow from the title of Adebayo's novel.[35] Black Nationalism, for instance, and its forms of political correctness become dormant and stale, and while Black Nationalism stays in the same place, it invariably comes to manifest a conservative approach to radicalism: the manner in which one rages against the machine becomes a standard expectation. In applying the proverbial cop-out of "each one teach one" to my argument (that we all have differing experiences that we can learn from), one can accuse me, I do believe, of being a post-modernist; but if I may invite

[34] Golden, op.cit, p.14-15.
[35] Adebayo, *Some Kind of Black.*

my readers to excuse this "disarming behaviour," then, perhaps, we may reason together in devising ways in which black British literature is not simply representative of the antagonised or the antagonistic, but embodies, all the same, a politics for all to see.

"Post-black," I say and invite sneers. The term is shrouded in controversy. Let us not be pig-headed in our glossing of terms, but recognise that essentially, in the arts, we are in need of an aesthetic that no longer merely re-presents what *black* meant in the past, but one that permits the expression of what we can be in the future and what our impact in a world driven by capital and global economics may become. I chose to adopt the term *post-black* because, like Golden, I see "post-black art" not as escaping colour, but rather as an admission that we never will. Instead, we should be happy to take on the challenge representation in more individual and personal terms. Post-black artists—like Evaristo, Adebayo, Oyeyemi, Mason-John, Nwokedi, and Evans are not leaving behind race, but articulating it in new ways. Essentially, if as black artists, we become mindful of the political unconsciousness being birthed in our own day in Britain, then we will not forget our history, but face it in new ways. We will challenge constantly the projections of what black is; and, then, we will not allow anyone, or any market, to dictate what black art is, but continually re-define it aesthetically ourselves, on an individual basis. This is what *post-black* means for me. Others may term it differently, but whatever it is called, it has the potential of being our Trojan horse to get us through the gates of Troy; and then, after that, who knows what other epic battles may lie in wait for us.

Works Cited

Adebayo, Diran. *Some Kind of Blac.* London: Abacus, 1996.

—. *My Once Upon a Tim.* London: Abacus, 2000.

—. "P is for Post-Black." In *Underwords: The Hidden City*, ed. Maggie Hamand. London: Maia Press, 2005.

Cotter, Holland. "Beyond Multiculturalism, Freedom?" *New York Times (Art Review)*, 29 July 2001.

Evans, Diana. *26a.* London: Chatto & Windus, 2005.

Evaristo, Bernardine. *Lara.* London: Angela Royal Publishing, 1997.

Getachew, Mahelete-Tsige. "Marginalia: Black Literature and the Problem of Recognition" in *Write Black Write British,* ed. Kadija Sesay. London: Hansib, 2005.

Golden, Thelma, with Christine Y. Kim, Hamza Walker, et al. *Freestyle.* New York: The Studio Museum in Harlem, New York, 200. 14 -15.

Hall, Stuart. *ICA Documents 7: Black Film, British Cinema*, ed. Kobena Mercer. ICA, 1989.

—. "Culture, Identity & Diaspora." In *Colonial Discourse and Post-Colonial Theory: A Reader*, eds. Patrick Williams and Chrisman Laura. New York: Columbia U P, 1994.

hooks, bell. "Postmodern Blackness." In *Yearning: Race, Gender, and Cultural Politics*. London: Turnaround, 1991; Boston: South End Press, 1991.

Jameson, Fredric. *The Political Unconscious: Narrative as a Socially Symbolic Act*. New York: Routledge, 1983.

Lee, Felicia R. "Conjuring an Imaginary Friend in the Search for an Authentic Self." *The New York Times*, 21 June 2005.

Mason-John, Valerie. *Borrowed Body*. London: Serpent's Tail, 2005.

Nwokedi, David. *Fitzgerald's Wood*. London: Jonathan Cape, 2005.

Oyedeji, Koye. "Prelude to a Brand New Purchase on Black Political Identity: A Reading of Bernardine Evaristo's *Lara* and Diran Adebayo's *Some Kind Of Black*." In Write Black, Write British, ed. Kadija Sesay. London: Hansib, 2005.

Oyeyemi, Helen. *The Icarus Girl*. London: Bloomsbury, 2005.

CHAPTER EIGHT

THE AESTHETICS OF REALISM IN CONTEMPORARY BLACK LONDON FICTION ✦

MAGDALENA MĄCZYŃSKA
MARYMOUNT MANHATTAN COLLEGE

Discussions of late twentieth-century "Black" writing frequently emphasize the difference between post-war, post-Windrush fiction and the work of the British-born generation that followed: whereas the former is said to be preoccupied with themes of migration, the latter develops themes of belonging; while the older authors look back to a distant home in search for meaning and identity, the younger ones are at home on British soil. The first group is "Post Colonial"; the second is "Black British." To this list of transitions, I would like to add another. The majority of novels written by British writers of African, Caribbean, and Asian origin in the second half of the twentieth century are committed to realist representation, drawing on genres developed by the classical realist tradition and adhering to a mimetic ontological agenda. Only in the last few years has this dominance of realist aesthetic in "Black" British literary production been challenged. My essay examines works of fiction as well as the responses to these works offered by academics and journalists elucidating the role realism has played in defining the identity of contemporary "Black" British writing and pointing out the possibility of new directions for that writing. I focus on London narratives because they illustrate most clearly the contrast between the experimental tendencies of authors such as Peter Ackroyd, Martin Amis, Angela Carter, Maggie Gee, Will Self, Iain Sinclair and Jeanette Winterson and the persistence of realist aesthetics in the work of "Black" urban novelists.

Before I begin my analysis, a few disclaimers and clarifications are necessary. Many of the terms used here (*realism, experimentation, Black, British, postmodern*) are famously controversial; employing them inevitably opens up thorny semantic and ideological fields that this paper cannot negotiate. Also, the generational distinctions outlined above can only be treated as

approximations, not rigid formulas of literary change. As often happens with surveys, subtlety of distinction has at times been sacrificed for the sake of breadth. Lastly, the idea of placing authors as different as Hanif Kureishi and Buchi Emecheta in the common category of "Black British writers"—a category that, as Mahlete-Tsigé Getachew has eloquently argued, is in its nature political, not aesthetic—has its limitations.[1] However, even if the once empowering meeting of cultural activists, intellectuals, and artists of African, Caribbean and Asian descent under the common name of "Blackness" has now outlived its purpose, giving way to more flexible and accurate formulations of identity, the term does retain its heuristic usefulness. As the patterns here described occur consistently in the writing of Commonwealth immigrants and their children, discussing these works together is illuminating as well as practical. Finally, it seems fitting that a discussion concerned with a time when the cultural currency of "Black Britishness" has not yet been devalued should employ that very category, thus itself becoming part of the cultural history it is mapping. For those reasons, I will forgo the quotation marks around the term *Black*, and continue my discussion in full awareness of the limitations inherent in the categories I have chosen to employ.

The second half of the twentieth century witnessed the dynamic development of Black London writing. Of course, as Judith Bryan (2004), Sukhdev Sandhu (2004), and others have demonstrated, the history of black Londoners goes back at least as far as the Roman Empire, and has remained a significant part of the city's cultural make up ever since. Never before, however, could the Black British literary canon claim such a powerful sense of identity, or boast such an impressive degree of institutional recognition. Mark Stein, for instance, points to the emerging practice of authorial endorsement—Zadie Smith being recommended by Salman Rushdie and in turn recommending Monica Ali, for instance—as a sign of self-aware canonicity. The growing academic apparatus of commentaries, conferences, and anthologies is another sign of vitality, as are burgeoning literary prizes and publishing initiatives. Finally, journalistic interest in the field is evident both on-line and off, bearing witness to Black fiction's presence on the literary London scene.

Several decades into this flourishing, an examination of its aesthetic principles is in order. Discussions of Black British cultural production have long been dominated, for historical and political reasons, by questions of ideology, identity, and power. Considerations of content have often overshadowed considerations of form. In the case of the novel, this has meant a focus on characters-as-real-people with authentic geographical, socio-economic, and

[1] For a compelling critique of the "Black British" categorization see Koye Oyedeji (2005).

linguistic backgrounds, undertaking quests for self-understanding, financial independence, or cultural recognition with which the readers can readily identify. Although all of the above are important aspects of novelistic discourse, and the content-form dichotomy may be artificial and unsatisfactory, the dearth of discussions that go beyond examining the world represented to tackle the modes of representation is still striking. This lack of aesthetic analysis points to the power of representation as the most highly valued aspect of Black London literary production.

A dedication to realist aesthetics dominated British fiction—Black and non-Black alike—in the post-war decades. The late 1970s, 1980s, and 1990s, however, marked a gradual movement away from classical realist representation, under the influences of international postmodernism, magic realism, metafiction, and a renewed interest in the traditions of fantasy and pre-nineteenth-century novelistic discourse. This tendency has been noted by a number of critics: Susana Onega and John Stotesbury (2002) followed Malcolm Bradbury (1993) in pointing out the visionary and apocalyptic character of recent urban fiction, while Richard Todd (1996) labeled the contemporary London novel's dominant mode as a "realism of excess, of magic or of the dreaming world" (164). Ascribed variously to the traumatic social crisis of the Thatcherite era, the pressures of globalization, and apocalyptic anxieties engendered by the cold war and the approaching end of millennium, London's turn away from the mimetic has been seen by many as subversive in nature, aimed at questioning the official representation of the city and its dominant political, social and symbolic orders. Realism's privileging of reason and scientifically inspired epistemological and ontological models has been denounced as a Leotardian "grand narrative" and a restrictive, totalizing paradigm. Realist writing came under attack for failing to question, or for mendaciously concealing, its own artistic strategies and ideological agendas. Consequently, writing that rejected traditional methods of representation was perceived as subversive, liberating, and free from the oppressive grip of the enlightenment West. [2]

[2] The above view of realist aesthetics is obviously partial and ideologically driven. Many Black authors have successfully used traditional fictional methods to subversive ends. Moreover, the rigid distinction between "realist" and "experimental" narrative strategies has its limitations. Andrzej Gąsiorek's discussion of post-war British fiction offers a much more nuanced view, according to which "the distinction between experimentalism and realism should be seen as ambiguous and context-dependent, the implications of both terms should be called into question, and realism should be seen as a complex phenomenon, which takes a variety of forms in different historical periods" (181). Gąsiorek further argues against "the claim that experimental writing is inherently radical," which he considers "as mistaken as the counter-claim that realism is a

Given the innovative turn in urban fiction of the late twentieth century, most Black Londoners seem curiously uninterested in questioning or abandoning traditional methods of representation. On the contrary, both Black novelists and their audiences—academic and non-academic alike—show a strong dedication to the principles of realist aesthetics. This preference demonstrates itself in a number of ways, from choice of genre to the emphasis on referentiality visible in current critical discourse and literary market demands. The following sections offer an overview of these directions in London cultural production since the 1970s, before moving on to examine the reasons behind realism's hold on the last few decades, and concluding with a map of new, twenty-first century departures.

One of the classical realist novel's most important sub-genres is the bildungsroman: a narrative form focused on a young protagonist's search for identity and subsequent initiation into a social milieu. Numerous critics have noticed the preponderance of this fictional form in Black British writing. Feroza Jussawala identifies such key subcategories as the "postcolonial Bildungsroman," exemplified by the work of Salman Rushdie, Arundhati Roy, and R.K. Narayan; the "female postcolonial bildungsroman," seen in the oeuvre of Anita Desai, Buchi Emecheta, and Zadie Smith; and the paradoxical "bildungsroman of unbelonging," named after *The Unbelonging* (1985) by Joan Riley (98-102). Maria Helena Lima proposes a further category: the "'double' bildungsroman" employed by Andrea Levy in *Never Far From Nowhere* (1996). This narrative type, popular in Caribbean novels, allows the writer to examine the varying effects of post-colonial society on individuals differentiated by skin colour and social status (Lima 2005: 63). More radically, Mark Stein identifies the dominant form of black British fiction as the "novel of transformation," which focuses on "subject formation under the influence of political, social, educational, familial, and other forces and thus resembles the *bildungsroman*" (xii). Stein's analysis goes beyond morphological catalogues to identify the narrative of transformation as the Black British canon's dominant paradigm. Such a canon would certainly include all the novels of Andrea Levy, especially *Every Light in the House Burnin'* (1994), Diran Adebayo's *Some Kind of Black* (1996), Bernardine Evaristo's *Lara* (1997), and Lucinda Roy's *Lady Moses* (1998). What characterizes these fictions, in addition to their emphasis on subject formation, is their autobiographical character, highlighting the close

fundamentally conservative form," concluding that "Both claims fail to attend to the specificities of context, the situations in which textual interventions operate, and the illocutionary force that such interventions possess (181). Nevertheless, in a time when bold experimentation was gaining currency in mainstream British fiction, the contrast between Black urban novels and other narratives of the metropolis remains noteworthy.

ideological and aesthetic connection between the bildungsroman and the autobiographical narrative—a connection particularly apparent in debut novels.

Inhabiting a space between fiction and non-fiction, autobiographical writings are the ultimate form of mimetic narrative. Beginning with the pioneering works of Olaudah Equiano and Ignatius Sancho, the tale of one's own life has been central to the Black literary canon, and continues to play an important role in the writings of the twentieth-century metropolis. Kwame Dawes calls the work of Bernardine Evaristo and Andrea "largely autobiographical," emphasizing their importance in conveying the experience of Black women negotiating British culture (267). Similarly, Beryl Gilroy's *Black Teacher* (1976) and *Boy-Sandwich* (1989), as well as the London novels of Buchi Emecheta, including *In the Ditch* (1972) and *Second Class Citizen* (1974), are commonly read, discussed, and marketed as autobiographical writing, their success stemming from their psychological veracity and firmly referential character.

Another referential genre strongly represented in Black London writing is urban realism and its subcategory, the ecological novel. The latter term was modeled on the narrowly focused studies developed by the Chicago school of sociology and adopted for the purposes of literary criticism by Blanche Gelfant in her study of American city narratives. Focusing on one neighbourhood or urban subculture, the ecological novel offers insights into its internal mechanisms and complexities. The close relationship to the sociological model is apparent, as is the dependence on a stable sense of reality and close empirical observation. London inner-city fiction, labelled by Fatimah Kelleher as "'frontline' and council estate (projects) realism" (242), is the most visible type of urban realist writing to emerge since the 1990s. Kelleher provides a long list of examples: Vanessa Walter's *Rude Girls* (1996) and *The Best Things in Life* 1998), Courttia Newland's *The Scholar* (1997) and *Society Within* (1999), Stephen Thompson's *Toy Soldiers* (2000), Alex Wheatle's *East of Acre Lane* (2001), Diran Adebayo's *Some Kind of Black* (1996) and Victor Headley's *Yardie* (1992). Not all the fictions listed here are ecological novels—*Some Kind of Black*, for instance, moves between London and Oxford as well as through a number of urban neighbourhoods. However, all provide close sociological observation of selected urban environments.

The purpose of "frontline" and "estates realism," according to Kelleher's analysis, was corrective, countering the falsifications of news accounts and "inner-city features" and "telling it like it is" (246). This goal points to the documentary ambitions of urban fiction, bringing it within the socially conscious traditions of nineteenth-century realism and naturalism (the latter mode seen, for instance, in the "doomed" characters of Newland). This desire for representation can be seen in such characteristic features of realist

discourse as attention to local speech patterns and customs (such as the nuances of fashion and music that constitute ephemeral but all-important code systems in the network of urban semantics). Language is of crucial importance here. Diran Adebayo, for example, is famous for his seamless combination of English, Jamaican, and American speech, while Courttia Newland is often praised for his rendition of fast-paced street-talk. The physical appearance of the Black urban neighbourhoods is also given carefully detailed treatment, perhaps best represented by Wheatle's evocative descriptions of Brixton's haunting tower blocks and graffiti-covered alleys. What we see here is the resurgence of a nineteenth-century London tradition, bearing the mark of writer-journalist Charles Dickens.[3]

Journalism is, of course, deeply connected to novelistic discourse, and lies at the roots of the novel's generic development.[4] Modern journalism and modern realist fiction grew up together, and many novelists retain strong journalistic ties. Sukhdev Sandhu points out that many Asian and Caribbean writers to take on the British metropolis have journalistic credentials: Behramji Malabari of the *Indian Spectator*; Sam Selvon and S.I. Martin, who used to write for the *Trinidad Guardian* and *The Voice*; Mike Phillips, who reported on Notting Hill in the 1960s. Sandhu observed that these authors "have tended to offer accounts of London which are unsentimental, dense with quotidian specificity" and that journalists have produced "some of the most arresting depictions of London" because of "their professional need to snout about in the corners and undertows of the capital (often for sensationalistic rather than latitudinarian reasons), to favour substance over form, information over commentary, as well as to keep abreast of shifts of power, fashion and rhetoric" (377). The emphasis on substance over form is particularly significant, pointing once again to the privileged position of the texts' mimetic function.

If mimesis is essential to the autobiography, the bildungsroman, and the contemporary urban/ecological novel (with its sociological and journalistic underpinnings), it can also be central to narratives that do not fall neatly into a single generic category. Arguably the two brightest stars on the Black British literary scene in terms of market success and pop credentials are Hanif Kureishi and Zadie Smith, both authors of complex fictions that draw on a number of literary genres and traditions. Kureishi's *The Buddha of Suburbia* (1990) and *The Black Album* (1995) and Smith's *White Teeth* (2000) and *Autograph Man*, (2002)—all key works of the Black London canon—are powerfully realist

[3] The link between Black London fiction and the heritage of Dickens (minus the sentimentality) has been emphasized by Victoria Arana (2005) in her discussion of Courttia Newland's psychological realism.

[4] For a detailed discussion of this point see Lennard J. Davis's *Factual Fictions: The Origins of the English Novel* (1983).

novels, even as they engage in intertextual allusion and metafictional play. Their nuanced character development, attention to the formative power of the environment, specificity of description, and inclination towards social satire make them accomplished contemporary heirs to the nineteenth-century novelistic tradition.

The dominance of realist aesthetics in Black urban writing is not only apparent in authorial choices, but also reinforced by the apparatus of critical analysis, book reviews, and literary prizes. While scholars focus on novelistic techniques valued in the tradition of realism, reviewers use the notion of "authenticity" as a marker of authorial achievement. Mentions of "powerful," "raw," and "unrelenting" realism abound in on-line and newspaper reviews of contemporary Black fiction, always applied as terms of praise. Among the recipients of the Saga Prize for fiction, only Judith Bryan's *Bernard and the Cloth Monkey* (the 1997 winner) weaves non-realistic elements such as dreams and legends into the narrative. In contrast, Ike Eze-anyika's *Canteen Culture* (winner in 1998) offers a consistently realist portrait of the London metropolitan police. The novel is praised in the *Barcelona Review* for letting out the "truth … about the treatment of women and minorities" by "the 'laddish' white, male majority" and for not shying away from "the disgusting reality of the Metropolitan Police." Many reviewers are also quick to note that the author himself is a former police officer, introducing another level of "authenticity" into the appraisal of his fiction. Similarly, the 1996 Saga winner, Joanna Traynor's *Sister Josephine*, is described by *Eclectica* reviewer Ann Skea as "a believable account" of a foster child's upbringing and praised for its unflinching descriptions of the nursing profession, while Diran Adebayo's *Some Kind of Black* (the first Saga recipient) is lauded by the *Sunday Express* for telling "some very real, untold stories." It appears that the recognition and applause are consistently based on veracity more than any other aspect of the evaluated narratives.

The emphasis on the authentic can be sometimes taken to uncomfortable extremes. The review of *Canteen Culture* quoted above goes on to admit that "the writing style is at times somewhat amateurish," but finds surprising merit in that very quality: "this in fact adds a sense of authenticity— it reads like an autobiography, thus giving the nasty goings-on an even more believable edge." In a similar vein, Leone Ross's review of Emecheta's *Second Class Citizen* affirms that the author does not need "pretty prose" to achieve her powerful effect. Ross admits that a novel must be considered in terms of its literary merit, but even her very brief discussion of Emecheta's fictional methods focuses on the author's "tangible sense of realism" and "powerful, "unsentimental" storytelling.

The general tendency to emphasise truthfulness over aesthetic/literary merit is particularly visible in discussions of recent novels published by the X-Press—a house specializing in urban narratives of the 1990s marketed for a largely working-class readership. Courttia Newland's *The Scholar* and Victor Headley's *Yardie*, for instance, are frequently admired for their ability to portray the raw and real life of the street, a quality that often becomes their major selling point. Andy Wood points out that both Headley and Newland's novels are often mistaken for authentic pictures of black youth by readers working on the erroneous assumption that black authors draw on their own experience when writing about crime, while white authors draw on research. Wood goes on to ask the question: "Would a journalist or critic ask Irvine Walsh how many tourists he mugged at this year's Edinburgh festival?" (22). Kwame Dawes exposes a similar slant in the publishers' comments on Newland's *Scholar*: "The dialogue is, according to the publishers, 'lifted straight off the street.' The subtext and supra-text is that Newland is being 'real'—that American adjective for honesty, relevance and sincerity, in its benign form, and blatant, raw, and unrelentingly graphic in its more malevolent rendering" (272). Wood's observation is particularly unsettling, pointing to the possibility of a double standard in the perception of white and Black urban British fiction, with the latter delegated to the realm of mere reportage.

If constant emphasis on referential capabilities undervalues fiction's aesthetic dimension, it may also undermine its status as a literary artefact. A notorious example is the fiction of Sam Selvon, repeatedly noted for its skilful reporting—a point of praise that does only limited justice to the author's artistic scope. James Procter observed that "The perceived 'naturalism' of *The Lonely Londoners* has even led to its appropriation *outside* literary discourse." Procter found references to Selvon's fiction "within a range of empiricist accounts and studies (historical, political, sociological) of post-war black Britain," where it has been "called upon as 'evidence' in the substantiation or validation of a black British past" (47). Similarly, Sandra Courtman demonstrated the appropriation of *Black Teacher* by Beryl Gilroy by discourses of education and sociology (51). The 1994's edition's blurb calls Gilroy's novel "essential reading not only for the teaching profession, but also for social workers and educationalists" (53), highlighting, again, the subject rather than method of representation.

What accounts for this preoccupation with mimesis in Black British authors and audiences? One set of answers grows out of postcolonial theory, pointing to the novelists' need, perhaps duty, both to represent the black London experience and to construct positive models of identity for their readers. James Procter, drawing on Isaac Julien's and Kobena Mercer's concept of "delegation," points to the "larger political pressures which required black art to be 'representative' in order to 'correct' dominant stereotypes and to 'inform,

agitate and mobilize political action.'" (9). Andrea Levy is a case in point. In an unpublished interview with Maria Lima, she articulated the connection between her desire to "change the world" and her choice of novelistic form. As Lima explained, Levy "chooses realist conventions because of her faith in the power of representation—because of her belief that if you can represent reality, you can attempt to change it" (Lima 2005: 80). Lima shares this belief with Levy: when faced with student resistance to the "old style realism" of Selvon's fiction, Lima countered with the claim that "Realism is radical because any purposeful attempt to change the world depends on a conviction that it can be realistically represented" (Lima 2004: 54). While the truthfulness of this claim may be questioned (one could argue that Orwell's dystopian fantasies had a greater influence in inspiring twentieth-century anti-totalitarian movements that any works written within the mimetic tradition), Lima's and Levy's positions elucidate the motivation behind the consistent choice of realism in Black British fiction.

Another powerful impulse discernible in Black British fiction is the adoption of old forms to express radically new content and subvert traditional modes developed by the dominant cultural system. John Clement Ball refers to this type of literary manoeuvre as the "enlistment of literature's mimetic and referential properties to postcolonial ends" (11). Such use of realist aesthetics has been noted repeatedly by critics working with Black narratives: Beate Neumier argues that Joan Riley makes use of realist techniques in order to explore the construction of non-white identities in a subversive manner, thus "contradicting those critics who have denounced realism as unsuitable for postcolonial literatures because of the implications of 'writing the master discourse'" (315); Feroza Jussawala points out the usefulness of adopting the traditional form of the bildungsroman for an exploration of the role of Anglocentric education had played in constructing postcolonial identities (99); Victoria Arana examines Courttia Newland's radical use of psychological realism to effect a transformation in the way readers view themselves (Arana 2005: 94-95). In the act of appropriating traditional realist conventions, novelists naturally enter into a dialogic relationship with the colonial culture, questioning and transforming it from within.

Both delegation and the subversion of traditional forms belong to the strategies of postcolonial discourse; representatives of the younger generation may choose realist aesthetics for other reasons, including conformity with reader expectations, lack of interest in formal experimentation, or its outright rejection in favor of more egalitarian models of storytelling. As the paradigm of postcolonial struggle gives way to a paradigm of belonging, however, more young authors show increased interest in aesthetic innovation. A focus on the formal dimensions of narrative has also become apparent in recent critical

studies and cultural conversations. One manifesto of this emerging sensitivity is
Sukhdev Sandhu's introduction to his *London Calling* (2003), a literary history
of three centuries of Black urban writing:

> The role of 'imagination' is central to this book. For too long black literature has
> been considered in extra-literary terms. It is treated primarily as a species of
> journalism, one that furnishes eyewitness accounts of sectors of British society to
> which mainstream newspapers and broadcasters have little access. Given that
> interest in black and Asian people tends to be at its highest when they are
> attackers, rioting, or the subject of official reports documenting prejudice in
> some tranche of daily life, it is hardly surprising if black writing comes to be
> viewed as a kind of emergency literature, one that is tough, angry, 'real'. (xxiii)

Sandhu's study aims to rectify this distorted perspective. In a similar if more
interdisciplinary effort, a recent Symposium at Howard University (out of which
this volume grows) focused exclusively on the aesthetics of Black British
cultural production.

The innovative potential of non-realist narrative modes has been
Several young voices at the 2006 Howard Symposium, most notably
those of Koye Oyedeji and Diran Adebayo, coincided in a call for more radical,
more formally and ontologically adventurous narratives. Adebayo outlined the
possibilities for a new aesthetics by invoking the pleasures of linguistic play, of
rhythm and improvisation, and of stylistic intoxication. He also pointed to the
creative potential lying in what he called African culture's "lighter" traditions—
the figure of the trickster, the art of the fable, and the poetics of playfulness.
Oyedeji, drawing on his analysis of four post-millennial narratives, likewise
indicated the tradition of African spiritualism, as well as those of magical
realism and fantasy, as fruitful sources for aesthetic and theoretical innovation
in contemporary fiction.

The innovative potential of non-realist narrative modes has been
subject of much theoretical attention in the last decades. Christine Brooke-Rose
sees post-war experimental fiction as "a displaced form of the fantastic" (65),
observing that in Anglo-American writing, "turning away from realistic
representation has taken the way of the fantastic, the absurd, the carnivalesque
(Barth, Vonnegut, Barthelme, Brautigan, and others), with corresponding formal
mutations" (338). Gerhard Hoffman proposes an examination of the ways in
which the fantastic tradition continues to suffuse the contemporary novel,
contending that "the history of the fantastic can be seen as a gradual
radicalization of the ways in which the various levels of narration are
'fantasized', the final outcome being the transformation of all basic elements in
the narrative situation," leading to "an alienating yet liberating expression of
discontinuity, relativity, and mere contingency" (282). Thus, in postmodernist
fiction, "the basic function of the fantastic for the first time in history
determines the character of *all* the elements in fiction, or, to be precise, that of

the fictional situation itself" (362-363). Brooke-Rose and Hoffman both see the paradigm of fantasy as a transformative force in postmodernist narrative, allowing for complex departures from realist conventions on multiple levels of the fictional construct.

While Brooke-Rose's and Hoffman's studies focus primarily on the work of white Euro-American writers, Theo D'Haen's analysis of magical realism broadens the discussion to include alternative contemporary novelistic traditions, arguing that the brand of postmodern fantasy described by Hoffman constitutes only one branch of contemporary post-realist development. D'Haen juxtaposes the tradition of the fantastic with the tradition of magic realism, seeing in the former a critique of the Western cultural order from the inside, and in the latter a corresponding critique from the outside. According to D'Haen's analysis, magic realism today invades the cultural "center" from the position of social, economic and political margins: "It is now the preferred mode for all postcolonial writing, including writers not just from former European colonies, but also from ethnic minorities in the United States and elsewhere, and women" (289). Britain's new generation of Black post-realist novelists appears to fit D'Haen's description. There is, however, a significant difference: the writing does not come as a voice from the margins, even though many of its authors are women, and all represent "ethnic minorities." Rather, any critique of the existent cultural order offered comes from the inside, from a position of belonging.

The new brand of Black British narratives also manages to escape another set of challenges faced by traditional magic realist fiction—problems related to its reception on the literary market. One is the accusation that magic realism's primary audience consists of Western intellectuals with an appetite for exotic textual products; another is the expectation that non-Western narratives will serve to renew the lifeblood of Western literary traditions. Kwame Dawes comments on this phenomenon when he describes the popularity of older Black British "internationalist" novelists (including Ben Okri, Caryl Phillips, and Fred D'Aguiar), whose readers "reveal a fascination with certain postmodern or modernist literary styles like magical realism or a pseudo-Rock and Roll nihilism, ensuring that the work is recognized as 'cutting edge' and speaking to the much maligned moribund literary practices of the regional writers of America and England" (262). In the case of young urban British authors writing about the British metropolis for fellow Britons the above concerns lose much of their validity.

Who are the new metropolitan novelists taking the Black London novel where it has not gone before? Unobtrusive ventures into the territory of spirituality and the non-rational can already be seen in texts that otherwise follow the traditional realist formula: dreams are important to Bryan's *Bernard and the Cloth Monkey*, as well as Roy's *Lady Moses*, a novel that emphasizes

the prophetic, cathartic and transformative significance of dream visions; Roy's Jacinta, as well as Evaristo's Lara communicate with ancestor spirits; Roy explores the twin themes of madness and imagination. These themes and motifs, however, do not substantially alter the formal and ontological structure of the novels, even though they go beyond the traditional concerns of realism. A more radical departure from the realist tradition can be seen in works such as Biyi Bandele's *The Street* (1999), Valerie Mason-John's *Borrowed Body* (2005), Diana Evans's *26a* (2005), and Diran Adebayo's *My Once Upon a Time* (2001)[5]—all highly innovative Black metropolitan narratives to appear in the recent decade.

What distinguishes this group of novels is the degree to which they transform traditional formulas of fiction. Fatimah Kelleher contrasts Bandele's *The Street* with London council estate narratives, whose "stark concrete realism" is replaced in Bandele's work by a fluid "urban dreamscape." Dreams and visions are important to Lucinda Roy and Judith Bryan, but they play a fundamental role in Diana Evans's *26a*, which opens with a story of reincarnation, immediately taking the text out of the ontological sphere of realism and pointing towards a broader spiritual and imaginative dimension of the protagonists' twin journeys. A similar function is played in the narrative by the storytelling of Georgia's and Bessi's Nigerian grandfather, who alerts the young girls (and the reader) to the possibility of alternative models for the relationship between physical and spiritual forms. The final, most powerful departure takes place at the end of the novel, when one sister commits suicide and enters the body of the other, breaking down the traditional conventions of characterization, as well as the traditional concept of self. By making reincarnation and spirit possession fundamental structural elements of her text, Evans creates a complex narrative of ontological, psychological, and metaphysical exploration.

Valerie Mason-John is likewise preoccupied with the subject of the body-spirit relationship. Pauline, the main character of *Borrowed Body*, converses with a dead childhood companion (Annabel), becomes possessed by spirits—both mischievous (Sparky) and menacing (Snake)—and discovers the source of her pain in memories of a previous existence. Mason-John's use of reincarnation, magic, and possession drives, rather than complements, the plot; the narrative abandons realist aesthetics and ventures into the realms of allegory and mythology. The result is a novelistic exploration of childhood trauma that maps the inner life of its protagonist with nuance and depth unavailable to more traditional fictional modes.

[5] I am grateful to Koye Oyedeji for pointing me towards Evans and Valerie Mason-John's work.

Another narrative that plays with fictional conventions is Diran Adebayo's *My Once Upon a Time*. In this novel, Adebayo offers the kind of ludic experimentation he called for in his 2006 Howard Symposium lecture. Emily Wroe points out that Adebayo's fiction takes on many of the urban themes explored by his peers, such as Headley in *Yardie* and Newland in *Scholar* or *Society Within*. Instead of grounding his texts in a contemporary ghetto/street mentality, however, the author draws on older spiritual and mythical traditions, including the African trickster-god Eshu Elegbara and the African-American figure of the Signifyin' Monkey (Wroe 24). The characteristics of the trickster not only drive the plot of the novel, but also transform its narrative shape. The text's "trickery," in Wroe's interpretation, includes generic flexibility, intertextuality, dialogic double-voicedness, and didacticism, all posing a challenge to "the so-called superiority of narrative forms from the western world and the kinds of reductive and arbitrary epistemological and ontological myths they create" (25). This thematic and formal playfulness places Adebayo's work firmly in the tradition of postmodernist innovation, especially as practiced by Salman Rushdie, master of trickster-protagonists and carnivalesque narrative structures.

When Rushdie published his *Satanic Verses* in 1988, this radical London novel stood alone on the Black British literary scene. Eighteen years later, the commitment to realist aesthetics among the practitioners and theoreticians of Black fiction is giving way to an increased interest in alterative modes of representation. Critics focus on the aesthetic dimension of narrative production; novelists seek new sources of inspiration in international postmodernism, fantasy, myth, and spirituality. Most importantly, perhaps, young authors of the Black British metropolis combine the world-quest for fictional innovation with an at-home feeling in a city that is rightfully theirs.

Works Cited

Arana, R. Victoria. "Courttia Newland's Psychological Realism and Consequentialist Ethics." *Write Black, Write British: From Post Colonial to Black British Literature*. Kadija Sesay, ed. Hertford, England: Hansib, 2005. 230-240.

Arana, R. Victoria, and Lauri Ramey, eds. *Black British Writing*. New York: Palgrave Macmillan, 2004.

Ball, John Clement. *Imagining London. Postcolonial Fiction and the Transnational Metropolis*. Buffalo: Toronto University Press, 2004.

Bryan, Judith. "The Evolution of Black London." *Black British Writing*. Victoria Arana and Lauri Ramey, eds. New York: Palgrave Macmillan, 2004. 63-71.

Brooke-Rose, Christine. *A Rhetoric of the Unreal*. New York: Cambridge University Press, 1981.

Courtman, Sandra. "A Black British Canon? The Uses of Beryl Gilroy's *Black Teacher* and Its Recovery as Literature." *Wasafiri: The Transnational Journal of International Writing* 36 (Summer 2002): 51-55.

Dawes, Kwame "Negotiating The Ship on the Head: Black British Fiction." *Write Black, Write British: From Post Colonial to Black British Literature*. Kadija Sesay, ed. Hertford, England: Hansib, 2005. 255-81.

D'Haen, Theo. "Postmodernisms: From Fantastic to Magic Realist." *International Postmodernism. Theory and Literary Practice*. Hans Bertens, and Douve Fokkeme, eds. Philadelphia: John Benjamin's Publishing Company, 1997. 283-93.

Getachew, Mahlete-Tsigé. "Marginalia: Black Literature and the Problem of Recognition." *Write Black, Write British: From Post Colonial to Black British Literature*. Kadija Sesay, ed. Hertford, England: Hansib, 2005. 323-45.

Gąsiorek, Andrzej. *Post-War British Fiction. Realism and After*. New York: Edward Arnold, 1995.

Hoffman, Gerhard. "The Fantastic in Fiction: It's 'Reality' Status, its Historical Development ,and its Transformation in Postmodern Narration." *REAL The Yearbook of Research in English and American Literature* 1 (1982). 267-364.

Jussawala, Feroza. "Postcolonial Novels and Theories.*" A Companion to British and Irish Novel 1945-2000*. Brian Shaffer, ed. Malden, MA: Blackwell, 2005. 96-111.

Kelleher, Fatimah "Concrete Vistas and Dreamtime Peoplescapes: the Rise of the Black Urban Novel in 1990s Britain." *Write Black, Write British: From Post Colonial to Black British Literature*. Kadija Sesay. Hertford, England: Hansib, 2005. 241-54.

Lima, Maria Helena. "'Pivoting the Centre': The Fiction of Andrea Levy." *Write Black,Write British: From Post Colonial to Black British Literature*. Kadija Sesay, ed. Hertford, England: Hansib, 2005. 56-85.

—. "The Politics of Teaching Black and British." *Black British Writing*. R. Victoria Arana and Lauri Ramey, eds. New York: Palgrave, 2004. 47-62.

Neumier, Beate "Crossing Boundaries: Joan Riley's No/mad Women." *Engendering Realism and Postmodernism. Contemporary Women Writers in Britain*. Beate Neumier, ed. Postmodern Studies Ser. 32. New York: Rodopi 2001. 306-316.

Oyedeji, Koye. "Prelude to a Brand New Purchase on Black Political Identity: A Reading of Bernadine Evaristo's *Lara* and Diran Adebayo's *Some Kind*

of Black." *Write Black, Write British: From Post Colonial to Black British Literature.* Kadija Sesay, ed. Hertford, England: Hansib, 2005. 347-74.

Procter, James. *Dwelling Places: Postwar Black British Writing.* NY: Palgrave Macmillian, 2003.

Sandhu, Sukhdev. *London Calling. How Black and Asian Writers Imagined a City.* London: Harper Perennial, 2004.

Sesay, Kadija, ed. *Write Black, Write British: From Post Colonial to Black British Literature.* Hertford, England: Hansib, 2005.

Stein, Mark. *Black British Literature. Novels of Transformation.* Columbus: The Ohio State University Press, 2004.

Wood, Andy. "Contemporary Black British urban Fiction: A 'Ghetto Perspective'?" *Wasafiri: The Transnational Journal of International Writing* 36 (Summer 2002): 18-22.

Wroe, Emily. "Towards a 'non-ghettocentric Black Brit Vibe': A Trickster Inspired Approach to Storytelling in Diran Adebayo's My Once Upon a Time." *Write Black, Write British: From Post Colonial to Black British Literature.* Kadija Sesay, ed. Hertford, England: Hansib, 2005. 23-40.

CHAPTER NINE

THE CONTINUOUS DIASPORA: EXPERIMENTAL PRACTICE/S IN CONTEMPORARY BLACK BRITISH POETRY

ANTHONY JOSEPH
POET, U.K.

When I was invited to present the paper from which this chapter evolved, my initial intention was to look at experimental practices in black British poetry, with particular emphasis on what I called the "continuous diaspora": those writers like myself, who had arrived in the U.K. from the Caribbean in the late 1980s and early 1990s, a period during which huge numbers of people were leaving Trinidad, where I was born, and other parts of the Caribbean for Europe and the U.S.A.

The problem was that there are very few black British poets writing today who could be called avant-garde—I mean, poets who are committed to experimental or avant-garde work. And so the focus of my paper turned to finding an explanation for this: Why isn't there a black British avant-garde movement in poetry? And if there is one, why are these poets silent? Why should this be so, when the U.K. has such a rich and complex history of immigration and exile? —when it has a culture that is preoccupied with issues of identity and belonging, some of the very things that precipitate an avant-garde?

And, after all, there are black British avant-garde visual artists. Filmmakers like John Akomfrah and Isaac Julien, painters like Chris Ofili and Frank Bowling, the architect David Adjaye. There are avant-garde theorists or black futurists like Kodwo Eshun, and there are a few fiction writers, too, whose work can be called avant-garde, or experimental.

I began to wonder if, as I had suspected, I had been writing in a vacuum all these years.

Before I continue, let me first define what I mean here by *experimental* or *avant-garde* poetry, as there are many types of experimentation in poetry, and not all of them are European or American. Many techniques arrive via the diaspora, for instance. The magical realism of the Anancy stories and the verbal gymnastics of Trinidadian robber talk, itself derived from Griot traditions, have both been influential. But in discussing 'avant-garde' writing, I am referring to what Professor Lauri Ramey has described quite succinctly in her essay "Diaspora and the Avant-Garde in Black British Poetry" as writing that

> questions the nature and possibility of a non-problematical speaking subject; animates multiple voices in preference to a centralized stable narrator or persona; draws on international influences, transcends boundaries of nationalism and maintains dialogue with artists in other nations and cultures; and frequently uses collage, bricolage, fragmentation and pastiche in order to create palimpsestic or dialogic texts revealing multiple frames of reference and mechanisms of interpretation [1]

—and, I would add, writing that challenges how the text is read by experimenting with syntax or typography. I am also using avant-garde in the original French sense of the phrase, as the advance guard, a movement of artists that pushes against the boundaries of contemporary art, in pursuit of the new, when the old modes have been exhausted. I've always considered avant-garde art to possess this searching quality, exhibiting the characteristics of the avant-garde artist mentioned by the critic Paul Goodman: silence, cunning and exile.[2]

[1] This essay is an expanded version of presentations delivered at two conferences: Diasporic Avant-Gardes: Experimental Poetics and Cultural Displacement (19-20 Nov. 2004, University of California, Irvine) and the Modern Language Association's 2005 Annual Convention (27-30 Dec. 2005, Washington, D.C.). It will be published in a forthcoming book of essays, selected from the UC-Irvine conference, eds. Carrie Noland and Barrett Watten.

[2] The phrase "silence, exile and cunning" and its variant "silence, cunning and exile" derive originally from Part V of James Joyce's *A Portrait of the Artist as a Young Man*, where Stephen Daedalus tells his friend Cranley, "I will not serve that in which I no longer believe whether it call itself home, my fatherland or my church: and I will try to express myself in some mode of life or art as freely as I can and as wholly as I can, using for my defense the only arms I allow myself to use, silence, exile, and cunning" (NY: Penguin, 1976), p.268. The catchy phrase has been used freely ever since and without quotation marks by writers too numerous to list, including Paul Goodman, in his manifesto "The Advance-Guard in Writing, 1900-1950" published in *Kenyon Review* 13 (1951): 357-380; Paul Mann, in his *The Theory-Death of the Avant-Garde* (Bloomington: Indiana UP, 1991), p.118; Greg Tate, in the title of his obituary for Miles Davis "Silence, Exile and Cunning: Miles Davis in Memoriam" (1991); & Libby Rifkin, in "Making It/New: Institutionalizing Postwar Avant-Gardes," *Poetics Today* 21.1 (2000), p. 132.

Still, unless we redefine what experimental or avant-garde means in contemporary black British literature, we must admit that very few such poets are writing today, fewer still are being published, even in recent anthologies of contemporary black literature.

Of course, there are elements of experimentalism in all poetry; that is the nature of poetry. And even within the canon of black British poetry there are elements of experimentation. There are glimpses of bricolage, surrealism, and abstraction in the work of Linton Kwesi Johnson, Jean "Binta" Breeze, E.A. Markham, Grace Nichols, and John Agard. There are the remarkable sound poems of Amryl Johnson, innovation in the performance art of Lemn Sissay and Benjamin Zephaniah. And, for a time, during the 1970s and 1980s, these poets *were* the avant-garde, that is, they represented a new and powerful voice that offered an alternative to the British poetry mainstream. But now they *are* the mainstream.

* * * * *

In order to answer the questions I raised, I had to turn inwards, to my own experience and practice as a so-called avant-garde poet in the U.K.

I was one of those explorers who arrive at Heathrow every day—alone, dressed in my pleated pants and polo neck sweater, shoes shiny, and suitcase heavy with island life, feeling the infamous cold for the first time. When I left Trinidad in 1989, it was a time of economic and political uncertainty, a time of flux and mutability within what the calypsonian David Rudder called "these tiny theatres of conflict and confusion." Immigration to the U.S. was at its highest level. People were sleeping on the pavement outside the U.S. embassy in Port of Spain, to queue for multiple indefinite visas. Those who had managed to leave were sending for their children. I lost a lot of friends this way.

To a Trinidadian brought up in the 1970s, America and England were these great places where life seemed so exciting, so full of promise, where you could "make something of yourself." And that April morning when I arrived at Heathrow, it was the first time I had been on a plane. One morning I was picking mangoes in my grandfather's backyard, the next I was having chicken fricassee on Sloane Street, shivering in my espadrilles. The following year there was an attempted coup in Port of Spain. I watched the smoke unfold from a bed-sit in Kilburn, west London.

I wasn't raised in what you could call an artistic house. I grew up with my grandparents in Mt. Lambert, a suburb about eight miles from Port of Spain. Mt. Lambert was a somewhat middle-class neighbourhood, but my grandparents were every much working-class folks. I had lived with them since I was about a year old, after the break-up of my parents' marriage. They were both creative

people in their own way. My grandmother was a country woman, with an intimate knowledge of herbs; her art was sewing. She made curtains, wedding dresses, shirts, skirts. She had worked as a seamstress in her youth, until she stitched a needle through her thumb. I would sit with her as she pressed the presser foot to hem. I learned to roll thread to knots between my fingers. My grandfather was a carpenter. His art was in bending wood for Baptist Shepard crook sticks, or in sanding cedar beams for fine chairs and commodes. I'd watch as he worked in his shed, as he pushed the plane, rhythmically, or cut delicate dovetail strokes from white pine.

They were both religious people; members of the spiritual Baptist faith, a slightly controversial, syncretic Afro-Caribbean religion, which combined elements of Protestant Christianity with West African religious rituals. Each Sunday we would drive deep into the secret centre of the island to attend four-hour-long services. There'd be clapping and hypnotic singing that eventually became guttural chants. I witnessed spirit possessions, saw spirits cast out in canefield exorcisms; I heard the travellers' tales of mourners who had meditated for fourteen days. The church shook with glossolalia and wrestling of spirit, the repetition of rhythm that led to transcendence. And all these experiences would inhabit my poems.

And then there was carnival: "the greatest show on earth," a festival of excess and rebellious colour, wire and steel. And there was music—music in the air, on the radio, in the lilt of Trinidadian dialect, between the wrist and the rubber of the steelpan, calypso, robber talk, wild indian tassa drum and tamboo bamboo, and the records my grandfather kept under the gramophone: the static hiss of Mighty Sparrow LPs, the orange and black of Impulse labels, the Latin dance bands, the Rufus Thomas 7's.

And in about 1978-1979, I started writing, transcribing songs at first, learning how poetry worked, and then writing my own poems. Because I grew up alone, with my grandparents, I wrote everyday to keep myself company. I filled notebooks and copybook pages with of poems and lyrics, a habit that continued into adulthood.

So, when I arrived in the U.K., I suddenly found that all the books and music I had heard about and hungered for were within reach. England offered me access to whichever route my creative appetite took. I could also place myself within a tradition, in a culture with a rich history of literature. I got a job in a bookshop in London, and I read voraciously—about cubism, surrealism, magical realism, Russian formalism. I read Kamau Brathwaite and discovered a kindred spirit. I read Derek Walcott and learned to respect poetry. I read William Carlos Williams and absorbed his cubist poetics. I read Charles Bukowski and learnt other things.

I realised that the poetry I enjoyed writing, the poems I felt resonated the most were the ones that were abstract or cryptic, the way they seemed to leap off the page. So, this was what I aimed for each time, moments of transcendence, when, as Allen Ginsberg himself says, "Form is what happens." The more I read, the more I found that certain techniques that I used had names: it was automatic writing, it was beat poetry, and it was collage. And all the time, I was incorporating the Trinidadian speech rhythms that formed an essential part of who I was.

I began a search then, for what I called "the core text." In 1994 I published a chapbook which illustrated some of the concepts I was preoccupied with—like dissonance, improvisation, and free verse. Then, over the next five years I became obsessed with the idea of the unconscious and with ways of accessing it. I believed that, as Madan Sarap wrote, "The true speech, the unconscious – breaks through usually in a veiled and incomprehensible form."[3] I was seeking a speed of notation that bypassed artifice; I wanted the poem to compose itself. I followed chains of reference from Walcott to Brathwaite to Ginsberg to William Blake to Kerouac's essential of spontaneous prose bob, to Amiri Baraka, Bob Kaufman; to Charlie Parker, Thelonious Monk, John Coltrane; to Ornette Coleman, André Breton, Ted Joans, Charles Olson; to Henry Dumas....

In surrealism I finally found what I had been searching for, the release of the ego. A way of writing from some internal space. Like a jazz musician reaching for the point where the right notes didn't matter, where what mattered was the purity of intent, the core, the truth. It was almost as if in my dislocation —from home and culture—I was trying to find myself within the text, or at least to record the memory of Trinidad.

* * * * *

But somehow what I was writing wasn't the right kind of black British writing that got you into anthologies or the kind that publishers seemed to want. I was in a peculiar position; having lived most of my life in Trinidad, I was perpetually in exile, so to speak. But being away made me understand home better. And in this way I begun to understand why I wrote the way I did. When I first met Kamau Brathwaite, one of the things he said that resonated with me was that you don't actually become a Caribbean person until you leave the Caribbean. And I was becoming more Trinidadian.

[3] Madan Sarup, *An Introductory Guide to Post-Structuralism and Postmodernism* (London: Harvester Wheatsheaf, 1988), p.9.

Still, I don't think anyone decides to become an avant-garde poet. My feeling is that it is something that happens over time, and evolves. Eventually, you make a choice as to which path you take.

To return to the original question as to why there isn't an identifiable avant-garde in black British poetry: Poetry is still primarily a minority sport in the U.K. It's a hard sell, even for white poets. The chief editor of my publishers (Salt) told me recently that if he sells 200 copies of a poetry title in the U.K. he considers it a bestseller. And how many new black poets have Faber published in the last decade? How many black women poets? Major publishers are publishing black and Asian fiction, but not new black poetry. It seems they're unwilling to publish new black poets because they think the market for black poetry is too small to be profitable; at least this is the theory. And while this may or may not be true, to some extent, I suspect that it's also true that black poets aren't sending out enough manuscripts to these publishers. And black experimental/avant-garde poets like myself are doubly marginalized for not writing the right kind of black British poetry. And yet, ironically, it was my experimentation that brought me to the attention of my publishers.

On the other hand, spoken word performance is thriving. Ten years ago when I started to perform on the circuit, there were only a handful of poetry performance events, very few open mic evenings. Now, almost every night there are spoken-word sessions going on in bars and cafés all over London. And the scene is growing. Perhaps this growth is evidence that the literature of the black diaspora emphasises orality, performance, and call and response. Accordingly, many young poets are also using new technologies to self-publish their chapbooks or CDs.

More and more schools are introducing poetry or slam workshops. There's also a lot of interaction between spoken word and music. And the Arts Council of England supports performance poetry with grants for individuals and funding for organisations. Has the focus gone from the page to the stage? And does this have anything to do with a crisis of representation, as we move into the twenty-first century? Performance poetry might indeed become the new avant-garde. I worry, though, that without books we have nothing that future generations of poets can be inspired by. Perhaps, they will be inspired by digitally recorded performances, taking us back, in a way, to the oral traditions of black literature.

As a black British poet interested in experimentation, where do you look for role models, for inspiration? In Europe the avant-garde seems still to suggest a white Euro-American phenomenon, one that's inaccessible and irrelevant to contemporary black writers. When I sought like-minded black experimentalists, I could find none in Britain. I had to turn to the Caribbean, to Kamau Brathwaite in Barbados, to Wilson Harris in Guyana, to Aimé Césaire

and Édouard Glissant in Martinique, to Leroy Clarke in Trinidad, and, of course, to the United States, but there were none from the U.K., although many had passed through at one time.

Another factor contributing to the lack of a Black British avant-garde in poetry must be the way poetry is taught. So many people I have taught have said how school turned them off poetry. They associated poetry with a type of white middle-class snobbery. Maybe we need to look at how poetry is taught; we need to engage children with challenging literature. The poet laureate Andrew Motion suggested recently that we help children to find out about poetry for themselves. He also suggested that "children who feel poetry is 'not for them' are not expressing a deep truth, but parroting learned behaviour, or responding to their particular circumstances, or showing they never had the chance to feel that poetry even might be for them."[4]

Ten years ago there were only a handful of creative writing courses being offered at degree level. In London, I think, there were just two universities that offered Bachelor of Arts degrees in creative writing. Now, there are at least forty-five universities throughout the U.K. offering both under- and post-graduate degrees in Creative Writing. There are also a number of literature development organisations actively promoting poetry in schools and the wider community. The hope is that if children can be exposed to less formal poetry and more modern or even postmodern poetry, then, when they come to write their own poems, they themselves will experiment.

But I am not a theorist: I am a practitioner, and maybe I have missed some important points. I only hope that, by looking at my own experience and practice, I can inspire others to follow their vision.

[4] Andrew Motion, "Children and Poetry," Children's Poetry Bookshelf. Online at www.childrenspoetrybookshelf.co.uk/Templates/adult/andrew_motion.asp.

CHAPTER TEN

THE RESOUNDING UNDERGROUND: PERFORMANCE POETRY IN THE U.K. TODAY

SAMERA OWUSU TUTU
INDEPENDENT JOURNALIST, U.K.

July 2004 – I'm entering one of the hottest poetry nights in north London and preparing to celebrate the first-year anniversary of Phenzwaan's Verbalized Mindz. The venue: just a pub on a north-London street. You see, like most of these events, you've got to know the password, find the hidden passage. In this case, it's the stairs at the back. They lead to the small function room upstairs, and in seconds you leave the smell of smoke and beer behind and are engulfed in the aroma of incense.

Over the last forty years, London's Black performance poetry scene has been bubbling, just beneath the radar. Though it has developed as a fresh style and mode of poetry, its stability has always been questionable. With its peaks and troughs in popularity, amongst both audience and artist, it is often dismissed as a mere phase in a poet's career. Admittedly, many of today's performance poets are likely to have initially utilised the circuit as a testing ground for their pieces, or seen the open mic events that are a keystone to the scene as a stepping stone into more highly regarded poetry arenas. Those who have remained in performance poetry have helped this scene evolve from what was deemed just a creative phase into something much more tangible.

On a base level, performance poetry is poetry that is performed on a stage and before a live audience. However, when orated poetry is partnered with the various performing arts, a natural synergy takes place. To measure the artistic merit of the outcome on scales predetermined for other poetic genres means that artists of this ilk are likely to be viewed forever as falling short. This scene has gained enough stylistic sophistication over the last four decades, however, to stand alone now as more than just a faction of the poetry world; it is a genre unto itself.

It is important to establish that this is not a chapter about Black poets. The particular collection of artists I speak of in this chapter are predominantly London-based Black poets who specifically perform on what can be loosely termed as a London circuit of events and happenings. I will refer to the circuit and individuals collectively as the "scene" throughout this chapter. The individuals on this scene use a number of different titles to describe themselves, including *poet, spoken word artist, creative,* and *performance poet*; and they call their art a variety of names, ranging from *poetry, oratory,* or *the spoken word*, to *performance poetry*. For the purpose of this book, I refer to the artists on this scene as "performance poet," "performer," or "creative," and the collective as the "performance poetry community" or "collective."

The keys to London's performance poetry community are the message and the poet's ability to express it. The message is the driving force that holds this self-reliant collective together. One of the main undercurrents is free speech; and, as well as regarding autonomy very highly, the scene has an ethos of having a message that belongs to the masses. For this reason, themes tend to be quite socially driven. Sometimes that social focus acknowledges other communities also facing the class battle; other times, themes are more like historical voyages into African heritage and reflections on diasporic social issues. The poetry offers an interpretation of facts and historical happenings; usually it is quite a personal take on current affairs. Tuggs.t.a.r's poem "Olympic Dreams" is a perfect example of this impulse, recounting situations from his youth, whilst incorporating perspectives on issues like Stephen Lawrence's death:

> I get to my marks
> Full of memories of bad marks
> That I scraped way back in class
> When the teacher marked a pass
> In the hope that I'd run fast
> On sports day for the class
> Now I wish Stephan Lawrence
> Had been marked with the same speed
> In his last time of need
> But the police would've marked him
> For using Nandrolene or even speed
> But some of us would rather have been architects...[1]

[1] Tuggs.t.a.r, *The Way of the World*, 2003.

The stage is a low platform about a foot high. Two windows, like eyes, sit behind the stage, staring at the audience – we young, mainly Black twenty-somethings. We're a contingent, perfectly enclosed in our oasis, with only windows to the world. Through them we see London. We see a traffic light on red and a brick wall.

Understanding the importance of their platform, the performance poetry community maintain their own events and independently produce and distribute their own merchandise. Self-reliance is a theme evident in all facets amongst this collective. Central to the ethos of autonomy and freedom of expression, self-reliance affords the performance poet the ability to control, in some respects, the growth and nature of expansion of their scene. However, without the objectivity of institutions and bodies outside of the poetic circle having an impact on the production, promotion, and distribution of the end product, the creative—and indeed the entire scene—can become very insular.

As well as freedom of expression, independence affords performers on the scene control over who is receiving the message and the art; furthermore, the performer has control over how their pieces are received. Art, history, and current affairs are amalgamated to produce a unique mix of education and entertainment, which they refer to as edutainment. This amalgam is disseminated via workshops in schools, youth centres, and even adult and youth prisons. These practises, now seen as conventions, are a by-product of circumstance, born out of the thematic nature of the topics of discourse amongst the performance poets and the Black British community in London that they are serving, as well as their objective of independence in work practises and, of course, their individual need for sustainability.

It is impossible to divorce the aesthetic of this developing genre from its social context. Many genres are born out of circumstance and governed by their environments, and the performance poetry scene is no exception. The cultural situation forms a distinct backdrop and informs the conventions and ideologies of the style, creating another element of variance upon which to slide.

Workshops are very indicative of a thematic community-orientated approach to poetry. Some may view the development of a thematic capacity as adverse to the development of craft and practice, but the two are not mutually exclusive; for, as well as passing on their messages and information, the positive upshot of workshops—and, indeed, of this approach as a whole—is that they encourage reflection, debate, and expression, and so cultivate the scene's pool of perspectives and opinions. Sometimes the viewpoints within the scene are polar, reflecting Black British heterogeneity. Even the term "Black British" is currently a matter of great debate. With nearly six hundred thousand migrants

from across the globe in 2004 alone,[2] London truly is a multicultural melting pot, and the unifying identity of those within it is somewhat ambiguous. With so much cultural diversity, there is a trend towards citizenship as opposed to nationalism, leaving many to find a sense of comfort in being foreign. For the early years, when expatriates were invited to build a new British workforce, Black people were the predominant significant "other" in Britain, and so the term *Black* in some ways (even subconsciously) came to represent any "significant other." Currently, there is a move away from the term *Black* and more towards to the descriptive *African*, since *Black* is now a politically loaded and all-inclusive term. Currently, "black" represents any minority, or "significant other" in Britain. The bi-sexual, gay, and lesbian communities qualify as "black." The title "African" is felt by some to be a more accurate descriptive adjective, one which makes, also, a powerful political statement due to the cultural authority it affords those who choose to be defined by it. There is certainly more than this one school of thought on this topic, though—for example, the view that recognizes the positive power of inclusion and the value of standing united under the banner of "black"—and this diversity of outlook, too, is audible in the poetry. Truly, it is quite a refreshing prospect that such a contextually driven genre provides a stage for so many viewpoints and opinions.

The works of this group are creating a tapestry of experiences and points of view that are a true reflection of the Black British reality in London. In short, it is fair to say that this grass-roots faction of British poetry has created a social barometer for London's Black youth.

> People are mingling, waiting for the acts to start. The official start-time passed an hour ago, but no one's fussed; as long as they get to witness all 30 performances. Eventually, the show begins. Artists perform back to back; the compere replaced with a simple list posted on the walls around the room outlining who was to follow whom. Late artists refer to this list to ensure they haven't missed their spot.

<p style="text-align:center">* * * * *</p>

Writer and director Amani Naphtali offers that "an artistic return to the styles and genres of Afrika's civilisations, matched and fused with the dynamism of contemporary culture, would result in a powerful cultural aesthetic."[3] The styles he wrote of are a fusion of dance, drama, music, the spoken and written word, poetry, song, visual arts and new media; their

[2] *International Migration.* National Statistics (published 15 December 2005).
[3] Amani Naphtali , "Afrikan Holistic Theatre: Towards a Cultural Revolution" in *IC3: The Penguin Book of New Black Writing in Britain.* Courttia Newland & Kadija Sesay, eds. London: Penguin, 2000.

amalgam represents a holistic methodology, which is evident, from a contemporary perspective, in London's Black performance poetry community.

The use of movement and space to represent the poetry is the most common form of performance used to accentuate the spoken word. Sometimes, it is in the form of spatial manipulation, with artists like Phenzwaan often choosing to stand at the back of an audience to deliver their poetry. Such flexibility demonstrates how the customary roles of the various performance styles are broken in order for their use to be coherent with a performer's specific piece and message.

Performance poets like shortMAN and Amen Noir are known for infusing physical theatre into their pieces. Both have animated styles to their performances. Amen Noir's movement follows the current of the words and their meanings—with hand gestures, bold movements of the body, and marked changing of facial expressions. In contrast, while shortMAN follows the current of the rhythm of his poetry and the cadence of the words, his movements are more repetitive and spasmodic. Indeed, shortMAN's use of body language and performance are renowned and act as a distinct trademark: He rocks to the stage. Limps. Repeating his trademark rhythmic sound: dat diggy diggy dat diggy diggy dat dat. Short sharp sounds. His locks shaking with every rock. There's something very spiritual about it. His earthy connectedness is threaded throughout his whole performance, attacking every word. His performance is charged. As he shakes and forces his high-octane words out of his body, the audience is engulfed in the adrenaline. There's poetry in shortMAN's movement alone. In his rhythm. His poetry lives and breathes, with his body adding to the expression intended in his words.

For Lyrical Healer, this expressivity is achieved through her face. She has the ability to express shear pain in the wrinkle of her nose. In the crease of that wrinkle lies an understanding of an experience. She talks of pride, strength, anger, distrust, beauty, London, and vulnerability in her poetry, and her nose wrinkles with every pang of emotion. There's a kinship between the woman and her words expressed through this simple gesture, an affirmation of honesty.

Sometimes the performance comes in the form of stillness. El Crisis, a particularly regal poet, brings a naturalistic element and sense of ancestral connectedness to his performance. He often performs his poetry to a melody and creates beautiful sounds by manipulating his mouth and tongue. The sound is reminiscent of the high-pitched song of the Masai tribe. When El Crisis performs, he stands perfectly still; this combined with his statuesque form evokes subconscious comparisons to a tree, adding to his persona of being connected to nature.

Another performance style that is often paired with poetry is singing. This tends to be most prevalent amongst the female performance poets, though

it is not a characteristic exclusive to this group. FLOetic Lara and Lyrical Healer both opt for a bluesy lilt to their poetry. This scene has its natural pairings when it comes to music genre: soul, blues, and jazz. To expand on this musical note, one frequently finds the use of instruments—including drums and percussion or acoustic guitars—on the performance poetry scene, although these additions tend to be employed more for the sake of general ambience than as specific signifiers in relation to the poetry's words.

It is hard to deny the threads that run through this scene, both aesthetically and contextually. These diverse conventions are what are helping to define this movement stylistically. More than just an indication of "what is expected," the codes and conventions act as a form of animated shorthand, hence aiding the accessibility of the poetry.

In the first half, performances flow from Ebele's "Me and My Lover" to professions of lost love regained by Dondamic. But while all speak from the heart, love is not the only issue raised as the sun goes down.

* * * * *

The performance scene's approach to the dissemination of information through art is comparable to the African oral tradition, where cultural and historical information would be passed on to younger generations through song and poetry by a griot. Some would even liken the more politically orientated poets to the *bjali*. Says OneNess, a poet and Pan-Africanist: "Whilst the griot's purpose was to entertain, the Bjali's words were more geared towards inciting action. I would like to think that we encourage proactivity in finding resolutions to some of the issues facing Africans in the diaspora today."

This arts scene did not just happen spontaneously. The path currently being trodden is not dissimilar to that of the dub poets of the 1970s and 1980s. Mixing socio-political statements with reggae rhythms, poets like Linton Kwesi Johnson, Jean "Binta" Breeze, and Benjamin Zephaniah gave their generation of Black Britons a voice, and they did it on their own terms. Benjamin Zephaniah explains: "There is no expert editor telling you what they think will work, you know how it works immediately, the public tell you. The feedback is automatic and it really is a great feeling to hear hundreds of people chant along with your poem when that poem has never been written down."[4]

The infusion of dialect initially acted as an indicator of unity between the performer and the audience. It facilitated a clear undercurrent of association between the audience and the performer—and, thus, an affinity. The message was for the people, as was the delivery.

[4] Benjamin Zephaniah, "Dub Poetry." Online at www.benjaminzephaniah.com/truth.

Admittedly, not everyone takes a direct or historical route into performance poetry. Some of today's Black performance poets may have been inspired initially in the mid-1990s by the likes of Jonzi D, a British rapper and hip hop artist who offered poetry almost as a hip hop segue. Despite some North American influences into the U.K.'s performance poetry scene, the verbal dimension of the "resounding underground"—as it is incorporated with the performance genres of dance, drama, and dynamic movement—gives this poetry a distinctly local, Black British essence.

It is important to remember that, relatively speaking, Black Britain is still a young nation, with a history spanning only 58 years. This is not to say that there were no Black people in Britain prior to 1948; on the contrary, the docking of the *Empire Windrush* saw not an introduction of Black people, but instead an introduction of a conceptual notion: Black British as an identity. The identity was an amalgam of a post-imperial mentality and the group's response to social exclusion. An identity of any sort is a subjective notion. A person's affiliation with a group helps to create an arbitrary framework against which to live—a guideline or predetermined perspective—as well as a sense of belonging and understanding of one's self, a context for life. With the majority of Black British people currently being first-, second-, third-, or fourth-generation, many of the somewhat mutable elements of the Black British identity—concepts of beauty, achievement, self-acceptance—are still in play and part of today's social discourse, as are the effects of the group's recent history.

Many of today's poets probably slept through the Brixton riots of 1981 and 1985, which were sparked respectively by the Metropolitan Police's racially insensitive initiatives and the accidental shooting, by police, of Mrs. Cherry Groce. The poets I have been mentioning were young children at the time of the Broadwater Farm riot of 1985, too—only a week after the second Brixton riot, a riot provoked by the death of Cynthia Jarrett. Some may even have seen the news footage of the New Cross fire of 1981, which killed thirteen young Black people attending a birthday party. Most have probably danced in the streets of West London during Notting Hill Carnivals, the first of which was put together as a response to the week-long Notting Hill Riot of 1958—just a decade after the freighter *Windrush* had docked. That one, the most violent racial clash Britain has ever seen, saw large gangs of white males roaming the streets of West London and attacking vulnerable Black people. With police, local political leaders, and curfews failing to protect Black citizens, they resolved to protect themselves. Black people from different parts of London, primarily Brixton, went to Notting Hill in droves to support the Black West-London residents, patrolling the streets in large numbers to show solidarity. Events and responses like these have done much to mould the identity, mentality, and culture of Black Britain. They also spawned issues hot on the lips of Black Britain's poets of

yesteryear. Linton Kwesi Johnson's poem "Sonny's Lettah"[5] is a perfect
example, documenting the injustice of the "Sus Law," the informal name for the
stop and search law that permitted police officers to arrest Black youths on
suspicion alone. Today, we are still fashioning that identity, and those events are
still relevant and poignant.

* * * * *

Darwood graces the stage, his hat casting a shadow over his face, all bar his
mouth. He gives us wise words on the state of society and the position of Black
people within it. According to Darwood, "we can't elevate, someone keeps
pissing in the lift." FLOetic Lara follows with some Gospel and tears. After a
declaration from Nolan Weekes, about there being more performers in the
audience than your average Joes, we have a welcome recess, where we let what
we've learnt simmer in our conversations.

The most appropriate way to approach this scene is holistically,
because peripheral elements are integral in its establishment and evolution. The
location, promoters, and audience are all essential elements and need to be
acknowledged.

One such organisation is Afropick Productions, which launched in
1999. Its trademark performance-led event, Soul Food—which also happens to
be one of this performance poetry scene's longest-running events—had its most
successful term in the Tabernacle, a church in the heart of West London that
was converted into a community space. The main seating areas were in front of
the stage and to the sides, where the choir would have been seated. Though
quite large, the venue was not imposing, but its religious sub-context added to
the substance and significance of the events held there, with all the connotations
of church being pinned to each performer: the preaching, the revelation, the
reverence, the importance.

Often this scene's events are held in the heart of London locations that
have a lot of social relevance to the Black British community. Brixton—steeped
in modern history for Black Londoners—houses many notable performance
poetry events, including V.O.I.C.Express, an open-mic event founded by
shortMAN. The event has previously been held at Lounge Bar, Dogstar, and
JAMM—under the name V.O.I.C.E. All are small venues, not really designed
for performance purposes. Dogstar and JAMM are primarily pubs, and Lounge
is a bar. The two pubs have small makeshift stages and a few leather couches.
Lounge Bar was more intimate. The small venue with its warm orange walls
was always full to capacity (probably no more than 80 of the 100 people

[5] Linton Kwesi Johnson. "Sonny's Lettah." *Forces of Victory*. Island Records, 1979.

attending). On summer days, the overflow has to stand outside of the packed bar and enjoy the show through the open windows to the right of the performance area. Like many venues used on this scene, it did not have a stage. This adds to the already very intimate relationship between the audience and the performer. With no physical difference in height, the psychological barriers are, to a degree, also diminished.

This closeness seems to affect the scene in various ways. First of all, being on the same level creates a feeling of equality. There is a heightened sense of community. The performers are not untouchable; instead, the audience is led to believe that they are very approachable. Also, with the closeness, there is a sense of being spoken to directly. For regular attendees, it is easy, soon, to feel as if the performer is a friend. This accessibility can prove a burden, with performers having to be "on" all the time. They are always performing in the eyes of their audience and have to be seen to be living the positive and idealistic words and messages they have recited, as the audience members sometimes find it hard to distinguish between the person/poet and the onstage persona of the performer. Being "on" is a task that proves easier for some than for others.

The same-level stage coupled with the community-orientated nature of performance poetry can also lead to a grey area between audience and performer. This particular scene celebrates the expression of opinion and the portrayal of viewpoint. All perspectives are valid. Facilitated by the scene's inclusive nature, there is clear passage for an audience member to graduate to performer. However, while the message expressed is celebrated, along with the courage to express it publicly, there is little to no vetting of poetic ability. The imbalance between message and craft caused by an influx of new audience-to-stage performers has, potentially, a rippling affect through the entire scene. For some, this bias towards message is damaging for the art form. For others, the ends justify the means, as they view the message as core—and not the means of communicating it. This notion raises the question of whether performance poetry is being used merely as a communication tool for various agendas. For others still, the audience-to-stage graduation is seen as a necessary process that ushers in the next generation of poets and encourages the evolution of the genre.

Mr.Gee opens the second half, offering a depiction of triumph over our inner demon, self esteem. Straight after, Oneness offers revolution. The smell of sweat mixes with the incense as people flap flyers for other performance poetry nights to keep cool. Only a few sit in the coveted leather sofas and wooden chairs, the rest of us stand. Phenzwaan delivers his message with a controlled urgency, which is mirrored in the performances of shortMAN, Redhead, Tuggs.t.a.r., and Mosaique, to name but a few of the givers of the second half. I offer my ears and attention; the near pin-drop silence of the audience confirms I'm not alone.

As I said earlier, message is key for this group, and so accessibility of that message is a priority. Like dub poetry, which ignores the official regional language in favour of Creole to give a more representative voice, distinctions in style are emerging on the performance poetry scene as an organic by-product of these measures. Currently, poets are using a London vernacular, where the region-specific intonations inform the cadence of the poetry. There are some that spike their poetry with the flavours of youth street-music, orating at a high-octane pace, and borrowing the rhythms of the rave MCs.

Due to the nature of this scene, the content of the messages within the poetry is often misconstrued, leading to misconceptions about these messages. It is not just talk of being Black; it involves expressions of a reality, which more often than not is impacted by Blackness. Sometimes it is gender that is the strongest aspect of the piece; on other occasions, it is age. In shortMAN's poem "Beautifully Hectic," he addresses the reality of life as an independent creative individual. His words, punctuated with gasps of air, create an impulsive rocking in the audience members.

As well as the message, there is the meaning. Performance poets are essentially poets—only that using performance poetry as an outlet gives them added control over the interpretation of their poetry. In some ways, the scene bears similarities to the Conceptual Art movement, where artistic practise and execution are perfunctory, the reasoning being that the core factor is the freedom to display a concept any way that suits the artist. In the performance poetry genre, words are not used just to paint pictures; their sounds and meanings are used to evoke reactions. In fact, the poet plays to this response. Performance poetry is a responsive art form, reliant on the combination of setting and ambience, rendering every piece a singular, if evanescent, artefact. The performance is so *ad hoc* that poets are often self-defined in an idiosyncratic way (like shortMAN by his rocking and convulsing to his trademark skatting). It is clear to see that the message and its meaning to a specific audience are important and used by the performers to guide their creativity, but performance poetry as a genre is actually established within the delivery itself of that message.

Many would dismiss the performance poetry scene as just a commercial leg, dumbed down for mass appeal. Those partaking would likely disagree since they suffer the same financial fate as the performers who follow the lure of the underground and its particular market niche. Non-validation via sales and other commercial endeavours is almost intrinsic—and cultivated to a certain degree—on the performance poetry scene. The ethos of free speech and of disseminating a message that belongs to the masses throws up a flawed paradigm for many of the poets who enter London's performance poetry scene

with professional aspirations. A paradoxical situation prevails there, where the worth of the work produced is appreciated, but not any for-profit value.

Some might be tempted to compare London's Black performance poetry scene to the early hip hop scene of New York and, thus, view its development as an exercise in hindsight. This would be a dangerous assumption, as it is their similarities that, paradoxically, make them mutually exclusive. Both movements were born out of the urban avant-garde and a desire to express and communicate collective realities. To try to plot London's rather socially specific Black performance poetry scene against the path of a group of a different demographic—with a different collective history and different social elements affecting its approach to art and the creation of meaning—is to obfuscate both the development and the promise of London's Black performance poetry scene, not to mention any understanding of it.

Currently, the challenge for these performers is to make the art tangible, for the good of the scene's sustainability. Performers have attempted to solidify their product, through the creation of books and poetry CDs. However, the effectiveness of these methods is questionable. Audio gives only a partial representation of the performance and, arguably, could be perceived as omitting much of the dynamics and generic definition created by movement. The written word is completely bereft of the performance dynamic: the senses of hearing and, to a large degree, of sight are not stimulated in the same way as they are by the performance. The reader has to infer how the poet might perform the piece—or has to have seen the poet perform the piece before. In the case of the latter, the words act as mere reminders, jogging memories of past experiences. Either way, knowledge of the performer and the experience of his or her performance are prerequisite, rendering events memorialized in the books and CDs fully accessible only by an audience already attuned and attained. Also, as neither of these art forms fully captures the manipulative essence of the specific performance, the intrinsic element of artistic control is also lost.

In saying this, I am not detracting from the merit of these new expressions. With a dynamic performance poet like shortMAN, you do not necessarily just listen to the words; sometimes, they are more of a footnote, pulling you through the dramatic/poetic expression of his physical movements. Just seeing or just hearing his words alone would give them a whole new dimension, but that gain would be at the expense of the essence of his performance.

Some poets have endeavoured to capture this performance essence in a more tangible form by channelling it through other performance-based art forms and modes of expression, and they have created some interesting explorations. One such excursion has been into production. By using group choreography and drama, Tuggs.t.a.r., Amen Noir, and OneNess—three of the performance

circuit's most politically charged poets—have infused life into their performances and created a thread that tied them and their views together, first during their triple album launch in 2004, and then as the Best Kept Secret collective, which also comprises ShakaRa. Dance and drama allow the stories and themes in their poetry to be elaborated. Also, they have the freedom to create characters to give their words an even deeper context, as in a skit where the differences and similarities between continental-African and Caribbean migration are explored to coincide with Tuggs.t.a.r's poem "Generation Change."[6]

Earlier I briefly touched on the natural pairing of music and performance poetry and the added expression found in instruments and rhythm. Darwood, a former member of the prolific collective 3+1 (which also comprised Nolan Weekes, Carl Ramsey, and Floetry's Natalie Stewart), utilises the audio and visual aspects of popular music to supplement his poetry. He uses the conventional music video models of the new British Grime music scene to depict his poetry. Darwood's rhythmic approach and gritty content have strong parallels to Grime music. This definitely aids in the expansion of Darwood's following in that he will likely attract members of a young generation currently on the cusp of their own music revolution.

Other disciplines have been explored, from design to dance, and even audio-visual media. Beyonder, known for his love of AV and anime, used the art of film to depict the images and meanings behind his words. This approach is very similar to that of Best Kept Secret and their use of production, but the capabilities of film afford Beyonder more breadth in depiction, allowing him to be either more literal or more surreal, where necessary, in order to be truer to his intended meaning. He can also fully develop characters. This method proves extremely expressive and, of course, with it being in an AV (audio-visual) format, very accessible.

For all the various modes of expansion, performance poetry has in some way been used as a generative nucleus. For some, one element of the genre is the springboard into their new venture. For others, the expansion of their art represents more of an evolution of their creative imagination. Of course, there is the question as to whether or not these explorations fall into the remit of performance poetry. Regardless of the answer to the question, this debate marks the birth of a consciousness of performance poetry as a genre in its own right.

The event ends and all pour onto the street, carrying with them an air of resonance. Some of the content was far from celebratory; with talk of deaths in

[6] Listen, for instance, to http://www.ricenpeas.com/docs/the%20griot.html.

police custody, conspiracy theories, and the labyrinth that is 'road' for young Black males. But this was a celebration; it was a celebration of expression.

* * * * *

When performance poetry is fully recognised as a legitimate poetic genre and an understanding of it as an artistic medium has been cultivated, the potential for expansion and development in this sector will be substantial. This neoteric approach to poetry and performance provides a service by aesthetically documenting a historical moment in the lives of Britons today.

You see, London's Black performance poets are telling the stories of London's Black community. Not just the historical dates and events—they are recalling emotions. They talk of their perspectives and express them through a medium that permits them to share their personal pain, pride, and guilt in an array of performance styles. Resounding underground, they recount the story, past and present, of a very young nation, Black Britain.

CHAPTER ELEVEN

"PRETTY IS THE NEW BLACK": NEW DIRECTIONS IN BLACK BRITISH AESTHETICS

DIRAN ADEBAYO
NOVELIST, U.K.

I do not claim for the following the rigour and full measure of the academic paper. This is more in the way of some remarks, really, about the types of black-British literature that are out or have been out there, from a current, someway ideological, practitioner. I guess it's something of a plea for a change in emphasis, a reorientation of energies, in what we "black-British" writers produce. A plea for more lightness really, more styles and more style. More, you could say, prettiness.

Before I continue, I should declare my interest. I think you can divide the literary world, very broadly, between story- or narrative-centred work (such as you find most obviously in commercial fiction) and voice-driven work, and I'm definitely one of and for the latter. I grew up on narrative-driven work—the Sherlock Holmes stories, Greek myths, the births, marriages and deaths novels of classic European literature; but the first thing I read that I really wanted to *write,* the first book I fell in love with, was J.D. Salinger's *The Catcher in the Rye*—just for the voice of its teenage hero, Holden Caulfield: conversational, particular, unimpressed by authority, societal or literary. Its opening, you remember, explicitly rejects the births, marriages, and deaths—what you might call the Dickens approach: "If you really want to hear about it, the first thing you'll probably want to hear is where I was born, and what my lousy childhood was like, and how my parents were occupied and all before they had me, and all that David Copperfield kind of crap...."

At the time I was also feeling P.G. Wodehouse, and here, too, you had the sense that his rather identikit plots weren't the main point of the books; rather, they were the necessary vehicle for his local, verbal pleasurings, his ludic love: "I could see that, if not exactly disgruntled, he was far from being gruntled...." Later, Samuel Beckett, Hunter S. Thompson, Donald Barthelme,

the essays of James Baldwin, and then, still later—as I ventured beyond the black familiar—Greg Tate's early 1990s' *Village Voice* columns.

All of these writers were doing things with words and cadence. They were all stylists, and style is what I think makes you fall in love.

It's the same, often, in real world love. We meet quite a few people with relatively similarly content, but we tend to fall for few. It'll be something about the way they hold their head when they smile, or their particular way of apprehending the world; the things that make you you.

Rhythm, vibe, is what seduces: the patterning, attitude towards words; these are what charges a character, a universe. I think the great worldwide impact of reggae in the 1970s wasn't primarily about the lyrics of Bob Marley et al., but that lulling Nyabinghi bass-drum sound, rumoured to echo the human heartbeat.

The sadness for a lot of black literature, though, is that we have mainly been remarked upon and desired for our content. Ever since the eighteenth-century days of Olaudah Equiano, whose depictions of the slave experience helped fuel the abolitionist movement in Britain, or the nineteenth-century days of Frederick Douglass in America, you could argue that black writing has been prized chiefly for its ability to bring information about lives beyond the experience of your average book buyer.

You could place the novels of Richard Wright, the gritty social realism of early hip-hop—Grandmaster Flash's *The Message*, etc., inside this camp. As *Granta* magazine said, tellingly, in its introduction to its pick of Young British Novelists 2003, about a friend of mine, Monica Ali, and her first novel, the London-Bangladeshi-set *Brick Lane*: we so liked this (I paraphrase) because it brought us "news." This does beg the question, "News to whom?" I don't think they meant news to Bengalis.

This "news to others"—information for those who don't know—has had a distorting effect, I believe, on black work down the years, from the Harlem Renaissance onwards, and is one aspect of this possibly un-winnable, multi-focal game that minority writers often find themselves ensnared in, that I call the "Black Catch 22."

It has also contributed to a certain heaviness in the black novel—or, at least, to most of the black novels that are held up as being "important." One thinks of the frequency of the "slave" or the "racism" narratives, or of the fact that Ralph Ellison or Richard Wright seem more prized than the lady who, for me, wrote the most exquisite novel of that whole period, Zora Neale Hurston, and her non-slave, non-racial *Their Eyes Were Watching God*; or that the headline-friendly black *vs.* white dramas of Spike Lee (*Do the Right Thing*, *Jungle Fever*) attracted so much more attention than the wonderfully subtle

studies of modern African-American interiority made by that master Charles Burnett.

Onyekachi Wambu picks up on this legacy of heaviness in his introduction to his black-British anthology *Empire Windrush* when he quotes two American critics writing in the 1960s. David Littlejohn had become discouraged wading through the African-American catalogue for his study, *Black and White*: "A white reader is saddened, then burdened, then numbed by the deadly sameness, the bleak wooden round of ugly emotions and ugly situations: the same, small, frustrated dreams, the same issues and charges and formulas and events repeated over and over, in book after book...one is finally bored by the iteration of hopelessness...." And African-American Blyden Jackson can only concur: "It seems to me that few, if any, literary universes are as impoverished as the universe of black fiction. [Of greatest interest] are the things that cannot be found there."

Writing in the late 1990s, Wambu did not find the black-British universe quite as bleak as that, and this was before the often comic voice, for example, of Zadie Smith emerged. Nevertheless, looking more widely at the British cultural scene—to judge, say, from a bunch of mainstream black feature and documentary films that have recently aired in the U.K., including *Bullet Boy*, *Shoot the Messenger*, *The Trouble with Black Men*—we remain in a heavy place, where black life is seen as problematic, or pathological. Simultaneously (and somewhat-related), within the literary world I detect an ongoing desire in certain quarters to revivify the big, psychological, realistic, nineteenth-century European novel tradition in post-colonial hands: the seemingly safe hands of a V.S. Naipaul or a Monica Ali.

I'm not saying this heaviness comes just from the tastes of white critics or commissioners; we have our own agents of gravity. Many of us, in the West, in Africa, do lead heavy lives and writers, unsurprisingly, wish to bear witness to them. Moreover, the drive to "represent" is particularly strong in minority cultures. Most of the black Western public, in truth, aren't about, aren't really concerned with, the *art* in their art; they're more about being "represented." And the pressure to "represent" tends to be a conservative-leaning force, both politically and stylistically.

One could, of course, say much more in this connection, I think, about African artworks in the British Museum and about how, in ancient African societies, the artist was often the figure that gave voice to the community on its big days—for its religious ceremonies, and so forth. (Many of us do indeed collect artefacts for their "representational aspects," there is no doubt.)

It's funny because, even if what helped to draw me into black writing was some of its obvious relevance and "representational" power—Langston

Hughes's short story collection *The Ways of White Folk* produced my first adult tears as a reader—what made me stay was language.

Hughes's jazz-inflected poetry, Greg Tate, music, black-British slang—all greatly increased the registers of English I had at my command, the same impulse that took me to Wodehouse. I liked how they inverted standard phrases. Not "We haven't met in ages," but its patois equivalent: "Is how long an' we don't catch up?"—or Roberta Flack's "The first time ever I saw your face...."

There was linguistic experimentation even at the beginning of black-British literature. Ignatius Sancho was an ally, both on the page and off it, of Lawrence Sterne, and more recently, in the diaspora, Sam Selvon, Amos Tutuola, Ayi Kwei Armah, Dambudzo Marechera, Linton Kwesi Johnson, Jean "Binta" Breeze, Nate McKee, and so on. Beyond them, in other fields, cinematographer Arthur Jafa, or the formally exciting British work of Sankofa and the Black Audio Film Collective in the 1980s. We can root "black" in other, non-race centred things: black as improvisation, as we found in jazz; black as rhythm, as we find in much music; black as vexing the Queen's English. Black, too, as the quintessential post-modern position—double consciousnesses, less or multiply-rooted identities, that should give rise naturally to daring, "post-modern" work: genre-riffs or New World "takes" on old-country notions, more playful, speculative fiction, perhaps, or musical, rhythmic, *pretty* work.

I can think of another aspect of the pieces in the British Museum's African collections. The sculptures there are not properly figurative, but symmetrical, geometric—the external quality pinpointed by the European Cubists who bit off them. But their carvers were attempting to give outward expression to a feeling or aspiration: the divine potential in human beings. The idea is that, once one has attained a certain level of overstanding, there will be an inner calm, a composure that they sought to express through these graceful shapes. It harks back to notions of cool—*Itutu*—in old Yoruba societies. Writers have that same feeling when they've nailed a passage, an insight. It manifests itself in a certain fluency, an ease on the page. Everything just so, in its place. As Keats wrote, "Beauty is truth, truth beauty."

As black artists, we have the reputation of innovators in other fields. If we can bring that to the page, bring more of the attitudes and energies we find elsewhere, we can alter, not just revivify, the vibe of the British poem, the British novel. And then there'll be no end to our audience, black and other.

UNIT III

EMBODIED AESTHETICS

CHAPTER TWELVE

THE AESTHETIC TURN IN "BLACK" LITERARY
STUDIES: ZADIE SMITH'S *ON BEAUTY* AND THE
CASE FOR AN INTERCULTURAL NARRATOLOGY

ROY SOMMER
WUPPERTAL UNIVERSITY, GERMANY

Introduction

Diasporic, multicultural, and cosmopolitan writing has produced some of the
most memorable (and bestselling) novels in recent years and continues to make
a vital contribution to contemporary fiction on both sides of the Atlantic. The
transition of "black" British literature from a fringe phenomenon to big business
has already begun, with all its consequences, both negative and positive,
depending on one's point of view. The days in which British bookshops
separated the A-Z sections of novelists from the "special interest" section
containing "black and Asian fiction" are over. Instead, Zadie Smith's most
recent novel *On Beauty* (2005) is now on sale both at Woolworth's and the
stores of supermarket chain Tesco's, alongside Andy McNab's war stories and
Jamie Oliver's latest cookbook.

This does not mean, of course, that all is well in "Happy Multicultural
Land," the frequently cited utopian vision ironically referred to by Smith's
omniscient narrator in *White Teeth* (398). As a result of the concentration on a
small canon of bestselling novels, it is becoming increasingly difficult to find
classics such as Buchi Emecheta's *Second Class Citizen* (1979) or Joan Riley's
The Unbelonging (1985), or even the more recent and well received works by
Diran Adebayo and Courttia Newland among the streamlined "buy-two-get-one-
free" selection on offer in high street book shops. Despite the huge success of a
few authors and their works, the majority of writers have only very limited
access to (and benefit from) what is now a global business. The current
popularity of "black" writing, both postcolonial and diasporic, within what has

been termed the "otherness machine,"[1] means that as much emphasis is put on marketability as on literary quality. The other side of the coin is the lack of media response criticized by Leone Ross in an interview with Kirk Henry; a reality which effectively excludes many, especially unknown authors, from critical recognition: "It seems to me that in Britain in particular, it is a matter of one nigger at a time. [...] These people [i.e., Diran Adebayo and Zadie Smith] are doing good work and should be recognized, but it appears to many of us that only one black author is recognized at a time, which is irritating and frustrating."[2]

In this situation, it is the responsibility of academic book reviewers and literary scholars to pay critical attention to "black" and Asian writing and to integrate it into the canon of contemporary British literature. There can be no doubt that initiatives such as the Saga Prize set up by Marsha Hunt or dedicated anthologies (cf. O. Wambu, 1998, or C. Newland/K. Sesay, 2000) have created an effective platform for "black" writing, paving the way for the current success of multicultural British fiction. It is, however, equally important that "black" writing be recognized as an innovative force in contemporary British literature as a whole. A recent collection of essays edited by Richard J. Lane, Rod Mengham, and Philip Tew (2003) offers examples of how this can be achieved: the works of Salman Rushdie and Caryl Phillips are—not very surprisingly— discussed in the section on cultural hybridity, which, however, also contains "white" Scottish authors (James Kelman and Irvine Welsh), while Zadie Smith and Hanif Kureishi are grouped with Will Self under the heading "Urban Thematics." Here, as in Stein's (2004) study of contemporary novels of transformation, "black" or multicultural fiction is no longer added as an afterthought or as an exotic footnote to the literary mainstream, but discussed as an integral part of British literary history.

By putting aesthetics on the "black" agenda, the Howard symposium from which this collection emerged may have started a new debate which will help bridge the gap between identity politics and literary theory. This endeavour

[1] Cf. Wachinger (2003: 104): "Otherness may be a profitable business for writers who know how successfully to negotiate their condition of postcoloniality. [...] On the other hand, it would be too easy to say that self-consciously marginal, or culturally different, writers only capitalise on their alterity, cashing in on exoticist predilections. Their strategic use of 'ethnicity', even their perfect mastery of what is wanted on the western market, does not mean that they are *selling out*. Rather, their full consciousness of the commercial apparatus in which they fuel the 'Otherness machine' leads to highly ambivalent patterns of complicity in and manipulation of the market forces that produce them."

2 The complete text of the interview can be found on Ross's website, at http://members.tripod.com/leoneross/leone.htm (no pagination).

takes into account the growing unease with categories and labels such as
"postcolonial" or "black" British among both writers and critics. Mahlete-Tsige
Getachew's claim that "traditional conceptions of Black literature are only
justifiable from a political rather than aesthetic point of view" (323) encourages
a fundamental rethinking of established critical positions: How "black" is
"black" British literature? What is the status of ethnicity in "black" literary
studies? If we move away from essentialist notions of "black" literature towards
aesthetic approaches to "black" literature *as literature*, we need to re-align the
parameters of our value judgements: we might be interested in perceived
truthfulness instead of street-credibility through authentic portrayals, in
representations of consciousness rather than photo-realistic descriptions of
"black" looks, clothes, and gestures, and in story-world participants or mental
models based on character-related textual data, rather than mimetic textual
"copies" of "real" people.

This essay favours such an approach, which tries to initiate a dialogue
between two separate, yet highly compatible, critical traditions: narrative theory
and the politics of representation. The following section presents this argument
in more detail and establishes a narratological framework for the description and
analysis of Zadie Smith's novel *On Beauty* in this essay's third part. Following
the classical narratological story-discourse distinction, my reading of *On Beauty*
is interested both in aesthetics as a dominant theme on the story level and in the
aesthetic function of narrative communication. My claim is that the narrative
communication between the narrator and narratee invites the construction of an
implied reader who is not racially defined but points towards an international,
cosmopolitan audience. This aspect will be further pursued in the final section
of this essay, which makes the case for an intercultural narratology with a focus
on the interactive aesthetics of contemporary "black" literature and the
possibilities of hermeneutical exchange and understanding across cultural and
ethnic boundaries.

The Aesthetic Turn in "Black" Literary Studies

Traditionally, critical approaches to "black" British literature have
either emphasized aspects of content, such as the treatment of racism and
cultural stereotypes, or have highlighted questions of ideology and identity:
"black" British writing is frequently theorized as part either of the larger
postcolonial movement of "writing back" to the former colonizers or of the
ongoing collective effort to create a distinctive "black" British identity. This
focus on the cultural functions of "black" British novels tends to neglect their
formal innovations, aesthetic achievements, and narrative structures (e.g.,
framing devices, multiple perspectives, characterization, plot structures, meta-

narrative and meta-fictional elements, narrative unreliability or irony). As a result, the strand of critical writing on "black" literature and identity which insists on linking race with fictional representation is beginning to sound rather repetitive.

A compelling analysis of the problematic nature of labels such as "black" writing or "black" literature has been put forward by Getachew (2005), who sums up the main arguments for and against political, biographical, and thematic definitions of "black" fiction. Getachew argues convincingly that neither black authorship (novels written by black authors) nor black readership (novels written for a black audience) provides distinctive features which suffice to define a black literature. The wide-spread notion of black content (novels in which black characters serve as representatives of and/or role models for the black community) is seen as equally problematic: "In focussing on controlling representation of the Black community though the portrayal of some fictional characters, Black literature does not challenge the idea that the Black community can be represented by some fictional characters" (Getachew 329). Finally, black experience as a main literary concern is disregarded as a common denominator for black fiction, due to its own hegemonic dynamics: "For the sake of unity, a plenitude of stories is replaced by just one narrative—the narrative of 'the' Black Experience; and this single narrative, with its focus on race, is used to characterize Black Britons" (332).

As the author's and reader's ethnic background as well as thematics and representational function have to be excluded from the list of potential categories for defining "black" British literature, Getachew concludes that "[t]he challenge Black writers face is to develop a mode of expression, a new language, which [...] makes Black literature a distinctive and aesthetically valuable enterprise" (339). This programmatic proposal of a new aesthetics, "a distinctive Black language with which one could produce Black literature" (342), is aimed at raising the profile of "black" British literature by encouraging black writers to engage with linguistic innovation—to create a literary language which is as distinctive as the artificial Nadzat employed by Anthony Burgess in *A Clockwork Orange* or James Joyce's linguistic experiments in *Ulysses* and *Finnegan's Wake*, and, preferably, as commercially and culturally successful as urban music, especially hip hop.

The relevance of linguistic criteria for a discussion of the postcolonial aesthetics has been discussed by Marion Gymnich, and her findings are largely valid for diasporic or cosmopolitan "black" writing. Gymnich (69ff.) distinguishes six prototypical scenarios: (1) the heterodiegetic narrator uses Standard English, while one or more characters use a language other than English; (2) the heterodiegetic narrator uses Standard English, while one or more characters use a non-standard language; (3) the heterodiegetic narrator and

one or more characters use a non-standard language; (4) the homodiegetic narrator uses Standard English; one or more characters use a language other than English; (5) the homodiegetic narrator uses Standard English; one or more characters use a non-standard language; or (6) the homodiegetic narrator and one or more of the characters use a non-standard language. Most of these scenarios also apply to linguistically innovative urban fiction, from Sam Selvon to Courttia Newland.[3]

To equate the new aesthetics with linguistic innovation, as proposed by Getachew, however, raises a number of questions. Firstly, original works of art have rarely served as a linguistic template for contemporaries but remained singular achievements admired by generations of readers: neither Nadzat nor Joyce's literary techniques have established a distinctive English or Irish language with which one could produce exclusively English or Irish literature. Secondly, the unique voices are already among us. Getachew herself refers to Salman Rushdie and Arundhati Roy, but writers such as Ben Okri, Caryl Phillips and Zadie Smith, to name but a few, might easily be added to this list. They speak in a variety of tongues, not with one unified voice: after all, multicultural narrative and monolingualism are mutually exclusive concepts. Thirdly, and most importantly, aesthetics is as much a way of reading as it is a way of writing: beauty is in the eye of the beholder. From a cognitive point of view, it is the specific interaction between textual signs and readers' expectations that renders reading fiction an aesthetic experience.

For these reasons, the aesthetic turn in "black" literary studies needs to be based on a broad understanding of both language and narrative which, in keeping with current linguistic and narratological approaches to narrative, treats narrative telling and reception as communicative processes, a text as their product, and a story-world as that text's referential ground (cf. Herman 278). Moreover, the new aesthetics is not so much about new writing as about new criticism (pun intended): instead of waiting for a new "black" *Ulysses* to emerge from the suburbs of London, critics genuinely interested in the rich body of fiction inadequately labelled "black" literature merely need to open their analytical toolboxes, apply the frameworks and criteria they habitually apply to other writing, and produce new readings of works of art that have often been unnecessarily and unfairly reduced to faithful representations of social realities, anti-racist manifestos, or seemingly authentic examples of ethnic self-fashioning.

This focus on aesthetics and narrative form does not imply, however, that the politics of "black" writing should be ignored altogether. As long as

[3] On the use and functions of language in 'black' British literature cf. Reichl 2002, esp. chapter 4 on "Microcosms of Heteroglossia" (75-111).

mechanisms of cultural marginalisation and race-related social selectivity are at work, as long as "IC3, the police identity code for Black, is the only collective term that relates to our situation here as residents," as Courttia Newland argues in the introduction to *New Black Writing in Britain* (Newland/Sesay x), we need to address the politics of marketing, the politics of labelling, and the politics of reading. After all, professional "beholders," i.e., publishers, book reviewers, and literary critics, still explicitly or implicitly uphold the distinction between "black" and Asian writing and "general" fiction, discussing the former mainly in terms of identity politics, and reserving aesthetics for the latter. Against this background, talking about form *is* a political statement.

Of course, theoretical frameworks and languages tend to develop their own momentum as well as their own specific blind spots, a concern rightly voiced by Lady Lola Young in her preface to Sesay's 2005 collection.[4] So, how can one talk about "black" literature from an aesthetic point of view without ignoring its political implications? By talking about it in the same language one uses to talk about other literature, e.g., the narratological terminology introduced below, yet without losing sight of the specific concerns of diasporic or cosmopolitan writing. Despite its structuralist heritage and traditional preference for (some might say, obsession with) systematic models, technical vocabulary, and typological distinctions, narratology—the study of the nature, forms and functions of narrative—is not exclusively concerned with identifying, naming, and describing specific structures of narration and focalization in literary texts. Both the emergence of a variety of so-called "post-classical" narratologies since the 1990s, especially feminist narratology and postcolonial narratology, and the frequent use of the preposition "towards" in many recent attempts to move beyond the structuralist concern with textual hierarchies bear witness to the ongoing re-invention of narratology.[5]

What the new context-oriented approaches share with text-centred, "classical" narratology is the grounding in the well-established communication model of fictional texts which separates text-external entities (the real author and his/her readers) from textual constructs such as the implied author, the

[4] Cf. Lola Young: "The drive to engage in different kinds of literary criticism has a momentum that will ensure that we continue to document and disseminate, to analyse critically and rigorously black styles, texts and representations in history and in contemporary society. I hope though, that we will not become totally enthralled by fixed critical terms and frameworks but that we are always sensitive to ongoing debates and alternative modes of articulating the politics of black cultural production" (in Sesay, 2005: 13).

[5] On the shift from "classical" to "postclassical" narratology and the move "towards" new narratological horizons, see Nünning (2000 and 2005) and Rimmon-Kenan (2002 [1983]: 141ff.).

narrator, and the narratee. Like all current narratological approaches, they
further distinguish between the narrative levels of discourse and story, i.e.,
between the narrating instance (*how* is the story transmitted?),[6] and the world of
the characters (*what* is told?), and the related opposition of narration and
focalization theorized by Genette (1988 [1983]). Genette's model proceeds from
two heuristic questions: "who speaks" (narrator) and "who perceives?"
(focalizer). There are three distinct types of focalization: zero focalization (a
wholly unrestricted point of view, such as that of the omniscient narrator in
authorial narratives), external focalization (a presentation which is restricted to
reporting what is visible from outside), and internal focalization (the literary
equivalent of the cinematic "point of view" shot). The latter may be
differentiated into three sub-types, i.e., fixed focalization (one single focal
character), variable focalization (two or more alternating focal characters), and
multiple focalization (the same event is seen through the eyes of several focal
characters).

These categories, together with corresponding models of
characterization, speech representation, description, strategies of framing and
embedding, temporal and spatial structure, and perspective structures, to name
but the most important aspects, form the common ground shared by most
current approaches to narrative. With regard to the general focus of narrative
research, however, text-centred narratology and context-oriented approaches
such as Nünning's cultural and historical narratology[7] follow different
trajectories. Inspired by ethnographic concepts such as Clifford Geertz's notion
of thick description, Stephen Greenblatt's New Historicism, and the overall
cultural turn in literary studies, the new narratologies emerging since the 1990s
have been concerned with the cultural functions, ethical dimensions, and
epistemological implications of literary texts, as well as with cognitive research
into the naturalisation or interpretation of fictional representations in the reading
process. The original structuralist concern with universal features of narrative
and the poetics of fiction has been abandoned in favour of the interaction of text

[6] This crucial question can be approached in different ways, depending on which of the
two major competing (yet compatible) models one prefers, the distinction between three
archetypal narrative situations (first person narrative situation, authorial narrative
situation, and figural narrative situation) proposed by Stanzel in 1979, or Genette's
opposition of narration *vs.* focalization.
[7] Cf. Nünning (2000): "Drawing upon the tools of narrative theory and new insights and
research strategies developed in cultural history, such an approach can arguably shed
light on both the history of narrative forms and the changing functions that narrative
strategies have fulfilled. It is the task of such a project to contextualize literary fictions by
situating them within the broader spectrum of discourses that constitute a given culture"
(357).

and context and the semantics of literary forms, while the main goal of theorizing narrative is seen in providing an analytical toolbox and evaluative paradigm to facilitate interpretation.

Despite the numerous student-oriented introductions promising to make narratology more accessible,[8] the typical reaction of students who first encounter narratological categories is healthy scepticism: certainly Zadie Smith didn't know about the intricacies of story-discourse distinctions and focalization, when she wrote *On Beauty*? Probably not. After all, critical language belongs to the theory and interpretation of, not to the production of fiction. Narratology proceeds from the assumption that narrative is an important cultural mode of coming to terms with the world, a mode of perceiving and explaining, of transforming lived experience into stories, thus making it accessible to a community. It also provides well-defined terms and concepts which help to describe and evaluate literary strategies as well as a relational network between narrative phenomena. On the other hand, narratology's precise descriptions allow not only for a critical evaluation of recurrent narrative features (character constellations, plots, endings, narrative situations, etc.) but also for the close analysis of (aesthetically, ideologically, or historically) motivated deviations from such established norms to whom the status of generic conventions is frequently ascribed: "Exceptions can only be discerned against the background of the rule, and narratology formulates some of the regularities which specific narratives gloriously defy" (Rimmon-Kenan 145).

The linguistic complexity of postcolonial writing, an umbrella term which, in most theories, includes "black" literature, has already elicited narratological and semiotic responses (see Gymnich 2002, Reichl 2002, Prince 2005). A closely related aspect is the question of narrative address. According to the sender-receiver-model on which communication-oriented narratologies are based, narratorial discourse may also construct the position of a narratee, i.e., the narrator's counterpart to whom the story is told—in theory. In practice, only few authorial narratives establish a narratee as visible as Victor, to whom the monster's tale is addressed, in Mary Shelley's *Frankenstein*. Nevertheless, "black" British novels frequently employ both linguistic and narrative strategies which imply the presence of a reader or intended audience. As I will argue in the last section of this chapter, these projected readers need not share the same social or ethnic background as the characters in the story. Zadie Smith's novel *On Beauty* is a prime example.

[8] For a general introduction to narratology, I recommend Genette (1988 [1983]) and Rimmon-Kenan (2002 [1983]) as well as Herman/Jahn/Ryan (2005), while the articles in Phelan (2005) and Kindt/Müller (2005) offer an overview over recent developments and current debates.

Zadie Smith's *On Beauty*: Aesthetics as a Theme and the Aesthetics of Fictional Communication

The complex plot of Smith's latest novel introduces readers to two families who represent different values and beliefs. The chaotic Belseys encounter the seemingly intact family of the self-righteous, religious Trinidadian professor Monty Kipps, a successful conservative critic who disturbs Howard Belsey's intellectual peace at Wellington, a New England university. Howard is white and British and repeatedly cheats on his African-American wife Kiki, big and beautiful, who finally prefers painful separation from her life's love to continued self-denial. Meanwhile, their three Americanized kids have to struggle through all the illusions, delusions, and obstacles which Smith, a true expert in sympathetic (and, from an external perspective, wildly funny) portrayals of the sad experience of growing up, throws at them: readers are introduced to a hip hop activist with a lack of street credibility (Levi), an untalented poet (Zora), and a rejected lover (Jerome).

The title, borrowed from a poem by Nick Laird, hints at aesthetics as one of the novel's dominant themes. Yet, far from celebrating the sublime, Smith's novel engages with the politics of beauty. Discourses on beauty are implicitly or explicitly based on notions of who or what is beautiful, and the novel's characters demonstrate that such decisions are influenced by one's social, educational, and ethnic background, as well as physical attraction: "'It's true that men—they respond to beauty…'", Howard admits (207). Thus, *On Beauty* might be described as a novel which stages conflicts between mutually exclusive concepts of beauty: the seductive body *vs.* the beautiful face, or individual love of a painting *vs.* academic aestheticism. These conflicts result in numerous misunderstandings and in disappointments and loss—loss of faith, confidence, and security; yet they also open up new possibilities. At the end of the novel, Kiki, who had devoted her life to Howard, giving up her friends and living in a "sea of white" (206), leaves her husband to regain her independence.

The interdependence of beauty and power defines Howard's academic attitude towards aesthetics: "Howard asked his students to imagine prettiness as the mask that power wears. To recast Aesthetics as a rarefied language of exclusion" (155). Ironically, Howard is later shown to be completely insensitive to the implications of his own definition, as he allows the language of exclusion to dominate his own class on seventeenth-century art, effectively silencing his student Katie. In an extended authorial characterization, she is described as someone who "loves the arts" (249), yet is "unsure," "naturally shy," and terrified by the incomprehensible, theoretical discourse preferred by Howard Belsey. Through authorial descriptions and comments, aspects that will be looked at below, readers witness how Katie prepares for this course, working

hard on her own subjective interpretations of two pictures by Rembrandt. She identifies with a "mishappen woman, naked, with tubby little breasts and a hugely distended belly" (251) and fails to realize, of course, that empathy and biographical readings are not what is required in this highly theoretical discourse. Thus, when beauty is discussed in class, she is unable to argue against her privileged fellow students, "a young man Kate fears more than anybody else in this whole university" (253) and Monty Kipps's beautiful daughter Victoria, "whom Katie, who is not easily given to hatred, hates" (253).

One could go on examining the ways in which links between art and social status are explicitly invoked, as high culture is seen to dominate popular culture. Carl, the gifted but self-conscious spoken word poet, longs for the recognition associated with being part of the academic community at Wellington. Significantly, when he is finally admitted to the university (though not as a student), after Erskine has created the post of a hip hop archivist at the Black Studies library, the poet-turned-librarian loses his interest in and talent for lyrical rap: street culture has been appropriated by the academic institution. Also, the political implications of the capitalist art market are openly discussed in this fictional world. Monty boasts of having "the largest collection of Haitian art in private hands outside of that unfortunate country" (113), a collection which, from Levi's point of view, has been stolen from the people of Haiti and must be returned by all means.

A reading interested in the aesthetics and poetics of black British literature, however, should move beyond such thematic issues and explore the narrative strategies employed, which, after all, are the difference between non-fictional writing and a novel's staging of its dominant themes and conflicts. As in *White Teeth*, the overall effect of Smith's writing—which has been characterized as ironic, funny and lively, and compared to Victorian storytelling, especially the novels by Charles Dickens—strongly depends on the narrative situation and the specific characteristics of the fictional communication. Narratological analysis is particularly suited to describe and explore such effects as it focuses on the kind of narrative situation and the functions of the narrator as well as on the relationships between narration and focalization, or telling and showing. It also investigates the construction of a narratee and his or her relationship with the narrator, an aspect that will be explored in detail below.

The novel's first sentence—"One may as well begin with Jerome's e-mails to his father" (3)—firmly establishes the presence of an authorial narrator. The cognitive effect of this authorial introduction is that the initial sequence of emails does not appear as a random collage but as the result of a deliberate process of selection and combination which happens on a different diegetic level from that of the characters inhabiting the story world. The narrator reappears at the beginning of the third chapter, with a lengthy descriptive sequence that is a

typical example of the way in which Smith makes use of the forms and
functions of authorial telling. First, the narrator introduces the reader to the
Belsey family home, describing the architecture and history of the building.
Both, the sudden switch to present tense (the preceding dialogue scene in the
second chapter is conventionally rendered in past tense) and a series of
comments which cannot be ascribed to any of the characters reveal the presence
of an authorial narrative instance: "Indeed much of the house is now a little
shabby—but this is part of its grandeur. There is nothing nouveau riche about it.
The house is ennobled by the work it has done for this family" (17). Authorial
narrative also marks the transition (visually indicated by the insertion of an
empty line) from telling to showing, as this present tense description of the
Belsey home gives way to figural narration, and authorial comment turns into
focalization: "Now Howard paused on the middle landing to use the phone"
(19).

Establishing the temporal and spatial structure of the narrative and
switching between extradiegetic comment and intradiegetic dialogue are among
the traditional functions of authorial narrators. In the scene quoted above, the
narrator moves from descriptions of the past of the Belsey home, which was
inherited by Kiki's grandmother, to the "now" of the fictional action. Similarly,
an authorial account of the historical events that led to the naming of the Keller
library at Wellington serves to connect past and present: "It is in this chilly
room that all faculty meetings for the Humanities are conducted. Today is
January tenth. The first faculty meeting of the year is due to begin in five
minutes" (319).

The omniscient nature of the authorial narrator is established early in
the novel, when chronology is abandoned in favour of a flashback at the
beginning of chapter five: "*We must now jump* nine months forward, and back
across the Atlantic Ocean" (42, my italics). This *we* reveals the presence of a
narratee, to whom—in narratological models of fictional communication—the
narrator's comments are addressed. Narratorial functions also include summing
up and interpreting characters' behavior: "The swearing policy in the Belsey
household was not self-evident. They had nothing as twee or pointless as a
swear jar (a popular household item among Wellington families), and swearing
was, *as we have seen*, generally accepted in most situations" (87, my italics).

Whereas the first person pronoun merely indicates the existence of an
extradiegetic level of communication, the artificial nature of fictional narrative
is explicitly addressed in an authorial comment on the first meeting between
Levi and the group of Haitian rappers: "'Hey, you want hip-hop? Hip-hop? We
got your hip-hop here,' said one of the guys, like an actor breaking the
suspended disbelief of the fourth wall" (194). This ironic reference to the
conventions of realistic drama also points at the range of possible effects of

storytelling, from realistic illusion (the dominant mode in "black" British writing since the days of Sam Selvon) to deliberate metanarrative and metafictional games, as in the fiction of Martin Amis and other contemporary writers influenced by postmodern aesthetics. Smith's novel occupies the middle ground between realism and experiment. Authorial narration is employed here to organize the temporal flow of the narrative and to link the various subplots, settings, and characters. This careful balance between showing and telling, extradiegetic authorial comment and intradiegetic dialogue or irony and empathy, first featured in *White Teeth*, has since become a hallmark of Smith's writing. The oscillation between opposite models of fictional communication in the novel, authorial and figural narrative, allows for a coherent narrative flow which is never (too) predictable.

This observation takes us back to the initial discussion of fictional aesthetics, as the analysis of the narrative situation in *On Beauty* highlights the difference between authorial narration in the twenty-first century and its "classical" models from Fielding to Eliot. Smith's narrative instance, other than the explicit authorial narrators in eighteenth- or nineteenth-century novels, remains largely invisible. Neither the narrating instance nor its narratee, implicitly constructed by the first-person pronouns *we*, *us*, and *our* (as in the examples given above), appear to be anthropomorphic entities, i.e., the reader has no sufficient textual information to conceive of them as characters in their own right. Despite the absence of an anthropomorphic narrator imposing his or her own views on the "gentle readers," however, some sort of extradiegetic communication is implied by the occasional use of the unobtrusive first-person pronoun. Yet who is the implied reader, the addressee constructed by the narrative as a whole? Who is "we"?

Cosmopolitan Reader-Constructs and Intercultural Understanding

Obviously, the pronoun *we* establishes some sort of link between the narrator who comments on the fictional world and the reader who—consciously or not—projects his or her own experiences and expectations onto the text, thus supplementing the actual textual information with his or her own mental models of characters, places, and so on. Due to the mental activity of the reader, which includes the triggering of existing frames and schemata, a minimal amount of textual information is usually sufficient to evoke complex images. These mental images are, of course, largely dependent on a reader's individual dispositions. Thus, one's own ethnic background or gender may have a strong influence on the mental image one creates of a literary character—whether he or she is thought of as male or female, black or white depends on the clarity or ambiguity

of linguistic markers. In the latter case, our reader-constructs tend to mirror our own background.

Cognitive narratology distinguishes between different types of reader-constructs, i.e., generalized assumptions by theorists regarding the potential reading effects inferred from an analysis of textual features.[9] The most popular reader-construct is the notion of the implied reader proposed by Wolfgang Iser as an integral part of his reader-response theory. In contrast, the intended reader or "authorial audience" refers to the kind of reader or readership an author has in mind when he or she writes a text. As a hypothetical construct which may or may not coincide with the actual reader(s) of the text, it is not to be confused with the publisher's target audience. Finally, postulated readers such as Stanley Fish's "informed reader" or Umberto Eco's "model reader" are working fictions used by narratologists in order to indicate the kind of interpretive community that an interpretation assumes. Discussing unreliable narration, for instance, requires some sort of standard of reliability against which the narrator's norms and values can be measured, and this standard is an assumed "average" reader reasonably familiar with literary conventions and cultural discourses.

Let's turn to characterisation for a moment, as this is a good example of the interplay of text and readers, in practice. The information about "black" characters in "black" novels includes a wide range of linguistic markers of ethnicity (cf. Gymnich 2002, Reichl 2002).[10] In addition to their language, portrayals of "black" characters regularly refer to specific gestures, such as touching knuckles or knocking fists,[11] references to skin colour, hair styles, fashion, and food, as well as to descriptions of culturally specific behavior (for instance, the relationship between parents and children). Semiotically speaking, the information conveyed by such characterizations contributes to a coding of characters as "black" within an overall "black" aesthetics.

The degree of cultural difference or familiarity (depending on whether one is part of the "encoded" group or not) increases with the frequency of specific references to a character's ethnicity. The possible effects of

[9] I recommend the articles on "audience," "character," "implied reader," "reader constructs," and "narratee" in Herman/Jahn/Ryan (2005).

[10] In Courttia Newland's novel *The Scholar* (1997) there is a scene in which this process of linguistic 'othering' is explicitly shown: "A small white youth played football with an empty tango can [...] 'Raas man, where you lot goin' wid dem big bags deh?' he said, peering up at them inquisitively. Levi ruffled the boy's head as he passed and laughed, with the teenagers joining in, amused by the white boy's attempt at chatting 'yard talk'" (240).

[11] The exclusive nature of culturally coded gestures is obvious in the scene when Levi welcomes his white colleague Tom in *On Beauty*: "'Yo, my man Tom – how's it hanging,' said Levi and tried to knock fists with Tom, always a mistake" (185).

characterisation techniques range from the exclusion of all but the intended readers in the real audience (this may be achieved through incomprehensible allusions, the use of non-standard language without added explanations or references that are only accessible for a small group of readers) to the deliberately broad appeal of novels which make it as easy as possible for a wide audience to understand what's going on. *On Beauty* belongs, as I would like to argue, to the latter group: the fictional communication between the narrator and "us" implies a readership which is not a homogenous audience but a rather heterogenous group of cosmopolitan readers interested not merely in transatlantic "black" experience but also in the intricacies of mixed-race relationships, generational conflicts, and intercultural misunderstandings. In short, the implied reader in *On Beauty* points towards the kind of international, potentially large audience a novel should be able to reach in reality, if it aims at becoming a bestseller.

 This impression (which is, of course, my own, individual reader-construct and needs to be supported by textual evidence) derives from the kind and amount of textual information on the story-world offered by the novel. Firstly, the novel uses a wide range of focalizers (with whom readers tend to sympathize), bridging the gaps between generations (e.g., Zora and Kiki), between different social backgrounds (Carl and Levi), and between races (Howard and Kiki). Secondly, the novel offers a wealth of textual clues which assist its various groups of intended readers in the process of constructing mental models. Thus, readers are introduced to Levi's hip hop universe via an extended, ironic authorial characterisation: "[...] Levi treasured the urban the same way previous generations worshipped the *pastoral*; if he could have written an *ode* he would have. But he had no ability in that area [....] He had learned to leave it to the *fast-talking guys* in his earphones, the *present-day American poets*, the rappers" (79, my italics). This characterisation is obviously not intended for Levi's peer group, but for those readers who are not familiar with contemporary youth culture, contextualising Levi's behaviour by linking it to a literary tradition (pastoral, ode), comparing rappers with poets, and even explaining the meaning of the word *rapper* ("fast-talking guys").

 The third textual strategy that contributes to the wide appeal of the novel to a heterogeneous audience is the frequent reference to social and linguistic barriers. When, for example, Claire's poetry group visits the Bus Stop, the students, who don't speak French, are unable to comprehend the political message by the Haitian rappers: "The language barrier had an interesting effect. The ten boys were clearly eager that their audience understand what was being said; they jumped and whooped and leaned into the crowd, and the crowd could not help but respond, although most understood nothing bar the beat" (228). Even Claire, who has the linguistic competence, is unable to get the point:

"Claire struggled to simultaneously translate for her class. She soon gave it up under the weight of too many unfamiliar terms" (228). The problem of incomprehensibility reappears a little later, in a clearly ironic characterisation: "Levi shrugged. 'It's true. He don't do no wilding out, he got no crunk, no hyphy, no East Coast vibe to test what be happening on the West Coast,' he said, thus happily rendering himself incomprehensible both to his siblings and 99.9 per cent of the world's population" (238).

These descriptions and characterisations amount to a meta-narrative commentary on the possibility of intercultural understanding—across generational, ethnic, social, and linguistic barriers. Crossing the ethnic and social divide is a dominant theme in Smith's novel, for instance, when Howard wonders whether he can't be "street," eliciting sharp protest from the rest of his family: "'I can be a brother. Check it out', said Howard, and proceeded to make a series of excruciating hand gestures and poses. Kiki squealed and covered her eyes" (63). Levi's rather futile endeavours to make friends among the Haitian rappers, however, also show that the street credibility usually associated with hip hop cannot be acquired, but is an essential quality that comes with the personal experience of growing up in less fortunate circumstances: it is a social or educational, rather than ethnic, gap that will always separate Levi from LaShonda, Bailey, or Choo.

Conclusion

In this essay, I have tried to demonstrate how narratology can be put to use in an analysis of the formal properties and aesthetic qualities of "black" novels. The essay also serves to demonstrate that the novels' strengths lie not merely in their "black" themes or in their contribution to the political struggle for recognition, but, first and foremost, in their achievements as fictional works of art. Andy Wood sums it up nicely in an article in *Wasafiri*: "These novels [by Headley, Adebayo, and Newland] are important novels, not only for what they say but for the way in which they say it" (22). Shifting critical attention to this issue of "how" a novel is made is what the aesthetic turn in "black" literary studies proposed here is all about.

One may as well end with a few remarks on opportunities for further research in this field. In her comments on the ubiquity of the preposition *towards* in current narratological publications, Shlomith Rimmon-Kenan remembers how the move beyond structuralist thinking transformed, in her own work, the relationship between literature and theory: "It was also an attempt to theorize *through* literature, to use novels as, in some sense, the source of theory" (143). Multicultural British fiction invites us to rethink certain neglected aspects—such as the construction of implied readers and readerships—through

what Reichl has termed "ethnic semiosis" (the cultural conditioning of mental models in the reading process) and, finally, to examine the cross-over of aesthetics between different genres and media inasmuch as music, TV, and film continue to influence the literary production (and vice versa). This is an invitation intercultural narratology will be happy to accept.

Works Cited

Genette, Gérard. *Narrative Discourse Revisited.* [transl. Jane E. Levin] New York: Cornell UP, 1988 [1983].

Getachew, Mahlete-Tsige. "Marginalia: Black Literature and the Problem of Recognition." In Sesay (2005), 323-345.

Gymnich, Marion. "Linguistics and Narratology: The Relevance of Linguistic Criteria to Postcolonial Narratology." In *Literature and Linguistics. Approaches, Models, and Applications.* Gymnich, Marion; Nünning, Ansgar; Nünning, Vera, editors. Trier: WVT, 2002. 61-76.

Herman, David. "Linguistic Approaches to Narrative." In Herman/Jahn/Ryan. (2005), 278ff.

Herman, David; Jahn, Manfred; Ryan, Marie-Laure, editors. *Routledge Encyclopedia of Narrative Theory.* London/New York: Routledge, 2005.

Kindt, Tom; Müller, Hans-Harald, editors. *What is Narratology? Questions and Answers Regarding the Status of a Theory.* (Narratologia 1) Berlin/New York: De Gruyter, 2005.

Lane, Richard J.; Mengham, Rod; and Philip Tew, editors. *Contemporary British Fiction.* Cambridge: Polity Press, 2003.

Newland, Courttia; Sesay, Kadija, editors. *IC3: The Penguin Book of New Black Writing in Britain.* London: Hamish Hamilton, 2000.

Nünning, Ansgar. "Towards a Cultural and Historical Narratology: A Survey of Diachronic Approaches, Concepts, and Research Projects." In *Anglistentag 1999 Mainz. Proceedings of the Conference of the German Association of University Teachers of English: Volume XXI.* Trier: WVT, 2000. 345-373.

—. "Narratology or Narratologies? Taking Stock of Recent Developments, Critique and Modest Proposals for Future Usages of the Term." In Kindt/Müller (2005). 239-275.

Phelan, James, editor. *A Companion to Narrative Theory.* Malven: Blackwell, 2005.

Prince, Gerald. "On a Postcolonial Narratology." In Phelan (2005). 372-381.

Reichl, Susanne. *Cultures in the Contact Zone. Ethnic Semiosis in Black British Literature.* Trier: WVT, 2002.

Rimmon-Kenan, Shlomith. *Narrative Fiction.* London, New York: Routledge, 2002 [1983].

Sesay, Kadija, editor. *Write Black, Write British. From Post Colonial to Black British Literature.* Hertford: Hansib, 2005.

Smith, Zadie. *White Teeth.* London: Hamish Hamilton, 2000.

—. *On Beauty.* London: Hamish Hamilton, 2005.

Sommer, Roy. *Fictions of Migration: Ein Beitrag zur Theorie und Gattungstypologie des zeitgenössischen interkulturellen Romans in Großbritannien.* Trier: WVT, 2001.

Stein, Mark. *Black British Literature: Novels of Transformation.* Columbus: Ohio State UP, 2004.

Wachinger, Tobias A. *Posing In-Between. Postcolonial Englishness and the Commodification of Hybridity.* Frankfurt a.M./Oxford: Lang, 2003.

Wambu, Onyekachi, editor. *Empire Windrush. Fifty Years of Writing About Black Britain.* London: Phoenix, 1998.

Wood, Andy. "Contemporary Black British Urban Fiction: A 'Ghetto Perspective'?" In *Wasafiri* (1998) 36: 18-22.

CHAPTER THIRTEEN

THE TWENTIETH-CENTURY DANDY AS CULTURAL PROVOCATEUR: YINKA SHONIBARE, MBE, AND THE *DIARY OF A VICTORIAN DANDY*

COURTNEY J. MARTIN
YALE UNIVERSITY

In October of 1998, a curious poster appeared throughout London's underground train stations, known popularly as the tube (Fig. 1). Large in scale (2m x 3m), the poster was placed alongside commercial advertisements and public announcements, like tube maps and safety bulletins. The image on the poster was a cinematically rendered period setting—a library of leather-bound volumes, panelled walls and a heraldic portrait on the rear wall. It displayed high colour, rich tones and textures, and a depth of details. The scene depicted a standing man, surrounded by other men in exaggerated physical animations: one clapped, another's head reared back in gleeful laughter, and another appeared to raise his arms, as if being surprised beyond physical restraint. In contrast to them, the central figure's stilled body was angled toward to the door, which was propped open by female servants rapt in the act of peeking in on the interior. Though he is physically within the borders of the image, his staid posture gestured to his psychic removal from the scene. He was in it, but not entirely of it. His gaze was neither in the room, nor toward the door. It was steadily focused on a point outside of the scene, but not toward the camera. The public audience of commuters who encountered the poster were not directly addressed, though their attention was certainly attracted.

Of course, the poster's most striking feature was the race of the central figure, a role filled by its artist, British Nigerian Yinka Shonibare, MBE.[1] Commissioned and produced by the Institute of International Visual Arts (inIVA) in London as a public art project for the Underground system, the poster was one image from Shonibare's five-part series *Diary of a Victorian*

[1] MBE is the acronym for the honorific, Member of the British Empire.

Dandy.[2] The poster's image was of a scene set in the afternoon—and would be accompanied in exhibitions by other photographs that depicted segments in the day of an unnamed Victorian dandy. Shonibare posed as the dandy for each of the photographs. Loosely modeled on the exploits of the young heir Tom Rakewell, from William Hogarth's painted and engraved series *Rake's Progress* from the mid-1730s, Shonibare's series substituted himself as this rakish, newly appointed man about town. The subsequent photographs chronicle his day: he succumbs to his bed to be attended to by fawning staff (Fig. 2); he gambles with friends in the late afternoon (Fig. 3); then attends a formal dinner with musical accompaniment (Fig. 4); and, to complete the day's activities, he falls into an orgy (Fig. 5).[3] In an interview about the *Diary* series, Shonibare explained why he updated Hogarth's eighteenth-century imagery to respond to the nineteenth century:

> But I always include an element of the unexpected. For example, I am well-known for my use of Victoriana, right? And for an artist of African background to be known for using Victoriana is a complete contradiction. I'm producing something that looks totally other, but it's actually a mimicking or a "kitschivization" of the establishment....[4]

Of course, Shonibare is not the only contemporary British artist to draw out the kitsch of the Hogarth series. In 1986, Lubaina Himid created a satirical set of cut-outs, titled *A Fashionable Marriage*, that placed Hogarth in a post-colonial context. David Hockney, the eclectic pop artist, produced engravings and illustrated an opera devoted to Hogarth's Rakewell, turning him into a counter-cultural youth caught up in consumerism and social upheaval.[5]

[2] The poster is a slightly altered version of the photograph, *14.00 hours* (Fig. 1).

[3] Initiated in 1733, Hogarth's series of paintings and engravings *A Rake's Progress* was undertaken as satire and to impart morality. Unlike, Shonibare's dandy, Hogarth's Tom Rakewell ends his spending spree as a fallen man jailed for his debts and, by implication, for his lapse(s) in judgment. See, also, David Dabydeen, *Hogarth, Walpole, and Commercial Britain* (London: Hansib Publications, 1987); Mark Hallett, "Manly Satire: William Hogarth's A Rake's Progress" in *The Other Hogarth: The Aesthetics of Difference,* Bernadette Fort and Angela Rosenthal, eds. (Princeton University Press, 2001); and Robin Simon and Christopher Woodward, *A Rake's Progress: From Hogarth to Hockney* (London: Apollo Magazine Ltd., 1997).

[4] Okwui Enwezor, "Of Hedonism, Masquerade, Carnivalesque, and Power" in *Looking Both Ways: Art of the Contemporary African Diaspora,* Laurie Ann Farrell, ed. (New York: Museum for African Art, 2003), p. 165.

[5] See the exhibition catalogue, *David Hockney: A Rake's Progress and Other Etchings, 3 to 24 December 1963* (London: Editions Alecto, 1963) or Paul Griffiths, *Igor Stravinsky, The Rake's Progress* (Cambridge: Cambridge University Press, 1982). Also, Bernadette

But, unlike Hockney's or Himid's work, Shonibare's *Diary of a Victorian Dandy* aroused London's commuters, as the artist predicted, for the most obvious reasons. The sight of a black man in a Victorian scene, dressed in period clothing, was both jarring and humorous. Though *Diary* was blatantly visible in the tube, its audience was demarcated by the tube's transitory function. As such, they saw the *Diary* poster, but they were not, principally, coming to see it. Despite its visibility, its meaning was difficult to decipher: the sense of its incomprehensiveness was felt acutely by its audience who saw it in passing, en route from one place to another. Many who saw it were not sure what it was. Following Hogarth, was the poster a satirical project with obscure messages for commuters? Was this a visual send-up on class and race? If so, which race and which class were being lampooned? Was this an art experiment with the medium of advertising? Or was there a high-minded motive? Was Shonibare out to remind Londoners of the history of black people in Britain before the twentieth century? Some nineteenth-century figures—like William Davidson, prominent for his radical activity during the late regency period; William Cuffay, the Chatham Chartist leader who was later exiled to Tasmania for his protests against the state; and the composer Samuel Coleridge-Taylor, born in Croydon—were all black men who moved within and through Britain's urban centres, mingling with people from different classes.[6] Was the poster an ode to their neglected history in Britain?

Though the *Diary* could contain any one of these themes, it seems too facile to reduce it to an educational tool or a prank—if only because this reduction would imply the existence of similar strategies in his entire praxis, thereby diminishing Shonibare's aesthetic to didacticism or gimmick. Rather, my aim in this chapter is to think through the function of the *Diary* series in two ways. The first is in relation to the history of British socialism and visuality. The second is in connection with the utility of visual culture for this project.

Fort, "Lubaina Himid's *A Fashionable Marriage*: A Post-Colonial Hogarthian Dumb Show," in *The Other Hogarth: Aesthetics of Difference*, eds. Bernadette Fort and Angela Rosenthal (Princeton: Princeton University Press, 2001: 278-293.

[6] For an overview of black Britons in the nineteenth century, see Peter Fryer, *Staying Power: The History of Black People in Britain* (London: Pluto Press, 1984); Paul Edwards and James Walvin, *Black Personalities in the Era of the Slave Trade* (Baton Rouge: Louisiana State University Press, 1983); and James Walvin's, *The Black Presence: A Documentary History of the Negro in England*, 1555-1860 (New York: Schocken Books, 1972). For Coleridge-Taylor, the biography by Geoffrey Self, *The Hiawatha Man: The Life and Work of Samuel Coleridge-Taylor* (Aldershot, Hants, England: Scholar Press, 1995) is useful—as are Norbert Gossman's article on Cuffay, "William Cuffay: London's Black Chartist," *Phylon* 44, no.1 (1983):56-65 and William Davidson's speech, reprinted in *Black Writers in Britain, 1760-1890,* Paul Edwards and David Dabydeen, eds. (New York: Columbia University Press, 1993).

Specifically, I use Shonibare's *Diary* to measure the usefulness of visual culture as a designation for art. For Shonibare, the confluence of these two systems is predicated upon their reliance on the field of Cultural Studies as the propagator of the former and the interlocutor for the latter.

Like other late-twentieth-century British artists, Shonibare was ushered into criticality through the mechanism of Cultural Studies. Critics quickly latched onto the colonial tropes in his visual vocabulary, and many transferred small doses of cultural theory into their assessment of Shonibare's biography and his work.[7] Most widely understood as the political and historical critique of culture through the modality of class, Cultural Studies was the product of work performed at the Centre for Contemporary Cultural Studies (CCCS) at the University of Birmingham, beginning in the mid-1960s. CCCS functioned as a laboratory for "New Left" intellectuals like Richard Hoggart, Raymond Williams, and Stuart Hall to abstract what they believed to be a missing component in the Marxist strategy of base and superstructure.[8] Working from Marx out to other continental social theorists, principally Antonio Gramasci, the economic and cultural structure of Britain was their "control." Visual culture evolved as a sub-field of Cultural Studies, wherein culture was read vis-à-vis visuality and visual objects. Art critics begin to "read" art objects that were not decidedly painting, sculpture, or drawing alongside the project of examining representations in visual culture: the space where new forms co-existed with reclaimed forms of pertinent cultural visual merit, like television, video games, or advertising.

Art and artists, many of those now identified as part of the "black arts movement" active in the 1970s and 1980s in Britain, were essential to Hall's formulation of an aesthetic of difference because these artists were subject to the intrusion of market forces and the extra-national permutation of race *and* class. Their working conditions were altered by their lived experiences in Britain, so it followed that their art production should evidence some of the conditions of its

[7] Shonibare's use of fabric has been described in numerous venues. Writer and artist Olu Oguibe provides a concise description of its initial reception in the 1990s. See Olu Oguibe's "Finding a Place: Nigerian Artists in the Contemporary Art World" in *Art Journal* 58, no.2 (summer, 1999): 30-41.

[8] For a discussion of the history of the Centre for Contemporary Cultural Studies (CCCS), see Richard Lee, "Cultural Studies a *Geisteswissenschaften*? Time, Objectivity, and the Future of Social Science," (1997); Richard Johnson, "What is Cultural Studies Anyway?" (1983); and Norma Schulman, "Conditions of their Own Making: An Intellectual History of the Centre for Contemporary Cultural Studies at the University of Birmingham" *Canadian Journal of Communications* (18.1, 1993). For a general discussion of the "New Left," see Mark Bevis, "Republicanism, Socialism, and Democracy in Britain: The Origins of the Radical Left" *Journal of Social History* (winter, 2000).

making. Increasingly, work from this period showed elements of graphic design (Keith Piper), political engagement (Eddie Chambers) and media experimentation (Ingrid Pollard), styles that challenged the heightened attention of the mass media—radio, television, film, and print—focussed on black and Asian bodies in Britain.

The critique of British art from the 1970s onwards engaged with the specificities of the new Britain, which included massive unemployment and the discord in Ireland that spread across the United Kingdom: what may have looked and felt new was not. The investigation of this missing component—culture and the internal critique of Britain—was part of a longer tradition in British rationalist thought dating back to the nineteenth century. William Morris (the designer, author, and leader of the craft revolution of the nineteenth century) made this connection as early as 1877 in a lecture on decorative art. Speaking to a public of like-minded gentlemen (reformists, socialists, craft idealists), he explained:

> Our subject is that great body of art, by means of which men have at all times more or less striven to beautify the familiar matters of everyday life: a wide subject, a great industry; both a great part of the history of the world, and a most helpful instrument to the study of that history.[9]

For Morris, this interest entailed his alignment with Britain's first socialist organization, the Democratic Federation (DF), for which he rallied in public protests and, in 1883, designed its membership card, putting, literally, his aesthetic practice with his politics.

The "great industry" of which he wrote had a double meaning. By connecting art to history, Morris implied the nexus of culture. The "great industry" is, primarily, the production of art, and, secondarily, the value added to personal industry, as in the sense of industriousness or usefulness. Before Morris became a socialist, he championed the idea of work born of pleasure, and goods accumulated for function and beauty. After Morris converted to socialism, he collapsed the ideas of work, use-value, and beauty into the individual plight of the worker in opposition to the wasteful machine of capitalism and the drudgery of "modern civilization." Thought to be the first prominent British socialist, he devised a program of social thought that linked the production of art to the market economy. In doing so, Morris helped spread socialism throughout Britain, serving as the bridge between workers and leisure-class thinkers for whom the investigation of class served entirely unrelated purposes. His DF membership card was a manifestation of the value he placed on infusing beauty with every aspect of working life. It was an early example of

[9] William Morris, *Hopes and Fears for Art* (London: 1902).

the currency of a visual and functional object that visual culture would later identify. It is not surprising that, upon meeting the senior Morris, artist Walter Crane followed him into the DF, after which he, too, began designing for socialist causes, ultimately making his mark as an avowed socialist designer.

Prior to the 1880s, there were no formal Socialist programs, nor was there organized socialist activity in Britain.[10] Oddly, Britain served as a refuge for leading continental anarchists, communists, and socialists. From 1849, Karl Marx and Friedrich Engels were residents of London—while Marx was in exile from the Prussian government. Together, they envisioned England as a possible laboratory for their vision of class warfare. By their estimation, the Industrial Revolution set England as the originator of the world's first authentic proletariat. These conditions were defined by mechanized, factory, and, above all, waged labour; by starker contrasts between owners and producers than had existed before; by social discord; and by deep-seated antagonism across class lines.[11] Unable to agitate a revolution among the English, Marx and Engels formed the nucleus for other dissidents entering the country from the continent. Among others, the Viennese socialist Andreas Scheu and the Russian anarchist Sergei Stepniak relocated to Britain in the 1870s.[12]

Britain's peculiar mix of insular political activity and aggressive colonial expansion, against the presence of the architects of continental social theory, was the ground for Cultural Studies in the twentieth century. The implications of this conjunction seem obvious now, but the problems of the world stage made residence in Britain in ways that slowly resounded over the next century. Photography, for example, was but one of these ironies. Mechanized in Britain by Henry Fox Talbot in the 1830s, it became one of the

[10] In the early 1880s, a former Tory radical, Henry Mayers (H.M.) Hyndman, formed Britain's first socialist organization, the Democratic Federation (DF), later the Social Democratic Federation (SDF), in response to a series of lectures at radical workingmen's clubs. After reading *Das Kapital* in French, Hyndman wrote his version of Marxism in *England for All* (1880). Since most of Britain's intellectual class had not read Marx's and Engel's text, Hyndman was falsely credited as the designer of the program to reconcile economic and class relations. Labour historians, G.D.H Cole, E.J. Hobsbawm, and E.P. Thompson provide unflattering portraits of Hyndman. In their accounts, he was an admixture of a careerist and a charlatan who was invested in imperialism under the guise of English socialism. Morris served as the treasurer of the DF and a key financial resource for Hyndman. Late in 1884, Morris reached the apex of his socialist transformation. He eclipsed Hyndman's thinking and joined with Karl Marx's daughter, Eleanor—a close contact of the aging Engels—to form the Socialist League.

[11] Jeremy Black and Donald M. MacRaild, *Nineteenth-Century Britain* (New York: Palgrave MacMillan, 2003), p. 105.

[12] Peter Stansky, *Redesigning the World: William Morris, the 1880s, and the Arts and Crafts* (Princeton: Princeton University Press, 1985), p. 20.

primary Victorian instruments of documenting, categorizing, and specularizing Britain's colonial landscape and its populations. In the move from colony to metropole, black and Asian Britons photographically transformed from pseudo-scientific samples to always-potential criminals, first by way of their depictions in print and broadcast media, then through closed circuit television (CCTV). In the 1970s, as photography emerged as a conduit for the new forms of installation art, video art, and the amorphous category of new media, non-white British artists become its strongest practitioners. The relative ease of video technologies coupled with their advancements and dissemination into Britain's art public may have aided black and Asian artists. It is also possible that moving from object/subject to auteur was a transition that many black and Asian artists could make within the confines of their own praxis, if not within the space of the city or that of the art world.[13]

So what does the long history of socialism in Britain have to do with a contemporary artist like Yinka Shonibare, MBE? Possibly everything. Raymond Williams, Stuart Hall, and others within Cultural Studies articulated queries into art and the distribution of power, labour, and class as a necessary process of understanding culture. Even if the socialism of Morris and the Victorians was not fully developed during their time, it served as a balm for the national economic crisis brought on by the inchoate disintegration of colonial trade. They opened the door for objects and actions to engage meaningfully, a move that was counter to academic art and patronage practices of the nineteenth century. In post-colonial Britain, the integration of socialist theory into intellectual thought morphed into a more usable mechanism for situating the past and the present. Williams began this query in the 1950s into what he termed "cultural developments and communication technologies" (like photography), under the rubric of the "culture industries." Hall extended this quest through his interest in the power of mass communication. Visuality was his next exploration. Under Hall's microscope, Britain's scopophilia was thrown a Fanonian turn, with the entrance of a quantifiable population of visually, non-English, i.e., non-white bodies into the Empire, supplementing the minor corpus of assimilated blacks and Asians with an inescapable panorama.[14] Visual culture came into full thrust in Britain because the nation had to reorder its collective sight. When Hall took on the art and film of this period, he, like the rest of the nation, was not simply looking at new art work, but at new bodies represented under new visual codes. It is not surprising, then, that the emergence of visual culture in Britain was concurrent with the nation's negotiations over the

[13] For one example of the black and Asian British photographic archive, see Stuart Hall and Mark Sealy, *Different* (London: Phaidon, 2001).

[14] See Ron Ramdin, *The Making of the Black Working Class in Britain* (Aldershot, Hants, England; Brookfield, VT: Gower, 1987).

actuality of black and Asian people within its borders. It is the friction among images, like those from Brixton in April of 1981; or the Saatchi-designed, Tory campaign poster from 1983, which objectified the political choices of blacks; or the naming of black identity in art, that incited the need to *level* what were once commonly understood as journalism, advertising, and art, respectively.

So, again, what does this have to do with a contemporary artist like Yinka Shonibare, MBE? Due to the link between visual culture and the earlier black British arts movement, later art and artists who expanded the conception of traditional media were automatically valued under the system of visual culture. Though this reaction is not necessarily reductive, it speaks to the larger issue of categorization in the art world, whereby the work of non-white artists is still evaluated by the mark of its difference, which always falls on its maker. If visual culture is an alternate space that has already been territorialized by non-white artists, it then becomes the *de facto* space for all visual production by non-white artists. I would extend this claim to non-Western artists as well. The real problem, then, is not that visual culture encompasses art, but rather that the art of non-white artists can be put into the realm of visual culture and eliminated from the categories of art and art making. The propagation of an ill-defined *Africanness*, colonialism, and cosmopolitanism in Shonibare's work, coupled with the obsessive interest in his person, attest to the manner in which his work, and that of others, is not fully approached as art, but rather is entered into as spectacle.

As to the condition of art criticism, Shonibare's series has another function—that of proving itself as art by way of the spectacle, a feat that he accomplishes through myriad conventions. The *Diary of a Victorian Dandy* was shot on location at a country estate in Hertfordshire. Its organization is on par with the production values for filmmaking. The five images are C-type prints, colour photographs printed on film, not digital images. The titling, cyclical progression from day to night, the reoccurrence of actors in different photographs, and the repeated presence of Shonibare—all filmicly serialize the *Diary*. The narrative may have been cemented by Shonibare as the active dandy, but the other elements aid in the project's visual continuity, a feature that insists on a cinematic reading of the project. The angle into each room undoes its dimensionality, suggesting that each room is in fact a two- or three-walled constructed set, rather than a fixed four-walled interior, domestic space. The stage-set illusion is further enhanced by the lack of exterior-facing windows.

Though there are no windows, there are intra-compositional egresses. Both photographs *14.00 hours* (Fig.1) and *17.00 hours* (Fig.3) have doorways. In the right-side of the former, an open door serves as a shield between the aristocratic men inside of the room and the servant women in the corridor outside of the room, allowing the women access into the room and into the

action of the scene while shielding them from their employers. Nonetheless, the class and gender play between "upstairs/downstairs" is undone by the figure seated behind the desk who gestures toward the door. She is a woman in drag. Her gesture toward the door and, presumably, toward the women, could be read as a gesture that encodes her own deception. It is also the acknowledgement of the room's depth. The corridor behind the servant women appears deep, if not also long. To a lesser degree, the door outside the billiards room in *17.00 hours* (Fig. 3) also suggests continued spatiality. In each, the door intimates the possibility of movement, which is a cinematic trope rather than a theatrical one.

There is also the issue of framing. When exhibited, each of the photographs was printed in large-scale and hung in a gilt frame. The frame situated each of them within the exhibition space as distinct stills pulled from a moving image and re-cast on their own screens.[15] These frames mimicked the frames of the paintings found in the backgrounds of the photographs, setting up a relational triangulation of painting, film, and photography. The connection that is made is intentional. Shonibare's *Diary* is "placed in" with methods of specific art production, rather than the range of options offered by visual culture. Throughout the production and exhibition of the work, Shonibare asserts that the *Diary* is art. The most obvious assertion is, of course, the reference to Hogarth and, through him, to the traditions of British painting and engraving. His pose in *19.00 hours* (Fig. 4) has a similar effect. Positioned underneath the panorama of formal portraits on the wall behind him, Shonibare as dandy stands in the same fashion as those subjects. The bodies around him are caught in forms of animated movement, many looking at him. Yet he gazes out toward the camera, an operation that fixes him as one of the painted portrait subjects, as opposed to the live figures who surround him. By doing so, he figuratively stops real-time to retreat into art and art history. The effect is one of a camera trick as well as a painting device.

Shonibare's intimations toward art do not rest with references to different artistic media and their associations. By titling the work *Diary of a Victorian Dandy*, he summons one of the key constructs of modernity, that of the dandy. The dandy came into being as a man so attuned to fashioning the self and his surroundings that self-fashioning became his occupation, one that may have lifted him from one class to another, if only in appearance. To some degree, the dandy was the figurative embodiment of London, just as the *flâneur* belonged to Paris, despite the presence of each in either location. Shonibare is aware of this history, having once described the dandy as frivolous:

Usually in period paintings, whenever there are black people, they are in some kind of subservient role, a servant or a barmaid. I wanted to recreate such a circle

[15] Each photograph is 72 x 90 inches and printed in an edition of three.

but put the black person, myself, in a more frivolous role. The dandy is not usually
a member of the aristocracy but through his wit and style, he somehow is admitted
into society. It's pure fantasy on my part.[16]

The fantasy of frivolity that he describes was also the one Charles Baudelaire
saw as a component of modernity because the dandy elevated the preoccupation
with beauty to an intellectual achievement.[17] The dandy is important to
contemporary art-making because he represents the possibility of defining new
subject positions based on aesthetic enquiry.

There is also the train. As a technological advancement, it brought
more bodies into contact with each other on both small (the city) and large (the
continent) scales. From 1863 in London, the train unified the city. It allowed its
villages to join the ranks of the metropole, creating a larger cosmopolitan public
from which to draw labour and to instigate commerce. The train, either over
ground or underground, was the motivation of the desire for visuality to
encompass the speed of sight. Photography and film enter this realm as devices
and aesthetic practices that can approximate the eye's function. Shonibare's
placement of the *Diary* poster in London's tube is an acknowledgement of the
relationships among London's commuters, visuality, and motion, and of the
thread(s) of modernity in his work. The time of each scene, as indicated by its
title, is only a guide as to how to view the scenes, not a prescription for order.
Like many early modern films, time is disrupted and fluid in *Diary*. For
example, does he fall into his bed (Fig. 2) on the morning after the orgy (Fig. 5),
or on the morning preceding the meeting in the library (Fig. 1)? The potentiality
of either order is the motivator of the cinematic-style continuum of the series.

Coming out of a national curriculum that had absorbed some of the
canon of Cultural Studies and coming after the black arts movement and
roughly in line with the art market phenomena know as the YBAs, or Young
British Artists, Shonibare reasserts the influence of all of these factors on his
work in a product that functions like a commercial, an eyewitness account, an
historical re-enactment, and even a fantasy; but it cannot be denied that the
Diary of A Victorian Dandy is ultimately a series of art objects. With deft
acuity, Shonibare lets the viewer know that the artist is steeped in canonical,
British art history, critical race theory, British history, new media technology,
and that he knows that his persona via his art is ultimately what is for sale. Yet,
the work is in the public realm, fiscally unattainable, and irritatingly
unavoidable, not unlike Nelson's column in Trafalgar Square. I am not arguing

[16] Jan Garden Castro, 'In Art Anything is Possible: A Conversation with Yinka
Shonibare,' *Sculpture* (July/August 2006): 26.
[17] Charles Baudelaire, *The Painter of Modern Life, and Other Essays*, translated by
Jonathan Mayne (London: Phaidon, 1964).

that visual culture has no place in the discussion of the *Diary of A Victorian Dandy*, nor that the work is without immediate shock value, but, rather, that Shonibare has taken the circuitous route (through the realms of the eighteenth-century print revival, nineteenth-century socialism, and twentieth-century Cultural Studies and visual culture) to propose a model for the twenty-first century, wherein art, without the accompaniment of theoretical qualifications or the assimilation of all circulated media, re-asserts itself as the primary mode of the provocateur. Art hiding in plain sight in London.

Fig. 1. *Diary of a Victorian Dandy: 14.00 hours*[1]. Yinka Shonibare, MBE, 1998. C-type print, 183 x 228.6 cm (72 x 90 in.). Original in colour. Edition of 3.

Fig. 2. *Diary of a Victorian Dandy: 11.00 hours*[1]. Yinka Shonibare, MBE, 1998. C-type print, 183 x 228.6 cm (72 x 90 in.). Original in colour. Edition of 3.

Fig.3. *Diary of a Victorian Dandy: 17.00 hours*[1]. Yinka Shonibare, MBE, 1998. C-type print, 183 x 228.6 cm (72 x 90 in.). Original in colour. Edition of 3.

Fig. 4. *Diary of a Victorian Dandy: 19.00 hours*[1]. Yinka Shonibare, MBE, 1998.
C-type print, 183 x 228.6 cm (72 x 90 in.). Original in colour. Edition of 3.

Fig. 5. *Diary of a Victorian Dandy: 03:00 hours*[1]. Yinka Shonibare, MBE, 1998.
C-type print, 183 x 228.6 cm (72 x 90 in.). Original in colour. Edition of 3.

CHAPTER FOURTEEN

ALIENATION AND ALIENATION EFFECTS IN WINSOME PINNOCK'S *TALKING IN TONGUES*

MEENAKSHI PONNUSWAMI
BUCKNELL UNIVERSITY

Critical interest in black British theatre has been growing steadily during the past decade, inspired by the increasing visibility of performances and published scripts, and, less obviously although as importantly, by ground-breaking black British cultural scholarship of the 1980s and 90s. Significant work still needs to be done in the field of theatre studies, however. Collections of black British literature and scholarship usually overlook drama (though performance poetry has enjoyed some attention), much as studies of British theatre as a whole marginalise or altogether ignore black drama and performance. The most sustained interest in black British theatre has, interestingly, come from scholars of women's and feminist theatre, so it is not surprising that the two monographs in the field have both centered on plays by black and Asian women.[1] As of this writing, however, the field still lacks a "primer," a comprehensive, theorised, historically contextualised survey of plays and performance practices by black British women and men from the 1940s onwards.

This is ironic because there has been a significant black British presence on the stage since, at least, the 1950s. The history of post-war British theatre is usually described in terms of two main "waves" coinciding with the evolution of the New Left—the angry young men of the Jimmy Porter or "1956" era, and the angrier young men, and some women, of the "68" generation. Feminist theatres of the 1970s and 1980s are typically

[1] Gabriele Griffin, *Contemporary Black and Asian Women Playwrights in Britain* (Cambridge: Cambridge University Press, 2003) and the forthcoming book by Lynette Goddard, *Staging Black Feminisms: Identity, Politics, Performance* (London: Palgrave Macmillan, 2007).

thought to have complicated both the politics and form of the theatres of the New Left, and, increasingly, the "in-yer-face" theatres of the 1990s are argued to have set new standards of iconoclastic social critique. Predictably, black British theatre is usually treated as an appendage to, rather than an integral part of, this narrative, even though Mustapha Matura, Wole Soyinka, Barry Reckord, Caryl Phillips, and other first-generation playwrights were active on the British stage during the 1960s, particularly in venues such as lunchtime theatres and the Royal Court; the ICA even had a "Black Power" season in 1970.[2] By the 1990s, black and Asian playwrights and performance artists who came of age after the Brixton uprisings were producing an original and innovative body of creative work, such as that recorded in Yvonne Brewster's three volumes of *Black Plays*, Kadija George [Sesay]'s *Six Plays by Black and Asian Women*, and Catherine Ugwu's *Let's Get It On*. In the mid-1990s, writing of filmmakers, Kobena Mercer argued that this "new generation of black British cultural practitioners ... [were] in the process of creating new, hybridized identities" by undertaking a very foundational interrogation of identity-formation, of "the need for nation" itself:

> ...cinema and image-making have become a crucial arena of cultural contestation today—contestation over what it means to be British; contestation over what Britishness itself means as a national or cultural identity; and contestation over the values that underpin the Britishness of British cinema as a *national* film culture.[3]

In other words, it is vital to replace the received genealogy of contemporary British theatre with one that considers not only the hybridity of the new black Britishness but also that of white performance.

It is similarly important for an examination of the aesthetics of black British theatre to consider its relations to the broader canons, traditions, and aesthetics of theatre and the performance arts, black or white. Particularly little has been done to examine the complex relationship of black British performance to Anglo-American and European theatre, although studies in the field do sometimes glance at black or Asian ancestries (relating the text or performance to the West Indian yard play or Bharatnatyam, for example). Much black and Asian theatre in Britain derives its vivacity and sometimes

[2] For a brief history of black British theatre from 1956 onwards, see my essay "'Small Island People': Black British Women and the Performance of Retrieval." In *A Cambridge Companion to British Women Playwrights*, edited by Janelle Reinelt and Elaine Aston (Cambridge University Press, 2000), 217-234.

[3] Kobena Mercer, *Welcome to the Jungle: New Positions in Black Cultural Studies* (New York & London: Routledge, 1994), 4-5.

even its *raison d'être* from intercultural display, and, with good reason, is itself likely to think of its aesthetic relationships to Bertolt Brecht or Samuel Beckett as secondary (although most black playwrights in Britain readily acknowledge these and other influences in their work). But a fuller examination of the novelty of black British performance aesthetics invites us to look more closely at the history of the British stage. Errol John wrote *Moon on a Rainbow Shawl* for a competition in the wake of John Osborne's epochal 1956 *Look Back in Anger*, and it is interesting to see how John's play, as a British rather than Caribbean play (though it is, of course, both), responds both politically and aesthetically to the notion of looking back developed in Osborne's. This angle of vision is especially illuminating when we consider second-generation works. The controversy surrounding Gurpreet Kaur Bhatti's 2004 play *Behzti* would then not be reducible to yet another Rushdiean struggle between "ethnic" orthodoxy and "British" free speech; the play would, *what's more*, seem exemplary of the controversial performance practices of contemporary British "in-yer-face" theatre, of which *Behzti* is equally a part.

Post-War British Performance Aesthetics: A Primer

The history of modern theatre in the West can and has been written as a mighty struggle between naturalism and its detractors, the various forms and descendants of Modernism. In relating this history to post-war British theatre, we find an apparent contradiction: British theatres, like popular performance (including music hall) traditions, bear an iconic weight in defining notions of heritage and authenticity—of Britishness and, of course, more specifically of Englishness. Yet, the two great performance aesthetics that are acknowledged to have shaped post-war British theatre are hardly English: Bertolt Brecht was German, and Samuel Beckett, an Irishman settled in Paris who wrote his first plays in French. Joan Littlewood, John McGrath, and a handful of other socialist artists in the 1950s and 1960s did experiment with "native" forms, drawing upon music hall and similar types of popular entertainment in an effort to create new varieties of people's theatre. But Brecht had drawn upon similar, albeit German, sources, and many of the British "people's theatre" pieces of the period have a strongly Brechtian aesthetic. So, modern British theatre is not wholly British to start with.

In Brecht, post-war British theatre found a way to reconcile its (often socialist) politics with the techniques of realist theatre, which, since the end of the nineteenth century, had been derided as ideologically complicit with bourgeois values. Brechtian "social" realism, in modified British New

Left guise, was a basically realist theatre that featured some of the staple mechanisms of epic theatre practice for effecting critical distance in audiences, to save them from the stranglehold of emotional identification and catharsis: e.g., episodic narratives; "alienation effects" such as projections; musical accompaniment; and other "distancing" techniques designed to encourage critical awareness and questioning in audiences.[4]

For British absurdists and other sorts of modernists, however, the search for deeper, greater spiritual truths necessitated a more radical break from realism than Brecht provided. They found this break in the silent, barren, hollow, directionless landscapes of Beckett's work, translated and, more importantly, indigenised by such writers as Joe Orton, Edward Bond, and Harold Pinter. Even the most Brechtian plays by feminist playwright Caryl Churchill (*Vinegar Tom*, *Light Shining in Buckinghamshire*) have an absurdist stillness, as do the postmodernist plays for which she is best known, *Cloud Nine* and *Top Girls*. (Her latest work has been increasingly minimalist, like Beckett's.)

For black playwrights (in Britain and elsewhere), however, realism has played a much more activist—arguably an even militant—role. In the first place, modernist performance practice has had a tainted history in its conceptualisation of the black body.[5] One of the most radical gestures in Lorraine Hansberry's *A Raisin in the Sun* was simply its cup-and-saucer realism, which broke through centuries of white representation and racist caricature to present a realistic African American family with "normal" aspirations, confronting real obstacles, hoping for real rewards.[6] Although Hansberry was criticized on both ideological and stylistic grounds by some avant-garde writers, including Amiri Baraka (then Leroi Jones), the play was in retrospect acknowledged to have captured the explosive energy of its times in authentic detail. Realism in black British theatre is similarly a boundary-defying project, potentially as subversive as modernist and postmodern performance.

[4] Caryl Churchill's *Light Shining in Buckinghamshire* and *Vinegar Tom* and David Hare's *Fanshen* are classic examples of British Brecht. See Janelle Reinelt, *After Brecht: British Epic Theater* (Ann Arbor: University of Michigan Press, 1994); and *Performing Brecht: Forty Years of British Performances* by Margaret Eddershaw (London and New York: Routledge, 1996).

[5] Examples include Dadaist "Negro soirees," and Artaud's unqualified primitivism.

[6] Hansberry's play was by no means the first to do so, but it was the first to attract a mass white audience -- and it was in that context, upon a stage with a long history of the minstrel show and its offshoots, that Hansberry's realism appears so dynamic.

Winsome Pinnock's *Talking in Tongues*

What, then, are the many aesthetic heritages of second-generation black British theatre? Addressing only a fraction of this complex question, this essay will focus on the ways in which one playwright, Winsome Pinnock, inherits Brecht and (to a lesser extent) Beckett. A second-generation writer of Caribbean descent, Pinnock has been regarded for the last decade as one of the most important of contemporary black British playwrights. Her work has invited the usual range of debate concerning "universality" and "particularity," categories which, always reductive, seem especially ill-suited to her work. Deftly negotiating the imagined boundaries between first- and second-generations, Pinnock writes about cultural translation and travel in ways that allow the diasporic space of black Britain to seem the starting-point for a newer, truer transnation. By focusing in this chapter on those themes as they relate to her 1991 play *Talking in Tongues*, I here explore theatrical forms of critical distanciation and alienation, the formal techniques that connect Pinnock's work to the wider contours of British theatre, but which are also reconfigured aesthetically in relation to the issues of diaspora and identity.[7]

Both race and gender add a specific urgency, directness, and political commitment to the play. As Lynette Goddard has observed, it is important to consider "the political force" of Pinnock's plays without reducing her work to its politics.[8] Pinnock herself is clear that politics contextualise the lives of her characters inescapably, shading events and actions whether or not they actually merit a politicised reading. However, her ultimate concern is with the inner transformations that must take place for her characters to learn to cope with the political realities of racism, sexism, and capitalism. Pinnock sees the political project of realism—authentication, verification, or legitimation—as incomplete and confining, although *Talking in Tongues* also seems to suggest that it is a necessary precondition to determining a finer truth. The "realist" first act, set in London, is thus followed by a more complex, inward-looking second act set in Jamaica, where the real space of Jamaica is used and abused by British characters as a site of psychic transformation and renewal.[9]

[7] Winsome Pinnock, *Talking in Tongues*. In *Black Plays: Three*, ed. Yvonne Brewster (London, Methuen, 1995).

[8] In Lynette Goddard, "West Indies *vs.* England in Winsome Pinnock's Migration Narratives," *Contemporary Theatre Review* 14.4 (2004): 24.

[9] See Goddard's perceptive reading of the parallel structure of the acts, with carefully planned role-doubling and inversions in "West Indies *vs.* England in Winsome Pinnock's Migration Narratives," *Contemporary Theatre Review* 14.4 (2004): 30.

The opening scene frames these issues by depicting an act of healing: Sugar gives Leela a massage, while telling her about a supernatural event. Although the full significance of this prologue does not become apparent until the end of the play, Sugar's accompanying narrative raises several key concerns of the play as a whole: black women's relationships and responsibilities towards each other; the importance of retrieving the hidden histories of black women's resistance and resilience; and the means and mechanisms of psychological and spiritual release. Sugar, who as we discover later is Jamaican, tells Leela the story of three women she knew as a girl, who used to disappear mysteriously from time to time, thwarting the attempts of any man who tried to follow them. Sugar managed to follow them to a gully, where, after a while, Dum-Dum, the woman whom no one had ever heard speak, began speaking in tongues, in a moment of overwhelming spiritual relief:

> Then all of a sudden the silent woman stand very still like her body seize up and lift her head to the sky and start to call out. She was shouting—a woman I never hear say a word in my life—was shouting to the sky loud loud and saying words very fast in a language you never hear before. A woman who couldn't even talk, filling the sky with words in a language must not be spoken in a million years, a language that go back before race. She lift her fist and strike out one more time. After, she collapse, but the other women catch her before she fall. (174)

"I always wonder," muses Sugar at the end of the narrative, "what madness them release when they shout like that." She concludes, however, that as a modern woman she has other options: "Me, I just go walk down by the beach, lift weight, jog, take aerobic exercise. No need now to go down to gully, eh?" (174). Of course, the play goes on to suggest exactly the opposite, lamenting that women no longer have a gully, which as Goddard notes, represents "a space for black women's liberation" (31).

The play suggests that the consequence of not having an opportunity for abandonment or liberation is that modern black British women remain alienated from their bodies, from their spirituality, and from each other. But, because history and dislocation have made this condition inevitable, alienation also becomes a Brechtian modality in Pinnock's work, a mechanism through which characters learn and grow. A few scenes later, Irma advocates "distance" as a medium of healing for a generation that no longer "has religion" (194). Many of Pinnock's characters do actually travel, from the West Indies to Britain and back, from one home to another. But the kind of distance that heals or cures is a strength that grows out of alienation—a spiritual distancing or detachment, an enlightened self-awareness and self-reliance, an independence from the body. As the Obeah

woman in Pinnock's *Leave Taking* (1987) puts it, "You at peace with yourself, you at home anywhere" (179).[10] It is precisely the difficulty of achieving this state—and learning to distinguish this healing notion of distance from the closely related states of separation, isolation, and loneliness—that motivates Pinnock's characters to move.

The quest for "distance" drives many of the characters in *Talking in Tongues*. Pinnock's protagonist Leela is a young black Londoner whose life in London has left her, as Gabriele Griffin succinctly puts it, "alienated from her body."[11] Leela is by no means isolated in her detachment; the play's first act reveals that not one of the young urban professionals, black or white, has managed to sustain an unconditional commitment or loyalty of any sort. "What happened to unno make you so broken?" asks Sugar later in the play. The play leaves this question largely unanswered, but the unblinking, cold realism of the first act provides some glimpses into the "broken," disconnected social and sexual relationships of a group of young people at a New Year's party, where Leela discovers her partner's infidelity in a painfully explicit way. Bentley's infidelity seems to be only one (if a particularly devastating) episode in a life which has left Leela voiceless, lacking a core sense of self. She is becoming disengaged from her two close women friends, Curly and Claudette; the three long-term friends (who mirror the women described in Sugar's story) are drifting apart, divided by ideological and stylistic differences as much as, allegedly at least, Leela's self-segregation since she has paired off with Bentley. Leela is neither able to enjoy the light-hearted camaraderie they have cultivated since their teenage years nor able to handle the politicisation of her friend Claudette, who is as insistently loud and voiced as Leela is silent.

The scenes of the first act are organised episodically and, in Brechtian style, move without smooth transitions, avoiding a sequential build-up to a predictable climax (the "discovery scene" for instance occurs without crisis or denouement). Also in Brechtian fashion, Pinnock juxtaposes events in such a way as to create a montage of contradictory or antithetical statements that force the audience to reflect dialectically upon the unfolding scenario. For example, having specified the basic conflicts of race and gender, Pinnock goes on to suggest that not all black British women understand their embodiment in the same way. Curly—apparently able to move with ease sexually and socially across racial lines—is more like Bentley than like Claudette or Leela. Even here, Pinnock's expository method is dialectical and exploratory, open-ended. On the one hand, Act

[10] Pinnock, *Leave Taking*, in *First Run: New Plays by New Writers*, edited by Kate Harwood (London: Nick Hern, 1989): 139-189.
[11] Griffin, Ibid., p.82.

One opens with Curly's description of her visit to the home of the parents of her white ex-boyfriend; evidently expecting a white woman, they presented her with an English rose cosmetics set. Claudette suggests that Curly is deluded in imagining that she can inhabit a colour-free world and that her choices have consequences that are still invisible to her. On the other hand, while Curly commiserates when they discover Bentley having sex with Fran, she promptly runs off to have sex with Fran's white husband Jeff and informs him about Fran's infidelity. Curly's blithe-spirited sexual opportunism seems to signal that she is unapologetically comfortable in her own body, sexually and racially, or at least that she demands less of it than Leela or Claudette. Interestingly, only Leela and Claudette go to Jamaica in Act Two; Curly has no "need" to go to Jamaica.

Part of Pinnock's purpose here is to explore whether it is possible or desirable to forget the ways in which one is racially and sexually embodied, given that these embodiments are the main causes of everyone's anguish. "What's wrong with forgetting myself for a while?" Curly asks innocently— but Pinnock reminds us that black women are not always allowed to forget or lose themselves. Fran, who is white, may love to dance, let go, and forget herself, while Leela laments, "I never forget my body. That's the trouble" (183), and Claudette, more aggressively, asserts, "I don't want to forget. I want to remember" (178). In the middle of the first act, Pinnock also explores the idea of an embodied invulnerability through a character named Irma, whom Leela encounters—or invents—at the party, at the height of her sexual and social humiliation. Leela's possibly imaginary new friend is a thirty-something-year-old hermaphrodite from south London who represents a black self that is so self-contained that s/he is invulnerable to the kinds of pain Leela is experiencing. Irma is the antithesis of Leela in many ways: talkative, unlimited by femininity, bold. Whereas Leela says she "wouldn't have the guts to shave" her head ("It wouldn't suit me"), Irma has simply refused to suffer the indignity of hair treatments by choosing baldness. It is Irma who suggests two key survival strategies to Leela: "distance" and a surrendering of the spirit.

As is apparent in her portrait of Irma, Pinnock's political sense also seems Brechtian in that her characters function in a political and economic universe that "determines" them without negating their capacity or desire for self-determination. "*Alterability*" is a key concept in Brechtian politics and aesthetics, and it is in many ways the core goal of "alienation" or distanciation in epic theatre. Brecht put it this way in an early essay: "Human behaviour is shown as alterable; man himself as dependent on certain political and economic factors and at the same time as capable of altering

them."[12] Pinnock is chiefly concerned with Leela's vulnerability and need
for change. Her condition, which is implied to be an absurdist mélange of
sadness, rage, detachment, and helplessness, is from the outset not speakable,
and therefore not materially explicable. However, it is clearly circumscribed
by the socio-politics of race and gender. Leela's trip to Jamaica is thus a part
of her effort to alter her circumstances, as she is unable to alter her body.
Possibly because Leela and Curly reject Claudette's separatist rhetoric, some
critics have misunderstood Pinnock's politics, declaring for instance that she
is "one of a crop of black writers who have seen that polemical, anti-racist
plays ... have had their day."[13] Pinnock's polemics and anti-racism are
apparent everywhere in *Talking in Tongues* as much as in her other plays.
She rejects what she calls Claudette's "fanaticism" and recognizes that
Bentley's infidelity is not reducible to the politics of race (as Claudette
insists). But there is no doubt whatsoever that Leela's alienation is deeply
rooted in her body's craving for a racial, ancestral, and matrilineal home. As
I argue below, Pinnock's purpose in the play is to explore what happens
when such a home cannot be found, or made, or imagined.

Leela's alienation is, however, most clearly marked as a physical
constraint that is ubiquitous in Beckett: aphasia. We discover that that she
has failed to return her friends' phone calls and that her relationship with
Bentley has been haunted by silences. Ironically, it is Bentley himself who
best articulates her predicament (post-coitally to his white lover Fran, while
Leela silently overhears):

> Every evening she comes home she needs to talk. I mean really talk. She
> never does, though. She just potters around, makes pleasant conversation:
> "had a nice day at the office, dear?" Underneath it all you can hear this, like
> a grating sound, you can hear what she really wants to say struggling to get
> out. (189)

Bentley is astute enough to understand that "She's fighting to make
something of herself" (189). But he can only conceptualise this need in terms
of career and success, failing to grasp the deeper nature of her silence, or the
absences that have fractured Leela's spirit. (And, of course, he does not seem
at all to suspect his own complicity in silencing Leela.)

Leela herself remains silent about her feelings until she speaks to
Irma in the middle of Act One; even then, she offers no specific sociological
or personal cause for her silences. But as she acknowledges her own

[12] Brecht, "On the Use of Music in an Epic Theatre" in *Brecht on Theatre: The
Development of an Aesthetic*, edited and translated by John Willett (New York: Hill
and Wang, 1966), 86.
[13] See Goddard's useful discussion of these views, op.cit., pp. 23-24.

voicelessness, she recognises that she has become alienated from language and explains her absurdist difficulty in more historicised terms. "[W]ords are sometimes like lumps of cold porridge sticking in my mouth," she tells Irma:

> It's because this isn't my first language, you see. Not that I do have any real first language, but sometimes I imagine that there must have been, at some time. . . . If you don't feel you belong to a language then you're only half alive, aren't you, because you haven't the words to bring yourself into existence. (195)

Pinnock proposes here and elsewhere that voicelessness, the absence of "a real first language," is a historical problem that has immediate spiritual consequences in the lives of individual black women. The act of "talking in tongues" thus brings together several of Leela's needs: the need for an ancestral tongue, the need for a connection to a homeland or motherland; and the need above all for spiritual and psychological restoration.

The idea of self-healing or rejuvenation through spiritual self-surrender is a central theme in *Talking in Tongues*, as much as in Pinnock's *Leave Taking*, a 1987 play in which two generations of women negotiate issues of identity and history. In both plays, second-generation Caribbean British women are sceptical of first-generation spiritualism, but come to understand its core significance as a womanist and feminist practice. When Irma suggests that their mothers' Sunday afternoon "surrendering to the spirit" might be a useful thing, Leela echoes Sugar's scepticism by dismissing it as "mass hysteria" (194). Irma, however, asks her to reorient her understanding of such religious and spiritual practices:

> The point is that our mothers found a way of releasing the pain, they never let themselves become victims of it. (195)

This result in effect becomes Leela's quest in Jamaica. Toward the end of the play, Leela finally does find such release, and at the critical moment speaks to her ancestors by talking in tongues. The literal is a metaphor.

At first sight, then, the play suggests that Leela's transformation is enabled by her visit to Jamaica: the Windrush generation's journey is reversed, and the British daughters of that generation seek solace in the old motherland. Leela's quest for a first language is indeed a quest for roots, for a black heritage and an identity beyond Britishness, and the Brechtian elements of critical distance and alienation become embodied in the more specific histories of slavery, colonialism, and diaspora. But Pinnock sets up a montage of disparate elements to propose a more dialectical approach to the "homecoming." Specifically, Act Two suggests that self-realization must involve something more than self-recognition in historical, raced terms—and

the trip to Jamaica is premised upon a *misrecognition* (of both selfhood and otherness) so serious that it almost ends up destroying Leela and the other women.

Both Claudette and Leela go to Jamaica apparently with the assumption that a sense of place, of placement, can help restore a sense of self. But like other British characters, black and white, they discover themselves to be dislocated still, although in not the same way they had been in London. The second act, again, is organized in a mosaic of non-sequential episodes, and here in Brechtian fashion the "climax" comes without predetermination by the plot, implicitly suggesting that characters could have made different choices and that events could have unfolded otherwise. More importantly, Pinnock complicates the realism of the first act to suggest ways in which Jamaica functions as an "imagined community" both in a political sense (it is where the British women hope to discover a sense of racial and national belonging) and in a psychological sense (Jamaica's material realities are "orientalised" by new forms of colonial reimagining and appropriation). Pinnock's purpose is in part to question the "using" of Jamaica by "broken" Britishers, and this part of the play reminds us of the inescapability of certain materialities, such as globalisation or the tourist industry. But Pinnock is also exploring the way a desperate searching for roots can leave black British women vulnerable to misrecognition of themselves. This is the most Brechtian move in the play, where we see Pinnock developing an aesthetics of silence that incorporates an absurdist conception of the body—Leela's "coming of age" into a new awareness of her body, an awareness that is not "beyond" race, ethnicity, or sexuality in a political sense, but that is capable of survival because it has internalized the mechanisms of coping with alienation and hurt.

Pinnock's dialectical method is very clearly apparent in the juxtapositions we find in Act Two of contesting writings of Jamaica. For Claudette, Jamaica is only a pleasure-palace that offers a simple opportunity: to experience the gratification of holding economic and, thus, sexual power—and thereby to be the equal of the white women by whom she feels demeaned and humiliated daily in her life in London. Claudette's rage against white people serves an agitational function in Act One, forcing Curly and Leela to acknowledge the impossibility of escaping race as a factor in private life. In Jamaica, however, Claudette's politics seem narrow and self-serving; she has no qualms about taking advantage of the economic power she commands. Defending her sexual escapade with Sugar's man Mikie (Sugar believes "in one man, one woman"), Claudette explains to Leela how the game is played:

Sugar doesn't own him. Nobody owns Mikie. Look along the beach Leel. Everybody knows what the score is. You don't begrudge me a little holiday fling, do you? We all use each other. Everyone goes home happy. No one gets hurt. (*She stretches out lazily.*) Even the sea smells of sex. (206)

Leela, on the other hand, is in search of deeper goal—a holistic transformation that will restore her lost voice and give her the "distance" she had left London to seek. Jamaica thus appears to her—simply and profoundly—as an escape from a smaller, uglier island:

It's more beautiful than I imagined. You can be alone yet not alone. There's a vastness about the place. It doesn't seem like an island at all. The people ... they seem so at ease with themselves. They have that confidence that comes from belonging. Everyone's got a story to tell. I could listen to them all day. London seems like a figment of my imagination. (206)

These starkly contrasted accounts underscore the differences between Claudette's explicitly consumerist sense of Jamaica and Leela's more self-effacing tourism. But Pinnock is highlighting that Leela is not—cannot be—at home in Jamaica and that Claudette's sexual tourism is in some respects the mirror image of Leela's search for a spiritual healing: both are forms of consumerism, enabled by the women's socio-economic position as British citizens. Pinnock thus demonstrates that second-generation Britons have relations of power to the Caribbean as complex and potentially as exploitative as any they have encountered at home in England or, for that matter, as those of white tourists.

The tourist's inevitable otherness is underlined by a new British character Pinnock introduces in Act Two, a white woman whose goals resemble Leela's, except that she has decided to make Jamaica her home. Kate's brother David has been sent to Jamaica to persuade her to come home, but Kate is not sure when, if ever, she will want to return: "I fit in here," she affirms (208), although she also asserts her right to change her mind as she pleases. But when David asks whether or not she ever feels homesick, Kate replies:

Never. The great thing is feeling yourself disappearing. A little part of you dissolves every day, but you hang on to those things that distinguish you: an accent, the way you walk. You don't give into the lazy hip-swaying that the other women have. You walk very straight, very fast. People think I'm mad. But the best times are when I feel myself stateless, colourless as a jellyfish. (209)

Kate's feelings about Jamaica, like Leela's own, reveal an inescapable sense of otherness and difference; and we note also that what Kate craves is

precisely what has disembodied and alienated Leela in her life in England. At
the same time, Pinnock underlines the similarities between the women's
needs—both walk obsessively, madly, wanting to disappear in some way, to
overcome the pain of the body and the memory of England by becoming
"stateless" and "colourless." The irony, as Griffin points out, is that the
desire to be colourless emerges "from a position of heightened visibility"
(85).

It is part the unreality of Jamaica as they have imagined it that
empowers Claudette and Leela to act upon the feelings of rage and revenge
they suppress in London. At the party, the women hide silently under a
blanket of coats while Bentley and Fran have sex, and do not confront the
transgressors with their knowledge, although it eventually becomes apparent
that everyone knows. In Jamaica, however, they do not hesitate to act upon
Claudette's anger when she finds that Mikie has been sleeping with Kate as
well as herself—that the racial power politics she has come to Jamaica to
escape have followed her; that is, ironically, by her discovery that her
Jamaica is not what she has imagined it to be. Predictably furious, Claudette
in a moment of drunken rage urges Leela into a cathartic rite of revenge,
vandalizing Kate as she lies sleeping on the beach. Pinnock's directions for
casting help to underscore the postmodern aesthetics at play in the scene. The
actor playing Fran doubles as Kate while Bentley doubles as Mikie so that
the women's "act of revenge for the anger that they feel towards white
women is given a double impact on the infidelity witnessed in the first act"
(Goddard 30). Pinnock meticulously stresses that Leela is a full, willing
participant in the act, which includes "colouring" Kate's face by smearing
lipstick on it and cutting off Kate's plait. The quiet violence of this act is
heightened, as in Edward Bond's *Saved*, by the callousness and indifference
of the perpetrators and by the depth and force of Claudette's rage:

> It's like there's no escape. You can't run away, it follows you. You can't be
> yourself because you've always got to be ready to defend yourself. I hate.
> Leel. I can't stop hating. I hate her. (217)

Pinnock is aware, as she writes in the Afterword to the play, that "Claudette's
fanaticism is an attempt to avoid her own pain and longing caused by the
traditional double oppression (both within and outside their communities)
that some black women experience." However, her implication is that
Claudette is unable to "stop hating" because of her "inability to separate the
personal from the political" (226). She will remain trapped by her body; the
best she can do is to move on to another lover. Pinnock thus undermines the
idea that rage or revenge can heal the wounds of the past.

This point is emphasised when, shortly after the scene of vandalism, the most defenceless woman in the play, Sugar—economically at the bottom of the totem pole—is accused of having cut Kate's hair and loses her job. The knowledge of the real, material consequences of her actions finally forces Leela to look beyond her self-centred misconception of Jamaica. When Leela confesses her guilt, Sugar bitterly reminds Leela that she is only a foreigner, a tourist:

> What you want from me? You come here looking for … You tell me what you looking for. Unno tourist think you belong here. But you come out and you don't know where to put yourself: one minute you talking sisterhood, the next minute you treating us like dirt. You just the same as all the other tourists them. (223)

Rejected, Leela can only ask "Where else can we go?" But it is only at this point—not when she cuts Kate's plait—that Leela herself is able to acknowledge her suppressed hatred and rage, which the assault on Kate has obviously not helped her to overcome. Echoing Claudette, her words rush out, and she finally experiences the emotional release, the catharsis she has been seeking:

> Broken, yes. Invisible people. We look all right on the outside, but take our clothes off and you'll find nothing underneath, just thin air. That's what happens to people who have no language—they disappear. Only your feelings tell you that you exist, so you cling on to them even if they're not nice. And they're not nice. I'm angry, Sugar. I can't stop hating. I hate the world that tries to stifle me. I'm angry with myself for not being strong enough to hit out at it. (223)

Leela explodes into speech and eventually starts talking in tongues, reclaiming the "first language" she had craved in Act One. Interestingly, as Sugar holds and supports Leela in a visual echo of the prologue, the opening scene retrospectively acquires a deeper set of meanings. Given the particular circumstances of their relationship, discomfiting nuances of power now complicate the audience's memory of Sugar's massaging Leela. But the act also seems to signal forgiveness and reconciliation, as though Sugar has come to understand what Leela seeks in Jamaica and why she cannot go anywhere else to look for it.

However, Pinnock leaves unanswered Leela's plaintive question "Where else can we go?"—seeming to doom travellers and diasporans to what Griffin calls "unbelonging." The motherland may massage and serve, the dolphins may swim along, and the sea may smell of sex, but Pinnock shows the bodily satisfactions of this homecoming to be deeply compromised and provisional. They ultimately cannot, by themselves, provide Leela with

the kind of knowledge she needs for London. Indeed, the play reveals knowledge in a political and material sense to be inadequate and unreliable: rather, it is the deeper state of preparedness that Leela acquires during her trip—enabled by "distance" and rest, long walks, the opportunity for introspection, and finally the glossolalia—that allows her to affirm with confidence at the end of the play that it is important "to displace the weight of your body": "You've got to be in touch with your body. It soon gets used to sudden challenges" (225). The choice of words here is very careful: Leela suggests that displacement, like alienation, involves a kind of deliberation and control rather than a loss of direction and, moreover, that it is a necessary prelude to balance and mental health.

Pinnock ends the play with a gesture towards reconciliation, one that seems to repudiate Claudette's values and allows the play to end on a note of cautious optimism on the eve of the women's return to London. When Kate offers to show Leela some of her walks, Leela at first refuses, but then partly relents, saying she will go with Kate "next time" and avowing that Kate's walk "sounds like my kind of walk" (225). The return of Leela's voice opens, albeit tentatively, the way for Leela to establish a relationship with a white woman (and here the theatrical doubling of Fran and Kate is especially significant aesthetically). The play derives its title from the Biblical story, which, Pinnock writes, has always fascinated her because "the idea that the whole world once shared the same language appeals to a certain sentimental idealism":

> This story suggests that we are potentially more alike than we know, and that, while we will never again speak the same language, one of our quests is to find our way back to each other. (226)

Leela is not yet prepared to walk with the white woman—it will take another visit to Jamaica to do that—but the implication of Pinnock's artistry is clearly that Leela's journey has provided her with the insights and the self-containment she needs to be able to find her own way home.

Commentators have noted that Pinnock's work is "realist" rather than "experimental" or non-mimetic. But that approach to her work is limited. In Pinnock, we *do* find a realist aesthetic as a political project—giving voice to the silenced or realising the hidden—but we also find strategies of critical alienation such as we find in epic theatre and an aesthetics of silence such as we find in Beckett and the absurdists. It is this juxtaposition of the materially authentic against inner silences and dislocation that mark Pinnock's reserved, elliptical style in *Talking in Tongues*. Her realist characters function in a post-Brecht, post-Beckett landscape: they are disenfranchised, unsure of their position in time or place, run over by the

forces of late capitalism, often angry—but are lacking revolutionary context or consciousness. They are, nevertheless, also postmodern subjects who learn the value of both discourse and silence in the process of self-refashioning.

Works Cited

Brecht, Bertolt. "On the Use of Music in an Epic Theatre." In *Brecht on Theatre: The Development of an Aesthetic*, edited and translated by John Willett. New York: Hill and Wang, 1966.

Goddard, Lynette. "West Indies *vs.* England in Winsome Pinnock's Migration Narratives." *Contemporary Theatre Review* 14.4 (2004): 23-33.

Griffin, Gabriele. *Contemporary Black and Asian Women Playwrights in Britain*. Cambridge: Cambridge University Press, 2003.

Mercer, Kobena. *Welcome to the Jungle: New Positions in Black Cultural Studies*. New York and London: Routledge, 1994.

Pinnock, Winsome. *Leave Taking*. In *First Run: New Plays by New Writers*, edited by Kate Harwood. London: Nick Hern, 1989.

—. *Talking in Tongues*. In *Black Plays: Three*, edited by Yvonne Brewster. London: Methuen, 1995.

CHAPTER FIFTEEN

NOT 'IN-YER-FACE' BUT WHAT LIES BENEATH: EXPERIENTIAL AND AESTHETIC INROADS IN THE DRAMA OF DEBBIE TUCKER GREEN AND DONA DALEY

DEIRDRE OSBORNE
GOLDSMITHS COLLEGE, UNIVERSITY OF LONDON

If we can believe the wooden O is now England, now France, why cannot we agree that emotional truth is more than skin deep?
—Benedict Nightingale, 1991

To use black culture and experience to further enrich British theatre.
To provide high quality productions that reflect the significant creative role that black theatre plays within the national and international arena.
To enlarge theatre audiences from the black community.
—Talawa Theatre Company[1]

Aleks Sierz coined the concept of "in-yer-face" theatre as a means of accounting for new dramatic writing by young British playwrights from the mid-1990s onwards. Consolidated via his journalism and a website, the term titled his subsequent book *In-yer-face Theatre: British Drama Today* (2000) and became a convenient "sound bite" wherein the staging of taboos, extreme violence, representations of graphic sex acts and the (initially) outraged responses of mainstream critics were combined to comprise a framework of reception for certain plays. Sierz declared that his intention was to "restore the writer to the centre of the theatrical process, and remind society at large that living writers are not only symbols of theatre's vitality but also a crucial resource for the whole culture" (Sierz 249) It is the sweeping claim—"resource for the whole

[1] Aims of the company available online at http://www.talawa.com.

culture"—which exposes the myopia of Sierz's vision. The book is completely devoid of any Black British playwrights. Former Royal National Theatre director Richard Eyre and co-author Nicholas Wright had also propagated this exclusion zone in their *Changing Stages: A View of British Theatre in the Twentieth Century* (2000), which garnered increased exposure when it became a television series that Eyre narrated. It does not, as Dimple Godiwala notes, "even pretend to include British black and Asian theatres as part of Britain's recently changing stages" (Godiwala 5)—changes catalysed, it should be added, by the increasing visibility of Black and Asian people as both practitioners and audience members in traditionally "all-white on the night" mainstream arenas of performance. The preserving of white-led cultural production in Britain—at the expense of logging the presence of black people's contributions—still clearly thrives in the new millennium and, in turn, perpetuates the distortions which have characterised traditional British theatre historiographies. In addition, the theorization and the calls for recognition of a Black British aesthetic—which have developed in relation to music and, increasingly, in relation to popular culture, film, visual arts, television, and various genres of literature—have not provoked concomitant research and application to the circumstances of black British theatre and performance.[2] There are changing definitions of blackness in relation to dramatic literature and theatre which require separate consideration from critical treatments of prose and poetry.[3] Opportunities for experimentation, failure, and refinement have not habitually accompanied the genesis of black theatre in Britain as black theatre practitioners in all spheres of expertise have encountered establishment roadblocks on their routes to development and practice.[4] Whilst African-derived traditions of performance have been an

[2] Only two anthologies of critical essays dedicated to Black British and Asian British theatre and performance have emerged to date: *Alternatives Within the Mainstream* (Godiwala ed.) and *Staging New Britain* (Davis and Fuchs eds.) both published in 2006. Other neo-millennial texts either privilege sex-gender (Griffin *Contemporary Black British and Asian Women Playwrights*, 2003) or constitute a single chapter in a larger volume (Aston and Reinelt eds. *The Cambridge Companion to Modern British Women Playwrights* 2000, Aston, *Feminist Views on the English Stage*, 2003 and Aston and Harrison eds. *Feminist Futures?*, 2006).

[3] Ralph Berry notes how contemporary demographic realities problematise theatrical literalism as acting 'depends upon casting, and casting is not commensurate with other rights in society. An actor is his body. Whatever his acting skills, he is inescapably his physical self.' (Berry 2000: 35) This has implications for opportunities afforded to actors who are not white in British theatre as, 'Even a non-naturalistic play needs to be rooted in some kind of social reality [...] the dynamics of the play can be blocked by insensitive casting.' (36)

[4] Recently American-born playwright and cultural commentator Bonnie Greer recalled that as she sat on a panel of 'two black producers and a black director, casting a "non-

acknowledged influence, a U.S.-/Euro-centric critical measuring stick has served as a definitive indicator of quality. Demands for instant expertise and success (in what has been scarcely a level "playing field" politically, financially, and culturally) have led to disparaging and dismissive critical responses to much black-led work. This history problematises overt identification of a uniquely Black British aesthetic in the theatre context. Moreover, dramatists seeking to have their work produced at the end of the twentieth century face the familiar conundrum of representationalism *vs.* artistic individualism—a constraint that their white counterparts simply do not have to face. Such limitations can also be exacerbated by Black communities' expectations of Black artists' work. Baroness (Professor) Lola Young points out: "There is complicity on the part of black people too, who view anything that isn't 'street' to be 'inauthentic' and not 'really black.'" The Black theatre artist's estrangement from mainstream (white-majority) audiences is increased by filtering access, as Christopher Rodriguez recognizes—"through a middleman [the venue]": "This could create a situation in which the work may be limited to sensationalism, or easy narratives that compound what the audiences believe of non-whites anyway."[5]

As long as theatre by Black practitioners is laced to issues-based contingencies, fears abound regarding the longevity of the work within cultural archiving and systems of historiography. The actor, playwright, and screen-writer Lennie James asks, "What happens to us when the 'issues' are no longer of interest to the programmers of today's theatre?" (personal interview, 11 May 2005). Kwame Kwei-Armah has noted the uphill battle to achieve canonical recognition that this situation produces: "History has taught us as black artists that our work is at best contemporary. Very few of our plays have fallen into the realm of the modern classic, revived again and again"(personal interview, 15 October 2004).

How are the merits of indigenous black theatre to be evaluated and included in British theatre history? At the close of the twentieth century, Jatinder Verma (founder of Tara Arts, the longest-running Asian Theatre company in the U.K.) considered that "if there is going to be any point in using the term 'black theatre,' it has to find a theatrical form for itself. It has to be

black" show', twenty years ago she had envisaged 'that such a scenario would by 2006, be run of the mill. But it isn't.' (Greer 22) In the same article she quoted an anonymous 'young black director' who told her, 'there are black people out there right now who start out far more qualified to run British cultural institutions [...] But for many boards we still represent a risk [...] that somehow a black person would lead their institution down some monocultural route that is race specific.'(23) The irony of this observation is striking for (white-Eurocentric) monoculturalism is exactly what the past forty years of official British multiculturalism has supposedly redressed.
[5] In B. Greer, "The Great Black Hope," *The Guardian G2*, 17 May 2006:23.

more than a question of equal opportunities or all-black productions" whilst Felix Cross (Artistic Director of NITRO, formerly the Black Theatre Co-operative) asserted: "It is only when black theatre develops something white theatre doesn't have that it will have the power and influence to move forward." Both of these observations identify how an aesthetic component is vital in characterising Black British theatre, together with its liberation from inhibitors to experimentation. In her re-visionary account of possibilities for the aesthetic, Isobel Armstrong summarises a similar dynamic,

> The aesthetic is emancipatory because access to the change of categories is possible in many ways and in many different areas of our culture and its productions. Categorical experiment—new kinds of knowledge—breaks down the binary of high and low culture because it is produced incessantly. (Armstrong 42)

She furthermore advocates a politicized aesthetic, something arguably appropriate and inevitable when considering Black British theatre. It is a tool, moreover, to be wielded by women who enter into language and the symbolic "in different ways and on different terms" to men.

> Women's first object must be to disband the gender-neutral language round the classless society built on privilege, with its free choice predicated on an underclass, and to ask where women function in this structure – poor women, Black and Asian women. We will not do this if we lose one of our strengths, a politicized aesthetic. The aesthetic is not political, but it may make the political possible. (Armstrong 43)

In the first decade of the new millennium, white men continue to maintain hegemonic sovereignty in the realm of theatre despite recent governmental arts policies,[6] contemporary media coverage highlighting the need for greater diversity,[7] and the fact that the first home grown (male-authored) Black British

[6] See Alibhai-Brown *The Independent* 9 July 2003. Indicative responses to the Arts Council of Britain's Race Equality Policy (2005) are profiled in Hastings and Jones *The Sunday Telegraph* 2005:9 For a view from abroad see Riding *The New York Times* who in profiling the Policy notes, 'Certainly no other Western country has tried to link culture and race so openly […] It risks charges of cultural Stalinism if it cancels grants to groups that ignore its new policy. Yet it also has in its hands an instrument that can help people of all backgrounds accept the different colors, voices, customs and rhythms of a Britain in transition.' (3)

[7] See Gardiner 27 July 2005; Greer 17 May 2006. Recent appointments of new Artistic Directors to the Royal Court and Theatre Royal, Stratford East (both with established traditions of staging plays by Black writers) have again resulted in white men taking over from white men.

productions of *Elmina's Kitchen* and *The Big Life* appeared in London's commercial West End in 2005. Male power is the reality. The staging of Black British women's drama, in particular, still remains, at best, rare. Sex-gender and race disadvantages appear to fuse more acutely in this context than in other arts disciplines. Tania Modleski observes that "until there is an appreciable change in the power structure, it is unlikely that women's fictional accounts of their lives [...] will have the force to induce masculine *jouissance*." This reality of male power is "the most crucial factor in men's traditional disregard and contempt for women's writings and women's modes of existence."

When considering the work of women playwrights, critics using the prevailing aesthetic against itself can open up not only a counter-aesthetic but also aspects of Helen Tiffin's "counter-discourse" (see Tiffin 22). Whilst Gilbert and Tompkins address "forms of canonical counter-discourse in post-colonial theatre" specifically, theirs proves a useful model to bear in mind in considering the work of contemporary Black British women dramatists because, by definition, "counter-discourse seeks to deconstruct significations of authority and power exercised in the canonical text ... to release its stranglehold on representation and, by implication, to intervene in social conditioning"'(Gilbert and Tompkins 1996:16). The canonical is, in this case, the all-pervasive genre of social-realism conditional to the staging of Black dramatists' work, or domestic dramas, diasporic dramas, and so on. Working against the tide of disregard, Black women dramatists in Britain, from Jamaican-born Una Marson onwards, have created their own vanguard in relation to mainstream theatres. Indeed, the habitually overlooked Marson wrote the very first play by a Black woman to be performed in London's West End, *At What a Price*, Scala Theatre (1933).

More recently, adding to the established legacy of contemporary playwright Winsome Pinnock, two more Black women dramatists—Dona Daley (1956-2002) and debbie tucker green—provide compelling examples of the key ways in which contemporary women dramatists articulate sensibilities and perspectives—arising from their positions within culture and theatre—that are distinct from those of their male contemporaries. Their plays exemplify the types of inroads and aesthetic possibilities evoked by Jatinder Verma, Felix Cross, and Isobel Armstrong. They experientially and linguistically take drama down new routes in the indigenous British theatrescape. Both tucker green and Daley distinctively dramatise articulations of the uncharacteristic in British theatre. The authority of Standard English occupies a secondary status as patois, choreo-poetical, and non-grammatical syntax are the means of articulating their dramatised dialogues. In fact, tucker green's idiom qualifies for Kristeva's revolution in poetic language. Her drama texts demonstrate a way of "shattering and maintaining position within the heterogeneous process" as her texts themselves become what Kristeva calls a semiotic device (Kristeva 109).

Daley and tucker green both effect substantial forays into dismantling the identity-politics or issues-based contingencies in which Black drama in Britain traditionally has been housed—to the point of claustrophobia. Additionally, their *dramatis personae* challenge assumptions, expectations, and stereotyping regarding age and race in relation to casting. In contrasting ways, they produce sustained experimentation with form, style, and subject matter to assert black experience as more universal than marginal. Whilst Daley employs unqualified naturalism in her patois-rendered dramatisations of the mundane intimacies that weave lives together, tucker green blows even this expectation apart with a blitz on the comfort zones of theatrical realism in her verbal freefalls and controversial or confrontational topics: incest, misogyny, female sex tourism, domestic violence, AIDS, genocide, and child soldiers. While Daley's plays provide the gently familiar fizz of sea water that laps ankle high, tucker green's work offers a swift immersion in often murky or uncharted depths of human experience.

Both writers can be characterised by a "less is more" aesthetic, whether the effects are the result of small casts, shorter than usual running-times on stage, lack of intervals between scenes, pared-down language, single-set locations, or minimal props.[8] This minimalism, however, diminishes neither the scope nor the vision of their drama. Of tucker green's play *trade*, Benjamin Davis noted: "An index of good writing seems to be having the confidence to tackle the big stuff in miniature form." He also observed that "the pithy treatment is made possible because the political is always refracted through the personal" (Davis 302). Of Daley's *Blest be the Tie*, Ian Shuttleworth wrote, "Daley's concerns emerge naturally through her characters rather than hammering an agenda[.... It is] the kind of drama that examines multicultural Britain from within the cultural mainstream" (Shuttleworth 494).

Blest be the Tie (2004) continues the epic trajectory of post-war Jamaican women's experience of migration, which Daley established in *Weathering the Storm* (1997) and re-captured in the unfinished *Barber Shop*. Read in succession, these plays chart the socio-economic aspirations stimulated by migration and its associated cultural compromises as women struggle and respond strategically to settling and raising English-born children. Biological bonds to the country of origin are set against those that emerge from their nurture and new connections rooted in England. The implied comparison between those who were left behind and those who emigrated invites identifications and evaluations as to which factors actually comprise the

[8] Writing in the year both Daley and tucker green premiered plays, Sierz lamented how, 'Many British plays are accounts of "me and my mates", often set on "sarf" London council estates. They have small casts, small ambitions and small subjects.' (2004: 23)

diasporic inheritance for African Caribbean women in Britain. Lyn Gardiner
outlines the course of diasporic drama—

> Plays about diaspora often have a formula. The one who left home—whether it's
> Ireland or Jamaica—returns in triumph or failure. Then they spend two hours
> discovering either that home is where the heart is or that the place of their birth
> has changed beyond recognition and the feelings that drew them back are
> nothing but nostalgia or a trick of memory.

—and notes that "Dona Daley's play offers a variation" (Gardiner 494). The
action remains in the U.K., and the result is not straightforward: "We are wooed
into a homecoming narrative in which the reference points of where 'home' is
and who is 'returning' are twisted and re-turned in a subtle undermining of
certainties" (Osborne 143).

Daley attested that acknowledging "the shoes that had pinched" the
feet of those who came before her was part of her development and heritage
(personal conversation 2001). *Blest be the Tie* is a fictional tribute to her own
mother's experiences. The *dramatis personae* of three women in their fifties
calls to mind the scarcity of central roles for women of this generation on the
British stage. Two sisters, Martha (who stayed in Jamaica) and Florence (who
emigrated), are re-united in Martha's council flat overlooking Clapham Junction
station. Now calling herself Cherise, Martha, the international prize-winning
hairdresser, clearly has the economic upper hand and is disdainful of London's
shabbiness ("plenty dirt and muck round de place..." p.44) and her sister's
circumstances ("People pee inna de lift, fighting to keep warm. Small balcony fe
a garden. Yu don't have to live like this..." p.30). The very differing
perspectives of giving and receiving material support and the feelings of
sacrifice and deprivation these produce highlight the rupture between the sisters.

> FLORENCE Tings woulda been better fe me coulda look straight. All the while I
> have to looking back. Mama have enough? Martha school fees pay dis term?
> [...] 'Dear Sister Florence ...I begging yu dis and, sis, I begging yu dat!'
> [...]
> So when I put me foot down and tell yu she yu must satisfy wid de one parcel a
> Christmas and anyting dat me can send, yu stop write!
> [...]
> The help I was giving to you to get out of a hole meant I was pushing myself
> into a deeper one!
> [...]
> MARTHA [...] Whey yu was when me haf fe a work and look after Mama?
> Whey yu was when me haf fe get up soon and tek care of my kids them and then
> stand up fe twelve and fourteen hour fe a few dollar a day?[...] Yu an yu blasted
> parcel dem! Pure cheap foolishness![...] Trouble was yu sending de wrong tings.
> (Daley 55-56)

Martha's description of supporting her family in Jamaica ("No help. Me one and me pickney dem! No husband! No mother!") leads her to suggest that other means of survival were necessary, in a side to her life withheld from both Florence and the audience (Daley 56). "Me haf fe do all kind of stinting fe mek sure me have money fe products fe do people hair![...] No mind! I did what I did haf fe do!" (56-57). Here, Daley alludes to the complexities which fuel people's choices in life and enables non-judgemental conjecture regarding the potential source of Martha's earnings. As Florence misread Martha's needs, in a reversal of their financial positions, Martha/Cherise similarly misreads Florence's. She seeks to exert her new economic power over Florence by purchasing a new (unasked for) sofa and then by compelling Florence to return to Jamaica: "Yu pension would carry yu far" (34). However, Florence is shown to "know her place" in a situation that, ironically, also recalls Martha's hardship as mother and breadwinner.

> FLORENCE You know how I have to suck salt out of a wooden spoon to get that settee. Leave the kids them sleeping early morning gawn fe clean. Run back to see to them. But it was worth it. Have a nice front room[....] Somewhere fe sit and consider de progress that me an Archie mek. (59)

Her place is unequivocally personified in her domestic landscape, a composite of the stages of her life in England, for better and for worse. "I used to smile and couldn't tell them that like Mr Whittington Cat, me bury de filth and was sitting on it so dem couldn't find it" (65). Involuntarily re-located to a new high-rise estate, she remembers the demolition of her street: "I stand and watch how dem tek down in a few minutes whey we did tek years fe build. Only bricks and mortar. But still. At least me did have me few tings" (66). In the periphery of the text, Florence's children and grandchildren thrive, testaments to the investment of her hardship. "Masters. I have two first-class degrees and a Masters! The children have done well!" (25).

Ian Rickson (Artistic Director of the Royal Court Theatre, London, which commissioned both Daley and tucker green) said that Daley had "the ability to write feeling, which is not fashionable." In doing so, she encouraged the audience to go to a specific place "which we occupy in a liberated, non-judgemental way to present a subtle, rich, pure distillation of a particular world and heritage that tends to be under-valued" (personal interview, 22 March 2004). Paulette Randall (who as Artistic Director of Talawa, Britain's premier black theatre company, directed the play as a co-production with the Royal Court) considered that Daley's unique contribution to Black British drama lay in its uncompromising female-perspective (personal interview, 19 March 2004). There are no male characters or children—traditional signifiers of female social

—as the cross-race friendship of two women (rather than a woman and a man) is the primary relationship dramatised.

This subtlety clearly tested some critics' endurance in what were in majority, positive reviews of the play. Sam Marlowe praised its poignancy, vivid and witty dialogue, and humanising of questions of race and nationality, but concluded that it was "schematic and predictable" and, whilst it was "impossible not to warm to" the three actors, "It's a pity the play doesn't give them a little more to work with" (Marlowe 494). Dominic Cavendish also found the play to be poignant and truthful, noting the ambiguously lesbian kiss[9] between Florence and Eunice as "perhaps the first of its kind between middle-aged women, one black the other white, on the British stage." However, he decided that "Much as you might chuckle at the patois-laden exchanges, after 100 minutes it's hard not to think: blest be the end" (Cavendish 494). Helen Chappell noted a domestic drama at work: "What Daley does so well is capture the tangle of affections and resentments festering in the bosom of every family," yet the play "stubbornly remains a piece with narrow horizons [...] a slice-of-life script without enough meat to sustain its two-hour running time" (Chappell 495). Rhoda Koenig offered the most slating critique of *Blest be the Tie*, a review which is also riddled with inaccuracies and indications that she had her own creative ideas about suitable subjects for theatre. "Eunice, the only white woman on this Brixton street" is her oblique comment on a play set in Clapham Junction. Koenig rails against "an actress in the part of Eunice who looks about 20 years younger and three stone lighter than her character"—based upon what? Certainly not the text!—and even offers her own storyline: "a different play, one that I would really like to see—about women who make themselves phony and gullible, colluding with their manipulators, because the truth is too painful to face" (Koenig 495). Her suggestion evokes the lives of millions of women across the centuries and proposes a topic that is neither radical nor original in theatre. Arising from the phase of British theatre's "in-yer-face" reductivist categorizations, the wistful qualities of Daley's drama (it is no wonder) can appear out of synch with what critics believe "theatre" should be. Daley's plays challenge preconceptions, calling into question theatre's production of certain kinds of knowledge. Yasmin Alibhai-Brown has consistently drawn attention to the scarcity of black critics in British theatre and the distorting effect of white-male domination upon the reception and understanding of black dramatists' work: "we often get prejudice parading as expertise or patronising tolerance" (Alibhai-Brown 2005). Like the "auto-correction" feature on MS Word® that

[9] In discussing Maya Chowdhry's plays Griffin follows Catharine Stimpson's definition that, 'The kiss has a particular and poignant history in lesbian cultural representation since it has figured as the symbol for lesbian sex.' (Griffin 248 n.23)

unfailingly imposes capitalisation on tucker green's name, so too have many of this critical coterie sought to "correct" or point out tucker green's deviations from—and, by implication, her deficiencies in—what they conceive of as "good theatre"—just as Koenig did in her review of Daley's play.

Sonia Boyce's remark on her having identifying herself as a Black woman artist was "That's not necessarily who I am, but what I am" (Baker et al. 308). Boyce here places herself in a self-consciously constructed category of creative artists. Her art is not some socio-realistic extension of herself inexorably laced to manifesting the personal. Similarly debbie tucker green resists collapsing her personal identity into her work. As she observed, "Writing is just something I'm doing at the moment; as I've said, I've done a bunch of other jobs," noting that "women are often clustered by what they write about" (talk at Goldsmiths College, University of London, 1 February 2005). In her relatively short time as a commissioned playwright, tucker green's achievements are impressive. *Two Women* (2000) for the Paines Plough Wild Lunch IV series was short-listed for the Alfred Fagon Award and her next play *born bad* won the Olivier Award for Most Promising Newcomer (2004).

tucker green's plays tend to be delivered via internal monologues or dialogues that uncompromisingly jar (both in content and rhythm) against the familiarity of social realism. Their linguistic remorselessness and rawness are simultaneously alienating and compelling. She resists the imposition of Standard English, a fact that led one white male critic to mimic and deride it in his review of *dirty butterfly* as "Ali G-style patois [...] not so much ethereal as absurd. A no-go zone innit" (Cavendish 2003), thus ignoring the emotional throb that this pared down language pounds out in delivery. Whilst acknowledging her radical voice and style, critics tend to liken her to Sarah Kane. This comparison is irksome to green. She cites poet Louise Bennett and singers Lauryn Hill and Jill Scott as influences. Her style of specified active silences evokes Suzan Lori Parks's technique, but she has stated that Ntozake Shange's choreopoems and Caryl Churchill's invention of multi-overlapping dialogue have also influenced her own dramatic strategies. In this respect, tucker green revives and revitalises the techniques of her woman dramatist forebears. Their innovations are embedded in her texts and, yet, taken in new directions. She has explained her creative method as listening to "a voice in her head that won't go away"—voices that "grow into scraps of writing that she then fits together" (Gardiner 13). For *born bad*, tucker green explains, she began with dialogue written chronologically—and not narrative—an ad hoc way of developing the play where it was not immediately apparent what had happened and who is actually in the family (talk at Goldsmiths College, 1February 2005). Mirroring the family

members' explosive interactions, their ascribed language alternately crashes and chimes. The repetition of a single word to shift conceptual contexts, releases the potency of her unique style of wordplay.

> SISTER 1. [...] It wasn't by misfortune. It weren't.
> It weren't all your misfortune.
> You weren't borned misfortunate.
> More misfortunate.
> Unfortunate.
> Unfortunately.
> Born bad. No. (8-9)

Like a Fury unleashed, Dawta uncompromisingly pursues her revelations of abuse. Naming and shaming is her dramatic *raison d'être*, and she leaves no stone unturned as everyone is drawn into her remorseless quest for the truth, forcing re-evaluations, admissions, and ultimately a confirmation that incest has occurred. The complexity of the delivery for actors is demonstrated as Brother, his Sisters (both 1. & 2.), and Dawta work up to confronting Mum and Dad.

> DAWTA. Don't
> BROTHER. It is –
> DAWTA. Don't, y'know
> BROTHER...only –
> DAWTA. Don't do this –
> BROTHER. A chair.
> Beat
> MUM. And why wouldn't he?
> BROTHER. Listen
> DAWTA. Don't
> SISTER 2. So, how does that work then?
> MUM. Why wouldn't he?
> BROTHER. Listen –
> SISTER 1. just sit down, just sit there just –
> MUM. Why would he not want to –
> SISTER 1. just sit. (tucker green 47)

Characters interrupting and continuing each other's sentences and thought processes—a method that accesses and displays language beyond formalising constraints—necessitates a "choreography" of lines in order for the actors to communicate the written text. In Churchill's *Top Girls*, Lesley Manville described how "horrendously difficult" was "to learn your lines" and "also the exact moment when you interrupt [...] it's a question of passing the baton successfully" (Goodman 83). The primacy of ensemble-playing applies equally to the demands of acting in all of tucker green's plays because she undermines

conventional syntax and weaves together her own melodic version of a script that allows multiple voices and perspectives to co-exist. In *dirty butterfly*, the physical wall between the (black) couple—Amelia and Jason—and Jo, their (white) neighbour, a victim of nightly domestic violence, is dissolved in a merging of their consciousnesses.

> AMELIA. I'm off.
> I'm off out.
> I went.
> To the caff.
> Beat.
> I went out to work.
> You should've come with, Jason.
>
> JASON....I'm not goin nowhere.
> AMELIA.
> JASON.
> JO.
> JO. Heard you the other side still, still trying not to be heard...
> JASON. I won't go nowhere.
> AMELIA. You shoulda come, Jase.
> JO. But you've gone, Amelia.
> You've got up, you've gone out and you have left.
> ...you ever –
> JASON. You ever –
> JO. You ever felt to piss like that then?
> ...Thought not. (tucker green 16-17)

Jason becomes increasingly obsessed with the nocturnal nastiness on which he compulsively eavesdrops whilst Amelia sleeps downstairs to escape it. tucker green's plays are unapologetically difficult to watch. Although no physical violence actually occurs on stage, the links between sex and violence (and their titillation possibilities) become unpalatably and unavoidable evident—a process in which the members of the audience turn out to be complicit voyeurs. Of *dirty butterfly*, Gardiner noted, "I cannot say that I enjoyed it very much, but I liked it a great deal" (Gardiner 252). The potency of evoking rather than enacting disturbing subject-matter effectively maintains a focus upon the identifiable aesthetics of the piece: an unhooking of language from Standard grammatical constraints, its demotic delivery, and the withholding of any catharsis.

In addition to her linguistic inventiveness, tucker green forces casting revisions in her most recent plays *stoning mary* (2005) and *trade* (2004/5). Ian Johns—from a clearly unabashed, mainstream, white-centred, perspective—summarised: "We tend to associate these three situations, respectively entitled The Aids Genocide: The Prescription, The Child Soldier and Stoning Mary,

with Africa. Perhaps attacking our sense of detachment from these distant problems, Tucker Green brings them closer to home by giving them a white, British urban voice" (Johns 424). The unproblematised "*we*" is, of course, the very viewing position tucker green seeks to destabilise. In specifying that "The play is set in the country it is performed in. All the characters are white" (*stoning mary* 2), tucker green confronts associations of Africa as a generalised site for suffering, victimhood, exploitation and disaster. As staged by Marianne Elliott, each component of the story was heralded by a luminous white sub-title in the cavernous space of the playing area (designed by Ultz), a subliminal reminder of Western imperial culpability for the tragedies dramatised. In what is the most detailed and discerning appraisal of the political theatre and aesthetics at work, Victoria Segal (one of the five female out of seventeen white reviewers), describes the result, "The impact is immediate and intimate, a headline you cannot look away from, human emotion spilling out from behind the flat, stark words" (Segal 425). tucker green's play prevents the white-majority audience (which the Royal Court demographically serves) from slipping into familiar generalizations, whilst for black audience members a dual viewing position is opened up, one of privilege derived from a European context and as black British citizens who are still separated from the "whole" through government-speak categories such as British Minority Ethnic.

In *stoning mary*, the AIDS afflicted characters, husband and wife (who can only afford one prescription), have their own "wife ego" and "husband ego" to dramatise repressed thoughts. They share equal dramatic status to reveal the destructive ritual of marriage.

HUSBAND EGO	Eyes to the floorin it like I've done her something. Playin powerless
WIFE EGO	play powerless
HUSBAND EGO	playin powerless badly.
WIFE	'What if I wanna look after you?'
HUSBAND	'What if I wanna live lookin after you? (I'd) look after you and love it.'
WIFE EGO	Liar.
HUSBAND EGO	Liar (*stoning mary* 16)

Another married couple (MUM and DAD) amplify the misogyny that underpins the institution of the family as enshrined in the Law of the Father. That couple's son is now a Child Soldier—"those two words which [as Jane Edwardes commented] should never be linked" (Edwardes 428). The male-male bonds serve to erode the mother's sense of self-worth and the original oneness she experienced with her son:

MUM	His time he'd / spend.
DAD	Laughin like that
MUM	his time he'd spend with me –
DAD	laughing at you like that
MUM	the time he'd make to / spend with me
DAD	laughin at your smell
MUM	The time he did spend with me.
DAD	Laughin at y'you and your smell, with me, like that.
	We did.
	That.
[...]	
MUM	
MUM	
DAD	
MUM	I wear it cos he bought it.
DAD	He bought it for a joke.
MUM	...It reminds me of / him.
DAD	You are a joke. (*stoning mary* 25-26)

In his review, Michael Billington declared, "Words alone do not make drama: what one craves is a marriage between action and language" and stated that *stoning mary* "feels more like an acted poem than a play" (Billington 28). *trade* again up-ends Billington's criteria for dramatic success, but confirms what Kate Bassett had declared in her review of *born bad* three years before: "I'd like to stick my neck out and say Debbie Tucker Green is one of the most assured and extraordinary new voices we've heard in a long while" (Bassett 12). It is telling that tucker green's critical advocates have been largely women. Most recently, Lyn Gardiner noted of *trade*, "While others struggle to find a distinctive voice, tucker green has developed her own unique way of saying things. [...] She makes you hang on every word" (Gardiner 38). In contrast, male critics are frequently fixated on "length"—deriding tucker green's previous plays for their brevity, presumably in comparison to a "comfort zone norm" regarding acceptable length. (Harold Pinter does not get charged with such temporal shortcomings.) Michael Billington felt the need to mention duration for *stoning mary*—"this highly wrought 60-minute piece" (28)—as did Charles Spencer of *The Daily Telegraph*, who denounced "yet another dud" for which "theatregoers who have paid top whack for an evening out (£27.50) might feel rather less enchanted" (Spencer 16). Although he responded positively to *trade*, Sam Marlowe opened his review with "It's only 40 minutes long, but [...]" (Marlowe 17); and Kieron Quirke noted early on that it is a "40-minute chamber piece" (36). It may be condensed, but *trade* continues the demands put upon actors in *born bad* and *stoning mary* as characters' voices interweave,

overlap, complete each other's thoughts, echo each other and, verbatim-like, re-
state phrases with shifts in emphasis and pronunciation and hence proliferate
meanings.

REGULAR	'Nice' / I / uh / haven't been called for… years.
	Beat.
	I haven't been called anything for years.
	I haven't called myself / even / well you
	(don't) / for / uh / for / for…for…
	years.
NOVICE	'Nice'?
	'Nice' came with another drink?
	'Nice' came with the drink did it?'
LOCAL	'Nice'…ice and a slice –
NOVICE	'Nice' was what did it was it?
	[…]
NOVICE	Nice and easy.
LOCAL	She is.
	Emotional.
	Emotionally easy.
	You are.
REGULAR	I –
LOCAL	Juss too easy –
	(re NOVICE) You are.
	NOVICE ups the middle finger to LOCAL and REGULAR

<div align="right">(trade 14)</div>

Timing and ensemble-coherence demand an intensive inter-play as the actors
slide between sexes, ages, races, and nationalities to deliver an inversion of the
world's "oldest profession," played out in a consumer context where European
women are travelling in ever-increasing numbers to former colonies to buy men
for sex. The title evokes not only Kieron Quirke's glib "The times being what
they are, I rather expected *Trade* to try and influence my choice of tea bag"
(Quirke 16), but given the implied location, the Caribbean, the play's title also
reminds the audience of another, earlier trade in human bodies, the commerce
relating to trans-Atlantic slavery. To represent a *dramatis personae* of eight
characters, "three black actresses" play female, male, white, and black
characters (*trade* 4). This authorial directive liberates casting expectations from
both "colour-blind" and "societal casting," which have dogged opportunities for
black actors in British theatre.

tucker green's paring down of language draws attention to the
unnecessary effluvia of much contemporary drama. The plays' mini-philippics

confront Billington's notion of drama (as a "marriage between language and action") since in tucker green's plays speech *is* the action of the drama. Although one internet critic referred to "The Novice, who jabbers incessantly and swears like a trooper with Tourette's Syndrome" (Kirsty Brown), perhaps Kristeva's linguistic model might more aptly account for the aesthetic at work here: "the semiotic pulverizes [the text]...only to make it a new device—for us, this is precisely what distinguishes a text as *signifying practice* from the 'drifting-into-non-sense'[*derive*] that characterizes neurotic discourse" (Kristeva 104). Exchanges among the plays characters (The Local, The Novice, and The Regular) propel the plot, revealing European tourism's footprints on both the geography and psyche of local people's lives. Each woman positions herself as a cut above the context in which the action takes place and, evoking Aristotle's template for tragedy, falls from this elevation. The Novice, "The Younger White Woman" (7), distances herself from the "ladette" excesses of Aya Napa or of "one a them Faliraki—out-on-the-piss-out-for-days-out-of-me-head-all-night-type-a-traveller. I don't do that" (24). She is Thatcher's child through and through: "I paid for it [...] so I can do what I want" (8). The Local initially has the upper hand: "I wouldn't be buyin a second and third drink of anything for no man I didn't know" (54). Exuding a tough capitalistic business façade through "Local Styles at Local Prices" (52), she is exposed as holding onto an illusion—which is rapidly reconfigured as a delusion—as much as the Novice and the Regular are.

> LOCAL [...]
> The me-an-the-he is a long-term ting.
> [...]
> The we of it/is inna long (term)/lissen –
> me-an-the-he of it is long-term tings / me
> and he been long-term from time/truss
> me.
> A trust ting.
> Truss mi. (55)

She does not use a condom with her prostitute boyfriend—"flesh to flesh it / y'noh / wid nobody but we self / before" (56)—imagining herself special until the Regular reveals that she, too, has unprotected sex with him, based upon a fallacious trust: "...Do you want to know how much I trusted...?" she asks (58). The "trade" is held together by female collusion, which renders the three women inter-dependent, their need for sexual attention framed by misplaced romantic rationalisations.

The set of the production (designed by Miriam Buether), at London's Soho Theatre, featured a circle of white sand on which the three actors sat or

stood. It revolved almost imperceptibly throughout the performance, mirroring the subtle shifts of emphasis and meaning created by the characters' verbatim-like playback of each other's lines. This device ratified the play's cyclical structure, which begins with three locals who say, "we juss live 'there'" (5) and ends with "We just ... live/live here" (61), the ellipsis emphasising the indigenous inhabitants' almost incidental worth in the relentlessness of the holidaymaking cycle. As trade reveals, the cliché of the "holiday romance" has developed a distinctly sardonic edge where women might exercise a superior economic prerogative over local men, but still end up exploited and devalued from their transactions.

* * * * *

It has been much lamented in a variety of contexts: media, theatrical, academic, and political, that Black theatre in Britain has been unable to sustain the strong visible presence it achieved during the mid-1980s. The lack of continuity between the decades means that "consequently every generation then has to come and build again, start gain, believe actually in themselves that they are the beginning" (Kwei-Armah, personal interview, 9 June 2005). Caryl Phillips claimed that there was a relative dearth of new black writing for theatre in the 1980s and 1090s, thus effectively expunging women writers of the Second Wave Women Playwrights movement of 1982 and onwards. ("I hope the Second Wave becomes an ocean," its patron, Glenda Jackson, had declared in its support in 1987). Phillips, furthermore, eradicates the impact of companies such as the Theatre of Black Women (1982), Imani-Faith (1983), Black Mime Theatre (1984), and Talawa (1985), where aspiring women playwrights and performers had the opportunities to develop their work throughout the 1980s and early 1990s. Despite Phillips's oversight, the paving stones were in place for Black women playwrights' entry into the main picture. Anthologies edited by women accompanied the momentum of this output (e.g., Brewster 1987,1989, 1995, Wandor 1985, Gray 1990, Griffin & Aston 1991, George 1993, Mason-John 1999). Academic critical work about Black women's drama also emerged in the 1990s (Croft 1993, Dahl 1995, Joseph 1998, Ponnuswami 2000), albeit, as Griffin points out, these essays are "explicitly political" (Griffin 6) in discussing drama and theatre. The aesthetic dimension was not uniformly addressed, as cases were made for acknowledging and recognising the existence of contextual factors, impediments, and legacies concerning this work. But their writers provided initiatory steps in challenging de-limiting categories and exclusion zones in British culture.

Women playwrights have broached the citadels of British theatre, but are still battling for inclusion. Black women dramatists face the dual

impediments of belonging neither to the dominant (male) theatre culture nor to the theatrical ethnic majority; and, as a result, they have difficulty gaining entry on their *own* terms. However, to recognize this reality is not to present a pathetic standpoint-politics based upon a hierarchy of oppressions. As has been the case for women writers per se, the "dynamics of disappearance" compromises any capacity to form a legacy, or power base. Griffin, for example, concluded that "Insofar as Black women's production for performance has been analysed, this has occurred at the intersection of postmodern, postcolonial, and subaltern studies" (Griffin 3), and it still remains the case that the critical infrastructure and archiving processes assumed for white dramatists by-pass their Black British peers. Furthermore, the dialogic relationship that white-male-dominated criticism engages with theatre is missing or mislaid in relation to the staging of black women's plays. Critical responses smack of thoughts of being "left out" or imply some didactic expectation—both as teacher and learner. The anticipated dispassionate authority of theatre criticism becomes destabilised when critics negotiate culturally unfamiliar territory in drama that tunnels under the bedrock of their expertise. Indeed, as Armstrong has argued,

> [t]he further away some of our discourses are from everyday discourse through the transformation of categories, the nearer they are to critique. It is harder to make critique from within a discourse than through the drama of difference in linguistic experiment [...] And women, with, if I am right, that heightened sense of contradiction, may have a greater part of the work to do in redefining communality and formulating critique. (Armstrong 42)

Whether staging intimacy and minutiae of lives easily overlooked or rendering the epic dimensions of humanity's moral universe, the works of both Daley and tucker green incorporate the linguistic innovations and the thematic complexities that texture contemporary Black British women's drama to charge British theatre with an extraordinarily challenging aesthetic.

Works Cited

Alibhai-Brown, Yasmin. "The Curse of Diversity." *The Independent*, 9 July 2003.

—. "Black art can be bad, just as art by whites; Real equality means tough judgements and criticism of black and Asian artists and their work." *The Independent*, 5 February 2005.

Armstrong, Isobel. *The Radical Aesthetic.* Oxford: Blackwell Publishers, 2000.

Aston, Elaine. *Feminist Views on the English stage: Women Playwrights, 1990-2000* Cambridge: Cambridge University press, 2003.

Aston, Elaine and Harris, Geraldine. editors. *Feminist Futures? Theatre, Performance, Theory.* New York: Palgrave Macmillan, 2006.

Aston, Elaine and Reinelt, Jane. editors. *The Cambridge Companion to Modern British Women Playwrights.* Cambridge: Cambridge University Press, 2000.

Baker, Houston A.; Diawara, Manthia; and Lindeberg, Ruth H., editors. *Black British Cultural Studies: A Reader.* Chicago: University of Chicago Press, 1996.

Bassett, Kate. Review of *born bad. The Independent on Sunday* 11 May 2003: 12.

Berry, Ralph. "Shakespeare and Integrated Casting." *Contemporary Review* 285. 1662 (July 2000): 35-39.

Billington, Michael. Review of *stoning mary. The Guardian,* 21 March 2006:38

Brewster, Yvonne. editor. *Black Plays.* London: Methuen, 1987.

—. *Black Plays Two.* London: Methuen, 1989.

—. *Black Plays Three.* London: Methuen, 1995.

Brown, Kirsty. *London Theatre Review,* 25 March 2006. Available online at http://www.londontheatrereview.com/.

Cavendish, Dominic. "Double Detention." *Daily Telegraph,* 4 March 2003. Available online at http://www.arts.telegraph.co.uk.

—.Review of *Blest be the Tie* (24/4/2004) in *Theatre Record* (8-21 April 2004): 494

Chappell, Helen. Review of *Blest be the Tie* (20/4/2004) in *Theatre Record* (8-21 April 2004): 495.

Croft, Susan. "Black Women Playwrights in Britain" in T.R. Griffiths and M. Llewellyn-Jones, editors. *British and Irish Women Dramatists since 1958.* Buckingham: Open University Press, 1993. 84-98.

Cross, Felix. "Missing in Action: our black stars." *The Independent* 1 April 1998. Black Theatre Miscellaneous File. Theatre Museum, London.

Dahl, Mary Karen. "Postcolonial British Theatre: Black Voices at the Center" Ellen J. Gainor. editor. *Imperialism and Theatre: Essays on World Theatre, Drama and Performance.* London: Routledge, 1995. 38-55.

Daley, Dona. *Blest be the Tie* London: Royal Court Theatre, English Stage Company, 2004.

—. *Love in the Afternoon.* Radio 3. Radio play, directed by Mary Peate, 2003.

—. *Weathering the Storm* (1997). MS. courtesy of the writer.

Davis, Benjamin. Review of *trade* (22/3/2006) in *Theatre Record,* 12-25 March 2006: 302.

Davis, Geoff, and Fuchs, Anna, editors. *Staging New Britain: Aspects of Black and South Asian British Theatre Practice.* Oxford: Peter Lang, 2006.

Gardiner, Lyn. Review of *dirty butterfly*. *The Guardian* (3 March 2003). Available at http://arts.guardian.co.uk.

—.Review of *Blest be the Tie* (24/4/04) in *Theatre Record* (8-21 April 2004): 494.

—. Review of *trade* in *The Guardian*, 20 March 2006: 38

—.*The Guardian* (27 July 2005): 13.

George, Kadija, editor. *Six Plays by Black and Asian Women Writers*. London: Aurora Metro Press, 1993, 2005.

Gilbert, Helen, and Tompkins, Jane, editors. *Post-colonial Drama: Theatre, Practice, Politics*. London and New York: Routledge, 1996.

Godiwala, Dimple, editor. *Alternatives within the Mainstream: British Black and Asian Theatre*. Cambridge: Cambridge Scholars Press, 2006.

Goodman, Lizbeth. "Overlapping Dialogue in Overlapping Media: Behind the Scenes of *Top Girls*." In *Essays on Caryl Churchill: Contemporary Representations*. Sheila Rabillard, editor. Winnipeg, Canada: Blizzard Publishing Inc., 1998.

Gray, Frances. editor. *Second Wave Plays: Women at the Albany Empire*. Sheffield: Sheffield Academic Press, 1990.

Green, Debbie. *Two Women*. London, British Library. MS.9391.

green, debbie tucker. *born bad* London: Nick Hern Books, 2003.

—. *dirty butterfly*. London: Nick Hern Books, 2003.

—. *Freefall*. Radio 3, Radio play, 2003.

—. *Handprint*. Radio 3, directed by Mary Peate. Sunday, 26 March 2006.

—. *stoning mary*. London: Nick Hern Books, 2005.

—. *to swallow*. Radio 4, June 2003.

—. *trade and generations: two plays by debbie tucker green*. London: Nick Hern Books, 2005 (2005a).

Greer, Bonnie. "The Great Black Hope." *The Guardian G2* (17 May 2006): 22-23.

Griffin, Gabriele. *Contemporary Black and Asian Women Playwrights in Britain*. London: Cambridge University Press, 2003.

Griffin, Gabriele and Aston, Elaine. editors. *Herstory* 2 vols. Sheffield: Shefflied Academic Press, 1991.

Hastings, Chris, and Jones, Beth. "Theatres told: meet ethnic targets or lose your funding." *The Sunday Telegraph* (May 15, 2005): 9.

Jackson, Glenda. *Dead Proud: From Second Wave Young Women Playwrights*. Ann Considine and Robyn Slovo, editors. London: The Women's Press Ltd., 1987. (Back cover copy.)

Johns, Ian. Review of *stoning mary* (7/4/2005) in *Theatre Record* (26 March-8 April 2005): 424.

Joseph, May. "Bodies Outside the State: Black British Women Playwrights and the Limits of Citizenship" Peggy Phelan and Jill Lane. editors. *The Ends of Performance.* New York: New York University Press, 1998. 197-213.

Koenig, Rhoda. Review of *Blest be the Tie* (3/5/2004) in *Theatre Record*, 8-21 April 2004: 495.

Kristeva, Julia. "Revolution in Poetic Language." In *The Kristeva Reader.* Toril Moi, editor. New York: Columbia University Press, 1986. 89-136.

Marlowe, Sam. Review of *Blest be the Tie* (24/4/2004) in *Theatre Record*, 8-21 April: 494.

—.Review of *trade* in *The Time* (22 March 2006): 17.

Mason-John, Valerie. *Brown Girl in the Ring.* London: Get a Grip Publishers, 1999.

Modleski, Tania. "Feminism and the Power of Interpretation: Some Critical Readings. I *Feminist Studies/Critical Studies.* Teresa de Laurentis, editor. Bloomington: Indiana University Press, 1986.

Nightingale, Benedict. "Casting couched in a colour code." *The Times Saturday Review*, 18 May 1991: 14.

Osborne, Deirdre. "The State of the Nation: Contemporary Black British Theatre and the Staging of the U.K." In *Staging Displacement, Exile and Diaspora.* Toril Moi, editor. Trier: Wissenschaftlicher Verlag Trier, 2005. 129-149.

Ponnuswami, Meenakshi. "Small Island People: Black British Women Playwrights" Aston and Reinelt. 217-34

Quirke, Kieron. Review of *trade. The Evening Standard*, March 16, 2006: 16.

Riding, Alan. "In Britain, Aid for Arts Places 'Ethnic' before 'Artist.'" *The New York Times*, Section E, Column 3 (31 May 2005): 3.

Sierz, Aleks. *In-yer-face Theatre: British Drama Today.* London: Faber and Faber, 2000.

—. "Plenty to get your teeth into." *Sunday Times* (15 February 2004): 23.

Shuttleworth, Ian. Review of *Blest be the Tie* (24/4/2004) in *Theatre Record*, 8-21 April 2004: 494.

Tiffin, Helen. "Post-colonial Literatures and Counter-Discourse." *Kunapipi* 9. 3: 17-34.

Wandor, Micheline. editor. *Plays by Women* Vol.IV. London: Methuen, 1985.

Acknowledgements to *Wasafiri*, for permission to use material from my review on *trade* (2006). Sincere thanks to Lennie James, Kwame Kwei-Armah, Paulette Randall, and Ian Rickson for interviews about their work and views on black British theatre.

CHAPTER SIXTEEN

MIGRATORY AESTHETICS, (DIS)PLACING THE "BLACK" MATERNAL SUBJECT IN MARTINA ATTILLE'S *DREAMING RIVERS* (1988)

AMNA MALIK
SLADE SCHOOL OF FINE ART, LONDON

Fig. 1. Miss T, seated. *Dreaming Rivers*, film still, 1988.
Courtesy of Martina Attille. Photograph by Christine Parry.

Dreaming Rivers is unique amongst the Black British films made in the 1980s. Unlike earlier films made by Sankofa—for instance, *Territories* (1984) and *The Passion of Remembrance* (1986)—here, the maternal subject is central to the film's examination of inter-generational dialogue of "black" British identity. The film centres on a middle-aged woman as she lies dying, surrounded by her children in her one-room apartment, and traces her memories of her life and her view of herself as mother, wife, and lover (Fig. 1). The set designs created in collaboration with the painter Sonia Boyce are central to the way the film engages with the past, present, and future of a "black" diaspora. The film opens with women's voices singing a French Creole song about the loss of a sweetheart and cuts to a downward shot of a woman, Miss T, lying on her bed. As the film unfolds, we see her lying silently with her eyes closed whilst a series of voices asking questions float around her. Next, a reverse shot places the camera in her position, looking outward at her children, who are staring sadly, but quizzically, back at her. A similar strategy is used in the prologue to *Looking for Langston* (1989) when the camera pans over Hughes's coffin to reveal Isaac Julien, followed by a series of head-shots of the mourners around the coffin, from within that space. As Julien was assistant director on *Dreaming Rivers,* we can assume a shared vision, or aesthetic, between these two films. In *Looking for Langston,* this opening manoeuvre was directed by the need to displace homophobia within "black" communities by constructing identification with an openly gay "black" man. In *Dreaming Rivers*, the strategy seems to have a different purpose that I want to explore in this paper through what I will call "migratory aesthetics." Indeed, my choice of the term *migratory aesthetics* comes partly from a symposium held at the University of Leeds, organized by the art historians Mieke Bal and Griselda Pollock, and at which Martina Attille's film featured as part of the accompanying exhibition and was touched on in Pollock's paper ("Migratory Aesthetics," University of Leeds, January 2006). However, whilst Pollock approached the film from the standpoints of voice and sound (she was attempting to rethink the post-modern and postcolonial discourse of the 1980s in relation to "black" women's "coming to voice"), my approach to the same film and set of issues comes from a different, an art historical, perspective—one more germane to the explorations in this volume on aesthetics.

As Keith Piper recently pointed out, debates over what constituted "black" art in the 1980s and the ways those debates remain relevant now are complex and highly disputed issues[1] that can threaten to disintegrate over questions of identity instead of illuminating the legacy of a particular approach to questions of aesthetics conceived from the perspective of cultural differences.

[1] Keith Piper, "Wait, Did I Miss Something? Some Personal Musings on the 1980s and Beyond." In *Shades of Black: Assembling Black Arts in 1980s Britain*. David Bailey et al., eds. (Duke University Press, 2005), pp. 36-37.

In this context, the trope of migration in *Dreaming Rivers*—with its attendant emphasis on borders and border crossings, on movement, as a means of thinking through questions of "black" aesthetics—suggests a way that one might approach the history of post-war British art from the perspectives of the Asian, Caribbean, and African diasporas. Alongside the overlapping Creole and English voices singing and speaking as though spirits from another realm, the set designs and clothing indicate the importance of an inter-generational circulation of style and taste, the special terrain privileged for the articulation of the 1980s struggles of black feminism.

Fig. 2. Sonia Boyce's *She Ain't Holding Them Up, She's Holding On (Some English Rose)* 1986, pastel conti and crayon on paper, 218 x 99 cm. Original in colour.
Cleveland County Museum Service.

In Sonia Boyce's *She Ain't Holding Them Up, She's Holding On (Some English Rose)* (1986) (Fig. 2), as in *Dreaming Rivers*, the earlier generation of post-war migrants are commemorated as part of the struggle for visibility at a moment when the story of post-war mass migration was seen by a younger generation to be tainted by the associations with foreignness, of not belonging to Britain, as Mike Phillips and Trevor Phillips argued in *Windrush, The Irresistible Rise of Multi-Racial Britain*:

> 'just come over on the banana boat' was the taunt we had heard so often as children and, somehow, whenever we caught sight of the *Windrush* pictures through the cold, distanced eye of the newsreel camera, it was hard not to catch an echo of that gibe. (2)

Examining this sensitivity to displacement necessitates a recognition that prior to the 1990s the post-modern position of the Afro-Caribbean and Asian presence in Britain was directed by immigration policies in the Thatcher government that continually contested rights to citizenship for British-born, British passport holders. From the vantage of the early 1990s (with its embrace or appropriation of questions of identity), the conditions of migration defined modernity in a manner that was far from conceivable a decade earlier. However, this shift also allows one the opportunity to draw out the potential of "migration" as a trope in which movement, borders, and crossings are privileged instances for the articulation of subjectivity. From this perspective, one might venture to propose that in *Dreaming Rivers* one observes conditions of proximity, hence, intimacy, that can be related to the migrant's status as one who appears to be a stranger and yet, paradoxically, is familiar with the customs and habits of the metropolitan centre. In a different vein, James Clifford called this sense of familiarity the "squanto" effect (Clifford 23). As the quotation from Mike and Trevor Phillips (above) suggests, images are important mediators between the migrant and the native, creating a spatial sense that the migrant does not belong, based on a concept of "here" and "there" which is as much psychic as it is a matter of geography. The associations with "there" have evoked "savagery" in the minds of "white" Europeans, an effect of the (conceptual) cultural distance between European and non-European. Contact with the migrant brings with it an imagined danger of pollution from spatial proximity and, through numerous stereotypes, contributes to phobic projections of "otherness" onto the migrant. *Dreaming Rivers*, like other films by Black British collectives commissioned by Channel 4 and broadcast on British television, was inspired by the need to challenge the racist logic instituted in the 1960s that equated the immigrant with a skin colour and did so in terms that defined Britishness as simultaneously biological and cultural. The Immigration Act of 1968, as Paul Gilroy argued, "specified that immigration controls would not apply to any would-be settler

who could claim national membership on the basis that one of their grandparents had been born in the U.K. The Nationality Act of 1981 rationalised the legal vocabulary involved so that partials are now known as British citizens."[2] By the late 1980s, the exclusionary strategy had changed to impose regulations on "black" Britons' entry and exit from the country. The artistic exploration of a sense of belonging and not belonging as expressed through emotions, desires, and memories for and among the "black" British—a sense not visible or acknowledged in the media—was one way of challenging this racist logic. The focus of *Dreaming Rivers* on a middle-aged "black" woman shifts the nature of the inter-generational dialogue already present in Sankofa's earlier films so that the 1950s—as the moment of arrival and, therefore, a moment full of possibilities, potentialities, and dreams—became the moment from which the present was articulated. The impact of this shift is considerable; but, for the reasons outlined above, it was not fully comprehended at the time because to articulate a sense of dislocation of "black" identity from the subject position of the migrant also necessitated a change in how modernity was conceptualised and represented within these relatively recent settler communities.

The implications of the proximity that marks the condition of the migrant—and, thus, conditions "black" aesthetics—can be grasped by comparing Sonia Boyce's images of the early- to mid-1980s with those works of Keith Piper and Eddie Chambers that have drawn on a postcolonial discourse in which art is recognised as cultural work that decodes the master narrative.

The ambivalence of the "black" British arts movement caught between the need for self-expression and the necessity of refusing colonial fantasies is arguably evident in Keith Piper's *Another Nigger Died Today* (1982). Its assemblage of ready-made elements and painted images places it in dialogue with Neo-Expressionist revivals in the 1980s of the male artists' self-representation as a suffering Christ; but the need to interrupt the violence of the "white" gaze with his own "voice"—his own textual statement—transforms the image into a critique of stereotyping as a form of colonial knowledge. Similarly, in Eddie Chamber's *Destruction of the National Front* (1980), the purpose of artistic expression is to expose the autonomy of abstract art as false consciousness by linking it to icons of English imperialism. Here, colour and pattern are motivated signs in flags that signify real or imagined nation states and occupy competing positions of sovereignty. By contrast, in Sonia Boyce's work of the 1980s, colour and pattern draw on culturally specific signifiers of femininity that evoke a migratory aesthetics in its form and subject matter. In

[2] Gilroy, Paul. *There Ain't No Black in the Union Jack* (London and New York: Routledge, 1989), p. 44.

Big Women's Talk (1986) (Fig. 3), the patterns in the mother's dress and the mass-produced wallpaper popular in British homes are brought together to create a site of reverie and reflection, a locus of visual pleasure that allows the spectator entry into this imaginative space.

The rhythmic patterns that lure the spectator into tracing repeTons and following shapes, colours, lines as they intertwine with one another create a sense of identification with the figures—an invitation that prompts comparison with critical writings on women's artistic practices, particularly in painting. In recent years, feminist art history has sought to consider the visual aesthetics of women's image-making through Julia Kristeva's psychoanalytic writings on the psychic effects of colour in essays like "Giotto's Joy" (1972) and "Motherhood according to Giovanni Bellini" (1975).[3] In Boyce's drawing, the sense of immersion of the young girl, the framing of the image that conveys a child's perspective from which the viewer sees the woman, and the title invoke the trans-Atlantic dialogue of "black" American and British feminists over speech

Fig. 3. Sonia Boyce, *Big Women's Talk*, 1984, pastels and ink on paper, 148 x 155 cm. Original in colour. Private Collection.

[3] See Hilary Robinson's "Border Crossings: Womanliness, Body, Representation" in *New Feminist Art Criticism, Critical Strategies,* edited by Katy Deepwell (Manchester University Press, 1995), p. 141.

and desire[4] or what Alice Walker described as *womanist* prose, a term that evokes a desire to know more of an adult female world than is good for one.[5] This sense of overhearing or eavesdropping is conveyed well by Boyce's judicious cropping of the image so that one only sees the child's rapturous absorption but cannot see (or have access to) what it is that absorbs her, the overall effect of which conveys a sense of concealment. In this connection, bell hooks's description of the female child's act of witnessing black women's speech is important here:

> Dialogue—the sharing of speech and recognition—took place not between mother and child or mother and male authority but among black women. I can remember watching fascinated as our mother talked with her mother, sisters, and women friends. The intimacy and intensity of their speech—the satisfaction they received in talking to one another, the pleasure, the joy. It was in this world of woman speech, loud talk, angry words, women with tongues quick and sharp, tender sweet tongues, touching our world with their words, that I made speech my birthright—and the right to voice, to authorship, a privilege I would not be denied.[6]

The autobiographical aspect of Boyce's drawing reiterates this association: "I was always sort of tagging on to my mum's skirts and listening to all these conversations, getting all the juicy bits of who did what when."[7] These associations have been made by Gilane Tawadros in her seminal monograph on Boyce,[8] but the curious similarities between African American women's and Black British women's views of speech as a form of call and response (what was known as *l'écriture feminine*) has not been remarked upon. There is, however, an interesting parallel to be made between feminist art historians' writings on women's image-making through paintings and drawings and Boyce's use of patterned surfaces as a form of pre-verbal language that seems to lie in the spectator's engagement with the affective dimension of colours: the acoustic rhythms, for instance, evoked by the lines and the contrasts between scales in *Big Women's Talk*. The visual pleasure of the eye moving in through

[4] See John Akomfrah et al., "Third Scenario, Theory and Politics of Location" in *Frameworks* 36, 1989, which features bell hooks and Michelle Wallace, among others.
[5] Alice Walker, *In Search of Our Mothers' Gardens, Womanist Prose* (London: Phoenix, 2005), p. xi.
[6] bell hooks, Talking Back, Thinking Feminist Thinking Black (Boston: Southend 1989), p. 6.
[7] Sonia Boyce in *State of the Art: Ideas and Images in the 1980s*, edited by Sandy Nairne et al. (1987), p. 23.
[8] Gilane Tawadros, *Sonia Boyce, Speaking in Tongues* London: Kala Press, 1997), pp. 29-30.

and around the patterning incorporates and "visually" entwines the "black" body as part of the surface's visual structure. Even if aspects of French feminist psychoanalysis are not fully appropriate to the study of the affective dimensions of "black" British and African American women's artistic practices, Luce Irigaray's use of the linguistic concept of contiguity prompts one to consider the transformation of existing meanings through spatial proximity between elements—a suggestion that Irit Rogoff has productively applied to the idea of contact in her work on the contemporary presence of migrants in Britain.[9]

This reading might be productively reconsidered in relation to Boyce's innovative, cadenced use of the family album to place the spectator at the centre of the migrant's home. In *The Lonely Londoners* (1956), Sam Selvon used an accented English to describe the migrants' encounters with white Londoners, which was quoted by Gordon Rohlehr in 1971 alongside calypso lyrics "to demonstrate that both relate to the same oral tradition."[10] Anne Walmsley, who made that observation in her paper "The Folk in Caribbean Literature," was reflecting debates that had taken place in London and Canterbury over the connections between oral traditions, vernacular forms, and the Caribbean novel as part of the wider discussions that constituted the Caribbean Artists Movement (Walmsley 260). In probing this rhythmic form as the artist's means of creating an acoustic identification that binds the reader to an imagined, accented subject in spatial terms, the reader is placed in a position of proximity to the narrator through the act of inserting herself into the narrator's mental space, occupying and (yet) still grappling with the strangeness of "seeing" London from the migrant's position. Examining Boyce's work from such a perspective, one might argue that she harnessed this proximity to different aesthetic ends: she replaced the male narrator's voice with the photographer's eye and, hence, positioned the spectator in an immersive relationship to the subject of the image—and, by creating a series of screens of these patterned surfaces, immersed the spectator in the act of looking. The complexity of private and public space appears to be fore-grounded in Boyce's early drawings and in Attille's film, just as it was a marked aspect of Sankofa's earlier film *The Passion of Remembrance*, in which the representation of "black" family histories as a site of contestation of the patriarchy of Black Power movements was a central concern. Martina Attille's *own* concern with how this representation was coded positioned the question of space in conjunction with the question of who writes history and how it is passed down:

[9] Irit Rogoff, "Of Fear, Of Contact, and Of Entanglement" in *Strangers to Ourselves*, edited by Judith Stewart, Mario Rossi, Maud Belléguic (Hastings Museum and Art Gallery, England, 2003), pp. 48-53.
[10] Anne Walmsley, *The Caribbean Artists Movement, 1966-1972: A Literary and Cultural History* (London: New Beacon Books, 1992), p. 261.

Even though there are spokespeople taken up by institutions, or elected by a particular group, it doesn't mean that they are necessarily known by everyday people like our parents. So the question is, for example, how did the generation of the 50s survive?—because they didn't really get involved in popular movements or Black power militancy. In fact, there were other ways of surviving, which often involved claiming some sort of invisibility, where you have a veneer which makes it appear as if everything was alright. But when you get down to it, what happened was your parents didn't go out, they didn't get involved, they didn't get into trouble. That's not to say they were naively thinking everything's okay, because they were well aware that the state was aggressive towards them, but they had their own way of actually dealing with that.[11]

What interests me greatly about these remarks by Attille is her concern with the past, the generation of post-war migrants to Britain that marked the Windrush era, and, more specifically, her attention to the microcosms of life lived in the everyday as a form of resistance. Arguably, this had already been examined at length by the Centre for Cultural Studies in Birmingham through the focus on subcultures; but the difficulties of simply existing, of living on a day-to-day level, were not generally acknowledged amongst a younger generation coming to voice in the 1980s. In *Dreaming Rivers*, love is the motive for migration and dislocation from home: Miss T came to England to be with her now-absent husband; and love is why she stayed: to bring up her children. It is through their eyes that she negotiates and locates herself whilst she goes about her rituals of self-adornment, lighting candles before a mirror (Fig. 4), braiding her hair, and donning a floral dress; but love is what also keeps her from belonging to England.

[11] Jim Pines, "The Passion of Remembrance." *Framework* 32/33 (1986), pp. 94-95.

252 Chapter Sixteen

Fig. 4. Miss T lighting candles, *Dreaming Rivers*, film still 1988, courtesy of Martina Attille. Photograph by Christine Parry.

The migrant's desire to return home and to the past is created by the sounds of overlapping voices speaking in Creole and English that evoke Miss T's hallucinatory state, as though those voices of mothers, sisters, and women friends have returned from her home in St. Lucia. They also establish the space of her one-room apartment as a private realm of memories, longing, and desire. These aspects of the film suggest that migrants recreate cartographies anew and redefine them through emotional and erotic attachments between people—and not simply by economics, the data of upward mobility and middle-class aspiration. Furthermore, the latter is transformed by the former, as fantasy and desire for the "mother" country. From the perspective of "black" aesthetics, what seems particularly significant about the film is the slow way the camera dwells on lingering shots of Miss T's objects. We see a mantelpiece decorated with lace and littered with objects, jewellery boxes, elaborate wrought-iron candle-holders, gilt-framed mirrors; among these, we glimpse a small black-and-white photograph of Miss T as a young woman and Christian imagery of a blue-eyed, blond Christ smiling benignly. As she prepares her toilette, we see her pour water from a beautiful white porcelain jug, decorated with floral patterns, into a matching bowl, in which rose petals swirl as the water flows. The camera also lingers at one point when she lies back on her bed and the quilt cover is pulled over her, its luxurious silken, embroidered texture appears momentarily as the primary focus of the camera.

These slow and lingering shots of the surfaces in the interior of the room make us want to touch the many patterned textures and colours given to the eye, stimuli that create a sense of visual pleasure. The camera holds onto the items, evoking something analogous to our sense of touch. The overlapping Creole and accented English voices that flow through the film (sometimes understably, at other times not), the music, and the lighting—all these elements together create a rhythmic texture in the spaces between voice(s) and image(s). They are like the different but repeated elements that entwine surface and interiority, as though the film's series of shots are also patterns that parallel Sonia Boyce's drawings of the early 1980s.

Michael McMillan's research has drawn attention to the aspirations of an earlier generation of "black" Britons, aspirations highly pertinent to *Dreaming Rivers*.[12] Miss T is seen performing various acts of good grooming that indicate another kind of passage from the Caribbean to Britain, and that migrant history is alluded to and encompassed by the objects that surround her. Design is a distinctive means by which the filmmakers visualise differences within the family. Miss T's older style contrasts with the appearance of her children: her eldest daughter wears a Batik hat, a younger girl sports long, large black earrings and the bouffant hairstyles popular in the 1980s, whilst the youngest (Sonny) appears the most "English" of the children, his clipped tones and appearance suggesting the aspirations of the middle-class university student. Although Sonny expresses his distaste for his mother's belongings as "junk," his generation and those newly arrived immigrants of his mother's generation mirror each other, arguably, in their shared aspirations to the lifestyle of middle-class "white" Britons.

What is the special significance of the set designs for *Dreaming Rivers* in the context of the 1980s, as opposed to now? To address this question, I want to focus on the migration of aesthetic forms that mark a specifically British form of the "black" Atlantic. The history of British colonial rule in India and the subsequent presence of indentured Indian servants in the Caribbean have contributed to its Creolisation and, arguably, can be found in the decorative elements that McMillan identifies as part of the "West Indian" Front Room. The emphasis on patterns, decorative designs, and other signifiers of a feminine space are distinctively outmoded for the context of the 1980s; but, in their nostalgic evocation of the designs of the 1950s, they offer a response as well, perhaps, to the emergence of an idealised British femininity in period films such as Merchant Ivory's adaptation of E.M. Forster's *A Passage to India* (1985) or *A Room with a View* (1986), where the attention to detail in the design of

[12] Michael McMillan, "The West Indian Front Room in the African Diaspora," *Fashion Theory* 7, 3-4 (2003): 1-18.

interior spaces creates an illusion of entering a past in which the class status and taste of the characters are found in the objects surrounding them. Similarly, the combination of highly patterned surfaces and the representation of the "black" female figures in Boyce's early images were, for Gilane Tawadros, indicative of Black British women artists' approach to history and tradition as a form of post-modern resistance in which drawings like *Lay Back, Keep Quiet and Think of What Made Britain So Great* (1986) appropriated William Morris's wallpaper designs to evoke "black" femininity, as Tawadros points out:

> The black woman who stares out at us from the final panel—a self-portrait of the artist herself—suggests that this English rose, as woman, or as identity, inherits a history of resistance as well as a history of oppression, that is, separate histories but ones which are locked together inextricably.[13]

In this series of images, crosses appear in large narrow panels of decorative surfaces, evoking the Missionary aspects of British colonialism, with the different colonies of Africa, India and Australia marked in each panel. The patterning serves both to disguise and to confuse the position of the cross in the surface of the image, acting as camouflage to mark its status as present, but also making it invisible. Yet, these different colonised cultures, in their respective transformations of Britishness, also effected a transformation of otherwise distinct and separate ethnicities. Orientalism, for example, played a particularly significant role in bringing these elements together. In particular, the post-war photographs from the family album that were the models for Boyce's work provided the opportunity to reframe the prevailing depictions of black womanhood as the abject counter to "white" odalisques featured in numerous nineteenth-century paintings of nudes.

Linda Nochlin's groundbreaking study "The Imaginary Orient" (1983) was one of the first art historical approaches to nineteenth-century colonial images to use Edward Said's postcolonial criticism to deconstruct paintings, including those of Jean-Leon Gerôme, as accurate representations of scenes like slave auctions and so forth in an attempt to naturalise the associations between "whiteness" and beauty and truth, and "blackness" and inferiority.[14] Coinciding with Boyce's and Attille's collaboration was the attempt to popularise feminist approaches to craft and textile design in a number of prominent exhibitions of

[13] Gilane Tawadros, "The Sphinx Contemplating Napoleon: Black Women Artists in Britain" in *New Feminist Art Criticism, Critical Strategies,* edited by Katy Deepwell (Manchester University Press, 1995), p. 26.

[14] See Linda Nochlin, "The Imaginary Orient" in *The Politics of Vision: Essays on Nineteenth-Century Art and Society* (New Harper and Row, 1989).

1988.[15] However, in the debates generated around these exhibitions and artistic practices of the 1980s and the earlier Orientalist examples, there appears to have been little attention to the history of textiles and crafts as part of the Arts and Crafts Movement that had informed Partha Mitter's study *Much Maligned Monsters, A History of European Reactions to Indian Art* (Oxford University Press, 1977) that, amongst other concerns, examined the development of hybrid forms of patterns and decorative designs that were taken from India to Britain in the nineteenth century and formed an important part of debate over British design. These issues were subsequently taken up in John MacKenzie's study of orientalism that amplified aspects of Nochlin's research.[16]

Perhaps one might see the impact of Orientalist influences on British design (and, hence, on paintings of the nineteenth century) in *Dreaming Rivers*, especially if one considers the chintz-like patterns that mark Miss T's porcelain jug and bowl and consider the beautiful embroidery that covers her blanket—patterns that were conventionally associated with William Morris's designs and his influences on the Arts and Crafts Movement, but, in fact, originated in textiles brought from India to Europe in the eighteenth century.[17] The anthropologist Daniel Miller has argued that the wealthier population of Trinidad employed seamstresses, many of them East Indian women, to create their unique styles even though most of the women who employed them were able themselves to use sewing machines.[18] The particular economic boom in Trinidad forms the backdrop to Miller's thesis that Trinidad, in its severing from any authentic "African" culture, is the postmodern society par excellence—in which fashion occupies an important model of self-fashioning as a form of "extreme modernity."[19] His model might also be applied to other parts of the Caribbean and to the migration of women to Britain. McMillan argues, for example, that many immigrant women in Britain were able to decorate the living room through embroidery or crochet, skills that began to fade out in Britain but were revived by these settlers for whom, on a subliminal level, "crocheting signifies a 'creolised' reconstruction of womanhood in response to

[15] See Pennina Barnett, "Curating 'The Subversive Stitch'" in *New Feminist Art Criticism, Critical Strategies,* edited by Katy Deepwell (Manchester University Press, 1995), pp. 76-86.

[16] See John M. MacKenzie, *Orientalism, History, Theory and The Arts* (Manchester Univeristy Press, 1995), pp. 105-137.

[17] Rosemary Crill, "Asia in Europe: Textiles for the West" in *Encounters, The Meeting of Asia and Europe 1500-*1800, edited by Anna Jackson and Amin Jaffer (London: Victoria and Albert Museum, 2005), p. 265.

[18] Daniel Miller, "Fashion and Ontology in Trinidad" in *Design and Aesthetics: A Reader* (London and New York: Routledge, 1996), p. 143.

[19] Miller, Ibid., p. 157.

the hegemonic construction of the black subject in the domestic domain."[20] One might speculate whether the beautiful objects in Miss T's apartment were part of her trousseau, given to her upon her marriage, objects handed down to her from her mother and made by earlier generations of women. They are an indication of a degree of proximity between the migrant and the host. These objects are in many ways very familiar. It is hard to see in them an "African" aesthetic; rather, they are indicative of the Caribbean as part of a European imagined community instead of one that is distinctly separate.

Drawing to some extent on McMillan's account, one might argue that these patterns in the film offer a visual equivalent to the Creolisation of the English language that we hear in the soundtrack. The voices speaking patois and singing folk songs in *Dreaming Rivers* belonged in fact to Isaac Julien's and Attille's mothers,[21] but as Julien recently argued, this linguistic patois "is a resurrection of a dying cultural practice" that has not continued into the lives of subsequent generations.[22] The recent resurgence of interest in Creole speech is a complex phenomenon (it is in danger of being preserved merely as an attempt to salvage a lost vernacular form); but, in *Dreaming Rivers*, its importance, as the voices flow into and out of the filmic space, is to place emphasis at the same time on the migrant's condition of being elsewhere *and* on the presence of spirits of earlier generations of women speaking through Miss T.

Examining the legacy of Boyce's and Attille's collaboration and the former's combination of figurative and decorative elements, it seems ironic that, whilst these aspects of their practices as part of an inter-generational dialogue within and beyond "black" family histories have faded to the background, the work of the Kashmiri British artist Raqib Shaw draws the attention of critics for evoking Orientalist-inspired motifs combined with figurative elements that recall the tradition of miniature painting. One might also mention the work of the Guyanese-born artist Hew Locke, alongside that of Italian British artist Enrico David and the Scots Claire Barclay, whose currently touring exhibits in the British Art Show 6 are indicative of the resurgence of interest in what is known as the "decorative." Like Boyce's drawings, much of this work tends to approach questions of craft within the parameters of high art. Enrico David's "queering" of Euro-American modernism—particularly his erotic approach to Art Deco through the use of decorative craft techniques, like embroidery, and his positioning of the figure within otherwise abstract forms—seems to recall

[20] McMillan, Op.cit., p. 12.

[21] Isaac Julien and Mark Nash, "Dialogues with Stuart Hall" in *Stuart Hall, Critical Dialogues in Cultural Studies*, edited by David Morley and Kuan-Hsing Chen (London and New York: Routledge, 1996), p. 477.

[22] Isaac Julien in *Créolité and Creolization*, Documenta 11_Platform 3, edited by Hatje Cantz (Kassell, 2002), p. 159.

Boyce's early work. Hew Locke's Guyanese background is significant to his approach to this tradition in the dominant appearance of the queen (Fig. 5), as the central motif is of course a distinctive aspect of Caribbean culture, but in Locke's work the installation takes on the appearance of shrines that emerged spontaneously in the streets of Britain to commemorate Princess Diana's death.

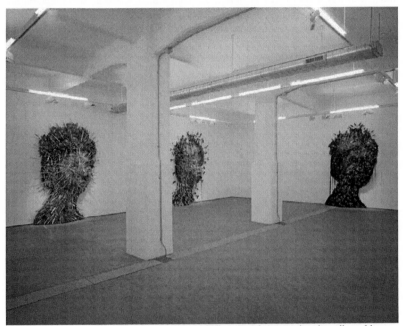

Fig. 5. Hew Locke installation shot, Hales Gallery London, wood and cardboard base, glue gun, screws, mixed media, plastic, fabric.
Courtesy Hales Gallery and Cherry Brisk, DACS, 2005

The assemblage form of his work is closely linked to the avant-garde convention that can be traced back to the German Dadaist Kurt Schwitters; but Locke's choice of materials—the plastic toys created in South Asian factories, rather than rubbish picked up from the streets—gives the work a geopolitical spin. In this respect, his deployment of popular and mass-produced design

attends to the processes of circulation and exchange that determine our increasingly globalised world.[23]

Attille's/Boyce's attention to inter-generational dialogue and the conditions through which geography marks the migrant experience of women speaking to women can also be found in the work of a number of contemporary women filmmakers. *Mother Tongue* (2002) (Fig. 6), made by Zenib Sedira, reveals a cultural genealogy within a given family, which has been subject to migration and movement, as a form of alienation between generations of women who cannot—except artificially—sustain continuity; but, in such instances, transformation through rupture and loss has also to be marked. In this installation, we see three screens in which Sedira's mother and her daughter attempt to speak to one another, but their only link is Sedira herself, as her mother's Arabic is incomprehensible to her daughter growing up in England.

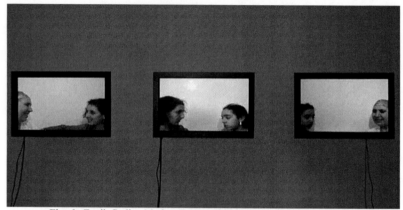

Fig. 6. Zenib Sedira *Mother Tongue* (2002), 3 videos, 5 mins., 4 secs.
Courtesy of the artist.

The acoustic rhythms of patterns between voice and image found in *Dreaming Rivers* are echoed in a different manner in Rosalind Nashashibi's film *Hreash House* (2004), which builds up a series of rhythmic patterns drawn from the accumulation of single shots that dwell on patterned surfaces in the home of a family living in an Palestinian enclave in the politically contentious site of the city of Nazareth. The interior of the living room, with its tightly upholstered furniture, is also decorated with elaborate arrangements of artificial flowers that

[23] "A Sargasso Sea-Hoard of Deciduous Things: Hew Locke and Sarat Maharaj in Conversation," *Hew Locke* (Walsall: The New Art Gallery & Cornerhouse Publications, 2005), pp. 8-16.

recall Matisse's still-life paintings. Nashashibi's filmic attention to the acoustics of everyday sounds as a gradual crescendo provides a visual parallel to traditional Arabic music that aims to evoke a condition of ecstasy.[24] However, more than any other contemporary artist, it is the filmmaker Alia Syed whose practice is indebted to the Black British film collectives of the 1980s. In *Eating Grass* (2003) and earlier films, her striking use of narrative and overlapping voices—exchanges between women of different generations within families, in Urdu and English, combined with an attention to location—creates rhythmic patterns that come closest to those of Attille's film. *Eating Grass* draws on the psychic structuring of identification between spectator and image created by the embodied voice that also reveals a considerable debt to Sankofa's approach to memory, desire, and language.

These diverse artistic practices in various ways place the (maternal) body in dialogue with the decorative and highlight historic connections of the decorative aesthetic with an Orientalist aspect of British design that moves between object and image. In the context of the collaboration between Sonia Boyce and Martina Attille on *Dreaming Rivers*, this legacy suggests the need for critics and scholars to reframe questions of gender and to place the complex and problematic history of the "black" maternal subject at the centre of contemporary "black" aesthetic practice—particularly where it is evidently an important aspect of the artwork. If one considers the flow of cultural exchange between different constituents of African, Caribbean, Asian, Chinese, and Arab artists that now make up the diaspora in Britain through the cipher of a migratory aesthetic, one might argue that the Caribbean's Creolisation offers an important paradigm for reconsidering the matter of artistic influence, permitting us to see it as a syncretic hybridity that contests essentialism and its threat to dominate the contemporary emphasis on ethnicity. "Black" British women's artistic practices have historically offered an important example of this refutation in their collaborative forms and in their acknowledgement of the shared legacy of colonialism. Perhaps it is now the task of art history and art criticism to meet this challenge by focusing on the creative syncretism that has come from this legacy.

Works Cited

Akomfrah, John; bell hooks, Michelle Wallace, Stuart Hall, et al. "Third Scenario, Theory and Politics of Location." *Frameworks* 36, 1989.

[24] Cf. Francis McKee, "Beyond Meantime" in *Rosalind Nashashibi* (Edinburgh: The Fruitmarket Gallery, 2003), p. 8.

Barnett, Pennina. "Curating 'The Subversive Stitch.'" In *New Feminist Art Criticism, Critical Strategies.* Katy Deepwell, editor. Manchester University Press, 1995. 76-86.

Boyce, Sonia. In *State of the Art: Ideas and Images in the 1980s.* Sandy Nairne, editor (1987), cited in Tawadros, Gilane, *Sonia Boyce, Speaking in Tongues.* London: Kala Press, 1997.

—. "The Sphinx Contemplating Napoleon: Black Women Artists in Britain." In *New Feminist Art Criticism.* in Katy Deepwell, editor. Manchester University Press, 1995. 25-30.

Clifford, James. *Routes, Travel and Translation in the Late Twentieth Century.* Cambridge, Massachusetts and London: Harvard University Press, 1999.

Crill, Rosemary. "Asia in Europe: Textiles for the West." In *Encounters, The Meeting of Asia and Europe 1500-1800.* Anna Jackson and Amin Jaffer, editors. London: Victoria and Albert Museum, 2004. 262-309

Enwezor- Okwui, et. Al, editors. *Créolité and Creolization.* Documenta 11_Platform 3. Hatje Cantz, Kassell, 2002.

Gilroy, Paul. *There Ain't No Black in the Union Jack.* London and New York: Routledge, 1989.

Phillips, Mike, and Trevor Phillips. *Windrush, The Irresistible Rise of Multi-Racial Britain.* London: Harper Collins, 1999.

hooks, bell. "Talking Back." In *Talking Back, Thinking Feminist Thinking Black.* Boston: Southend Press, 1989. 5-9.

Julien, Isaac, and Mark Nash. "Dialogues with Stuart Hall." In *Stuart Hall, Critical Dialogues in Cultural Studies.* David Morley and Kuan-Hsing Chen, editors. London and New York: Routledge, 1996. 476-483.

Locke, Hew, and Sarat Maharaj. "A Sargasso Sea-Hoard of Deciduous Things: Hew Locke and Sarat Maharaj in Conversation." *Hew Locke.* Walsall: The New Art Gallery and Cornerhouse Publications, 2005. 8-16.

McKee, Francis. "Beyond Meantime." In *Rosalind Nashashibi.* Edinburgh: The Fruitmarket Gallery, 2003. 7-13.

MacKenzie, John M. *Orientalism, History, Theory and The Arts.* Manchester and New York: Manchester University Press, 1995.

McMillan, Michael. "The West Indian Front Room in the African Diaspora." In *Fashion Theory* 7, 3-4 (2003): 1-18.

Miller, Daniel. "Fashion and Ontology in Trinidad." In *Design and Aesthetics, A Reader.* Jerry Palmer and Mo Dodson, editors. London and New York: Routledge, 1996. 133-159.

Mitter, Partha. *Much Maligned Monsters: A History of European Reactions to Indian Art.* Oxford: Oxford University Press, 1977.

Nairne, Sandy, Geoff Dunlop, John Wyver, eds. *State of the Art: Ideas and Images in the 1980s*. London: Chatto & Windus, 1987.
Nochlin, Linda. "The Imaginary Orient." In *The Politics of Vision: Essays on Nineteenth-Century Art and Society*. New Harper and Row, 1989
Pines, Jim. "The Passion of Remembrance." *Framework* 32/33 (1986). 92-99.
Piper, Keith. "Wait, Did I Miss Something? Some Personal Musings on the 1980s and Beyond." In *Shades of Black: Assembling Black Arts in 1980s Britain*. David Bailey, Ian Baucom, and Sonia Boyce, editors. Duke University Press, 2005. 35-40.
Robinson, Hilary. "Border Crossings: Womanliness, Body, Representation." In *New Feminist Art Criticism*. Katy Deepwell, editor. Manchester University Press, 1995. 138-146.
Rogoff, Irit. "Of Fear, Of Contact, and Of Entanglement." In *Strangers to Ourselves*. Judith Stewart, Mario Rossi, Maud Belléguic, editors. Hastings Museum and Art Gallery, England, 2003. 48-53.
Walker, Alice. *In Search of Our Mothers' Gardens, Womanist Prose*. London: Phoenix, 2005.
Walmsley, Anne. *The Caribbean Artists Movement, 1966-1972: A Literary and Cultural History*. London: New Beacon Books, 1992.

CHAPTER SEVENTEEN

"THERE'S NO JUSTICE – JUST US": BLACK BRITONS, BRITISH ASIANS, AND THE CRIMINAL JUSTICE SYSTEM IN VERBATIM DRAMA

VALERIE KANEKO LUCAS
THE OHIO STATE UNIVERSITY, COLUMBUS

In February 1999, I was walking along Coldharbour Lane in Brixton, home to Londoners from the many countries of the post-Empire diaspora. Scrawled on a hoarding were the words: "there's no justice: just us." Needless to say, these sentiments depressed me profoundly, for it was just after the publication of the Macpherson Report, which (after half a year of investigation) provocatively condemned the London Metropolitan Police for institutional racism. Yet the "word on the street" suggested that, despite the death of Stephen Lawrence, cited by Home Secretary Jack Straw as "a catalyst for permanent and irrevocable change," [1] little would change. For those unfamiliar with the case, here are the key facts. Late on Thursday 22 April 1993, Stephen Lawrence, an eighteen-year-old Black student, and his friend Duwayne Brooks were waiting for a bus in Eltham, South London. They were approached by a gang of white youths, and Stephen was surrounded and fatally stabbed. When Brooks approached the police for help, he was arrested as a murder suspect. The subsequent police inquiry was bungled: the murder weapon and other key evidence went missing, so the suspects were acquitted. In 2004, the Crown Prosecution Service closed the case, ruling that no one would stand trial for the murder of Stephen Lawrence. [2]

[1] Jack Straw quoted in Nicholas Timmins and Simon Buckby, "Justice and Stephen Lawrence," *Financial Times*, 25 February 1999: 27.
[2] Jonathan Brown, "Suspects who still swagger in the shadows," *The Independent*, 8 May 2004: 19.

The Stephen Lawrence case became the subject of Richard Norton-Taylor's 1999 play, *The Colour of Justice*, which examined how institutions such as the law courts and police fail Black victims of violent crime. In 2005, the issue of race hate crime surfaced in another play—Tanika Gupta's *Gladiator Games*—the 2000 murder of a British Asian Muslim, nineteen-year-old Zahid Mubarek. Mubarek, a first-time offender, was sentenced to 90 days in H.M. Feltham Young Offenders Institution for stealing £6 worth of razor blades and interfering with a car. There, he was forced to share a cell with Robert Stewart, a known White supremacist. On 21 March 2000, five hours before Zahid Mubarek was due to be released, Robert Stewart beat him with a weapon fashioned from a prison table leg. Mubarek sustained massive skull injuries before lapsing into a coma and died of cardiac arrest on 28 March 2000.[3]

In Richard Norton-Taylor's *The Colour of Justice* (1999) and Tanika Gupta's *Gladiator Games* (2005), the challenges of national identity, civic entitlement, and the politicisation of minority communities are foregrounded in theatrically provocative ways. Both are verbatim dramas which draw upon extensive primary sources such as interviews with the murdered men's families, eyewitness accounts, court testimonies, and police reports. Both champion a family's right to challenge the institutions of the law courts, the police, and the prison system in their relentless quest for the truth about the racially-motivated murders of their sons. *The Colour of Justice*, based on the Stephen Lawrence case, addresses institutional racism within the London Metropolitan Police Force. *Gladiator Games* exposes how negligence and condoned racism within the youth prison service contributed to the death of Zahid Mubarek.

The production contexts of these plays are noteworthy: they were first performed in cities and regions with a large percentage of ethnic minorities. *The Colour of Justice* was initially performed at London's Tricycle Theatre (12 January–6 February 1999).[4] The Tricycle Theatre is located in Kilburn, an area with large numbers of Irish and Afro-Caribbean residents—two groups who regard themselves as under-protected and over-policed. It was then performed at the Theatre Royal Stratford East (16–27 February 1999) in London's East End. Its subsequent transfers to the West End enabled the play not only to contribute to the ongoing debate about the Lawrence murder, but to gain a national profile and wider audience. After playing at the Victoria Palace Theatre (3–13 March

[3] Suresh Grover, *The London Monitor: A Special Edition for Gladiator Games*, November 2005 – January 2006: 2.

[4] *The Colour of Justice* was directed by Nicholas Kent (with Surian Fletcher-Jones); the production team were: Bunny Christie (designer), Heather Leat (costumes), Chris Davey (lighting), and Shaz McGhee (Production Manager). Source: Richard Norton-Taylor, *The Colour of Justice*: 17-18.

1999) and the Lyttleton Theatre at the Royal National Theatre (21–25 September 1999), the production then toured throughout England, winning the 1999 Barclay's Touring Stages Award; and the play was televised on BBC 2 on 21 February 1999.[5] The significance of this achievement should not be underestimated: in 1999, Michael Billington found that the Tricycle was one of only three producing theatres in England to have Black representatives on their boards of trustees. In addition to the eight representatives at the Tricycle, there were five Black representatives at the Theatre Royal Stratford East, and two at the Hampstead Theatre; all of these are London theatres.

Gladiator Games, by Tanika Gupta, was first performed from 20-29 October 2005 at the Crucible Studio Sheffield, and then at the Theatre Royal Stratford East from 2-12 November 2005, returning for a second run from 2-25 February 2006.[6] Sheffield is a Midlands city with a sizable British Asian population, and the Theatre Royal's East End location is close to London's greatest concentration of British Asians, who find themselves increasingly the object of police harassment.[7] At both venues, audiences offered their views on

[5] Production dates are from the websites of the Tricycle Theatre, the Royal National Theatre, and the Victoria Palace Theatre. The broadcast date of the film version is from the British Theatre Guide. Statistics from Michael Billington, "White Out: Is There a Crisis in Black Theatre in Britain?" *The Guardian*, 18 October 2000: 14.

[6] It was directed by Charlotte Westenra; the production team was Paul Wills (designer), Harley T.A. Kemp (lighting designer), Niraj Chag (sound designer), Nick Greenhill (casting), Zahra Ahmadi (assistant director), Jeannette Nelson (dialect coach), Johann Persson (production photographer). Source: production information in the 2005 published text of *Gladiator Games*, n.p.

[7] Nick Hopkins, in "Met Stop and Search 'Now Hitting Asians,'" reports: "The police risk alienating a generation of young Asians by misusing their stop and search powers, repeating mistakes made with the black community 20 years ago which triggered the Brixton riots, a study warned yesterday. Marian Fitzgerald said some officers flout the 1984 police and criminal evidence act, which states someone can be stopped if there are reasonable grounds for suspicion, and use searches as a 'mechanism for social control'." *The Guardian*, 16 December 1999: 4. Vikram Dodd's "Police Could Face Action Over Stop and Search" claims that figures in 2003 " showed stop and searches of Asian and black people in 2001-02 up by 16% and 6% respectively compared with 2000-01, while those of white people fell by 2%. In London the Metropolitan police stopped 40% more Asians and 30% more black people, but 8% fewer white people." See *The Guardian*, 21 March 2003. http://www.guardian.co.uk/crime/article/0,,918866,00.html. Following the recent bomb threats at Heathrow Airport on 10 August 2006 and the arrests of British Asian suspects, racial profiling has been on the increase. Sandra Laville reports that passengers on a Monarch flight demanded that two British Asian students, Sohail Ashraf and Khurram Zeb, be removed. See "Asian Students Tell of Ejection from Airliner," *The Guardian*, 24 August 2006. http://www.guardian.co.uk/airlines/story/0,,1857081,00.html.

the Mubarek case at post-show discussions with guests such as Suresh Grover (Director of the Monitoring Group, an independent anti-racism agency) and *Guardian* journalist Vikram Dodd, one of the leading reporters on the Mubarek case. The topicality and popularity of the play led to a second run at the Theatre Royal Stratford from 2-25 February 2006. This later production took into account many of the opinions voiced at the post-show discussions.

* * * * *

These demographics suggest that the theatricalisation of racism and oppression may hold strong resonances with the lived experience of ethnic minorities in these communities. Duwayne Brooks, calling for the resignation of Police Commissioner Sir Paul Condon, condemned the police for treating him as a suspect: "the stereotyping and the racist attitudes were down to me being black." [8] On 2 November 2005, the night when I saw *Gladiator Games*, the majority of the audience was Black Britons and British Asians.

In form as well as in content, these plays embrace an aesthetic which engages the spectator as witness and as judge. In so doing, these two plays construct theatre as public tribunal, laying differing accounts of events and complex and often contradictory evidence for an audience to evaluate, much as jurors do in a trial. Part of the performative strategy encourages the audience to recognise the challenges of civic entitlement facing Black and British Asian citizens. Reflecting upon her son's murder, Doreen Lawrence remarked:

> When my son was killed I genuinely believed that those responsible would be caught and be punished for their crime. I waited patiently for this, [but] knew that this would never happen because my son is Black, but still hoped for justice.[9]

But she also noted that "Right from the start, on the night our son was murdered, it seemed that in the minds of the police he was only a black boy—why

[8] John Sturgis, "Condon Should Do Honourable Thing and Resign," *The Evening Standard*, 25 February 1999: 8.
[9] Doreen Lawrence quoted in unsigned article. "Stephen Lawrence: 1974-1993; The Lessons That Must be Learned," *The Voice*, 22 February 1999. http://www.highbeam.com/library/doc3.asp?DOCID=1P1:23058356&num=2&ctrlInfo= Round19%3AProd%3ASR%3AResult&ao=&FreePremium=BOTH. Accessed 1 Jan 2006.

bother?"[10] In her statement read at the 1997 inquest, she claimed that the justice system effectively denied Black victims their civic entitlement to fair trial:

> ...In my opinion what happened in the Crown Court last year was staged.... what happened was the way of the judicial system making a clear statement, saying to the black community that their lives are worth nothing and the justice system will support anyone, any white person who wishes to commit a crime or even murder against a black person. You will be protected. You will be supported by the British system. To the black community: your lives are nothing. You do not have any rights to the law in this country. That is only here to protect the white man and his family, not you ... I hope our family will be the last—even though there is no sign of it to date—the last to be put through this nightmare. . .[11]

Without a doubt, the London Metropolitan Police investigations were seriously flawed and influenced by negative preconceptions about young Black men. As Norton-Taylor's selections from the Macpherson Report note, the police did not give first aid to Stephen Lawrence, performed only a perfunctory search of the neighbourhood, intimidated the principal eyewitness Duwayne Brooks, and failed to follow the leads provided by other eyewitnesses. It was not until two weeks after the murder that the police arrested the suspects, allowing ample time for the murder weapon and bloodstained clothes to be destroyed. By then, twenty-six people had come forward and named five youths—Jamie and Neil Acourt, Gary Dobson, Luke Knight, and David Norris—as the killers. This gang already had a local reputation as bullyboys and troublemakers: the Acourt brothers styled themselves "the Krays" (after the notorious East End mobsters) and were publicly known to carry knives; Norris's father was a drug baron under investigation by the police. Moreover, these youths already had a record of race hate crimes. Doreen Lawrence recalls that

> Neil Acourt had been thrown out of the Samuel Montague Club...for pulling a knife and holding it to the neck of a black child.... Jamie Acourt had kicked a black child down the concrete steps of his school and knocked him unconscious. The school refused to treat this as a racist attack and both boys were expelled. In May 1992, David Norris and Jamie Acourt stabbed and beat [a boy] ... [who] had a deep holiday tan and dark hair, and looked Turkish or Asian. Norris was charged, but the CPS dropped the charge just six weeks before Stephen was killed. (Later I discovered that the CPS never explained to the Witham family

[10] Doreen Lawrence, quoted in Nick Hopkins, "Family Anger at Lawrence Whitewash'," *The Guardian*, 14 July 1999: 4.
[11] Doreen Lawrence, *And Still I Rise: Seeking Justice for Stephen*: 168.

why they refused to press on with the case. Had they not dropped it, Stephen might still be here). [12]

However, at the criminal proceedings in July 1993, the Crown Prosecution Service ruled that Duwayne Brooks's identification of the suspects could not be put to the jury since Detective Sergeant Crowley's statement questioned its veracity. The Crown Prosecution Service then concluded that there was "insufficient evidence" to convict. [13] Dissatisfied with the police investigations, the Lawrence family then launched their own private prosecution (a rarity in the U.K.). From 1995-1997, two inquests re-examined the evidence, and the suspects were recalled, but refused to answer questions, claiming the privilege against self-incrimination. Nonetheless, the inquests revealed substantial flaws in police practices, resulting in a public inquiry, led by Sir William Macpherson. Lawyers representing the Lawrence family, Duwayne Brooks, and the Metropolitan Police interrogated eyewitnesses and all the police officers who had been involved in the case. *The Macpherson Report* (1999)[14] concluded that the police investigation was "marred by a combination of professional incompetence, institutional racism and a failure of leadership by senior officers." [15] Its findings were particularly damning for the London Metropolitan Police: whilst condemning the overt racism of the white assailants, it cited covert racism of "unwitting prejudice, ignorance, thoughtlessness and racist stereotyping … in other police services and institutions countrywide."[16] *The Macpherson Report* recommendations sought to combat racism within the police and public services. [17] The Lawrences then launched a second civil suit

[12] Doreen Lawrence, Ibid., 138-139.

[13] Janet Shallice, "Chronology" in Richard Norton-Taylor, Ibid.: 9.

[14] *The Macpherson Report* defined institutional racism as "the collective failure of an organisation to provide an appropriate and professional service to people because of their colour, culture or ethnic origin", which "can be seen or detected in processes, attitudes and behaviour which amount to discrimination through unwitting prejudice, ignorance, thoughtlessness, and racist stereotyping which disadvantages minority ethnic people." Staff and Agencies, "Metropolitan Police Still Institutionally Racist," *The Guardian*, 22 April 2003. http://www.guardian.co.uk/lawrence/Story/0,,941167,00.html.

[15] Nicholas Timmins and Simon Buckby, "Justice and Stephen Lawrence," *Financial Times*, 25 February 1999: 27.

[16] Timmins and Buckby, Ibid., 27.

[17] These included that police and public services be subject to the Race Relations Act and that targets be set for the recruitment and advancement of ethnic minority officers. Police were to receive training in racial awareness and racist words or acts could be considered grounds for discipline or dismissal. Deborah Hargreaves noted that in 1999 only 3% of the London Met were non-white, in a city where 25% of the population were

against 41 officers of the London Metropolitan Police (including the then-Commissioner Sir Paul Condon). The London Metropolitan Police offered a public apology and financial compensation of £320,000 to Stephen Lawrence's parents, Doreen and Neville, but refused to admit negligence in its handling of the inquiry or the conduct of its officers.[18]

 Guardian journalist Richard Norton-Taylor drew upon the 11,000 pages of the Macpherson Report for the text of *The Colour of Justice*. Both Norton-Taylor and director Nicholas Kent envisioned the play as a form of public tribunal, laying the complex and often contradictory evidence before the audience to review and reflect upon the competing claims. Norton-Taylor decided to edit the inquiry transcripts, but not to alter or amend what the witnesses said:

> I set out to include the most telling exchanges for a theatre audience, many of which did not hit the headlines at the time…. I wanted to select evidence to the inquiry which presented as fair, balanced and as rounded a picture as possible. It was not an easy task [19] …the practical incompetence of the police is shown, as is the thread of racism, conscious or unconscious, that lies behind it…. the language that…many of the police witnesses use often damns them…. [But] this shouldn't turn into a pillorying of the police. [20]

 As a genre, verbatim drama is created from primary sources, both oral and written. The writer crafts the words spoken by those who have lived these events into a theatrical whole. The aesthetic of verbatim drama, therefore, privileges "authentic" experience over a fictional recreation of real events.[21] *The Colour of Justice* creates the ambiance of an English courtroom, where the conventions of professional comportment ask the witness to "report" rather than "relive" the event, keeping an aesthetic distance from the material. The majority of witnesses are the police constables and superintendent detectives, but their stories are tempered with accounts from Duwayne Brooks, passer-by Conor Taaffe, teenager first-aider Helen Avery, and murder suspect Jamie Acourt.

Black or Asian; source: "Inquiry Into Race Murder Exposes Society's Divisions" in *Financial Times*, 25 February 1999: 10.

[18] In March 2006, Scotland Yard awarded Duwayne Brooks £100,000 compensation for wrongful arrest and police negligence. This was noted by Jason Bennetto, "Friend who survived racist attack on Stephen Lawrence wins police payout," *The Independent*, 11 March 2006: 19.

[19] Richard Norton-Taylor, Ibid., 6.

[20] Richard Norton-Taylor quoted in Dominic Cavendish, "Theatre: And Nothing But the Truth," *The Independent*, 6 January 1999: 11.

[21] Whilst *The Colour of Justice* is entirely composed of verbatim material, *Gladiator Games* uses a mixture of verbatim material and the playwright's own interpretation of events.

Even the inflammatory remarks of murder suspect David Norris are delivered coolly and impartially: Queens Counsel Michael Mansfield reads the transcript of a surveillance video to Acourt:

> David Norris is saying: "I'd go down Catford and places like that, I am telling you now, with two submachine guns and, I am telling you, I'd take one of them, skin the black cunt alive, torture him, set him alight.... I would blow their two legs and arms off and say, and say, 'Go on, you can swim home now,' and he laughs.[22]

Such a straightforward statement of fact was immensely powerful in its simplicity. As the evidence mounts up, the police are shown to be contradicting themselves, and "I don't remember" (the refrain of murder suspect Jamie Acourt) speaks volumes. This directorial choice asked the actors to "represent their characters faithfully," and to "inhabit" rather than imitate" their characters.[23] This proved a difficult task for some actors who portrayed the police witnesses, some of whom may have been "performing" for the jury: director Nicholas Kent advised Tim Woodward (who played Assistant Commisioner Ian Johnston) about the reading out of a formal apology to Neville Lawrence: "you've got to be really careful with that character. If you're not, you're patronising him. He's a man with limited sensitivities but he's got to think he's being enormously sensitive."[24]

The production style opted for a blurring of the boundaries between real life and theatre, not only through the verbatim text, but in its visual text, particularly in spatial relationships between audience and actors. The stage configuration positioned the audience as if they were the jury, thus making them a part of the courtroom proceedings. This verisimilitude was commented upon by the reviewer for *The Daily Telegraph*:

> It is hard to get the overall picture of a case like this from news reports. Nicolas Kent's meticulous reconstruction of the inquiry before Sir William McPherson last year often takes the breath away as the police damn themselves from their own mouths... The staging and the acting are so realistic that you feel you are attending the inquiry itself. And the piece has a resonance well beyond the Lawrence case, providing a depressing impression of the racial divisions of our multi-cultural society....[25]

[22] Norton-Taylor, Ibid., 137.
[23] Cavendish, Ibid., 11.
[24] Nicholas Kent, quoted in Dominic Cavendish, Ibid., 11.
[25] *The Daily Telegraph*, cited by Albemarle of London. See http://www.albemarle-london.com/colourofj.html. Accessed 1 Jan. 2005.

When the actor playing Macpherson (the inquest chairman) asked the enquiry to take a twenty-minute break, the audience had a twenty-minute interval. At its close, he asked all those present to stand for a minute's silence in memory of Stephen. As the actors rose, so did the audience in the Tricycle. On the first night, this was particularly moving, for the Lawrence family and many of the solicitors involved in the case were in the auditorium and stood facing their fictional counterparts. It is evident, then, that the production intended to create a politicized theatre, but one which would not preach at its audience. This stance of (relative) objectivity impressed critic Robert Butler, who noted that in "these tribunals, subject-matter comes first, which makes for the most effective kind of political theatre. We hear the evidence and reach our own conclusions. Kent's production achieves a documentary authenticity that's more telling than TV documentaries." [26] This style is a hallmark of Richard Norton-Taylor's work; *The Colour of Justice* was the fourth of Richard Norton-Taylor's tribunal plays, following on from the 1994 *Half the Picture* (about the arms to Iraq enquiry), the 1998 *The Nuremburg War Crimes Trial* and *Srebrenica*. His *Justifying War: Scenes from the Hutton Inquiry* was produced in 2003.

In contrast, a very different tactic is taken by *Gladiator Games*, which tells the story of a British Asian family's hopes and despair during their five-year struggle to get to the truth about their son's murder. Like Doreen and Neville Lawrence, Sajida and Amin Mubarek believed that they had been failed by the criminal justice system. Zahid Mubarek's death at H.M. Feltham Young Offenders Institution immediately prompted both a police investigation and an internal enquiry, led by Ted Butt, a senior prison officer. The Mubareks found that both investigations left many unanswered questions, and they met with the Prisons Minister at the Home Office on 6 April 2000 to request an independent public enquiry. Although Robert Stewart was convicted of murder and sentenced to life imprisonment on 1 November 2000,[27] Zahid Mubarek's murder was not condemned as a race hate crime, an oversight which the Mubareks felt was unacceptable. At the conclusion of the trial, the Mubarek family launched a press, public, and parliamentary campaign, again calling for an independent public enquiry, a request granted by Mr. Justice Hooper on 5 September 2001. After significant delays from the Home Office, the public enquiry finally began

[26] Robert Butler, "Trial by Tricycle Theatre," *The Independent*, 17 January 1999: 4. A television docudrama, *The Murder of Stephen Lawrence*, was broadcast by Granada TV on 18 February 1999, and reviewed by Brian Reade in *The Daily Mirror*.

[27] Suresh Grover, *The London Monitor: Special Edition for Gladiator Games*, November 2005–January 2006: 4.

on 18 November 2004.[28] Zahid's uncle, Imtiaz Mubarek, who led the campaign, stated:

> Our case has been driven by one simple question: why was a racist allowed to share a cell with an Asian youth? On April 29, 2004, our legal battle took us to the House of Lords, where we won a unanimous decision effectively forcing David Blunkett, the then Home Secretary, to allow my family a public inquiry. Five years later we are now nearing the end of the Zahid Mubarek inquiry. It is hoped that it will do for the British prison system what the Stephen Lawrence inquiry did for British policing. [29]

Suresh Grover (Director of the Monitoring Unit of the Institute of Race Relations) argued that "you can begin to eradicate racism if you bring it out into the open and the people responsible are held publicly accountable." [30]

Arguably, theatre can raise awareness about institutional racism and the need for public accountability in extremely powerful ways. The immediacy of live performance and the craft of the actor can provoke a visceral, empathetic response, putting a human face on what otherwise might be dry statistics about race hate crimes. Such, I feel, is the performative strategy of *Gladiator Games*: as family members share their intimate memories and fears, they appeal directly to the emotions of the live audience. Stylistically, this is a very different performative strategy from that of *The Colour of Justice*, whose tribunal format foregrounds the institutional structures of the police and criminal justice system. Indeed, there, the Black protagonists are largely silent presences: Doreen Lawrence is given only a few lines, and the testimonies of Duwayne Brooks, Neville Lawrence, and Doreen Lawrence are read by their legal counsel. Their testimonies are contained in three scenes, occupying a total of fifteen pages in a 143-page play.[31]

Director Charlotte Westenra and playwright Tanika Gupta had a very different agenda in writing *Gladiator Games*: to allow the family to tell its story. Westenra had been a co-director for the Tricycle's 2003 production of Norton-Taylor's *Justifying War: The Hutton Inquiry*, but she "didn't want this to be a

[28] Suresh Grover, Ibid., 5.

[29] Imtiaz Mubarek, quoted in "It was Officers v. Inmates," *The Guardian*, 14 November 2005: 22.

[30] Taped interview with Imtiaz Mubarek and Suresh Grover, quoted in Tanika Gupta, *Gladiator Games* (London: Oberon, 2005), p.43. All subsequent citations are from this edition.

[31] See "From the Evidence of Doreen Lawrence, 11 June 1989," "Statement of Neville Lawrence 30 March 1998," and "From the Evidence of Duwayne Brooks," 1 May 1998 in *The Colour of Justice*: 117-122; 62-62; 94-98.

court-based drama populated with white middle class lawyers. It was really important to give the family a voice, to give Zahid a voice."[32]

Gladiator Games is structured as a thriller. At the start of the play, we already know that Zahid Mubarek is dead, but the play's journey is one where the audience is launched into the web of miscommunication, negligence, denial, and condoned racism at H.M. Feltham Young Offenders Institution.

Ray Panthaki as Imtiaz Mubarek. Photo: Johan Persson.

The visual elements of Paul Wills's set also draw us into this world: at floor level is a diamond-shaped acting space, white and antiseptic. The gallery level, which wraps around all three sides of the stage, consists of dull steel doors and echoing metal mesh walkways, connoting the Swallow Wing of H.M. Feltham Young Offenders Institution as well as the court-room. The spatial arrangement of the prison encroaches upon and threatens to extend into

[32] Charlotte Westenra, quoted in Kelly Hitditch, "Gladiator Games: Fighting for Justice," *Socialist Worker*, 18 February 2006.
http://www.socialistworker.co.uk/article.php?article_id=8288.

audience space, creating a sinister atmosphere. Even in the scenes set in the Mubarek home, we are constantly aware of the half-lit hulk of the prison, hovering just above their heads.

At a post-show discussion, Vikram Dodd pointed out that "you need public pressure for prison reform," but the "public's point of view is not about better conditions for prisoners."[33] The action of *Gladiator Games* raises questions about the efficacy of the current youth prison regime and asks what human rights and duty of care are owed to minors who have broken the law. It does so through two performative strategies: 1) in presenting the Mubareks as close-knit family and trusting citizens who genuinely believed that Feltham was a place "to rehabilitate" Zahid [34], and 2) through split scenes which contrast trial evidence with the nightmarish reality of life at H.M. Feltham Young Offenders Institute.

Gladiator Games is framed by opening and closing scenes where family members directly address the audience. These "bookend" moments show the Mubareks as devoted parents and Zahid as a personable young man who repented his petty crime. This emphasis upon stable family life is perhaps intended to create a more sympathetic response to Zahid. Unlike Stephen Lawrence, who was studying for A-levels (university entrance examinations), Zahid Mubarek was not entirely a "model minority" youth, but one who stole and dabbled in drugs. The play begins with Imtiaz Mubarek's recollection of his nephew, painting a picture of a lively, athletic lad:

> Zahid wanted to go into the army. He had a sense of humour, always joking with us—made us smile. Anyone you speak to, they'll tell you he was such a nice guy. But he got into trouble…. Nobody understood why he got sent down for what he did. It was, it was a shock. [35]

The final scene begins with Amin and Sajida Mubarek's last visit to their son and their preparations for his homecoming and ends with Zahid himself, speaking the text of a letter home:

> Dear Mum and Dad, How are you? I am fine now. How are Zahir and Shahid [his brothers]? They mean the world to me. Tell them not to turn out like me. I was always hanging around with the wrong people and f-king smoking drugs and that's what f—ked me up. Dad I knew I should've listened to you from the beginning. Dad when I get out I want you to get me a job. And how are granddad

[33] Vikram Dodd, Post-show discussion for *Gladiator Games* at the Theatre Royal Stratford East, 2 November 2005.
[34] Gupta, Ibid., 107.
[35] Gupta, Ibid., 33.

and grandma? Tell them I love them. Dad, tell mum I have not forgotten about her and tell her I love her so much. Tell my mum not to worry. I am okay. Love Zahid. [36]

Spatially, the audience occupies the position of his parents, to whom he confesses his repentance and desire for a new start. Lyn Gardner, reviewing the play remarked that "you leave the theatre feeling you've met and known Zahid Mubarek. This is no faceless statistic, but a laughing young man who was full of flaws and promise." [37]

The Mubarek family scenes are juxtaposed with split scenes, where witnesses give evidence at one stage level whilst life in Feltham goes on at the main stage level. The function of the Feltham scenes is to reveal the dehumanizing conditions where the young male offenders receive no education and are locked up for 22 hours a day in cramped ill-lit cells.[38] Lucy Bogue, former Chairwoman of the Independent Monitoring Board Feltham, reported:

Each cell contained one lavatory bowl with no privacy screen, 12 inches from the foot of the bottom bed. With only one metal seat, welded to the wall and one metal table welded to the wall, the second person would be forced to eat all meals seated on the bottom bunk, in close proximity to the lavatory bowl....[39]

Intercut with her testimony is the howling of an inmate, Caps, who has "lost it big time." As Zahid soon learns, despite the chaos, bullying, and relentless noise, he must find ways to "stop flipping out." [40]

But *Gladiator Games* is more than a simple lament for the unrealised potential of Zahid Mubarek. The play goes beyond the injustices done to a British Asian to demonstrate how the prison system failed another vulnerable youth in custody: through Zahid's murderer, Robert Stewart.

The assessment of Gunn, a professor of psychiatry, introduces Stewart to the audience and predisposes one to view him as a heartless monster. Gunn cites him as a hardened criminal who, by 2000, had racked up eighteen convictions and sixty-five offences, and had served six prison sentences.[41] Stewart's first appearances corroborate such a view: he sets fire to prison furniture and colludes in the fatal stabbing of an inmate. There is no doubt that Stewart was a known racist: upon arrival at Feltham, he wrote a complaint about

[36] Gupta, Ibid., 111.
[37] Lyn Gardner, "Gladiator Games," *The Guardian*, 27 October 2005: 38.
[38] Gupta, Ibid., 69-71.
[39] Gupta, Ibid., 68.
[40] Gupta, Ibid., 67.
[41] Gupta, Ibid., 48.

the number of Black inmates, but prison officers returned it to him and asked him to write it more acceptable form. Prior to murdering Zahid Mubarek, Stewart had written 200 racist letters, including six on the night of the murder; one of them threatened to "nail bomb the Asian community of Great Norbury.... It's all about immigrants getting smuggled in here. Romanians, Pakis, Niggers, Chinkies, tryin' to take over the country and using us to breed half castes."[42]

Tom McKay as Robert Stewart. Note 'R.I.P.' tattoo on his forehead.
Photo:Johan Persson.

Since Stewart seemed a "quiet prisoner,"[43] prison officers did not consider the letters as a serious threat and moved Stewart into Mubarek's cell for six weeks,

[42] Gupta, Ibid., 97.
[43] Gupta, Ibid., 81.

thereby enabling Stewart's racist fantasies to thrive and finally come to fruition. As barrister O'Connor pointed out, if Mubarek had been a White Christian and Stewart a racist Black Muslim, prison officers would never have allowed Mubarek to be put into such danger. [44] The condemnation of race discrimination and negligence at Feltham were the main issues the Mubarek family wanted to highlight. Imtiaz Mubarek discussed possible dramatization with Gupta:

> ...to sustain the publicity surrounding the case ... to highlight the problems of institutional racism in the prison system; to show the predicament facing young offenders.... We hoped that a dramatisation of Zahid's case and the events leading up to his death would help create an awareness of the problems he faced and maybe galvanise further action. [45]

Gladiator Games, however, complicates the issue of Stewart's racism, by showing how the prison system fails not only people of colour, but also at-risk, working-class white men. Gupta learned that "Stewart's long-standing mental illness... was never addressed or recognised....[His] history of self-harm tell[s]another story of a young man who has also been failed by society."[46]

Gunn assesses him as a "psychopath" with a "severe personality disorder" who "shows a glaring lack of remorse, feeling, foresight or other emotion."[47] Stewart's history outlines some of the contributory factors: he had no family, spent his childhood in care homes, and never completed school. Since 1995, he had been seen twenty-nine times by medical or health care staff. Despite his aberrant behaviour—which included hearing voices and attempts at hanging and cutting himself—he was assessed with an "untreatable mental condition" which required "no further action."[48] Stewart was never referred to a psychiatrist and received virtually no counselling or treatment. *Gladiator Games* refuses to excuse Stewart's actions on the ground of mental illness. Rather, it chillingly shows how the prison system failed in its duty of care for this white youth: his mental illness manifested itself in racist paranoia, which was left unchecked and untreated. As Stewart himself said, he was a "time bomb ready to explode."[49]

* * * * *

[44] Gupta, Ibid., 97.

[45] Imtiaz Mubarek, "It was Officers v Inmates," *The Guardian*, 14 November 2005: 22.

[46] Gupta, Preface to *Gladiator Games*.

[47] Gupta, Ibid., 49, 55.

[48] Gupta, Ibid., 55.

[49] Gupta, Ibid., 66.

Both plays serve as reminders of the insidious presence of institutional racism within powerful governmental agencies: the police force and the prison system. Seven years after the Macpherson Report, the police system has begun to make small but significant changes; however, it still experiences difficulties in the recruitment and retention of Black and Asian police officers.[50] A report by the Zahid Mubarek race equalities advisor found racism is still rife within the prison system:

> . . .prisons with a swastika daubed on the wall, racist language and 'belligerent behaviour' by staff, officers telling racist jokes to white inmates, and claims of bullying and abuse. Staff at one jail were also found to be hostile to the prison services's investigation team which was mostly black. At Portland jail the race equality report found that on the investigator's first day a staff member told them 'we're being overrun by you lot.' Some staff at Portland saw demands to reform by their bosses as 'political correctness from London.' At Leeds jail staff were 'openly' hostile to prison service inspectors. Leeds is being investigated by the prisons ombudsman after an Asian inmate was killed by his white cellmate.[51]

The *Report of the Zahid Mubarek Inquiry* was released on 29 June 2006. Whilst it acknowledged negligence and condoned racism at Feltham, the charge of "gladiator" remained unsubstantiated. Its recommendations focused upon improving communication between and within prisons, advocating against prisoners sharing cells, requiring prison officers to keep up-to-reports and ensuring that a prisoner's written records are with him when s/he is transferred

[50] Vikram Dodd reports that, by 2009, 7% of all police forces are supposed to be Asian or Black. At present 3.5% of Britain's 140,000 officers are from ethnic minorities. However the "Association of Chief Police Officers says the law does not allow them to recruit Asian and black candidates fast enough, and that their attempts to get the law changed to allow positive discrimination have been rebuffed. Cheshire's chief constable, Peter Fahy, and ACPO spokesman on race and diversity issues, said: "We have to hold our hands up. What the police force has failed to do is get across the business and operational case for diversity. We've lost the diversity argument with our own staff, the popular press and public overall. They see it solely in terms of political correctness." See "Diversity target is unrealistic say police chiefs, *"The Guardian*, 31 March 2006. http://www.guardian.co.uk/race/story/0,,1743755,00.html. Accessed 31 March 2006.

[51] Vikram Dodd reports that "According to the report by Beverley Thompson, the segregation wing at Leeds was of most concern: 'Some staff were unable to disguise the hostility they felt about race relations.' At the top security Belmarsh jail, where terrorism suspects are held, white inmates complained about the racism of white officers. The white prisoners took offence because some of them were in mixed race relationships. Vikram Dodd, "Racism still rife in jails, five years after the murder of Zahid Mubarek," *The Guardian,* 06 October 2005.
http://www.guardian.co.uk/prisons/story/0,,1585682,00.html. Accessed 6 October 2005.

to a new prison. However, ten of the eighty-eight recommendations specifically
called for improvement of conditions for BME (Black Minority Ethnic)
prisoners. These included publication of race equality policies or race equality
schemes under the Race Relations Act 1976.[52]

Whether conveyed by the restrained eyewitness accounts of *The
Colour of Justice* or by the embodied rage and pain of the Mubareks, each play
asks its audience to recognise its individual as well as collective responsibility
to recognise and to confront racism. Charlotte Westenra argues that verbatim
theatre is a form of civic engagement, giving audiences a glimpse into the
hidden workings of governmental institutions:

> There has been a real resurgence in political theatre. I think one of the reasons
> that these testimony plays are so powerful is because they allow us to see behind
> that closed door. Public inquiries should be just that, public, but they're not.
> They should be televised.[53]

Director Nicholas Kent claims that the collective experience of

> ...strangers, all feeling a common indignation, a common passion, is immensely
> strengthening. It restores theatre's ancient role as part of the democratic
> process.... Stephen Lawrence's murderers are not going to be brought to justice
> any more than Karadzic and Mladic are, but at least what happened is being
> rehearsed in public, and the wrong done to the Lawrences by the people who
> killed their son, the police and society is being aired. That must be a healing
> process.[54]

Writing about *The Colour of Justice*, critic Paul Taylor offers a utopian view of
the power of theatre: "The act of framing this event on stage puts it under a
piercing light and renews the original sense of shock... [It] also reasserts the
theatre's role as a supreme invention of democracy."[55] The plays certainly
present a grim view of the racism within the criminal justice and prison systems.
But as critic Robert Butler noted, it is far too easy for audiences to feel good
about their own liberalism and to pillory only the police:

> *The Colour of Justice* demonstrates the role played in our society by unconscious
> racism. *The Colour of Justice* isn't about a few bent coppers. It's about how

[52] See *The Zahid Mubarek Inquiry, Vol. 2* (London: The Stationery Office, 2006):
Appendix 8.
[53] Charlotte Westenra, quoted in Hitditch, Ibid.
[54] Nicholas Kent, quoted in Cavendish, Ibid.
[55] Paul Taylor, "Theatre: Guilt in All Its Subtle Shades," *The Independent*, 14 January
1999, p. 10.

white Britain treats black Britain. As a black woman said to me in the interval. 'It is not enough for a white person to say, "I am not racist". You have to ask yourself if other people find you racist.'[56]

And this, I believe, is the significance of the moments of counter-narrative within these plays: to remind audiences that the potential for change begins, not with institutions, but with individuals who transcend the divides of racism to work towards a more equitable future for all Britons. The Lawrences founded the Stephen Lawrence Trust to provide anti-racism education and opportunities for disadvantaged youth, and the Mubareks created The Zahid Mubarek Trust to provide services and support to young offenders and their families. Each play has a defining moment, where one man goes against his social conditioning or workplace loyalties. *The Colour of Justice* presents Conor Taaffe, a "good Samaritan" who admits that his own racist assumptions initially prevented him from aiding the two Black youths:

TAAFFE: …perhaps it was a ploy. One would fall down and you would think: 'Oh my God, there's something wrong.' You would go over and the other might get you. That did pass through my mind.

MACDONALD: Was that because it was two young black men running along the other side of the road.

TAAFE: I would say that was part of my assessment, yes. [57]

Yet it is Taaffe who overcomes his suspicions to comfort the dying Stephen:

Louise and I both knew that hearing is one of the last things to go, and so, while he was there, she said: 'You are loved. You are loved.' I had some blood on my hands. When I went home—this isn't material, but I will say it anyway—I went home and washed the blood off my hands with some water in a container, and there is a rose bush in our back garden, a very, very old, huge rose bush—rose tree is I suppose more appropriate—and I poured the water with his blood in it into the bottom of that rose tree. So in a way I suppose he is kind of living on a bit. [58]

In *Gladiator Games*, Duncan Keys (Assistant Secretary for the Prison Officers' Association) overhears that the prison officers at Feltham indulge in the game of "Gladiator," where two prisoners are put in a cell in the expectation that they

[56] Robert Butler, Ibid.
[57] Norton-Taylor, Ibid., 38.
[58] Norton-Taylor, Ibid., 37.

might fight.[59] When his line manager tells him he should do nothing, Keys makes an anonymous phone call to the Commission for Racial Equality and outs his colleagues:

> Mubarek was killed because people thought it was funny to see what would happen when they put a young Asian lad in with someone who wanted to kill Asians.... [It] was bloody human beings who put those two people together rather than bloody processes and procedures. [60]

Works Cited

Bennetto, Jason. "Friend who survived racist attack on Stephen Lawrence wins police payout," *The Independent*, 11 March 2006: 19.

Billington, Michael. "White Out: Is There a Crisis in Black Theatre in Britain?" *The Guardian*, 18 October 2000: 14.

British Theatre Guide. 20 August 2006. Available at http://www.britishtheatreguide.info/articles/280299.htm.

Brown, Jonathan. "Suspects who still swagger in the shadows," *The Independent*, 8 May 2004: 19.

Butler, Robert. "Trial by Tricycle Theatre," *The Independent*, 17 January 1999: 4.

Cavendish, Dominic. "Theatre: And Nothing But the Truth," *The Independent*, 06 Jan.1999: 11.

The Daily Telegraph, cited by Albemarle of London. http://www.albemarle-london.com/colourofj.html. Accessed 1 Jan. 2005.

Dodd, Vikram. "Diversity target is unrealistic say police chiefs," *The Guardian*, 31 March 2006. http://www.guardian.co.uk/race/story/0,,1743755,00.html.

—. "Police Could Face Action Over Stop and Search." *The Guardian*. 21 March 2003. http://www.guardian.co.uk/crime/article/0,,918866,00.html.

—. Post-show discussion for Gladiator Games at the Theatre Royal Stratford East, 2 November 2005.

—. "Racism still rife in jails, five years after the murder of Zahid Mubarek," 6 October 2005. http://www.guardian.co.uk/prisons/story/0,,1585682,00.html.

Gardner, Lyn. "Gladiator Games," *The Guardian*, 27 October 2005: 38.

Grover, Suresh. *The London Monitor: A Special Edition for Gladiator Games*, November 2005–January 2006: 8.

[59] Gupta, Ibid.: 74.
[60] Gupta, Ibid.: 73.

Gupta, Tanika. *Gladiator Games*. London: Oberon Books, 2005.

Hargreaves, Deborah. "Inquiry Into Race Murder Exposes Society's Divisions." *Financial Times*, 25 February 1999: 10.

Hitditch, Kelly. "Gladiator Games: Fighting for Justice." *Socialist Worker*, 18 February 2006.
http://www.socialistworker.co.uk/article.php?article_id=8288.

Hopkins, Nick. "Family Anger at Lawrence 'Whitewash,'" *The Guardian*, 14 July 1999: 4.

—. "Met Stop and Search 'Now Hitting Asians,'" *The Guardian*, 16 December 1999: 4.

Hyland, Julie and Chris Marsden, "Britain: Macpherson Inquiry into the Murder of Stephen Lawrence Provokes Ring-Wing Backlash." *World Socialist Website*. 25 February 1999.
http://www.wsws.org/articles/1999/feb1999/lawr-f25.shtml.

Laville, Sandra. "Asian Students Tell of Ejection from Airliner." *The Guardian*, 24 August 2006.
http://www.guardian.co.uk/airlines/story/0,,1857081,00.html.

Lawrence, Doreen. *And Still I Rise: Seeking Justice for Stephen*. London: Faber and Faber, 2006.

Mubarek, Imtiaz. "It was Officers *v*. Inmates." *The Guardian*, 14 November 2005: 22.

Norton-Taylor, Richard. *The Colour of Justice*. London: Oberon Books, 1999.

Reade, Brian. "Racism U.K.: A Video Nasty." *The Daily Mirror*, 19 February 2006.
http://www.highbeam.com/library/doc3.asp?DOCID=1G1:60390614&ctrlInfo=Roun. Accessed 25 August 2006.

Royal National Theatre. 26th August 2006.
http://www.nationaltheatre.org.uk/?lid=1258&dspl=dates.

Shallice, Janet. "Chronology" in Richard Norton-Taylor, *The Colour of Justice*. London: Oberon Books, 1999. (Page 9.)

Staff and Agencies. "Metropolitan Police Still Institutionally Racist," *The Guardian*, 22 April 2003.
http://www.guardian.co.uk/lawrence/Story/0,,941167,00.html.
Accessed 31 December 2005.

"Stephen Lawrence: 1974-1993; The Lessons That Must be Learned," *The Voice*, 22 February 1999.
http://www.highbeam.com/library/doc3.asp?DOCID=1P1:23058356&num=2&ctrlInfo=Round19%3AProd%3ASR%3AResult&ao=&FreePremium=BOTH. Accessed 1 Jan 2006.

Sturgis, John. "Condon Should Do Honourable Thing and Resign." *The Evening Standard*, 25 February 1999: 8.

Taylor, Paul. "Theatre: Guilt in All Its Subtle Shades." *The Independent*, 14
 January 1999: 10.
Timmins, Nicholas and Simon Buckby, "Justice and Stephen Lawrence,"
 Financial Times, 25 February 1999: 27.
Tricycle Theatre. 26th August 2006.
 http://www.tricycle.co.uk/htmlnew/whatson/show.php3?id=52.
The Zahid Mubarek Inquiry, Vols. 1 and 2. London: The Stationery Office,
 2006.

CHAPTER EIGHTEEN

DIGITAL MEDIA PRACTICE AS CRITIQUE: ROSHINI KEMPADOO'S INSTALLATIONS *GHOSTING* AND *ENDLESS PROSPECTS*

ROSHINI KEMPADOO
GOLDSMITHS COLLEGE, LONDON

Fig. 1: *Future Looms* (1998)

This text will refer to the artworks *Ghosting (2004)* and *Endless Prospects (2004)* to explore a mode of digital media production that involves differing narrative forms, experiments with temporal and spatial constructs, and employs what may be described as a "still-moving" aesthetic.[1] I examine digital technologies and networked environments as places of production that allow for an enhanced dimension of *critical* black art practice, often associated with the black arts movement of the 1990s in Britain. I argue that digital artistic practice of this kind is able to extend conventional practices of film, photography, and sound. It places the user experience as central to engaging with the artwork, and is able to contribute a more individualised life story that adds to the dominant and de-personalised hegemonic narrative of mass enslavement, brutality, and de-humanised history of the black Atlantic. I will begin by contextualising my practice. I will then go on to explore particular conceptual aspects of *Ghosting* and *Endless Prospects* to present notions of narrativity, temporality, and visual aesthetics as ways of exploring the critical dimensions of the work.

Challenging Documentary Practice

My multimedia practice emerges from a period in which *independent* photography and film shaped the debate in Britain of media arts practice from the late 1980's and during the decade that followed. The term *independent photography and film* is associated with the work of photographers, film-makers, writers, and critics whose work was informed by feminist, psychoanalytic, and black identity politics. Stuart Hall's seminal writings on cultural identity in the 1990's, in which he describes the notion of exploring representations that position "the black subject at the centre" and implicate "the positions from which we speak or write—the positions of *enunciation*,"[2] resonated with my original interest and intention in creating photographs and getting into photography. My personal experience is as a first-generation British Guyanese whose parents had made the *return* journey to the Caribbean in the nineteen-seventies with an optimism of post-independence. I had a deep and continuous longing to explore British Caribbean/Caribbean identity with its long and interrelated history. I loved photography for its efficacy and association: as a popular medium and its currency symbolising migration and travel; as a medium that had historically proscribed and visually signified the black body; and as a medium that had provided a creative space for rehabilitation and

[1] Cheryl Finley uses this term in her interview "the still-moving image" in *Roshini Kempadoo: Work 1990 – 2004.*
[2] Stuart Hall, "The Whites of Their Eyes: Racist Ideologies and the Media." *The Media Reader* (London: BFI, 1990) p. 222.

restitution. Kellie Jones—art historian and critic—sometime ago aptly described this notion in her essay "Re-creation" where she examined my work among that of other black women photographers:

> Much of this photography and text work has to do with 'making ourselves visible', redefining the image/position of the woman/person of colour in the large discourse.... Reterritorialisation includes recapturing one's (combined and various) history, much of which has been dismissed as an insignificant footnote to the dominant culture. These objects become texts of redemption and emancipation then; not simply adaptations of Western codes, they construct and (re)define their makers' own relationship with the world.[3]

What was key to the emergence of independent practice was its association with both an artistic intervention and an aesthetic that challenged the conventions of photography—particularly social documentary practices—*and* explored the extent to which such practices provided the basis for a level of advocacy and critique to challenge the cultural climate of the 1990s politically and socially.

To that end, I become involved in an independent critical practice defined by a distinctly black[4] arts/photographic/film formation and development. Separate autonomous agencies and institutional spaces were opened up through the activism of Asian and Caribbean groups for a critical engagement of media in relation to the black presence in Britain that had come to be so fully associated with social unrest and the basis of political anxiety.[5]

[3] Kellie Jones, "Re-creation," in *Ten 8 'Critical Decade: Black Photography in the 80s'* (Spring 1992).

[4] The term *black* was widely used during this period of history and was marked by the notion of solidarity, commitment, and political/social agency. It was used by black activists, politicians, theorists, and producers to describe individuals and communities of African, Asian, and Caribbean origin.

[5] Collective groups and resource bases such as the Black Audio Film Collective (1983), Autograph ABP—the London based Photographic Agency (1988), AVAA—the African & Asian Visual Artists Archive (1989), and InIVA (1994) were formed with combinations of public funds and freelance independent, autonomous, and voluntary effort, for production, curation, archiving, publication, development, and training of contemporary media: film and photography. Most importantly the agencies and the individuals running them advocated for the key issues of equality of opportunity, voice, visibility, and access to be addressed by art film and television institutions and governmental funding bodies for British black people collectively and individually, as audiences and practitioners. Journals and publications included *Third Text* (1987), *Ten.8* (1979 – 92), *Screen Education* (1974-82), *Framework* (1975 – 92), *October* (1976 -), and publications such *There Ain't No Black in the Union Jack: The Cultural Politics of Race and Nation* (1987) by Paul Gilroy and *Disrupted Borders* (1993), edited by Sunil Gupta. Stuart Hall's writings were key contributions to, and reflections of, the debates of the

There was no one coherent or consistent approach or style that can describe the aesthetic associated with independent photographic/film practice. Having said this, there was what David Bailey and Stuart Hall described as an "obsession"[6] to challenge notions of the authentic subject and the truth-value system that is an integral part of social documentary practice. Photography of this kind sought (a) to challenge the conventions of social documentary traditions of framing and composition; (b) to expand and critique the genres associated with documentary practices and to place importance on other forms, such as the family album portrait; and (c) to provide a challenge to the historical conventions of photographic practices in documenting world races and ethnicity —in other words, to question the authority and agency of the anthropological photograph as integral to the imperial period of colonisation whereby the black body was the subject of the colonialist, voyeuristic gaze.

There was, therefore, a visual exploration of aesthetics that included using techniques such as studio work and/or the staging of a moment or scene: construed photographs. Often the work contained autobiographical, domestic, and familial references to personal archives, individual histories, or previously untold/unknown stories of Caribbean and Asian communities. These photographs and films operated as critiques and counter-responses to stereotypical popular press images of the time. Common examples were the reoccurring image of the angry black man as violent or the exoticised figure of the black woman, whether veiled or sexually available. They became the resultant media created by black media practitioners that were autonomous and nuanced statements from previously invisible subject positions.

On the other side of the Atlantic, photography had a history of supplying the notion of the counter-narrative[7] which was being continued during

time. Also, importantly, a series of key themed and issue-based shows exhibited the work that explored historical and contemporary articulations of what it meant to be black and living in Britain, including *From Two Worlds*, Whitechapel (1986); *D-Max*, Ikon Gallery Birmingham (1987); *Fabled Territories*, Leeds City Art Gallery (1989); and *The Other Story*, Hayward Gallery, London (1989). Films and screenings such as *The Passion of Remembrance* and *Handsworth Songs* (1986), produced by Sankofa Film and Video and Black Audio Film Collective, and festivals such as *Caribbean Focus '86* and *Africa '95* also marked this period of formation, creativity, and articulation.

[6] David Bailey and Stuart Hall, editors, *Critical Decade: Black British Photography in the 1980s, Ten-8* 3 (1992): esp. pp. 15-23.

[7] Deborah Willis writes about W.E.B. Du Bois's work, stating that "Black photographers, whose work Du Bois drew on for the Paris Exposition, offered a provocative challenge to the blatantly stereotypical images of African Americans as inferior, unattractive, and unintelligent. Their photographs served as evidence that black Americans were as multifaceted as anyone else, and they played an important role in making the black experience visible"; and as Du Bois himself put it, it was "an honest, straightforward

this period, through the work of curators such as Deborah Willis[8] and the work of photographers such as Carrie Mae Weems and Lorna Simpson. It was the central focus of photography's (and film's) relationship to realism that was crucial to this period. The photographed black subject, its relationship to the techniques and technologies of the camera, and the European gaze became the nexuses of debate. It was the historic and inextricable link of photography and film to memory, notions of identity, history, and loss that provided the most potent backdrop.

Fig. 2: *Identity in Production* (1990) 'Who do they expect me to be today?'

exhibit of a small nation of people, picturing their life and development without apology or gloss, and above all made by themselves" (see Willis, 2003).
[8] Deborah Willis has published extensively on African American photography and has been an international spokeswoman and supporter for Autograph, the Association of Black Photographers, since its inception.

Critical Artworks: Narrative and Temporal Techniques

The artwork *Ghosting* (2004) illustrates a continuance of an independent practice into a digital media environment. My artwork creations from 1996 not only occupied the walls of the white gallery space as framed, digitally manipulated photographs, but extended into becoming screen-based projections or web-based artworks.[9]

Fig. 3: *Ghosting* (2004). Original in colour.

Ghosting[10] is concerned with presenting characters of the post-abolition colonial plantation and the Trinidad landscape—from the subject position of the plantation worker as "ex-slave," "ex-indentured labourer," or "free-coloured." A brief explanation of how *Ghosting* works would be to describe it as a single-screen, multi-media projection combining a visual and sound experience and dependent on a tactile intervention by the gallery user moving stones found in a wooden board. The artwork is triggered and experienced by a user/viewer using

[9] Other web-based and multimedia artworks include *Sweetness and Light* (1996), *Future Looms* (1998), and *Back Routes* (2002).

[10] *Ghosting* (2004) was originally commissioned by the Peepul Centre and Leicester Art Gallery as part of the retrospective touring show (curated by OVA) entitled: *Roshini Kempadoo: Works 1990 – 2004*. It has subsequently appeared in several group shows and toured internationally, including *Racing the Cultural Interface: African Diasporic Identities in the Digital Age* (curated by Sheila Petty for venues in Canada, 2005/6) and *Crossing the Atlantic…Uneasy Spaces* (curated by Ann Chwatsky and Liz Wells, New York, 2006).

the pit-and-pebble computer interface. Five pits and four stones (large pebbles) comprise the board, made of recycled wood. The artwork will play a sequence (a visual experience combined with soundworks dominated by a Creole monologue or conversation) if the user moves a pebble from one pit to another. The revealing of the "stories" is reliant on the pebbles being moved around by the user in a sequence of his/her choice. If no one engages with the artwork, it defaults to silence, with a single photograph on the screen and text inviting the user to "move dem stones."

The pit and pebble board that I created was conceived as a Creolised derivative from the *warai* board game.[11] Combining this triggering action, using *Director* as a games-authoring software programme, allowed me to present a different way in which a user may be able to experience a series of life stories that collectively and individually animate a legacy of the plantation lifestyle.

Figs. 4/5: *Ghosting* (2004), installation stills. Original in colour.

The history of plantation life in Trinidad is known about through the documents made and generated by the plantation-owning class, and dominate the tone and subject position of the archive material available, with a few exceptions that provide some insight into the plantation workers daily experience. I am concerned with the plantation workers viewpoint and material in which their own voice is evident in the documents. These are mostly male personalities noted for their significant contribution in bringing about change or a particular event in Trinidad history: Jonas Mohammed Bath[12] is one such example. The stories for *Ghosting* then (visually and aurally), were researched and conceived by Marc Matthews and myself and took their starting point from these historical

[11] The *warai* board name is Ijo dialect meaning "houses." There are some three hundred ways in which this game is named internationally. Considered to be one of the oldest strategy games exploring notions of cause and effect, it originated in the Sudan (Kush civilisation) and was originally used for mathematical calculations.

[12] Jonas Mohammed Bath was referred to in the local newspapers of the period and was known to have existed between 1796 and 1838. This document is reproduced in the publication *The Book of Trinidad* by Gérard Besson (1991).

figures that were known to have existed. Their histories were written down and developed further by Matthews as fictional *characterisations* (through Creolise monologues or conversations) whose lives and relations were intertwined around a single plantation space and the surrounding village, spanning a period of several generations.[13] I developed the visual style to accompany/compliment the characters dialogues, devising what I would describe as 'spatial attributes' in which each character becomes visually associated with a signified location or space.

Fig. 6: *Ghosting* (2004). Original in colour.

Using multimedia techniques and concepts, *Ghosting* proposes a multiple trajectory to the user/viewer. Through the "act" of moving one pebble and then another, the user/viewer is able to encounter the stories of plantation life from the perspective of a different character. Being able to "start, stop and repeat" a characterisation forms the basis for the engagement with the artwork. The user/viewer determines which character (and perspective) s/he may want experience and how often s/he may want to engage with it.

Equally so, a range of temporal moments become apparent through the visual and aural characterisations of the work. The characters are visually associated with separate and different landscapes such as the beach, plantation house, or field. As a fictional piece, it is not necessarily apparent to the user/viewer any one particular date or time – but rather each character and their experience is placed within different time frames. An example of this is the

[13] The fictional characters for *Ghosting* are centred on women's lives on the plantation, in which Elsie, once mistress to the plantation owner, has twin girls that were brought up separately, one in the plantation house with her mother, the other in the nearby village. The stories place emphasis on the two girls/women, their relationships and survival, in what may seem to be the post-abolition period.

characterisation of Victoria May, whose monologue signifies her reflecting on her situation as an adult, while our encounter with Aunt Ruth's narrative associated with the plantation owner's domestic space, refers to her as a child. The temporal and narrative intentions of *Ghosting* conjure a "presentness" of the characters and scenes, whilst referring to an event that visually relates to something that may have occurred before. It compresses and disrupts any time continuum whilst presenting a "playing field" that offers multiple ways in which to encounter the piece.

Fig. 7: *Ghosting* (2004). Original in colour.

Critical Artworks: "Still-moving" Aesthetics

I now turn to the artwork *Endless Prospects* as a site-specific commission for the Pitzhanger Manor and Gallery (London, July 2004) installed as a way of presenting the use of what I referred to as a "still-moving" aesthetic. *Endless Prospects* introduces the architecture and space of Jagan, a village in the Santa Cruz Valley, Trinidad, into the physical space of the Pitzhanger Manor in west London, making use of the library room, which overlooks what once was the gardens for the house, and the adjoining breakfast room, both on the first floor.

Pitzhanger Manor once was John Soane's country house and weekend retreat (completed in 1804) now owned and run as a public contemporary gallery and museum. John Soane was a significant British architect, instrumental in creating and altering significant buildings in Britain, including the Bank of England (1788/1807) and Nos. 10, 11, and 12 Downing Street, London (1825), during the period of Empire expansion and consolidation. Pitzhanger Manor was clearly conceived and built by him as a place of leisure and relaxation that embodies a style redolent of the confidence and power that the ruling elite maintained during this period of British global expansion.

Mirrors are employed in the architectural space to create infinite views and designed to emphasize opulence and grandeur visually through the repeating optical reflections of neoclassical female figures and classical signs. Stereoscopic views of the garden and countryside are carefully introduced into the building through large doorways and windows.

Figs. 8/9: *Endless Prospects* (2004), installation stills. Originals in colour.

The installation combines digitally manipulated still-image photographs—that replace the full-length glass doorways of the library space and the projection/sound work in the breakfast room. The visual experience of the projection is the aspect of the installation that I want to focus on for the purpose of this essay. It comprises a series of photographs, moving from one to another, complimented with sound work. It was created using the multimedia *Director* software in order to have a running sequence of images often *interrupted* by a random and quick series of images that relate to a Creole dialogue between a couple discussing the way in which their house is being built. The artwork makes specific use of the breakfast room—embedding the Caribbean landscape imagery onto the *trompe-l'oeil* of sky and clouds in the central area of the ceiling. The projected photographs often cut away to reveal the sky and clouds on the ceiling and run continuously on a loop system.

The photographs themselves are landscape/environment images of the Santa Cruz Valley, Trinidad, with little or no figural references present in the work. The visuals are accompanied by a continuous monologue of Creole terms, read by Matthews, with music created by Gary Stewart, that relates the local flora/fauna found in the Santa Cruz Valley. Familiar digital production techniques are associated with the aesthetics of speed and multiple objects moving fast across the screen surface, or freeze framing and zooming in to macro-focal length, or a wandering and continuous movement of the camera—in other words an agitation and restlessness about the visual that becomes the antithesis to a single, still contemplative photograph or image-sequence. The visual projection of *Endless Prospects* is dissociated from these conventions, where the photographic sequence dissolves, with one image replacing another at

a slow and ponderous pace—often rendered in a way that heightens and disrupts, sometimes bringing attention to the textual qualities of the surface, rather than the powerful "window on the world" quality of the documentary image.

Fig. 10: *Endless Prospects* (2004). Original in colour.

The image-sequence[14] refers, then, to a slightly caught and suspended temporality that commits wholeheartedly to the photographic rather than to the "cinema's affinity with sequence" and "illusory movement of the frames."[15] It is this stillness that I wish to hold onto, as a quality that rehearses a photographic status and is embedded with associations of loss, absence, and transience—so symptomatic of the black disaporic experience.

Cheryl Finley evokes an additional sense of my use of the still-moving image when she describes "montage" as "a hallmark" of my *"oeuvre"*—and

[14] The concept of the image-sequence, as developed by Victor Burgin in his publication *The Remembered Film* (London: Reaktion Books, 2004), has also influenced my creative process of visual narratives for *Ghosting* and *Endless Prospects.*
[15] Laura Mulvey, "Death 24 times a second: the tension between movement and stillness in the cinema." *Coil,* 9/10 (2000): 1-12.

one, I would argue, that is central to the production technique of the still-moving images, which are often juxtaposed, layered—more or less employing a sampling technique. The still-moving aesthetic, then, contains the possibility of critique. It stands outside the conventions and aesthetics of both film and photography, and its interstices and disjunctures provide the space of/for displacement, fantasy, and imagination.

Fig. 11: *Endless Prospects* (2004). Original in colour.

Traces in the Here and Now

In conclusion, then, my fascination with exploring photography lies with its remarkable and inextricable link to our everyday perception of truth and authenticity. How we make sense of the world and what we believe to be truthful evidence of something that has taken place—both the process and the ideas rely substantially on our perception and reception of photographic and video/visual experiences. With this in mind, I continue to explore ways in which photography's efficacy, associated with realism and documentary practices, may be converted and *tipped* into multimedia forms. In working with extended or additional multimedia techniques and post-production digital aesthetics, I am

able to re-position documentary practices within a fictional framing. That is, by putting social-documentary photographs under pressure, or better still, under erasure,[16] through conceptual strategies such as game-playing, fictional characterisations, and montage processes, I encourage a conversation about interpretations of historical material and pastness. This, I believe, continues a critical approach to media and one that proceeds onward from the feminist, psychoanalytical, and black film/photography practices defined as independent and autonomous. The artwork proposes a more complex relationship towards media work—a relationship that places it into a wider system, operating as a "narrative chain of signification"[17] in which photography and film constitute a system of prior texts and knowledge. I am also interested in the space of *possibilities* that digital media practice seems to make more readily available than many other graphic media. The "what if" scenario—where notions of futuristic imaginings may be introduced and offered to the user/viewer to engage with—is an exciting prospect for the creation of more Creolised imagery and sound work.

Works Cited

Besson, G., & Brereton, B., editors. *The Book of Trinidad.* Port-of Spain: Paria
 Publishing Company, 1992.
Burgin, Victor. *The Remembered Film,* London: Reaktion Books, 2004.
Finley, Cheryl. "the still-moving image." In OVA, *Roshini Kempadoo: Work
 1990–2004.* London: OVA, 2004. pp. 40-45.
Jones, Kellie. "In Their Own Image." *ArtForum* (1990):132-138
McGrath, Roberta. *Seeing Her Sex: Medical Archives and the Female Body,*
 Manchester & New York: Manchester University Press, 2002.
Mulvey, Laura. "Death 24 times a second: the tension between movement and
 stillness in the cinema." *Coil,* 9/10 (2000): 1-12.
OVA. *Roshini Kempadoo: Work 1990 – 2004.* London: OVA, 2004.
Willis, Deborah. *Reflections in Black: A History of Black Photographers 1840
 to the present.* New York/London: W.W. Norton & Company, 2000.
—. "The Sociologist's Eye: W.E.B. Du Bois and the Paris Exposition." In *A
 Small Nation of People: W.E.B. Du Bois and African American*

[16] I have been interested in the Derridian term *sous rature*, which literally means to write a word, cross it out, and then print both word and deletion. See *Of Grammatology* (Baltimore: John Hopkins University Press, 1974).
[17] Roberta McGrath, *Seeing her Sex: Medical Archives and the Female Body* (Manchester & New York: Manchester University Press, 2002), p. 6.

Portraits of Progress. New York: Armistad, HarperCollins Publishers, 2003.

Willis, D., & Williams, C. *The Black Female Body: A Photographic History,* Philadelphia, Temple University Press, 2002.

CHAPTER NINETEEN

AESTHETICS OF THE WEST INDIAN FRONT ROOM

MICHAEL MCMILLAN
MIDDLESEX UNIVERSITY, UK

The floors are carpeted, often with the high pile carpet locally termed 'plush'. The furniture consists of thick foam-based seats covered in fake velvet, arranged in sets of one or often two couches, plus armchairs often providing upholstered seating.... The maroon of the upholstery may be picked up in curtains, carpets, coverings for tables, artificial flowers such as roses and countless other decorations, amounting to a general 'any colour as long as it's maroon' principle, or its equivalent in gold/brown arrays. Artificial flowers are extremely common, often set into elaborate arrangements with perhaps half a dozen examples within the living room. There is a buffet which is a glass-fronted cabinet filled with china and glassware. It may also have internal lining of white or maroon plush. Wall decorations will be dominated by a machine-made tapestry with a religious theme, such as the Last Supper ... prints of oil paintings with gilt surrounds.... Prints with a West Indian theme would very rarely be found in the normative living room.[1]

Daniel Miller's description from his essay "Fashion and Ontology in Trinidad" echoes an iconic aesthetic found in what has been called the "Front Room." As a social and cultural phenomenon, the aesthetic resonates all over Africa and the African diaspora: from Kingstown to Toronto, from Brooklyn to Brixton, from Accra to Johannesburg. It was usually the one room in the home where you weren't permitted, unless it was a Sunday or a special occasion when guests visited. As an opulent shrine to kitsch furniture, consumer fetish, and home-made furnishings, it was a symbol of status and respectability, announcing that no matter how poor you were, if the Front Room looked good, then you were "decent" people.

[1] Daniel Miller, "Fashion and Ontology in Trinidad" in *Design and Aesthetics: A Reader*, edited by Jerry Palmer & Mo Dodson (London: Routledge, 1996), p.136.

Diaspora as a term in this context has to be used metaphorically, as "diaspora does not refer us to those scattered tribes whose identity can only be secured in relation to some sacred homeland to which they must at all costs return...." It is defined "not by essence or purity, but recognition of a necessary heterogeneity and diversity: by a conception of 'identity' that lives with and through as process, the idea of difference; by hybridity."[2] The Front Room was a contradictory space, where the efficacy of the display, was sometimes more important than the authenticity of the objects. The presence of Jim Reeves, lace crochet, the "Blue-Spot" gramophone, Jesus Christ in 3-D at *The Last Supper*, or plastic covered upholstery was less about valorised white-biased ideals of beauty, than the creolisation of popular culture.

The dressing and maintenance of the Front Room, therefore, reveals a form of "impression management"—as in the flexible presentation of self, which throws up issues of "good grooming" amongst people of African descent. The Front Room was very much my mother's room. And as a second-generation, black British person from an aspirant working-class family of Vincentian parentage, I have my own memories, reflections, and meanings of the "Front Room." Unpacking the detail of this space, therefore, raises questions about diasporic identities, inter-generational identifications and disavowal, gendered practices in the domestic domain, and mis(sed)-representations, struggles over meaning, and authenticity in the museum/gallery culture.

The culturally syncretic nature of black popular culture, where "there is no such thing as a pure point of origin"[3] raises questions of authenticity in terms of defining a black aesthetic. Who, where, and what is legitimised as an authentic black aesthetic? Given the history of representation of the "Other" in museum /gallery culture, authenticity is problematic, in terms of how it is constructed, policed, and legitimised.

The term *West Indian* in association with the classic representation of the Front Room refers to a particular juncture in British history signified by cultural political shifts brought about by anti-colonialist struggle and movements for independence, Civil Rights, and Black Power. Post-War black settlers may have been represented as socially problematic "Others," but their participation in an emerging consumer culture meant that the Front Room came to signify the ongoing decolonising process—and their attempts to re-define themselves. Therefore, the dialectic of how the subjects of the Front Room were

[2] Stuart Hall, "Cultural Identity and Diaspora'" in *Colonial Discourse and Post-Colonial Theory: A Reader*, edited by Patrick Williams & Laura Williams (London: Harvester Wheatsheaf, 1993), p.401.
[3] Dick Hebdige, *Cut 'N' Mix: Culture, Identity and Caribbean Music* (London: Comedia, 1987), p.10.

represented and how they reconstructed themselves sheds light on the complex practises and processes in dressing this space.

The 'Speaky Spokey' of the Front Room

On British TV, during the 1970s, the Front Room as communal family space was where *The Fosters* attempted to reassure viewers that black families in sitcoms were just as "normal" as white ones, by sanitising cultural and racial difference.[4] Inscribed in the representation of black experience on British TV was a race-relations agenda about assimilation, and so the Front Room, as emblematic motif, came to signify the "West Indian" parents as conservative, upstanding, God-fearing citizens as opposed to their children (read *males*, inscribed as "black youth"), seen as problematic deviants. In a number of plays by black writers, the Front Room became a site of contested cultural identities and race politics. The tone of Caryl Phillips's description of the main set in his play *Strange Fruit* suggests this ambivalent relationship:

> The action takes place in the front room of the Marshall's terraced house in one of England's inner city areas. Whilst the district is not a ghetto it is hardly suburbia. The room is cramped but comfortable and tidy ... a cabinet full of crockery that has never been, and never will be used.... In the centre of the display is a plate commemorating the Queen's Silver Jubilee. In the centre of the room is an imitation black leather settee with orange/yellow cushions... As to the surroundings: the wallpaper is tasteless, and on the wall hang the usual trinkets... As I said the room is cramped, even claustrophobic, but tidy.[5]

In the Obaala Arts Collective's *From Generation to Generation:The Installation* (The Black Art Gallery, London, 1985), there is "a realistic simulation of the respective living rooms of two generations." Two rooms are constructed and dressed, like a stage set, with the first room symbolic of a "typical" living room of West Indian parents: we see "a female mannequin is poised over an ironing board, the iron flex connected to the light bulb socket above ... opposite, another mannequin, male, dressed in a British Rail uniform and sitting in an armchair with a radio in his lap."[6] Reached by a dark passage, the second room is, by contrast, alive with music, books, and a canvas in the shape of the African continent, stretched on a black frame on which are

[4]John Donley & Kurt Taylor, *The Fosters* (London: London Weekend Television, transmission dates: 9.4.96 - 2.7.76 (1st Series), 16.4.77-9.7.77 (2nd Series). Cast: Sharon Rosita, Lenny Henry, Isabelle Lucas, Norman Beaton, Lawrie Mark, Carmen Munro.

[5] Caryl Phillips, *Strange Fruit* (London: Amber Lane Press, 1981), Act I, Scene 1, p.7.

[6] Errol Francis, *From Generation to Generation: The Installation*, the Obaala Arts Collective, Birmingham, in *Ten 8*, No.22 (1986), p.41.

inscribed the names of African heroes: Patrice Lumumba, Walter Rodney, Amilcar Cabral, Kwame Nkrumah. There are two mannequins: a male dressed in a tracksuit and a female in a batik frock. The domesticated room of the "older generation" suggests a quaint and naïve image fixed in the past, while the undomesticated room of the "younger generation" is highly cultured and politicised. Ironically, here a domestic tradition is disavowed for the reconstruction of a contemporary domestic space. In setting a context, the artists' notes said, of African-Caribbean parents, that

> their general attitude towards their children's behaviour [was that] they should be seen and not heard; [and in] the language they used (and attempted to use), especially when addressing their children, [the parents] tried hard to follow the adage "when in Rome—do as the Romans do" and sought to polish up their "bad talking" and speak "the Queen's English."[7]

In his critique of this installation, Errol Francis sees an over-domestication of the older generation in the suggestion that African-Caribbean parents wanted their children to be "seen and not heard" because that desire echoes a well-worn stereotype that blames black families for their own oppression, by enforcing draconian discipline in the home. This over-simplistic representation of the older generation negates their activism and political radicalism during the era of the Civil Rights and Black Power movements. Active in labour struggles, they set up voluntary welfare organisations and publicly protested the inferior education of their children in the British school system. They also read and supported the *West Indian Gazette*, one of the first black presses in Britain, edited and published by Claudia Jones, a journalist from the Caribbean, who was deported as a Communist from the United States. Jones used the Gazette to campaign on behalf of black defendants prosecuted after the 1958 race riots in Notting Hill, which gave its name to the first Carnival during the 1960s and which she was instrumental in organising. In that light, therefore, as Francis asks, "Can we accept the characterisation of our parents as virtually illiterate, save the Bible and correspondence courses?"[8]

Francis wonders how, on the basis of this caricature, the younger "second generation" were able to keep alive patois/creole traditions from the Caribbean if they were suppressed in England. This suppression also occurred in the Caribbean; therefore, the question is not whether, but how, where, and by whom this patois/creole (read "bad talking") was suppressed, hidden, and used. The cultural hegemony of colonialism reflected in the "Orientalist knowledge" coded the "Other's" language as bastardised, pidgin, and uncivilised. It is this

[7] Ibid.
[8] Ibid.

psychic inferiorisation of "Nation Language" that has "provided a systematic framework for the political analysis of racial hegemonies at the level of black subjectivity."[9] And it is at this level of the subjective that Suzanne Scafe, in her book *Teaching Black Literature*, notes that black British students, weary of the stigma of being labelled as the "race experts" claimed not to know how to speak creole while reading aloud black literary texts.[10] The performative survival strategy utilised by these students echoes Ralph Ellison's recommendation to "Slip the yoke, and change the joke" and reflects the duality of race politics as a sobering lesson in the paradox of modernity: a means of freedom in expression, but also a means of suppression.[11] It is the duality of the archetypal "speaky spokey"—the speech of those Jamaicans and other Caribbeans who spoke or "(attempted to use)" the "Queen's English" better than the Queen. The proverb of the older generation (*"when in Rome—do as the Romans do"*) can now take on a double meaning in our discussion of how inter-generational identifications are signified in the representation of the Front Room.

Within this framework, Stuart Hall argues that identity is a performative process, continually negotiating through

> a complex historical process of appropriation, compromise, subversion, masking, invention and revival'. In this sense, 'Otherness' is not fixed and predetermined. Cultural identity in this formation is an, 'articulation' fostered in a complex structure of diverse and contradictory, yet connected relations.[12]

Beyond the essentialising binary opposition between colonialist and anti-colonialist, Hall proposes a concept of cultural identity as dialectically continuous and disruptive unstable points of identification, made within the discourse of history and culture. This idea—that cultural identities can be dialectically continuous and disruptive—reveals a duality as double consciousness. Applied to our discussion, identification and disavowal can occupy the same space and together enable a repositioning of where we sit in the Front Room.

[9] Frantz Fanon, "On National Culture" in *Colonial Discourse and Post-Colonial Theory: A Reader*, edited by Patrick Williams & Laura Williams (London: Harvester Wheatsheaf, 1993), p.37.

[10] See Suzanne Scafe, *Teaching Black Literature* (London: Virago Press, 1989).

[11] See Ralph Ellison, *Shadow and Act* (New York: Quality Paperback Book Club/ Random House, 1994).

[12] Hall (1993), op.cit, p.395.

Maroon is a colour which is red but not red, but it is more Englishanese, North
Americanese, Europeanese, I have never been there (England) but I believe they
use a lot of this reddish off-reddish in their upholstery.[13]

The ambivalence of this word, *maroon*, invites a rethinking of the concept of
difference as put forward by Stuart Hall in his usage of Jacques Derrida's
anomalous "*a*" in *differance*, which challenges any fixed meaning and
representation of difference. This "strategic and arbitrary" conception enables a
rethinking of the positioning and repositioning of Caribbean cultural identities,
as suggested by Aimé Césaire's and Léopold Senghor's metaphor: *Présence
Africaine, Présence Européenne* and, more ambiguously, *Présence Americaine.*

The dialogue of power and resistance, of refusal and recognition, with and
against Présence Européenne is almost as complex as the "dialogue" with Africa.
In terms of popular cultural life, it is nowhere to be found in its pure, pristine
state.[14]

The "*difference*" in these presences is a strategic and random display and
masking/covering up taking place at the same time, which resists the dominant
hegemonic representation of the colonised "Other" as savage/un-educated. The
mask is the signifier, while the masquerade is the signified, which as a ritual
practice from Africa, served as a means of camouflage in slave plantation
society. The masquerade in this masking is the phenomenon of the "cool": "*To
exhibit grace under pressure*" as reflected in personal character, or *ashe*, a
means of inverting and subverting the brutal oppression of plantation society
through imitation, reinvention, and artifice.[15] In response to racial oppression,
"grooming" became a performance of the socialised and reconstructed a*she* (the
power to make things happen) as embodied in the style of black men's and
women's presentation.

"Grooming" as performance does not reveal all there is to know about
black subjectivity, but it does reveal the mythic nature of black popular culture,
as a theatre of popular desires. "Popular culture carries that affirmative ring
because of the prominence of the word *popular.*"[16] Popular culture always has
its base in the experiences, the pleasures, the memories, the traditions of the
people. What Mikhail Bakhtin calls the "the vulgar"—the popular, the informal,

[13] Daniel Miller, "Trinidadian shopkeeper" cited in *Modernity: An Ethnographic
Approach* (Oxford: Berg Oxford/Providence, 1994), p.214.
[14] Hall (1993), op.cit., p.400.
[15] See Robert Farris Thompson, *Flash of the Spirit* (New York: Random House, 1983).
[16] Stuart Hall, "What is this 'Black' in Black Popular Culture" in *Black Popular Culture:
A Project by Michele Wallace*, edited by Gina Dent (San Francisco: Bay Press, 1992),
p.21.

the underside, the grotesque—is always treated as weary by the dominant tradition.[17] The popular is associated with the carnivalesque, reflecting the tension between the cultures of high and low. Cultural hegemony, as Gramsci argued, is made, lost, and struggled over, just as carnival was appropriated and reconstructed to subvert and transgress the power relations between master and slave.[18] The unpacking of the aesthetics and cultural practices of the Front Room reflects a blurring of boundaries between "high" and "low" culture, between taste and style, all of which connects to the "dialogic interventions of diasporic, creolizing cultures."[19]

In *The Black Chair: An Installation and Exhibition Rediscovering the West Indian Front Room*, curated by the author and mounted first in the Wycombe Chair Museum (1998-99) and afterwards at the Slough Museum (1999-2000), a front room was created as a full-scale installation. Alongside was an exhibition, based on *The Black Boy Pub & Other Stories: The Black Experience in High Wycombe*, which emerged from the author's year long residency in the town. In both High Wycombe and Slough, towns which have large settled black communities, the presence of black populations had theretofore been largely invisible, altogether erased from previous exhibitions curated by these two cultural institutions. Coming into the dressed front room, black (and white) spectators experienced aching flashbacks and fond memories; and anecdotes were evoked about events, customs, rituals, conversations, encounters, colours, smells, and images of the occasional and everyday life of experiences in Britain and "back home" in the Caribbean.[20]

The Framing of Arrival and Ambition

In his essay "Reconstruction Work," Stuart Hall looks at images of post-World War II black settlement, such as *Picture Post*'s 1956 pictorial essay on migration to England: "Thirty Thousand Colour Problems." The documentary realism of that article's images represents these black migrant

[17] Mikhail Bakhtin, *Speech Genres and Other Later Essays* (Austin: University of Texas, 1935, 1981).
[18] Antonio Gramsci, *Selections from the Prison Notebooks* (London: Lawrence & Wishart, 1930, 1971).
[19] Kobena Mercer, "Diaspora culture and dialogic imagination" *Blackframes: Critical perspectives on Black independent cinema,* edited by M. Cham & C. Watkins (1998), p.57; cited by Hall (1993), op.cit, p.402.
[20] Michael McMillan, *The Black Chair: An Installation and Exhibition Rediscovering the West Indian Front Room* (High Wycombe: Wycombe Chair Museum, 1998-99/Slough: Slough Museum, 1999-2000).

subjects as "social problems" waiting to happen, a view that echoed a colonialist construction of the "innocent simpleton," too slow for the fast ways of the advanced modern world. The reality was, as Stuart Hall put it, that they were "probably from a city, like Kingston, as big and swinging in its poverty and style as any small colonial capital."[21]

Hall, who came to England from Jamaica as a young man, notes that they were arriving at the end of one traumatic journey, uncertain at the beginning of another. With dignity packed deep in their suitcases, they were formally dressed as a sign of self-respect; with pressed dresses, hats at an angle in a "universally jaunty cocky" style, in preparation for whatever was to happen next. For these immigrants, coming from the colonies, saw themselves as British citizens and, through their formal educations in the Caribbean, sometimes knew more about English culture than the English themselves. To wear one's best garments on special occasions, such as attending church, was part of their sartorial principles, and travelling to a distant foreign land was no exception. "Edwardian portraiture and the codes of the formal photograph, a formal icon in the domestic gallery of memories, was as common in poor but respectable homes in Kingston as it was in Kingston-upon-Thames."[22] Style, self respect, and respectability were inscribed in one's appearance, the same as in the "High Street" photo-portraits, where we might find photos of

> ...the young woman with the gloves and handbag, holding up or being held up by the basket of artificial flowers. The well-dressed young man with the clip-on fountain pens, talking on a phone which is not connected to anything, but sitting on top of a mock-Greek half-column straight from the disused basement of the British Museum.[23]

Frozen in time, these studio-composed photos, posed in artificial environments representing neither home nor work, were the way the colonials imagined themselves. A reconstructed self, the subject as document, was sent "back home" in the form photos and adhesive backed pale blue airmail letters that were also portraitures on the Front Room wall.

In his essay, "Aspiration and Attitude: Reflections on Black Britain in the Nineties," Hall uses "frontlines/backyards" as a metaphor in the context of exploring the meanings of an emergent Black British identity:

[21]Stuart Hall, "Reconstruction Work: Stuart Hall on images of post war black settlement" in *Ten 8*, Issue 16 (Birmingham, 1984), p.4.
[22] Ibid.
[23] Ibid., p.5.

In the public realm, frontlines are the politicised edge between black culture and white culture; backyards are where some less confrontational, more informal, more complicated, private negotiations might take place....[24]

The Front Room is a metaphorical "frontline" because, through its aesthetics and domestic practices, it displays a subtle "politicised edge between black and white culture." This "edge" is a performance of private "backyard"-imagined and -reconstructed narratives, mediated by desire, status, difference, race, class, gender, and generation. My parents tell me that an incentive for many West Indians to get married when they arrived in England was that one could claim tax relief. And while the home in England reinforced the patriarchal division of labour, with the man possibly buying the furniture, it was the woman's tastes and desires, in consumer fetish and the like, that made the room a potentially shared investment. Black women have usually had no choice but to deal with the domestic and go out to work. The making of the Front Room signifies on one level black women's aspirant mobility through their financial independence from men. The fruits of black women's labour ("through the slog of long, remorseless and difficult work") on show in the Front Room and the associated gendered practices in the domestic domain contribute to the narrative of post-war black settlement.[25]

The front room is a generic term that includes the living room and sitting room; and for aspirant white working-class families, the front room was inscribed with middle-class values. The etiquette of decorum, protocol, polite manners, and proper behaviour as performed rituals of this room echoed the drawing rooms of the Victorian, middle-class, two-storey, semi-detached and terraced houses. This image became the Front Room of an aspirant, burgeoning, suburban bourgeoisie of the early twentieth century.

Racism meant that post-World War II black settlers could generally find only a one-room rented accommodation. But as families were sent for or were being made, these insecure environments did not provide the stability they needed. If they did not get a council flat, then black people found getting a loan or mortgage to buy a house nearly impossible. The "Partner Hand"/"SuSu," an informal localised saving scheme, enabled a deposit to be raised. In many urban inner-city areas, black families moved into properties made vacant by the white middle class who had fled to the suburbs. Whether in flats or houses, the Front Room began to take shape.

In comparing the Front Rooms of post-World War II black settlers with those of the white working class, one notes in both an emphasis on the desire for

[24] Stuart Hall, "Aspiration and Attitude: Reflections on Black Britain in the Nineties" in (London: New Formations: Frontlines/Backyards, No.33, Spring 1998) p.38
[25] Ibid., p.42.

social status through a display of consumer fetish. What may not be evident is difference: difference in terms of how the settlers struggled to acquire a Front Room in Britain and how displacement, exile, and alienation affected the meaning of that space. For post-World War II black settlers from the Caribbean, the Front Room was a response of "arrival" and "ambition" to their sense of displacement, exile, and alienation in a foreign land. The Front Room could be an ostentatious display of wealth through material reality, but it was also a treasuring for tomorrow of dreams that had been deferred.

The Hoarding of "Nice Things"

In finding a framework within which to unpack the complex subjective negotiations around identities, desire, and ontology practised in the Front Room, Daniel Miller proposes the duality of two related concepts: the *transcendent* and the *transient*. The setting for Miller's anthropological research is the oil boom in Trinidad during the 1970s, which transformed the lives of the poor, the wealthy, and the *nouveau riche* alike. Materially, this short lived boom found its most manifest expression in people's homes, cars, and clothes.[26] Semiotically, in the vernacular of the African diaspora, the *transcendent* and *transient* have their equivalence in the terms *"follow-fashion"* or *"never see, come see"* and *"poppy-show"* or *"extra,"* respectively. As adjectives, verbs and nouns, these expressions serve as descriptions of consumer fetish and fashion desires in black popular culture.

As modes of expression, the *transcendent* signifies a desire for conventional form in "artificial things which are viewed as long-lasting, and things covered over which are seen as cherished for the future" whereas the *transient* is concerned with the expression of style as a "highly personalised and self-controlled expression of a particular aesthetic." The dialectic of the *transcendent* and the *transient* means that fashion can be an agreement to conform and a struggle as "a symbol of transience and disconformity."[27]

The interplay between the *transcendent* and the *transient* sheds light on the contradictory nature of the Front Room—as a space for negotiating being seen to conform to conventions in fashion, displaying certain standards of taste, dealing with the realities of everyday life, and finding one's own style. The frisson of consumer fetish is not necessarily over what women see in the shop-front window, but over what they see in a context which illuminates an object's aesthetic value, such as another woman's home.

[26] Miller (1996), op.cit, p.137.
[27] Ibid.

Furniture in the Front Room was "cherished for the future" by being covered over with homemade and handed-down lace crocheted mats and later clear with plastic upholstery coverings. "Runway"/passage carpets, a style from the United States, became in vogue from the 1970s. As a fetish of the Front Room, crochet or lace "doilies" were made by knitting thread, using a hooked needle. Patterns were often shared, but the intricate designs, colours and innovative shapes were always unique to the individual maker, with the added effect of being sugar starched. From a friend, my mother learned a new method for making "doilies" that involved weaving strands of luminous coloured synthetic wools into a grid and then cutting the knotted junctions, to bring up a delicate, fluffy effect.

Crocheting had been a cottage industry in late nineteenth-century England, practised in a colonial context along with seamstressing and garment making, as the "proper training" for women as part of a wider Victorian puritanical ethos. Though crocheting was largely discontinued in England, women from immigrant communities continued and revived these skills when they arrived and settled in Britain. On a subliminal level, crocheting signifies a "creolised" reconstruction of womanhood in response to the hegemonic construction of the black subject in the domestic domain.

Long hollow glass fish with iridescent paint inside, smoked glass bowls of plastic fruits or fibre optic table lamps, bubble lamps, glass vases of artificial or plastic flowers were often placed on crochet to enhance the lavishness of their decorative appearance. Ornaments were expensive; so, creating a sense of opulence in the Front Room required ingenuity—such as making artificial flowers from recycled stockings, metal coat hangers, and food colourings or stitching carpet remnants together to make a unique patchwork carpet.

Covering up in the Front Room extended to the windows, which were decorated by elaborate lace net curtains and pleated drapes of rich fabrics and colours. At Easter and Christmas and for "Spring Cleaning" rituals of renewal took place throughout the home. Curtains were taken down, washed, and replaced. They announced respectability and decency, but showing the curtains best-side-out was considered in bad taste because facing outwards meant "dressing up the street" or "just for show," as if to cover up what the home did not have. Smell in a properly maintained Front Room was another signifier of "good grooming" even though the fragrance of air freshener only masked the smell of the paraffin heater.

Souvenirs from trips to seaside towns such as Margate, Blackpool, and Great Yarmouth, collected by predominantly female black church congregations, projected the image of a seasoned traveller. Decorative plates, straw bags, and ornaments with the name of an island painted, stitched, or embossed denoted a sophisticated worldliness even though the souvenir had

been brought back by a friend. Another iconic fetish of belonging was the black velvet wall scroll with a tourist map of a Caribbean island in coloured glitter, later replaced by flat varnished wooden clocks carved in the shape of the same island. Beside religious icons with Biblical captions about redemption and salvation might be a fake gold framed print of a blue bare-breasted woman, leaning seductively against a tree. These juxtapositions were placed against wallpaper, usually floral patterned, though the really sophisticated look was baroque velvet flock wall coverings in maroon.

Some have argued that the Front Room was dressed by women and used by men. For many black settlers, excluded or alienated from public social spaces, the Front Room became a site of informal social gatherings, beyond its formal symbolic function. At these events, we might see men playing cards, slapping down dominoes, and chatting, while women supplemented their income by selling home-made food and drinks. The "Blue-Spot" was the focus of entertainment for many of these gatherings and my dad had one in the Front Room. It was an art-deco styled, wooden-veneered, and cloth-panelled cabinet that housed a phonograph or "stereogram" and "radiogram." Colloquially known as the "Blue-spot," many were made by Gerrard, where the turntable could hold several seven-inch records, while the needle arm's movement regulated what was played. The technology was a forerunner of state transistors, and so the glass valves and circuitry of the radio would often over heat. On a Saturday night, I would often listen to Greg Edwards's programme, *Soul Spectrum*, and his popular section, *The Bathroom Call*, or Reggae, Rockers, Lovers Rock, and Dub with Tommy Vance and David Rodigan on Capital Radio. But on a Sunday, the playing of *buff buff* music such as Reggae was strictly prohibited or frowned upon. My dad would reclaim his "gram," after the ritual Sunday dinner of chicken and rice and peas, and play his Country & Western music: Jim Reeves, Pat Boone, or Elvis Presley.

Known as "Gentleman Jim," Jim Reeves recorded over 400 songs, "from traditional Country to Pop, from Afrikaans folk songs to international standards, from novelty numbers to duets, from narrations to secular songs, from seasonal offerings to waltzes, from his own big hits to his covers of the hits of others."[28] *From a Jack to a King* was a number one hit in South Africa though, ironically, it was a favourite of my parents' generation. After his premature death in a plane crash in 1964, the release of *Distant Drums*, along with other reworked demos and studio cuts, gave him posthumous cult status, culminating in "duet successes" with Patsy Cline and Deborah Allen in the

[28] Steve Morewood, sleeve notes for *Jim Reeves: The Ultimate Collection* (BMG Entertainment International U.K. & Ireland, Ltd., 1996), Ballads.

1980s. It is a myth that Jim Reeves was reappropriated by just the "older generation"; his sounds resonate all over the African diaspora today. The reason lies not so much in the style of his "silky smooth" ballads as in their content. Gentleman Jim sang about transcending the trials and tribulations of everyday life, in recurring themes of loneliness, love, infidelity, loss. Therefore, it did not matter that he toured South Africa at the height of Apartheid, because the lyrics of Jim Reeves's songs (like those of other artists of the Country & Western genre) echo the hymns, spirituals, and gospel music of the black Christian church, which sang of the "intense desire and yearning to transcend the misery of oppression."[29] In short, the sounds emanating from the Front Room were as significant a part of the space's aesthetics as the visual and aromatic impressions it was meant to create.

Grooming and Dressing of the Front Room

Some post-World War II black settlers had their black-and-white passport photos enlarged, colour painted, and proudly displayed in their Front Rooms. A yellowish brown seemed to be a flesh tone paint of choice in this practice of "touching-up" portraits, regardless of the complexion of the subject. The palette of pigments signified how they imagined themselves and desired to be seen— ethnically inscribed with a valorised tilt towards whiteness as a legacy of a racial hierarchy based on a "pigmentocracy" instituted in plantation societies. This colouring functioned as an ideological basis for status ascription, where European elements both physical and cultural were positively valorised as attributes enabling upward social mobility. On this "ethnic scale," social status was not simply determined by socio-economic factors such as wealth, income, education, and marriage, but also by those less easily changed elements of status symbolism such as the shape of one's nose, the shade of one's blackness, or the texture of one's hair.[30] What has sometimes been overlooked by commentators are the different, specifically gendered ways race domination expresses itself in the lives of men and women. For instance, the practical realities of black hair maintenance, in terms of how appearance is gendered, meant that black women had greater concerns over how their hair looked than men did.[31]

[29] Kobena Mercer & Isaac Julien, "True Confessions" in *Black Male: Representations of Masculinity in Contemporary American Art*, edited by Thelma Golden (New York: Whitney Museum of American Art, 1994), p.199.

[30] See Kobena Mercer, "Black Hair/Style Politics" in *Welcome to the Jungle: New Positions in Black Cultural Studies* (London: Routledge, 1994).

[31] In the politics of black hair styling, straightening has been interpreted as ideologically imitating a white-biased conception of beauty as opposed to a "natural" and counter-hegemonic notion of blackness. Kobena Mercer's questions hair straightening as simply

Making similar links between hair straightening and dignity, many black women taught their daughters the importance of hair straightening as nothing more than good grooming.[32]

In the dressing and maintenance of the Front Room, it was women who were judged on the basis of "good grooming" in the domestic domain. Washing, cleaning, and cooking rice and peas, amongst other Caribbean dishes, were other elements of "good grooming." These practises, along with the crocheting and "spring cleaning" rituals, formed part of a moral code, which fused religion, hygiene, and the Protestant work ethic: "Cleanliness is next to godliness" and "By the sweat of your brow, thou shall eat bread." This ethos would find expression aesthetically in the presentation of the home and the self, where cleanliness and order meant beauty.

This aesthetic was not a simple imitation of white bias and ideals of beauty, but rather the consequence of settlers' having to negotiate dominant ideologies and regimes of power that objectified race in the realm of the domestic. As Anne McClintock points out, the domestic realm during the sway of colonialism was a construction to maintain hegemony over the division of labour at home and the subordinate "Other" abroad. In the colonialist representation of the domestic and popular culture, the black subject had been either erased out or stereotyped as objects of servitude, caricature, fear, and desire. The first advertisements for soap, for instance, used the ethnic signifier of skin colour, depicting black people as unclean and dirty (code for savage and uncivilised) and inscribed the use of soap as a means to maintain civilised Christian values, as an antidote to moral chaos and disorder.[33]

Black women did not exist in the colour supplements' advertisements of kitchen and other domestic commodities. The black woman's (un-)domestic representation in popular culture was that of the "black mama" of Aunt Jemima pancakes and other exoticised objects in the colonialist construction of domesticity.[34] In reply, in her series of images titled *Auntie Linda's Front Room* (1987), Maxine Walker restages the familiar terrain of the Sunday colour supplements. Her starting point is to claim "a woman's room of her own"

a recycling of binary opposition between black and white in its of imitation white-bias, but rather a negotiation between ethnic signifiers in the syncretic process of incorporating other cultural motifs.
[32] Maxine Craig , "The Decline and Fall of the Conk; or How to Read a Process" in *Fashion Theory*, Vol.1, Issue 4 (London: 1997), p.403.
[33] See Anne McClintock, "Soft-Soaping Empire: Commodity Racism and Imperial Advertising" in *Travellers' Tales: Narratives of Home and Displacement* edited by George Robertson, Melinda Mash, Lisa Tickner, Jon Bird, Barry Curtis & Tim Putman (London: Routledge, 1994).
[34] Ibid.

(alluding to Virginia Woolf's *A Room of One's Own*) as a means of interrogating the photographic document which frames individual identity and experience in terms of material objectivity.[35] The series plays with human presence. Just as with the regular supplement feature, the documentary images claim to represent all that makes the subject individual, by putting under public scrutiny the material evidence of a person's private life. Walker, though, is suggesting that material reality remains incoherent and ambivalent as the sum of individual fragments until these fragments are invested with specific and subjective meaning. With Auntie Linda's presence, objects of functional utility and ornamental decoration that surround her as she sits on the edge of her settee, hands calmly placed together on her lap, suggest an order and coherence of her own. The image is transformed from reality into representation through the layering upon layering of memories and experiences as souvenirs and fragments, resisting any complete interpretation. Ultimately the framing excludes as much as it contains.[36]

[35] Virginia Woolf, *A Room of One's Own* (Granada 1929, 1977).

[36] Gilane Tawadros, "Redrawing the Boundaries" in *Critical Decade: Black British Photography in the 80's*, edited by David A. Bailey & Stuart Hall, an issue of *Ten 8 (Photo Paperback)*, Vol.2, No.3, (Birmingham: Spring 1992), p.90.

A version of this chapter was first published as "The West Indian Front Room: A Diasporic View" in *Fashion Theory: The Journal of Dress, Body and Culture* (Vol.7, Special Double Issue 3/4, *Fashion and Orientalism* (September/December 2003), edited by Nirmal Puwar & Nandi Bhatia.

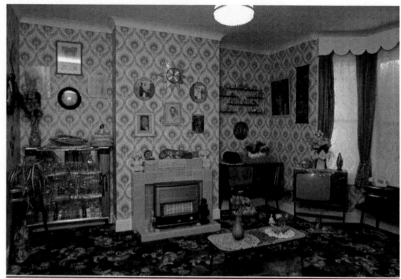

Image from *The West Indian Front Room: Memories and Impressions of Black British Homes* (Geffrye Museum, October 2005-February 2006, Curator Michael McMillan)

CHAPTER TWENTY

"SPEAKING IN TONGUES": DIALOGUES OF SELF, SOCIETY, AND PSYCHE

SHEREE MACK
UNIVERSITY OF NEWCASTLE-UPON-TYNE

In her essay "False memory syndrome," Bernardine Evaristo, born of Nigerian and English parentage in 1960s London, describes her experience of trying to fit into a particular literary heritage;

> People of the majority culture of a society often don't understand this need for validation. Over the years I've heard such people say, "I don't read fiction to see myself in it! Well neither do I now, but don't we all look for writing that explains ourselves to ourselves when we're younger? When the gap between our own cultural backgrounds and those portrayed in literature is a chasm, we can fall into it, screaming, sometimes silently or sometimes noisily, as I did. I loved literature, but literature, it seemed, did not love me.[1]

Evaristo is infatuated with the void that exists within history as history continues to be written by those with the power to do so. The versions of history recorded as fact leave out narratives that were not considered important or which those in positions of power wanted to bury. Through her writing, Evaristo is exploring this void. She writes about identity, history, and belonging in a deliberate and inventive way. Following the concept described by Homi Bhabha, Evaristo takes ownership of the marginal space, the "third space" she has been assigned as a Black woman and a cultural and social hybrid in Britain. It was bell hooks who argued that a Black aesthetic is a question of space. How Evaristo occupies this space is the question that will be explored in this chapter.

[1] Bernardine Evaristo, "We've had enough of Greek myths," in *The Independent*, 13 August 2006, http://enjoyment.independent.co.uk/books/features/article1218972.ece. Accessed 21 August 2006.

There are three stages to my discussion: first, I position Black British women's poetry within a history and context, uncovering the aesthetic issues explored within this writing; second, I look closely at Evaristo's text *Lara*, relating it to these issues raised; third, I place this discussion in the wider arena of British literature and society and explore the significance of these current efforts to pointing a way forward for Britain to consider its own identity in transcultural terms.

Widening the Tradition

Teaching of literature has always meant the teaching of an aesthetic and political order, in which no women and people of colour were ever able to discover the reflection or representation of their images or hear resonances of their cultural voices.[2]

According to Hegel, the very capacity to make art was a European prerogative. The narratives of European imperial conquest were that non-European civilisations were not civilized, but consisted of uneducated savages who had no culture or art until the white man brought them. It was one way of keeping the colonial fires burning. A propos, Harold Bloom wrote:

the "expansion of the [Western] Canon" has meant the destruction of the Canon, since now it includes those women, African, Hispanic or Asian [writers] who offer little but the resentment they have developed as part of their sense of identity.[3]

The point is that, with its gate-keeping canons and academies, Western aesthetics—or "high art"—has historically belittled and barred other cultures' art forms and creativity, placing them in the lower realms of their hierarchies of value.

It is critical approval that is the engine behind the poetry world and this is closely protected: Poets review poets and poets sit on panels and present awards to poets. Validation totally from within ... its function is to keep out those who are not in the club or clubs.[4]

[2] Henry Louis Gates, Jr., quoted in John Guillory, *Cultural Capital: The Problem of Literary Canon Formation* (Chicago: University of Chicago Press, 1993), pp. vii-ix.
[3] Harold Bloom quoted in "Dubious divisions" by Maya Jaggi in *The Guardian*, 1 November 2000.
[4] *Free Verse* (funded by Arts Council England and published by Spread the Word Literature Development Agency), June 2006.

Here, Bernardine Evaristo, quoted in a recent *Free Verse* publication, a report into the publishing opportunities for Black and Asian poets in the United Kingdom, presents the reality surrounding the poetry world within Britain. The report's results show that there is a thriving community of ethnic poets within the performing circuit, but that these same poets are failing to reach publication. Fewer than one percent of all poets published by mainstream presses in Britain are Black or Asian. The editors in question are white and male and declare that their selection criteria are based on quality, irrespective of race or gender. Are we to assume, then, that Black and Asian poets are basically just not good enough? This is the message we are receiving. Nii Ayikwei Parkes set up his own imprint, Mouthmark, just over a year ago because of this culture of exclusion. The editors' decisions regarding who gets published, or not, are subjective. What is being overlooked is that these subjective decisions with regards to "quality" exist within the context of history, culture, literary traditions, and values. [5]

The existence of a Black British literary canon, therefore, has to be recognized as an achievement—a sign of acceptance finally within British society. Bearing in mind the history of black people as part of the British Isles,[6] a canon is an indication of recognition. The move away from the emphasis simply on *what* the writer is saying—on the social or political content of the work—to how the writers are crafting their messages, the aesthetics of the literature, is a welcome development on the history of Black British literature. It is as if the big oak doors we've been banging against for centuries have finally opened so that the world of literature is transformed into one which is more inclusive and representative. Well, maybe the door has opened just a crack, but it's a start, as we see that Daljit Nagra's first collection, *Look We Have Coming to Dover!*, is being published by Faber and Faber in 2007, only the third poet of colour to grace their list in their seventy-five-year history. Just recently one of Nii Ayikwei Parkes's poets, Jacob Sam La Rose, was made the Poetry Book Society's choice for his first chapbook, *Communion.* More Black and ethnic minority writers are included in examination syllabuses, reaching a wider audience under the title of "Poetry from other cultures and traditions."[7] But questions can still be asked about the use of "other cultures" in that title, a phrase indicating a desire to distance this work from British literature, especially as the poetry by Black and ethnic minority writers is included in the English Language examinations, not the English Literature examinations. All of these issues arise when we consider using "black" as the label of identification for a

[5] Bernardine Evaristo, "We've had enough of Greek myths," Ibid.
[6] See Peter Fryer, *Staying Power: The History of Black People in Britain* (London: Pluto Press, 1984).
[7] *AQA, NEAB English Language Specification A syllabus.* 2000-2003.

writer. Other categories that we should also be thinking about—in relation to representation—are those of gender, class, and location.

Black women have been represented in works of literature, but seldom in their own words. Until quite recently, Black women writers have had to challenge the images perpetuated by others in order to express their own representation of themselves for themselves. Studies in and appreciation of Black British women's writing started in a piecemeal fashion with introductions to poetry collections, such as *A Dangerous Knowing*, edited by Pratibha Parmar and Sona Osman (1985), and compilations such as *Black Plays* edited by Yvonne Brewster (1987). *The Heart of the Race, Black Women's Lives in Britain*, a collection of essays, was a breakthrough because this was the first time Black women saw their experiences of Britain in print. Lauretta Ngcobo brought together an anthology of self-analysis by Black British women writers, *Let it be Told*, and Susheila Nasta edited a series of a critical essays on these and other authors, calling attention specifically to the agency of Black women from Africa, the Caribbean, and South Asia, some of which are by Black critics and draw on American models (e.g., *Motherlands,* Woman's Press, 1991).

These publications were welcomed, but, again, still leaned heavily on Black American feminists to detail the Black women's experience. Now, in the twenty-first century, Black British women writers are being looked at by women through a Black feminist lens, with the groundbreaking work of Heidi Safia Mirza, *Black Feminism: A Reader* (1997). This is an edited volume of essays of classic key texts and new Black feminist scholarship. Topics include feminisms, mixed-race identity, sexuality, cultural hybridity, and postcolonial space. To keep up this momentum, it is important that Black British women writers write through the narrowness of representation and, thereby, be included within this country's literary history and traditions.

Black women are still seen as objects, with a reality defined as "other." Elite white men and their representatives manipulate stereotypes and images concerning Black women.[8] Black women are still seen as mammies, the faithful servants to the white families, originating from the slave era. Other limiting stereotypes surrounding Black women are those of matriarchs, welfare mothers, and jezebels. Therefore, I am concerned that the term *Black British aesthetics* may carry the unspoken assumption that it only includes the metropolitan and the male. London is still the "Centre of the Empire"[9] in people's hearts, minds, and pockets. It is the Westminster village, the Square Mile, the centre of political, intellectual, and economic power. People have gravitated to London

[8] Patricia Hill Collins, *Black Feminist Thought: Knowledge, Consciousness, and the Politics of Empowerment.* (New York: Routledge, 1991), p.67.
[9] Bernardine Evaristo, *Lara* (London: Angela Royal Publishing, 1997), p.4.

from the colonies for centuries. As John McLeod argues in *Postcolonial London* (2004),

> London is imagined to possess a particular relationship with nation. The slippage between London, England, and Britain as corresponding terms can be unhelpful, perplexing and extremely difficult to resist.[10]

This "slippage" is not just imagined; for anyone living in Britain, it is the reality. What I'd like to stress is that there is no grand narrative in Britain. No writer can present a universally authentic depiction of Black Britain. For example, I'm a northern voice coming out of the run-down industrial cities. My experience of being a Black woman in Newcastle will be different to the experience of a Black male in Birmingham, whose own experience will be different again from that of the archetypal Londoner, not assuming that Londoners are homogeneous either. So, terminology has to be sensitive to geography and class, as well as to gender imbalances within the United Kingdom, otherwise these terms used to rectify an imbalance do so at the expense of excluding others, recreating the original problem.

Further examples can be used to illustrate the narrowness of focus within British literature—and, sometimes, within Black British literature, too. Liverpool-born SuAndi, the freelance director of Black Arts Alliance now living in Manchester, receives invitations to perform at conferences and literary and political events world wide. She has been on the scene since 1985. She has had four collections of poetry published.[11] Only recently, however, have we seen critical engagement with her work in *Black British Writing*.[12] Rommi Smith started out in poetry at the age of fourteen, and she has been a writer in residence for BBC Africa 5 and the British Council. Even so, it is difficult to obtain her poetry collections *Moveable Type*[13] and *Mornings and Midnight*.[14] Shirley Ann May, with connections to Cultureword, Manchester, is a woman who works hard within the writing community, but we are yet to see her own poetry collection. The list goes on as there are northern Black Women writers who have made a name for themselves as movers and shakers within the literary world and on the performance circuit, yet have still not made an impression in

[10] John McLeod, *Postcolonial London – Rewriting the Metropolis* (London: Routledge, 2004) p. 6

[11] SuAndi, *Style* (Manchester and Leicester: Purple Heather & Pankhurst Press, 1990); *Nearly Forty* (Liverpool: Spike Books, 1994); *Kiss* (Manchester: Crocus Press, 1994); There Will Be No Tears: Selected Poems (Manchester: Pankhurst Press, 1995).

[12] Lauri Ramey, "Contemporary Black British Poetry" in *Black British Writing*, eds. R. Victoria Arana and Lauri Ramey (New York: Palgrave Macmillan, 2004), pp.109-136.

[13] Rommi Smith, *Moveable Type* (Leeds: Peepal Tree Press, 2000).

[14] Rommi Smith, *Mornings and Midnights* (Leeds: Peepal Tree Press, 2004).

...e mainstream and are not being published by recognised presses. Is it the case, then, that not only are race and location working against these writers, but also their gender? It is a fact that Black women have been discounted and unaccounted for in the several "traditions" of black, women's, and British literature. On that note, Mae Gwendolyn Henderson commented, "My voice has been silent, not because I've had nothing to say but because my voice has no say."[15] My aim with this chapter is to make sure that Black British women writers are included within this consideration of Black British aesthetics.

Black Women Writing in Britain

Since space is limited, I aim to demonstrate the development of a Black British women's literary ancestry at key moments in its evolution, by a series of snapshots, showing how issues of positioning within society and culture affect issues of form and style as well as theme. I believe Black women, as a necessary part of self-actualisation, need to study the writings, both critical and autobiographical, of those women who have developed their potential and chosen to be radical subjects. According to bell hooks, coming to power, coming to selfhood, does not happen in isolation. However, I propose that without a context of critical affirmation radical Black female subjectivity cannot sustain itself.[16] More Black British women should be breaking into academia, recognising and establishing the tradition of our writings, opening up the space for ourselves and others.

Referring to the problem, Mae Gwendolyn Henderson stated that Black women speak from a multiple and complex social, historical, and cultural positionalities, which in effect constitute Black female subjectivity.[17] Further still, Black women's speech/writing is all at once a dialogue between self and society and self and psyche.[18] Bearing this in mind, therefore, what is true of all the generations of Black women writing in Britain is this:

[15] Mae Gwendolyn Henderson, "Speaking in tongues: dialogic and dialectics and the black women writer's literary tradition" in *Colonial Discourse and Post-colonial Theory: A Reader*, ed. Patrick Williams (London: Longman, 1993), pp.258, 263.
[16] bell hooks, "Revolutionary Black Women: Making Ourselves Subject" in *Postcolonial Criticism*, ed. Bart Moore-Gilbert, Gareth Stanton, and Willy Maley (London: Longman, 1997).
[17] Henderson, Ibid., p.260.
[18] Henderson, Ibid., p.259.

Inherent in their words and deeds is a definition of Black feminism as a process of self-conscious struggle that empowers women and men to actualise a humanist vision of community.[19]

The roots of Black British feminism lie within the nineteenth century as Mary Prince finds her voice with her narrative, writing out of the silence but making sure that she brings other silenced voices with her, those of both Black women and men. *The History of Mary Prince: A West Indian Slave* was published in 1831. It was the first female slave narrative published in Britain; before her narrative, the Black experience of slavery was portrayed by Afro-British men (those who were taken from Africa to become slaves in British colonies). Mary Prince took a pioneering step in telling her story about her life and experiences of slavery, for she wanted the people of Britain to realise what atrocities were happening in the Caribbean in their name. Prince's history is an oral narrative, told to Susanna Strickland. Whether Prince's *History* was reshaped after she dictated her experiences to Strickland—and, if so, by how much—is difficult to establish. But what is evident from the text, as it stands, is the space Prince carves out for herself to document her experiences, identity, and place in history as a means of asserting not just her subjectivity, but ultimately her freedom:

> I have felt what a slave feels, and I know what a slave knows; and I would have all the good people in England to know it too, that they may break our chains, and set us free.[20]

Even though the British public found Mary Prince's narrative hard to believe, it went into its third edition within a year of being published. The need to describe self to hostile outsiders, to relate the experienced truth from the point of view of a Black woman, was and remains the driving force behind the creation of much Black literature.[21] In line with Professor Linda Anderson's argument, Prince used her narrative as a means of asserting not just her own subjectivity, but also that of her fellow Black community. This follows the idea that autobiography can become

> the text of the oppressed, articulating through one person's experience, experience which may be representative of a particular marginalised group as an

[19] Patricia Hill Collins, *Black Feminist Thought: Knowledge, Consciousness, and the Politics of Empowerment*. (New York: Routledge, 1990), p.39.
[20] *The History of Mary Prince: A West Indian Slave,* Moira Ferguson, ed. (University of Michigan Press, 1993[1987]), p.74.
[21] Paul Edwards and David Dabydeen, *Black Writers in Britain, 1760-1890* (Edinburgh: Edinburgh University Press, 1991) p.157.

important one: autobiography becomes both a way of testifying to oppression and expressing the subject through their cultural inscription and recognition.[22]

I pick up the critical discussion surrounding autobiography later in the chapter, but what is important to note here is that Prince worked to position herself in a certain way within the text and ultimately in British society. She showed herself as a thinking and feeling, reflecting subject. The function of memory and its reconstruction in her narrative entail a claim to a self-fashioned identity.

Another literary foremother to include within this exploration would be Una Marson, a Jamaican who stayed in England for an extended period of cultural and political activities, carrying out a supportive role for West Indian independence before and during the Second World War. She was involved in the League of Coloured People in the 1930s and in 1941 was a full-time programme assistant on the BBC Empire Service, where she coordinated and introduced a series of programmes called "Calling the West Indies." Rhonda Cobham wrote that Marson "... was a pioneer for her time in the search for an authentic literary style; a style that could reflect and utilise the heritage of those half-forgotten voices, skills and justice."[23] When Marson writes, there is the sense of "in-betweenness," of being caught between cultures "over here" and "over there," illustrating the double bind of the migrant person and poet.[24] In "To be a Poet," Marson concludes with

> Hearts of poets past and present
> I your anguish feel too well,
> Fortify my ailing spirit
> Let me in your greatness dwell.
> ...
> Humbly now I seek to join you
> Here is love that overflows,
> May your spirits hear my pleading
> Set to music my dull prose.[25]

Here Marson expresses an anxiety surrounding the task she is undertaking: the right to write. The construction of herself as a poet is an embattled position, especially as she is moving into the patriarchal tradition. The tone is humble as she asks for the "poets of the past and present" to accept her place of entry into

[22] Linda Anderson, *The New Critical Idiom: Autobiography*, (London: Routledge, 2001) p. 103.
[23] Rhonda Cobham, quoted in Denise deCaires Narain, *Contemporary Caribbean Women's Poetry—Making Style* (London: Routledge, 2002), p.44.
[24] deCaires Narain, p.46.
[25] Una Marson, *The Moth and The Star* (Kingston, Jamaica: Self-published, 1937), p. 67.

their literary tradition, as only then can her words, her "dull prose" become music, therefore, good. Marson adopts the all-seeing "I" of the Romantic poets, almost mimicking their style. Is this a natural development from an admiration of this style, or is it a deliberate manipulation to destabilise the coloniser's authority? As Bhabha has argued, "The menace of mimicry is its double vision, which in disclosing the ambivalence of colonial discourse also disrupts its authority."[26] There is power and play here. This is mimicry, an aesthetic alignment to legitimise her work—but, at the same time, never forgetting her roots, her other identity as a Black poet. Her point is made very clearly in another of her poems:

> They tell us
> That our skin is black
> But our hearts are white.
>
> We tell them
> That their skin is white
> But their hearts are black.[27]

Marson's poetic style indicates a cultural exchange between England and the West Indies, but the tentativeness in her voice is an indication of her sense of cultural unbelonging in Britain and, at the same time, of her "desire to belong to, and challenge the poetic status quo."[28]

British history is marked by immigration throughout the Windrush years—the period from 1948 through 1961 named after the first ship that docked in Tilbury in 1948, bringing a much needed labour force to the Mother Country to help rebuild the British Isles after the Second World War. Organisations such as the National Health Service and London Transport actively went to the Caribbean in an effort to recruit labour to overcome the growing shortage of people due to the war and its destruction. Between 1948 and 1961, 61,600 West Indian immigrants arrived in Britain. These people came to the United Kingdom in search of the better life. Due to colonialism, under British rule, West Indians were educated under the British system—meaning, they knew everything about England, its history, and Monarchy—and looked upon Britain as home. It was, they felt, their birthright to come live and work in England. The indigenous population did not welcome the immigrants and looked upon the influx as threatening to the British way of life: by taking

[26] Homi Bhabha, *The Location of Culture* (London: Routledge, 1994), pp.85-92.
[27] Una Marson, "Politeness" from *Tropic Reveries* (Kingston, Jamaica: Gleaner, 1930), p.44.
[28] deCaires Narain, Ibid., p.17.

homes, jobs, and women away from home-grown Britons. Racism and discrimination were widespread, and the immigrants were ghettoised into the worst jobs and housing. These immigrants were far from welcomed.

Luckily, the Windrush generation had a "home" to look back to. They had a strong sense of cultural identity and drew upon it within the hostile new country. Examples of poets who grew out of this generation include Grace Nichols, Amryl Johnson, Merle Collins, and Jean "Binta" Breeze, who paint Jamaica, Guyana, and Trinidad and Tobago with the bright colours and sounds of paradise against the greys and harshness of Britain. Look at "Island Man" by Grace Nichols:

> …
> the sun surfacing defiantly
>
> from the east
> of his small emerald island
> he always comes back groggily groggily
>
> Comes back to sands
> of a grey metallic soar
> to surge of wheels
> to dull North Circular roar[29]

Island Man "defiantly" refuses to forget his home and keeps the memories alive. Just as there is the repetition of the word *groggily*, illustrating how he does not want to wake up from his dream of his lush home, there is an imitation of waves in the poem's lineation, a pattern like the "blue surf / in his head" (mentioned earlier in the poem) that emphasises how the images of home keep coming back to him again and again. Once the Island Man comes back to reality, there is a mixing of images—"the grey metallic *soar*" when we are expecting *roar*. *Soar* suggests the sea birds, and this image is mixed with the "surge of wheels" from vehicles in London. Nichols's versification illustrates through concrete imagery the idea of being caught between two worlds.

The Black women writing in Britain explore this space while shaping a better position for themselves in it, using their cultures and language, challenging the norm, the standard. Merle Collins's "No Dialects Please" indicates what sorts of challenges I mean.

> Den when we start to shout
> bout a culture o we own

[29] Grace Nichols, "Island Man" in *The Fat Black Woman's Poems*. (London: Virago, 1984), p.29.

a language o we own
a identity o we own
dem an de others dey leave to control us say
STOP THAT NONSENSE NOW
We're all British!
Every time we lif we foot to do we own ting
to fight we own fight
dey tell us how British we British.[30]

The poem underlines the contradictions which exist in British society. Immigrants are only accepted as British when it suits the British to do so. Once immigrants become disillusioned with their British identity, they are seen as a threat. This threat is increased if they start to promote their own cultures and languages, as seen in the 1970s when there was a rise in the popularity amongst Black youth of the Black Power Movement and Rastafarianism, following Bob Marley's influence. When trends like that begin, then, as a means of control, the British establishment persuades the immigrants, the people previously deemed "outsiders," that they are welcome and we are all British. It is safer to keep them close. The fact that Collins writes this piece in Creole, dismissed as a dialect by the establishment, is an aesthetic expression of identity, claiming power and space through a challenge to the standard. It is as Salman Rushdie said: "we can't simply use the language in the way the British did…. [It] needs remaking for our own purposes."[31]

Contemporary Black women writers born in Britain have Britain as our home. No matter how hostile British society can be, Britain is still part of our identity. It is easy to identify with Caryl Phillips's mixed feelings about the realm. In his collection of essays *A New World Order*, Phillips wrote: "I recognise the place, I feel at home here, but I don't belong; I am of, and not of, this place." His observation illustrates the position of second- and third-generation children of immigrants who came to England in the 1950s. Their relationship to the rest of the country, as Black citizens born in the U.K., is one of both insidership and outsidership. And Black British writers often do comment on our invisibility due to the absence of representation, as illustrated in the passage from Bernardine Evaristo with which I began this chapter. The lack of representation has led to a sense of isolation, alienation, and potential cultural confusion. These feelings, in turn, develop into a politicised sense of identity. A particular kind of black culture is created: "being 'black' in Britain

[30] Merle Collins, "No Dialects Please" available online at http://www.newi.ac.uk/englishresources/workunits/alevel/poetry/contblkwomen/merle.html. Accessed 28 August 2006.
[31] Salman Rushdie, *Imaginary Homelands: Essays and Criticism, 1981 to 1991* (London: Penguin Books / Granta, 1992).

is about a state of 'becoming' racialised; a process of consciousness, when colour becomes the defining factor about who you are."[32] There is a conflict as we struggle to view Britain as home. We women do not often have first hand experience of Africa or the Caribbean, so where do we feel at home? I would argue that we are part of the middle ground, the land in between cultures. So what kind of writers does this situation create? How do *we* create a sense of "self"? In order to answer these questions, I explore one Black British woman's aesthetic, Bernardine Evaristo's. I do not claim that Evaristo can be used as a representative for the whole body of Black British women poets. What follows is an attempt to document how one woman attempts to write out of the narrowness of history and society, to explore her identity and claim her aesthetic space.

Lara, **The Next Generation**

Traversing three continents and two centuries, at the heart of *Lara* is a heroine who shares similarities with her creator, Bernardine Evaristo. Born in 1962 in Woolwich, Lara is the fourth child in a line of eight children from the marriage of Taiwo and Ellen da Costa. Lara's parents were wed in 1949, to the disapproval of Ellen's mother, who could not get over what the neighbours would think about the match and "the poor children, half-breeds, mongrels."[33] Recently arrived from Lagos after the Second World War, Taiwo has ancestral connections to the plantation slaves in Brazil and the Yoruba tribes of West Africa. Ellen is descended from "Emma of O'Donoghue clan," who arrived in London in 1888 from southern Ireland. Growing up in London during the 1960s and 1970s, Lara knows little of her family's history—the marriage of her parents dooming any chance of a close relationship with her grandmother and her father being very reluctant to talk about his past, as if that door had been firmly shut. From her feelings of not belonging, produced through her experiences of discrimination and racism, Lara begins to uncover and explore her family's history, an exploration which eventually takes her to Nigeria and Brazil.

Her travails between different pasts and places are echoed in the structure of *Lara*, which similarly moves unexpectedly back and forth across history and nation, plaiting together different strands of culture and ancestry into a linked yet

[32] Chela Sandoval, in *Black Feminism: A Reader*, Heidi Safia Mirza, ed. (London: Routledge, 1997).
[33] Evaristo, *Lara* (Kent: Angela Royal Publishing, 1997), p.33.

by no means homogenizing narrative which approximates to the transcultural character of Lara.[34]

The creative aspects of these crossings are captured and sustained in the text's repeated water imagery, from the first page, recounting the Yoruba proverb,

> However far the stream flows, it never forgets it source.

—to the novel's epilogue (from Milton Nascimento):

> Sing rainwater, sea water
> River water, holy water
> Wrap this child in mercy—heal her.[35]

In between we have "dirty washing up water," references to "the Atlantic pub," and "Yemanja, Goddess of the sea." Lara's full name at birth is Omilara, meaning "the family are like water."[36]

In *The Black Atlantic*, Paul Gilroy argues that Black identity is today in process, a creation of constant travel and exchange across the Atlantic, where a variety of cultural influences can be felt.[37] Gilroy acknowledges the shared experience of slavery as the basis of the Black diaspora. This is something that Evaristo does not fail to pick up and use:

> my entry to this island was messy, impatient, and dramatic.
> …
> when a gloved hand smacked my wrinkled bum I bawled
> air into activated lungs, grieving the sea I'd left behind.
> They named me Omilara, 'the family are like water'.[38]

The fluidity of identity, the criss-crossing of the Atlantic Ocean but also of the Irish Sea, the voice of Lara narrating her own birth—all reveal to the reader the idea that identity is not fixed and secure, but is always in the making, in process.

Complementing this argument are the ideas presented by Trinh Minh-Ha in *Framer Framed*.[39] Here, she sees the spaces, the borderlines, where hybridity lies, as constantly dissolving and reforming, revealing a place that is

[34] McLeod, Ibid., p.178.

[35] Evaristo, *Lara*, p.135.

[36] Evaristo, Ibid., pp. 14, 88, 128, 43.

[37] Paul Gilroy, *The Black Atlantic: Modernity and Double Consciousness* (New York and London: Verso Books, 1993).

[38] Evaristo, Ibid., p.43.

[39] Trinh Minh-Ha, *Framer Framed* (London: Routledge, 1992).

"always emerging" and "always in the making." She wants to play with the space, the hybridity, "like a musical score" so that identity "is not an end point in struggle" but is rather "a point of departure." Reopening the creative space is what the Black British aesthetic movement is doing to the traditional, limited, white, male, London-based literary scene. And Bernardine Evaristo is firmly in that aesthetic space.

In *Lara*, there are 140 sections, none longer than a page. There are fourteen chapters, with a prologue and an epilogue. There is no linear narrative: the story roams across time and space. It starts in 1844, with the prologue describing slavery, then it jumps to 1949 and Taiwo, Lara's father, coming to England, then back to 1939. The text offers a timeline frequently broken by flashbacks to provide the past origins of the present-day events. This device unmasks the instabilities of linear historical narratives, exposing the fiction of a fixed British culture, where British equates to "white." It suggests displacement and the fractures of a subjectivity based in diaspora.[40] Halfway through the book, the protagonist says,

> ... I longed for an image,
> a story, to speak to me, describe me, birth me whole.
> Living in my skin, I was, but which one?[41]

Lara cannot find "home," a place of validation in the U.K. She is living in a city that refuses to recognise the legitimacy of her presence. She is not allowed to enjoy London, even though she was born "here." Lara is trapped between the white world of her friends and family, where she is too black and endures racial taunts and ignorance, and the black world where she is not black enough. This predicament is seen through a visit from her cousin Beatrice and when Lara goes to college. During an argument with her Nigerian boyfriend, Josh, over the issue of marriage, Lara laughs, saying she loves freedom too much to get married. Josh throws at her

> 'Just as well, because you don't even know what
> Jollof rice is, let alone how to cook it. You're strictly
> a fish fingers and mash girl. You'll make a sorry wife.'[42]

[40] Pilar Cuder-Dominguez, "(Re)Turning to Africa: Bernardine Evaristo's *Lara* and Lucinda Roy's *Lady Moses*" in *Write Black Write British*, ed. Kadija Sesay (London: Hansib Publications, 2005), p.301.
[41] Evaristo, Ibid., p.69.
[42] Evaristo, Ibid., p.90.

Lara follows the path of self-destruction through drink, eventually finding solace through her art work. Like the typical *Bildungsroman*, the text takes on the structure of a quest, as Lara must go on a search for her true self, which is displaced. It is through these journeys that she starts to piece together a new way of conceiving her identity and space in the world. She travels through Europe and the East, only to find out that she fantasises about

> ...baths of iced water, dream of a full Sunday roast,
> all of a sudden: spuds, cabbage, gravy, salivate, PG Tips,
> in the heat, fried breakfast? ketchup, even. We become
> more British, Trish and I, darker with the Turkish sun,
> yet less aware of race for we are simply: İngiltere.[43]

It is as if only outside Britain, displaced in foreign lands, that Lara is allowed to become British or feel that connection to this part of her identity. Lara journeys to Africa, taking her father back, in order to recognise the presence of Africa within her identity. "This is the land of my father, she mused. I wonder if I could belong."[44] But she does not belong here either because she is seen as "Oyinbo," meaning "Whitey."[45] Finally, on her travels to Brazil, still searching for her true self, Lara realises that

> Entering the Afro-Brasileiro museum, I secretly hope
> for a clue, a photograph of a great grandfather or ancestor,
> whom I will some how instantly miraculously know.
> 'Any da Costas still around?' I ask the attendant.
> 'Of course! Hundreds! Thousands! Hundreds of thousands!'
> I leave the city of passion for the port of Belem,
> not knowing what to look for anymore.[46]

These "in-between" spaces have been created, in Homi Bhabha's interpretation, as the result of the disorientations in modern society. Having found itself moving away from the singularities of "gender" and "class" as primary organisational categories, modern society is now aware of other (and intersecting) subject positions, such as race, gender, generation, and location. Bhabha's statements bear repeating here:

> for me the importance of hybridity is not to be able to trace two original moments from which the third emerges, rather hybridity for me is the 'third

[43] Evaristo, Ibid., p. 97.
[44] Evaristo, Ibid., p.104.
[45] Evaristo, Ibid., p.104.
[46] Evaristo, Ibid., p.138.

space' which enables other positions to emerge. This third space displaces the
histories that constitute it, and sets up new structures of authority, new political
initiatives, which are adequately understood through received wisdom.[47]

In Bhabha's definition, the "third space" is where the constructing and
reconstructing of identity—which is fluid, not static—takes place.[48] These "in-
between" spaces enable the negotiations of cultural identity and selfhood to
initiate new signs of identity. Bhabha hopes that in these spaces "we will find
those words with which we can speak of Ourselves and Others."[49] These spaces
can be seen when Lara is in Brazil and finds a remote settlement down the
Amazon:

> ... I stretch my pins, earthed, follow
> my singing ears, Catholic hymns hybridized by drums,
> it is a hilltop church, Indian congregation, holding flowers
> and palm fronds. It is Palm Sunday! I hum from the door,
> witness to one culture being orchestrated by another,
> yet the past is gone, the future means transformation.[50]

The blending of cultural rituals provides a template for social and creative
change. Style, too, can be a hybrid accomplishment.

 The word *voice* has various meanings in common usage. The straight
forward sense refers to the actual sound, received by the ear, of the speaking or
singing agency of an individual. Metaphorically, the meaning of "finding one's
voice" involves empowerment—such as when women secured the vote and
obtained the political power to have a "say" in the mainstream of society. On a
more personal level, "finding one's voice" can refer to a process, which begins
with fear of speaking in front of crowds of people and ends when that fear is
overcome with time and practise. In a literary context, *voice* is used mainly in
the metaphorical way and largely relates to the reader's point of view.

> The reader 'hears' with the inner ear the 'voice' of a writer's writing when she
> reads a novel or poem.... [The] choice and juxtaposition of words, the rhythms
> and the tone of the language, particular themes or characters, all combine to

[47] Bhabha, Ibid., p.37.
[48] Bhabha, Ibid., p.4.
[49] Bill Ashcroft, Gareth Griffiths and Helen Tiffin, eds. *The Post-Colonial Reader.*
(London: Routledge, 1995), p. 183.
[50] Evaristo, Ibid., p.139.

create a style that summons up in the imagination the familiar 'voice' of a 'Conrad novel' for example.[51]

With Evaristo, her literary voice is heard through the themes she chooses to write about, such as the importance of history and family to identity. She demonstrates the confidence to write out of her own experience, but we also sense the echoes of others' voices, other writers' styles, upon her writing. As she herself attests: "Dylan Thomas's *Under Milk Wood*? I see the influence of this 'play for voices' in the way I've captured snapshots of many characters in *Lara*."[52]

The artistic strength of Evaristo's writing is felt for the most part in her poetic monologues—the individual voices of each of her characters, communicating, externalising their stories.

1 8 3 9

The gods born me on a fazenda in the hills of Brazil.
(Baba's sonorous rasp of cigarillos and cachaças deepened,
jaded brown marbles glazed, affixed this memory place.)
Born into the time of slavery, ten short decades ago.
...
When I was able to run and carry, I worked the fields.
My muscles forever ached like the fever, tiredness
made my walk an old man's drag, my stomach gnawed itself,
and always the shadow of fear—long-haired men
mounted on silent stallions silhouetted against the sun.
No link to the outside world, cut off in time, losing time,
I felt my whole lifetime would be spent killing sugar cane.
My scrawny back arched like a sickle.[53]

Evaristo succeeds in capturing the existence of Baba in bondage by letting him speak for himself of the life he suffered, including the hard labour and hunger. This horrendous life, however, is told in such poetic terms, with such vivid images, that the figures of speech make the message particularly effective. Baba describes his hunger as if it is alive (it "gnawed itself") because there was no sustenance within his body to allay it. As part of the description of the masters, the repeated *s*-sounds in "*s*ilent *s*tallions *s*ilhouetted again*s*t the *s*un" create an auditory impression of hissing snakes and evilness. The word play is evident as

[51] Celia Hunt and Fiona Sampson, *Writing: Self and Reflexivity* (London: Palgrave Macmillan, 2005), p.24.
[52] Evaristo, "We've had enough of Greek myths," Ibid.
[53] Evaristo, *Lara*, p.121.

the theme of slavery is drawn in heightened colours, portraying the endlessness
of the suffering. Time itself has been as enslaved, as these people are, and Baba
at a very young age knew he had a back curved like the very tool he used to cut
the cane. But Baba's is just one of the many voices that Evaristo brings to life.

In *Lara*, Evaristo gives voice to a great diversity of subject positions,
social experiences, and cultural identities that comprise the category "black"[54]—
voices that are forgotten or neglected within British society. Indeed, Evaristo
expressed the overall effect of her aesthetic in poetic terms: "Baba opened his
mouth to speak; ghosts flew out."[55] In this connection, Kwame Dawes has
argued that "most of the Black poets working in Britain today have emerged
through the performance medium—a medium that is seriously aware of voice,
idiom, dialogue and popular discourse."[56]

What we have as a challenge in Britain, though, is the task of creating
some kind of space, some way of owning that voice, since we are operating with
the oppressor's tongue. If we were born in one culture and brought up in
another, it might well feel alienating or uncomfortable to use the language of the
host culture, but as Sujata Bhatt asks, "Which language has not been the
oppressor's tongue?"[57] We were born into a conversation that had already begun
and will go on after we are gone, and we have to embrace the language we use
and know. But to become writers we have, also, to make the language our own.
As Evaristo has said herself:

> I was raised by my Nigerian father and white English mother in predominately
> white, suburban London. Little of my father's Yoruba culture was passed on to
> me; not his language, his food or his traditions. I went to a school of 500 where I
> was all but the only black pupil. Sure I liked the Jackson Five, but I adored
> Donny Osmond. I didn't feel very black and I certainly wasn't white. So what
> was I in the polarised society of the time? I didn't quite fit in, but I didn't have
> the vocabulary to express it.[58]

Within *Lara*, Evaristo succeeds in finding the vocabulary again and again to
express the thought and feelings of those individuals who do not fit into the neat

[54] Stuart Hall, "New Ethnicities," in *Stuart Hall: Critical Dialogues in Cultural Studies*,
eds. David Morley and Kuan-Hsing Chen (London and New York: Routledge, 1996), p.
441.
[55] Evaristo, Ibid., p.130.
[56] Kwame Dawes, "Black British Poetry: Some Considerations" in *Write Black Write
British*, ed. Kadija Sesay (London: Hansib Publications, 2005), p.282.
[57] Sujata Bhatt, "A Different History" in *Point No Point: Selected Poems*, (Manchester:
Carcanet Press, 1997), p.24.
[58] Bernardine Evaristo, "We've had enough of Greek myths," Ibid.

categories of black and white, British and non-British. Taiwo talking to Ellen, his wife-to-be, says hopefully:

> 'Ellie, marry me soon, you are of age now.
> Your mama will cease this nonsense or disown you
> but at least she will stop dousing you with water
> then running a live electric wire over your body.
> ...
> These British think they are so superior to coloureds,
> they believe those stupid Tarzan films from America.
> To me they are cardboard people with chessboard minds.[']⁵⁹

Here we have a vibrant collage of references that come together to make the unique voice of Taiwo, an immigrant from Lagos, getting used to life in London. He now uses the word *coloured* to describe himself and other non-white people living in Britain, a term that the immigrants became known by once they arrived in Britain. Before this they were Nigerians, Jamaicans, Indians, able to define themselves. *Coloured* is a term used to lump them all together, but it is also a control mechanism.

Mikhail Bakhtin's theories about developing a reflexive relationship with the languages—or the discourses—of others as a central part to finding one's voice are relevant here. The discourse of others—be they teachers, parents, social or political authorities—determine the very bases of our ideological interrelations with the world, the very basis of our behaviour. These "authoritative discourses" (which, until we develop views of our own, are "internally persuasive") determine how we think and speak. We see it here with Taiwo's internalisation and identification with the term *coloured*. A healthy development of subjectivity involves a struggle with these internally persuasive discourses, not to the point that they are completely rejected, but rather to where they are transformed, re-written, and re-told. At the same time that he takes this term on board, Taiwo demonstrates that he is not complicit in the brain-washing activity, for he shows his inner thoughts about these British people, highlighting their shortcomings at the same time as demonstrating his own intelligence through his clever use of language. The phrase "cardboard people with chessboard minds" reveals his powers of imagination. White people, he thinks, do not behave like "real" people; they pretend to be something they are not and live their lives through separating white from black and want no mixing.

The point regarding "authoritative discourses" can be further illustrated through the development of Lara, especially the way Evaristo shows that she becomes racialised. During a visit from cousin Beatrice, Lara's cousin says:

⁵⁹ Evaristo, Ibid., p. 39.

> '...Liverpool is the apartheid state of Great Britain.
> ...
> ...They won't give good jobs to
> our sort, whether we're plain, milk or even white chocolate,
> if you get my drift. Yet we built that great city with our
> precious blood, the biggest slave port in England it was...'
> Lara jumped up, butted in, adamant, 'Hah! Caught you!
> There weren't any slaves in England, Mama Kunta Kinte!'
> 'Eeeh! You make me sick. Ignorant? Pig ignorant!'[60]

Lara is shown at this point to be suffering from an internalised, potted school history that had white-washed Britain's true involvement in the slave trade and denied her access to her heritage.

Evaristo decided to give voices to these undocumented narratives within history from the third space by manipulating the form. She chose to use a hybrid form, a fusion, using the best of both poetry and prose in this text to create something that might be called a novel in verse, prose poetry, or poetic prose. When an individual belongs to a minority group within a society, the language used to represent, or create the self, often serves to reinforce the sense of otherness and disparity. The task that then faces the "other" is to use this language positively to construct an identity. Evaristo, I argue, takes ownership of the only language available to her and moulds it to speak her story and the stories of those people who are in the U.K. but do not feel "at home."

> ...Chimneys, ordered as sentries, discharge
> bulbous smoke; buses crawl through blizzards past
> snow-filled bomb craters, faceless back-to-backs,
> timbers dangling mid-air like dismembered limbs,
> winds creaking, no-man's land. [...]
> Now the Emperor's disowned sons
> congregate in Commonwealth dance halls.
> At the Catholic Overseas Club, Victoria, Taiwo,
> proud of his zoot suit and loafers, partners the excited,
> nubile, paleskins who flock in from the snow
> for the heat brought in from the tropics.[61]

The language used fits into the continuum of British poetry through its adherence to attractive rhythms and figurative devices, but it stretches the boundaries with its alliterative sound patterning and figurative language referencing the U.K. in an original way. Evaristo exploits the English language,

[60] Evaristo, Ibid., p.75.
[61] Evaristo, Ibid., p.6.

exploits the poetic device of alliteration, with *bulbous*, *buses*, and *blizzard* all in one line. She creates sharp images of the time ("snow-filled bomb craters") and place (the "faceless back-to-backs"). Adding to this, there is also a new viewpoint, that of the "Emperor's ... sons" who view the white population from the outside, as "paleskins" drawn towards the heat, their heat.

Conclusions: Transcultural Britain

Evaristo has succeeded in playing with autobiography, primarily a Western form of cultural expression, to explore her "hybrid" identity, at the same time displacing Britain's identity. Evaristo's literary influences include Shakespeare, Greek tragedy, Chaucer, and Tennyson. But also Toni Morrison, Audre Lorde and Alice Walker, Afro-American women who Evaristo says spoke to her through their works. Yet, she has learnt through these polyphonic voices to do her own thing, write in her own way. This individuality is evident in her texts as she gives aesthetic space to a multitude of voices in order to depict life in the "in between" spaces of British society.

Lara is a London-born child of Nigerian, British, Irish, and Brazilian histories. Her presence tells us about the many different threads and histories, the transnational cultural influences that impact upon her attempt to understand and be "at home" with the experience of being a black woman in Britain. By the end of the text, Lara is confident, aware of her transcultural past, optimistic about "the future [which] means transformation."[62] As do so many Black British women writers today, Evaristo's Lara images returning to London from her many travels and being able to "savour living in the world"—a world in which her city is a transcultural rainbow metropolis[63]:

> I savour living in the world, planet of growth, of decay,
> think of my island—the 'Great' Tippexed out of it—
> tiny amid massive floating continents, the African one
> an embryo within me.
> ...
> Back to London, across international time zones,
> I step out of Heathrow into my future.[64]

The work closes on that note, but opens on new possibilities, bringing to mind a passage written by bell hooks: "Do you believe that space can give life, or take

[62] Evaristo, Ibid., p.139.
[63] Evaristo, Ibid., p.140.
[64] Evaristo, Ibid., p.140.

it away, that space has power?[65] These questions, asked by bell hooks, recognize that the Black aesthetic is a question of space, location. In hooks's view, an aesthetic "is more than a philosophy or theory of art; it is a way of inhabiting that space, a particular location, a way of looking, and a way of becoming."[66] Part of this aesthetic is the acknowledgement that we are constantly changing positions and locations, that our needs and concerns vary, that these diverse directions must correspond with shifts in our critical thinking.

In using Bernardine Evaristo's art as just one possible example, what I have attempted to show here is that, during the development of contemporary Black women's poetry in the U.K., we have been writing with confidence of our experience in Britain. From the limited spaces that we inhabit, assigned to us by society at large, we have used this place as a starting point, not an end, and have worked out of this space, from the margins towards the centre. Leaving aside fiction, we have seen Patience Agbabi included in the prestigious Next Generation Poets list, the only Black poet who has made that list. We have seen Jackie Kay win an award nearly every year for her writing, the latest one being an MBE in 2006. Bernardine Evaristo herself has been elected as a Fellow of the Royal Society of Literature. These advances have taken place without these women neglecting their true identities. To the "third space," to our many selves, we have remained true. The Black British women writers' tradition has always had its feet in different cultures and influences. It has always had eclectic tastes, mixing and fusing differences to create beauty.

Works Cited

Anderson, Linda. *The New Critical Idiom: Autobiography.* London: Routledge, 2001.
Ashcroft, Bill, Gareth Griffiths and Helen Tiffin, eds. *The Post-Colonial Reader.* London: Routledge, 1995.
Bhabha, Homi. *The Location of Culture.* London: Routledge, 1994.
Bhatt, Sujata. "A Different History." In *Point No Point: Selected Poems.* Manchester: Carcanet Press, 1997.
Collins, Patricia Hill. *Black Feminist Thought: Knowledge, Consciousness, and the Politics of Empowerment.* New York: Routledge, 1991.
Collins, Merle. "No Dialects Please." Available online at http://www.newi.ac.uk/englishresources/workunits/alevel/poetry/contbl kwomen/merle.html. Accessed 28 August 2006.

[65] bell hooks, *Yearning: race, gender, and cultural politics* (Boston, MA: South End Press, 1990), p.103.
[66] bell hooks, Ibid., p.103.

Cuder-Dominguez, Pilar . "(Re)Turning to Africa: Bernardine Evaristo's *Lara* and Lucinda Roy's *Lady Moses.*" In *Write Black Write British*, ed. Kadija Sesay. London: Hansib Publications, 2005.

Dawes, Kwame. "Black British Poetry: Some Considerations." In *Write Black Write British*, ed. Kadija Sesay. London: Hansib Publications, 2005.

deCaires Narain, Denise. *Contemporary Caribbean Women's Poetry—Making Style.* London: Routledge, 2002.

Edwards, Paul, and David Dabydeen. *Black Writers in Britain, 1760-1890.* Edinburgh: Edinburgh University Press, 1991.

Evaristo, Bernardine. *Lara.* Kent: Angela Royal Publishing, 1997.

—. "We've had enough of Greek myths." In *The Independent*, 13 August 2006. http://enjoyment.independent.co.uk/books/features/article1218972.ece.

Free Verse (Arts Council, England: Spread the Word Literature Development Agency), June 2006.

Fryer, Peter. *Staying Power: The History of Black People in Britain* (London: Pluto Press, 1984.

Gates, Henry Louis, Jr. In John Guillory, *Cultural Capital: The Problem of Literary Canon Formation.* Chicago: University of Chicago Press, 1993.

Gilroy, Paul. *The Black Atlantic: Modernity and Double Consciousness.* New York and London: Verso Books, 1993.

Guillory, John. *Cultural Capital: The Problem of Literary Canon Formation.* Chicago: University of Chicago Press, 1993.

Hall, Stuart. "New Ethnicities." In *Stuart Hall: Critical Dialogues in Cultural Studies.* David Morley and Kuan-Hsing Chen, editors. London and New York: Routledge, 1996.

Henderson, Mae Gwendolyn. "Speaking in tongues: dialogic and dialectics and the black women writer's literary tradition." In *Colonial Discourse and Post-colonial Theory: A Reader*, ed. Patrick Williams. London: Longman, 1993.

hooks, bell. "Revolutionary Black Women: Making Ourselves Subject." In *Postcolonial Criticism*, eds. Bart Moore-Gilbert, Gareth Stanton, and Willy Maley. London: Longman, 1997.

—. *Yearning: race, gender, and cultural politics.* Boston, MA: South End Press, 1990.

Hunt, Celia, and Fiona Sampson. *Writing: Self and Reflexivity.* London: Palgrave Macmillan, 2005.

Jaggi, Maya. "Dubious divisions." In *The Guardian*, 1 November 2000.

Marson, Una. *The Moth and The Star.* Kingston, Jamaica: Self-published, 1937.

—. "Politeness" In *Tropic Reveries.* Kingston, Jamaica: Gleaner, 1930.

McLeod, John. *Postcolonial London – Rewriting the Metropolis* (London: Routledge, 2004.

Minh-Ha, Trinh. *Framer Framed*. London: Routledge, 1992.

Nichols, Grace. "Island Man." In *The Fat Black Woman's Poems*. London: Virago, 1984.

Prince, Mary. *The History of Mary Prince: A West Indian Slave,* Moira Ferguson, ed. University of Michigan Press, 1993[1987].

Ramey, Lauri. "Contemporary Black British Poetry." In *Black British Writing*, eds. R. Victoria Arana and Lauri Ramey. New York: Palgrave Macmillan, 2004. pp.109-136.

Rushdie, Salman. *Imaginary Homelands: Essays and Criticism, 1981 to 1991*. London: Penguin Books / Granta, 1992.

Sandoval, Chela. In *Black Feminism: A Reader*, Heidi Safia Mirza, ed. London: Routledge, 1997.

Smith, Rommi. *Mornings and Midnights*. Leeds: Peepal Tree Press, 2004.

—. *Moveable Type*. Leeds: Peepal Tree Press, 2000.

SuAndi. *Kiss*. Manchester: Crocus Press, 1994.

—. *Nearly Forty*. Liverpool: Spike Books, 1994.

—. *Style*. Manchester and Leicester: Purple Heather & Pankhurst Press, 1990.

—. *There Will Be No More Tears*. Manchester: Pankhurst Press, 1995.

CHAPTER TWENTY-ONE

AESTHETICS OF THE TRANS-RAISED DIASPORIC BLACK BRITISH

VALERIE MASON-JOHN
NOVELIST, U.K.

On the eve of the millennium, Britain saw its first black British female writer, Zadie Smith, break through onto the international arena with her novel *White Teeth* (2000). *White Teeth* won a raft of awards and prizes, including the *Guardian* First Book Award, the Whitbread First Novel Award, and the Commonwealth Writers Prize (Best First Book Award). It also won two Ethnic and Multicultural Media Awards (for Best Book and Best Female Media Newcomer) and was short-listed for the *Mail on Sunday*/John Llewellyn Rhys Prize, the Orange Prize for Fiction, and the Author's Club First Novel Award. *White Teeth* has been translated into over twenty languages and was adapted for Channel 4 television for broadcast in the autumn of 2002. Andrea Levy broke through with her fourth novel, *Small Island* (2004), which won the coveted Orange Prize for Fiction in 2004 and best novel of all time to win the Orange Fiction Prize. Five years after *White Teeth* was published, Zadie Smith won the coveted Orange Prize for Fiction for 2006 with *On Beauty*, published in 2005. These two writers have since won international critical acclaim and commercial success and have finally put part of the black British aesthetic onto the international literary arena.

However, the black British aesthetic has been very much alive since we came here to Britain *en masse* in the 1950s. Even then, we could see an evolution from the aesthetics of the writers of the eighteenth century (for instance, Ignatius Sanchez and Olaudah Equinoh) to that of the influx of *migrant* black British, with writers like Beryl Gilroy, Merle Collins, Ben Okri— to name but a few of our literary predecessors. They set the scene by writing about the myths, the landscape, the life, and the spirit world back home in

Africa and the Caribbean. Migrant black British writing has given black writers born in Britain a fertile literary landscape to emerge from.

In 2003, Monica Ali published her debut novel *Brick Lane*, an epic saga about a Bangladeshi family living in the U.K., which explores the Asian British immigrant experience. With the break through of *Brick Lane* by Ali, we began to see more of the next generation of black British writers emerging and becoming visible internationally. *Brick Lane* was a finalist for the 2003 Man Booker Prize for Fiction, the National Book Critics Circle Award for Fiction, and the 2004 Kiriyama Prize for fiction.

This newest generation's aesthetic is influenced by the dislocation of cultures, the rites of passage of our parents to the "promised land," and their settling in a new country. Andrea Levy reflected that influence by focussing in *Small Island* on the arrival of new black immigrants to Britain in the 1950s. In her earlier novels, she had explored what it was like to be born in Britain to Jamaican parents and to grow up in England. Zadie Smith, however, went one step further and examined ironically the U.K.'s reputation as "a happy multicultural land" by looking at the interconnectedness of three families—from Bangladesh, Jamaica, and England. Smith's novel reflects her own cultural heritage and her own experience of being black British of mixed racial heritage—Jamaican and English. Indeed, the black British aesthetic has been influenced by our assimilation into the dominant white culture. This can be clearly seen in what Levy, Smith, and Ali have all written about. Levy is the only one born to two black parents, but the overlap in aesthetics is clear in *Small Island* when it is critiqued alongside Smith's *On Beauty* and Ali's *Brick Lane*. Negotiating black and white cultures within the predominant white British society. It is as if this aesthetic is the acceptable one among the white publishing houses, agents, and literary critics. Books which emanate from bi-racial writers have broken through into the white British market. Other writers who also fit in this category are Chris Abani, Bernardine Evaristo, Martin Glynn, Kazuo Ishiguro, Jackie Kay, Ayub Khan-Din, Hanif Kureishi, Timothy Mo, Leone Ross, and Maud Sulter.

However, when discussing the black British aesthetic, we must be specific with regards to whom *precisely* we are discussing because *black British* means different things to different people. It is certainly not a homogenous group of people. Literary activist Kadija George said in a recent interview about the current black British literary scene, "Muslim lit could be just around the corner, Mixed Race lit, Diversity lit." These are undeniably some of the components which make up black British literature today. The black British person born in Britain to two African parents will be different to those who were born to two Caribbean parents, or to two Asian parents, or to one black parent and one white parent; and so the different cultural mixes and concomitant social

and educational experiences will at times define who we are and what we do in our written work.

Within the group "black British" there is a population that, while extremely prevalent at present, will perhaps soon die out—due to some changes in the current socio-political climate. This is the set of those of us who were adopted or fostered by white parents, or placed in white children's homes during the 1960s and 1970s. The practice of placing black children with white families is today seen as something to try to avoid wherever and whenever possible, though the practice still exists. Nevertheless, the arrangement is not as common as it was in the 1960s and 1970s. And so we are a cohort who will perhaps die out in this century.

Inevitably, we—a trans-raised generation—are connected to our black British fellow-writers who have been brought up by their biological families. Because we have all been dislocated from our countries of origin, some of our common experiences will resonate with those of the Black writer who was primarily raised by the white side of their family. Questions of identity (where do we fit? in black or white society?) are issues continually examined in black British writing. Still, I would argue that the aesthetics among those of us who have been trans-racially placed may be different on account of our childhoods.

We, the trans-racially raised, are a generation of black British writers who were disenfranchised early from our black families, or parents. That separation, then, set us apart from the rest of the black British culture "on the street"—because we were often deemed "English" (not black British) by our (other) black peers. I call our voice "the trans-racial voice," and it is the trans-racial literary voice that I find most exciting because it is the experience and the voice that I, too, represent in this country.

Trans-racially raised black people are concerned about the assimilation, fusion, and integration of black and white cultures—perhaps in ways similar to those who were born of mixed-racial heritage; however, what can distinguish *our* perspective is that some of our creative writing uses fiction to tell the stories of re-discovering who we are, of the search for our biological parents, or about the lives of black children growing up in orphanages. In 1991, poet and author Isha McKenzie-Mavinga and her sister Thelma Perkins broke another sort of silence with their novel *In Search of Mr Mckenzie*. The novel opens with a letter:

> ...My wife is a Jewess, and I am a Negro. The two races are classified as inferior by Hitler.... I find that the home is on verge of breaking, through pressure put on my wife by her family members who are bitterly prejudiced against my complexion. My wife declares that she finds it wholly impossible to care for the children, and so I must find somewhere to put them.

Trans-racially raised writers are concerned with certain cultural themes of interest to other black Britons, but they often treat these themes in bold new ways.

In 1991, Jackie Kay, one of Britain's leading poets and authors today, broke into the mainstream with her collection of poems *The Adoption Papers* (1991). Kay is of Nigerian and Scottish racial heritage, and her personal life is often inextricably linked to her written work. In *The Adoption Papers*, she tells the story of a black girl's adoption by a white Scottish couple. The story is voiced from three different view points—the mother's, the birth mother's, and the daughter's. Thematically, these poems show the cultural poverty of a black child who grows up within a white family. Kay writes: "Mammy why aren't you and me the same colour" (21); later, she speaks of seeing her first black person: "Angela Davis is the only female person / I've seen (except for a nurse on TV) / who looks like me. She had big hair like mine / that grows out instead of down. / My mum says it's called an *Afro*" (27). In her most recent collection of poems, *Life Mask*, published 2005, Kay writes several poems fictionalising her difficult experience of visiting Nigeria as an adult and meeting her father. In the poem "The Wood Father," she writes, "I couldn't tell if he loved me or not. / His eyes were darker than his barking hands, / nor if he wanted to meet again / in the dark forest, in the old red land" (34). But, technically, Kay's poetry owes a great deal to the mainstream (white) British poetic tradition.

Lemn Sissay, a trans-raised author of four poetry collections, is following swiftly behind his literary predecessors Linton Kwesi Johnson and Benjamin Zephaniah. He writes: "I have spent most of my adult life searching for my family: searching for my mother, father, sisters, brothers, aunts, uncles, brothers and sisters. In having no family since leaving the children's homes at 18, I had no proof of my own existence. Poetry and finding my family are my two journeys.... Poetry was a conversation with family—a proof that I was alive at any given time. I write therefore I am."[1] In his very early work, Sissay explored his confusion and the disenfranchisement of being trans-racially placed. In a poem, titled "I alone," he writes,

> Them change me name
> I alone
> Them drive me insane
> I alone
> Them force me fe believe
> I alone
> With them cunning them deceive

[1] Available online at http://www.contemporarywriters..com./authors.

I alone.[2]

In one of his early collections of poems, *Perceptions of the Pen*, he creates an aesthetic which could only belong to those of us who have been trans-racially placed. He writes about Social Services, explores what he may say to his biological mother if he ever met her. In his poem "Well 'I'," he writes: "My life is my paper my knife is my pen." For those of us who grew up in orphanages, our whole life was documented on paper; we have the files to prove it, which document everything from the demeaning terms about our colour and hair, to how we ate, to how we behaved. The pen has been the way that some of us have been able to tell our stories of what it was like to be trans-racially placed. In Lemn Sissay's most recent drama, *Something Dark*, he deals again with his search for his family, exposing what it was like to be a black kid growing up in orphanages and white families. The play is scary and surreal. It plays against a *gothic aesthetic*, but it is also a *realistic* depiction of the *psychological* traumas such children often experienced. Similar tropes of disorientation and deracination can be found in the early novels (*Brixton Rock* and *The Seven Sisters*) of Alex Wheatle, another trans-raised black British author; Wheatle's most recent novel, *Island Songs* (2005), however, celebrates his discovery of family and heritage in Jamaica in an up-beat, epic effort to convey the story of up to seven generations of several Caribbean black families.

In my early work, I, too, explore the confusion and estrangement of being black and brought up in a totally white context. In one of my first published poems, "Tangled Roots" (*City Limits Magazine*), which is now a piece of public art,[3] I wrote:

Tangled to life's roots
Rooted to life's tangles
Tangling to manmade ways
Rooting to life's decay,
New roots grow,
New tangles show
My roots are tangling
My tangles are tangling
I am the tangled root.

At an early age, I felt like many of my contemporaries who were in the same situation, and I found comfort in expressing my confusion about my

[2] *Black and In Care*, Conference Report, October 1984, page 27.
[3] It is permanently installed in the reception area of a leading Housing Association, Unity for Black and Asian People, in Leeds, U.K.

childhood experiences through writing. Some years later, in my debut novel *Borrowed Body*, published in 2005 (and winner of the MIND Book of the Year Award 2006), I felt the need to tell a fictional story of a black child growing up in 1960s Britain in orphanages—partly because orphanages of this kind do not exist anymore and partly to add to the multilayered black British experience. Ours is an experience which is missing from the predominant black British culture. I wanted to show that the black British aesthetic is influenced by many experiences. I wanted to create a character that was pulled between two cultures, not feeling at home in either one, a character who was black outside and white inside. "*Coconut*" is the term of abuse often thrown at many black people who have been trans-racially placed. The hurtful irony of that epithet is that those who use it assume that we thought ourselves better because of our white middle-class up-bringing when, in fact, many of us were insecure and confused due to our cultural poverty.

Nevertheless, I could create the character whom I called "Her Royal Highness, the Queen" in my one-woman show *Brown Girl in the Ring* because I knew that "Queen's English" voice intimately and nearly from birth. This character, too, displays confusion: she claims to be the Queen when, in fact, she is actually just claiming to be white. Of course, I was simply "signifyin'," as they say. Some black people who are trans-racially placed believe themselves to be white. While Lemn Sissay's aesthetic took on elements of the ominous gothic, mine took a more humorously eerie cast.

There is also another strength which comes out of the trans-racial experience: a voice that tackles taboos that the predominant black community would rather not acknowledge—for example, the gay, lesbian, bisexual, transgender, and queer experiences. It is as if because as black people we, the trans-racially raised, have already faced taboos within both our black and white communities—black outside, white inside (having to discover our cultural heritage as adults), it is perhaps easier for us to take expressive risks. Jackie Kay has written boldly and creatively about lesbian sexuality; and in her novel, *Trumpet*, she tells the story of a black woman, Joss Moody, the jazz trumpeter who passed her entire adulthood as a happily married man. Moody tells "his" son of the necessity for black people to cobble together their cultural heritages through research and to invent their own spiritual genealogies.

I also pushed the boundaries in my box-office sell-out play, *Sin Dykes* (1990), which explored black-white relationships and S and M sexuality between black women as well as between black women and white women. It was the first play to discuss publicly and so audaciously these taboo areas. (*Sin Dykes* was published in *Brown Girl in The Ring*, a collection of plays, poetry, and prose [Get A Grip, 2000]).

Patience Agbabi—performance and page poet (and named as one of Britain's top twenty "new generation" poets)—was also brought up in a white family, in Wales. In the title poem of her first collection, *R.A.W.* (1995), she wrote that she was "Uncooked, uncut, uncaged, unchained, uncensored." That is an apt description of someone who has grown up trans-racially placed and creatively endowed. Trans-racially raised individuals are culturally different to their black sisters and brothers who grew up in black families around them. Agbabi has managed to weave her white culture skilfully in with her black culture and to create a blend which has become acceptable to both the public and the academy. Agbabi went from protest poet to performance poet to page poet, writing and performing in classical forms—including the sestina, villanelle, and sonnet forms—and incorporating many diverse and contemporary black British themes at the same time. Agbabi has also courageously included lesbian sexuality in her work.

Just as Andrea Levy, Zadie Smith and Monica Ali have managed to find an acceptable voice for the wider market, the voice of the trans-racially placed black person is also apparently "acceptable." We have emerged and made our mark on the black British writing scene. We are writing from our unique experience, which has had an impact on the aesthetic that we have created. While we overlap in our themes sometimes with the black writers who grew up with their biological parents, we also separate out—and have another fertile landscape that we can appropriate from in order to create our characters and voices. While the Caribbean voice is strong in writers like Linton Kwesi John and Benjamin Zephaniah, the *Scottish voice* is strong in Jacky Kay. While the trans-racial writers search for their real mothers and fathers, they often share the experience with other black British writers of searching for their Mothers' and Fathers' ancestral land and its cultural features. My novel *Borrowed Body*, for example, contains African cultural material that I found extremely powerful and helpful in my efforts to convey the experiences of a trans-raised child.

Just like the black writer who is of mixed-racial heritage brought up by the white family, we, too, have an intimate insight into white people, which we can use to create our characters, voices, and stories in literature. The trans-raised voice is part of black British history. Ours is part of the black British aesthetic today—that complex of signifiers. Our voice emerges from our history in Africa, or of being settled in the Caribbean, or in Africa after the abolishment of slavery, or from living under British rule in India. Olaudah Equiano, Ignatius Sanchez, and Mary Seacole made their mark, which has been etched into British History. The black people shipped back over to Britain in the 1950s and 1960s from Africa and the Caribbean, and the Asian migration to Britain represent, perhaps, the progenitors of the second wave of our evolving aesthetics. The third wave embodies the fusing with Asian and European cultures. Black

Britain has finally created a large enough body of work that we don't have to borrow from the African American experience to shape our future aesthetic.

The writing and presentation of this essay were supported by a Grant for the Arts, Arts Council, England, and the British Council, Washington, D.C.

UNIT IV

ACTIVISTS IN THE VANGUARD
OF "BLACK" BRITISH AESTHETICS

Chapter Twenty-Two

Kadija Sesay: Literary Activist for the New Black British Aesthetic

Kevin Etienne-Cummings
University of Michigan

Although Kadija Sesay has literary works to her credit, she is known internationally more as a literary activist than as a creative writer. A major part of her professional life has been devoted to active engagement in the institutional restructuring of British literary culture. Her goal has been to educate people about writers of African ancestry while also working *with* writers of African descent in "whichever positive way possible." Her promotional efforts on behalf of contemporary black British literature encompass works in print, stage, and radio media, and she has represented black British writing at numerous international conferences and symposia in her capacity as an activist. Her work as a leading member of the new British cultural avant-garde has emerged within the broader context of a countrywide socio-political endeavour, specifically that of second-generation British citizens asserting, claiming, and redefining British national identity. She is felt as a force by the current generation of writers.

Kadija Sesay was born 10 December 1962, in Hammersmith, West London. She is the second child of parents from Sierra Leone, a former British colony. Her mother, Kosnattu Kadijattu Sesay, is of the Mende ethnic group; her father, Oluwole Reginald George, is a Creole from Freetown, Sierra Leone. Sesay's parents emigrated from Sierra Leone to England—her father in 1958 and her mother in 1959—following provisions of the postwar British Nationality Act of 1948, which was enacted to regulate matters of citizenship within the British Empire following World War II. The Act permitted British subjects to hold dual citizenship, as Britons as well as of their Commonwealth nations. Sesay's parents entered England legally as citizens of both the United Kingdom and Sierra Leone, thereby joining a large influx of immigrants from the colonies and former colonies that were still landing on the British Isles as a

result of the 1948 Act. The British reaction to the increased number of immigrants from Africa, Asia, and the West Indies was similar on both governmental and local levels. These new immigrants experienced racist attacks and increasingly marked discrimination. By the end of August 1958, fights, mobs, riots, destruction, and racially motivated mayhem against immigrants were the norm. The British government eventually instituted the Immigration Act of 1971, designed to curb the number of immigrants—and the aspiring immigrant population now had to claim an arguable *right of abode* in Britain in order to live there.

By the time Kadija was twelve years old, these racial and national tensions had proliferated around Britain. In the midst of the turmoil, in 1974, Kadija traveled to visit Sierra Leone with her sister and mother. There, she was introduced to African writers by an uncle. She was given her first book by an African writer, Chinua Achebe's *Things Fall Apart*, and recalls being flabbergasted at seeing an entire shelf of the Heinemann African Writers series in her uncle's home. Because of the dearth of African writers in the English education system, she did not realize there were any black writers in the world.

Sesay was a sixteen-year-old student when, in a 1978 speech, Prime Minister Margaret Thatcher summarized the spirit of the times, declaring that the immigrants' different cultures were causing fear within the British population of being "swamped" and that "hostile" reactions by the overwhelmed and threatened white British population should be expected. The homogenizing nature of the Establishment's racist response to the mounting social tensions encouraged Indian, African, and West Indian immigrants to group self-protectively under a collective political banner as "Blacks." Indeed, during the 1970s in Britain, *black* was a term that described any "non-white" and would therefore include Indian-born Salman Rushdie in the same camp as Nigerian Ben Okri—an incongruity not lost on the young British-born Sesay.

Growing up as a teenager in England, Sesay became increasingly aware of the fact that the "Black British" literary scene during this period comprised writers who were principally concerned with the country they had left behind. Such writers included, for example, Derek Walcott, Kamau Braithwaite, George Lamming, V.S. Naipaul, and Louise Bennett. Sesay was also reading the works of Chinua Achebe and Buchi Emecheta, whose novels were sometimes set in Africa and sometimes in Britain. The public and private presentation of this group of "Black British" writers was as members of former colonies now residing in Britain. As immigrants, they were not made to feel at home in Britain, nor did they want to. The goal of these writers, seemingly, was to write the humanity of "Black" colonized peoples against the dominant British narrative that immigrants from the colonies were a sort of living virus on the host nation. Also, these writers were first Indian, West Indian, or African, and

only secondarily British—both because of their self-association with the
growing nationalist causes in the colonies of their birth and because the British
critics and publishing houses preferred, for hegemonic reasons, to define these
writers as essentially "foreign." As she would become conscious of Black
British writing later in the 1990s, Sesay found, in short, that these immigrant
authors' representations of "Black British" life did not include her own socio-
emotional experience as a London-born, second-generation English girl of
Sierra Leonean heritage.

 By the 1980s, Britain was still occupied with tensions surrounding its
racial and national identity. Tensions increased ever larger numbers of second-
generation British citizens, the children (like Kadija) of "British subjects," felt
they had no other place to call home but their British dwelling places. From
Edinburgh to Maidstone, race riots ran rampant in the spring and summer of
1981. This time, however, black and white teenagers rioted against racist police
violence, which had started in the predominantly West Indian and African
community of Brixton, London. In response, the British government, under
Margaret Thatcher, proposed and enacted a narrower redefinition of British
citizenship: the British Nationality Act of 1981, a measure that allowed only
those whose parents had been born in the United Kingdom, or had been legally
settled in the United Kingdom, to qualify as *bona fide* British citizens. Sesay's
legal status was technically safe, but the streets were not when she first enrolled,
in 1981, as a first-year student at Birmingham University, in a city which also
saw a proliferation of race riots that year.

 The 1980s were a critical decade for both Sesay and Britain. As the
British establishment attempted to narrow the racial categories of British
citizenship, culture workers were busy expanding the racial categories
subsumed under the nation's embrace. The literary and cultural production of
1980s Britain was similar to, but also different in important ways from, the
"Black Arts Movement" of 1960s and 1970s in the United States. The 1980s
saw a re-conceptualization of the term *black* in Britain. Whereas in the 1970s
non-white racial groups banded together under the "Black" banner as a reaction
to their collective racialisation, in the 1980s "*Black*" began to be seen as an
essentialist, homogenizing term that gave no weight to the experiences of non-
Black (or non-African and non-Caribbean) minority groups. This era integrated
the lived realities of "new ethnicities"—namely the African, Caribbean, or
South Asian—in the British racial/national debates of the 1980s and 1990s. It
also implicitly incorporated generational debates between those who called
Britain home and those who did not. During this critical decade, Sesay was
majoring in West African Studies at Birmingham University. She was politically
and intellectually engaged in the ferment of the day and was elected President of
the African and Caribbean Student Society. She had dreams of furthering her

study of Africa at the School of Oriental and African Studies (SOAS) in London, but discovered that her options were limited. With so few universities in Britain offering programs of study on Africa, she was told that her degree from Birmingham would not help her to gain admission to SOAS and that she should continue in pursuit of her Master's degree at Birmingham. With no intentions of staying on at Birmingham beyond graduation, she nevertheless completed her undergraduate program of study, earned her Bachelor's of Arts degree with General Honours, and graduated in June 1985.

For the next few years, she worked in catering, with the goal of eventually opening her own restaurant. She supplemented her catering income by doing public relations work relating to the arts and by producing journalistic essays on cultural events. Her first writing job was obtained through jazz artist Soweto Kinch's father, playwright Don Kinch, who owned *Staunch* magazine. In 1983, she became press officer for the Apples and Snakes Performance Poetry Organization. This nationwide poetry association is dedicated to educating audiences and to promoting performance poetry throughout England. As press officer for Apples and Snakes, Sesay met many future members of the new literary vanguard, including, for example, Dorothea Smartt and Patience Agbabi.

By the 1990s, Black British literature was undergoing a further redefinition, in which Sesay was a major player. As a result of the detailing of "Black" representation through the 1980s, the term *black British* now began to resemble the term *black American*. *Black* designated not all "non-white" individuals and entities (as before), but only those who had ancestral or familial ties with Africa and for whom Britain was home. During these years, Sesay's primary objective as a leading advocate of her own generation's creativity was to draw attention to new works by younger black British writers who, like herself, had their roots in Africa. British publishing houses and critics, however, were resistant. By the mid-1990s, according to R. Victoria Arana, white critics were still placing the products of British-born black writers outside the national canon (29-30). Sesay saw that her self-imposed charge as a literary activist was to correct this cultural and historical blindness. She set out to redress the fact that British-born black writers were invisible and struggling for recognition by academia and the public—as *British* writers.

During the 1990s, Sesay's writing shifted from press relations to journalism, and she became a pivotal figure in black British literary production. Her journalistic interests were varied. She profiled Caribbean prime ministers, but also celebrity artists, such as comedian Lenny Henry, reggae artist Maxi Priest, singer Sade, and black American singers, Diana Ross and Chaka Khan. In general, her journalism, which also extends to the present, focused on Britain's black population, and her articles appeared in the following

publications: *Untold, Pride, Sonia Sanchez Review, Artrage, Black Briton Newspaper, Class/Black Diaspora, The Weekly Journal Newspaper, PACE, Afroscope, African Concord* (she started the Concord Lifestyle supplement for the United Kingdom).

In 1992, Sesay co-founded SAKS Media publishing services. SAKS was established by three women: her younger sister, Saffiatu George (now Haines), her friend Stella Oni (now Ahmadou), and Sesay herself. The company is devoted to publishing works by African and Asian writers. Part of Sesay's literary activism is, in fact, her efforts to resist the marginalization of black British writers and to redefine the racial contours of "British" national identity. She does this through the traditional literary avenues of writing and speaking, but unlike her literary predecessors, she confronts the British establishment at the institutional level as well. Since its inception, SAKS has created three publications noted for their timely staging on the British literary scene: *Burning Words, Flaming Images* (1996); *Playing Sidney Poitier and Other Stories* (1998); and *SABLE LitMag* for new writing by writers of colour (since 2001).

While working with SAKS, Sesay continued to write, to work with writers of the new British literature, and to speak at British and international conferences and symposia. In 1993, Sesay compiled an "anthology to represent women writers alone," *Six Plays by Black and Asian Women Writers*. The collection deals with generational and cultural "conflicts faced by African and Asian youth evident today." A secondary purpose for the anthology, according to its editor, was to "encourage other undiscovered writers to come into the open and inspire new writers to recognise a career in the theatre—as more writing needs to come from women with African and Asian backgrounds." Demonstrating her re-envisioning of British national identity, the anthology also celebrates a few of the distinguished women writers who have "rid [themselves] of the term 'ethnic minority' and [moved] into the national framework where they rightfully belong."

Sesay also promoted black British arts through various other venues, for example, on the "Arts slot for African scene" program on IDTV/BET cable TV and the Community Billboard for Choice FM's radio gospel show (in 1992). For her efforts, she was granted the 1994 Cosmopolitan Magazine's "Woman of Achievement in the Creative Arts Award." The same year, she conducted the press relations for Zambian President Chiluba's 1994 international tour. She also presented her address on "Writing and Publishing: The Black Presence in Literature during the Last 50 Years" to the Kent County Council's conference "A Celebration of African, Asian, and Caribbean Literature and Arts." During the decade of the 1990s, her work took on a decidedly internationalist fervor. Crucial to black British literary production, she created *The Writer's Hotspot* in 1996. *The Writer's Hotspot* promotes and

connects writers of colour throughout the world. The organization sponsored travel by groups of British writers to The Gambia, Cuba, New York City, Zanzibar, Jamaica, and Egypt.

In 1996, Sesay was awarded the Candace Magazine's "Woman of Achievement Award" (for Work in the Community). In that year, she also brought out her edited collection *Burning Words, Flaming Images: Poems and Short Stories by Writers of African Descent*. The collection introduced a number of writers who went on to acquire distinguished reputations as the new avant-garde of black British literature. Among them were Bernardine Evaristo, Patience Agbabi, Dorothea Smartt, and Chris Abani. The collection included two poems and a short story by Sesay: "Elevated," "Socks and Sunglasses," and "Cook for Talk," respectively. "Cook for Talk" reiterates a familiar theme in Sesay's work, the complicated definition of home. The story pivots on the generational conflicts of an African family in Britain: the older, African immigrant "Aunties" (mis)understand their younger niece's love choice, namely a fellow white male student. The exasperated claim made by one of the aunties ("We can only keep Africa in our homes") provides an apt example of the ambiguous meaning of "home" for immigrants in a foreign national culture.

Various scholars, but particularly R. Victoria Arana, describe the tenor of the new literary vanguard as bold and assertive. The internationally recognized March 1997 conference held in London, "Reinventing Britain," formally marked such a movement. At the conference, black British writers and activists, including Sesay, asserted to the British public that they were British (English, Scottish, and Welsh) and did belong, in actual fact, to British society. Their artistic works, they affirmed, clearly embodied a new British aesthetic.

Sesay's activism earned her various accolades over the next few years: she judged the Young Black Achievers Award in 1997 at Cambridge University, and in 1998, she became a Fellow of the George Bell Institute, for which she has served as Book Review editor for the Institute's journal, *Humanitas*. Later in 1998, she founded another publishing venue for black writers in Britain, *Calabash: The Newsletter for Writers of African and Asian Descent*. Her promotion of African writers continued with various speeches, lectures, and consultancy projects around Britain. She participated in the Women's Studies Network Conference, which sponsored a meeting titled "Gendered Space: Women's Choices & Constraints" at the Centre for Gender Studies, Hull University, and spoke on "Black Women's Publishing in Britain" (1998); she became consulting editor for *BlackOut: The Essential Guide to Black Entertainment and Lifestyles* (1999); at the Africana Forum at Cambridge University, she read her paper "Black Women in Publishing" (1999); and she travelled throughout the country to speak on topics too numerous to list here.

In 1999, she published some of her own creative writing in *The Fire People: A Collection of Contemporary Black British Poets,* edited by Lemn Sissay, and in *Afrobeat: New Black British Fiction,* edited by Patsy Antoine. While her 1996 short story "Cook for Talk" was focused on African life in Britain, Sesay's 1999 short story "A Slice of Quiet" turns the lens to African British citizens, specifically women, returning to Africa. It was published in *Playing Sidney Poitier and Other Stories* (1999), edited by Catherine Johnson, and is the story of a black British woman visiting a Muslim, Bambara-speaking country. Cultural tensions abound. The woman is prejudged by Lamin, the Fulani store owner, as being rich: "he could triple his prices without question" because she "didn't look as if she was Bambara with those foreign words spread across her chest." She commits a gross cultural faux-pas by walking into a shop without greeting the owner. Then, she has the audacity to ask for "fresh" bread, which Lamin takes as an insult. The recurrent cultural and linguistic miscommunication forces Lamin to order his son, Seku, who speaks a little English, to help him with "Miss Britisher." Seku does what he can, but the female protagonist leaves the shop without the bread she came to buy. To show appreciation for his help, the protagonist offers Seku some money. "She stretched out her left hand.... Did she hear or feel the slap first?" This story exemplifies the intellectual parameters set forth by Sesay's literary niche: not only is Britain home, but home is also where one participates and shares in the national culture.

The end of the 1990s brought Sesay several more awards: The *Voice* Newspaper's Community Award for Literature, 1999; and Britain's Woman of the Millennium, 2000. At a conference in Cuba at the start of the millennium, Sesay presented her address "Transformations in Black British Writing," a talk whose theme she would reiterate at various other international venues that year. With her reputation as a literary activist for writers of colour firmly established by the millennium, she toured Britain giving speeches and presentations on the British publishing industry, including her popular presentation "Getting into Publishing," inaugurated at the National Black Writers' Conference at the Cultureword Literature Development Project, Manchester, England (2000).

Always concerned with promoting the production of new creative writing, she co-edited, with Courttia Newland, *IC3: The Penguin Book of New Black Writing in Britain* (2000). The book again proved to be a landmark collection. The multi-genre anthology is divided into three chronology-based sections, "Settlers," "Explorers," and "Crusaders"—with each subtitle describing an era of black writing in Britain. The prefix of the title engages state sponsored racial classification schemes. "IC3" is the police identity code for "Black," after IC1 – Caucasian; IC2 – Mediterranean; and then IC4 – Asian. As she states in the introduction, the book's intention is to revive and to commune

marginalized writers in Britain following the "demise of the Caribbean Arts Movement" in the 1970s. The collection is clearly the work of a new generation:

> Despite the torments and trials that our ancestors went through in teaching the point we are at today, racism continues to be rife, in overt and covert forms, in Britain, amongst individuals and institutions. But that fight goes on – and what this landmark anthology says most of all is that this continued hope is evident in the advances that Black people in England have made and the positive impact we have made on British society, daring and challenging it. […] But in saying this, the aim of this anthology is not to profess our "tigritude"—our Blackness—or even our "Black Britishness"; it is not necessary—it's in everything we do and however we choose to live.

There is again a recurrence of the same personal-intellectual debates faced by writers of the vanguard: conflicts of identity. Reviewer Bruce King (*World Literature Today*, 2000) described some of the work in the 461-page book as "excellent" and "sensitive," noting that the "anthology is more an exploration than a canon."

Also in 2000, Sesay was invited to speak at the symposium "Teaching Black British Writers" held at Howard University in Washington, D.C. Sesay's speech, "Transformation within the Black British Novel," asserted a respectful distance between her literary ancestors and the work of her generation. She demonstrated this in three key measures, those of identity markers, language usage, and imagery. For the new writers, identity does not equal "displacement," as it did for the previous generation, but rather as "acceptance." Britain is unmistakably home. Similarly, language use for this new crop of writers is British-Isles based. Whereas, for example, the earlier writers would pepper their work with Creole or Patois, "second-and third-generation Black Britons are native speakers of a great spectrum of regional dialects, including, of course, 'London English' (or Cockney), which was likely unfamiliar to those migrants who arrived in England speaking, first and foremost, the 'Queen's English.'" Last, because "the common birthmark of these writers is that, for the most part, they were born in the United Kingdom and are the descendents of the wave of migrants from Africa and the Caribbean who began to arrive *en masse* in the 1950s and 1960s," the textual imagery of the new generation is more urban than rural or tropical. This new crop of writers looks to Britain itself for aesthetic inspiration and the idiom used to describe their lives there.

In 2001, Sesay extended the influence of her SAKS Media publishing house with the inauguration of *SABLE LitMag* for new writers of colour. As the website (www.sablelitmag.org) notes, the name, "Sable, was chosen to reflect the colour of the diversity of people—a mixture of blacks and browns, reflecting the various shades of people of colour. It is a name that carries the same meaning in English, French, and Spanish, too." The magazine is published in

glossy black-and-white layout and differs from other literary publications in Britain in that its emphasis is on literature, not advertisements. This aesthetic dimension is reinforced by its generous allowance of white space on the page. The magazine has featured Linton Kwesi Johnson (Spring 2001), Sonia Sanchez (Winter 2002), Niyi Osundare (Spring/Summer 2003), Buchi Emecheta (Spring 2004), four previously unpublished women: Barbara Graham, Ranbir Sahota, Heather Imani, and Shiromi Pinot, (Autumn/ Fall 2004), Chinua Achebe (2006), and Jackie Kay (2006). Of the above, Sesay names, above all, Johnson, Emecheta, and Sanchez as her literary inspirations. Through *SABLE*, Sesay has consistently demonstrated a Pan-African sentiment. She wrote, "I don't believe that as a race, we can afford to be contained by boundaries. If we want to progress as a people, we have to be Pan-African. We are so diasporic—found everywhere! That's why *SABLE* [features] 'writers of colour' in the broadest sense possible."

In the spring of 2001, Sesay was invited to serve as an advisor and contributor to *BMa: The Sonia Sanchez Literary Review*, for a special issue on black British writing titled *Sea Change*. Here, again, she restated her case for recognizing a new black British aesthetic and disposition emerging in the British Isles. Still touring Britain to advance the new national literature, she spoke on "Black Ink: Developing New Writing," a conference sponsored by the Brent Council (Black Women in the Media Forum) in London, 2001; and presented a paper titled "Geography, Race, and Culture" at UKwithNY: A British Council Arts Festival in New York, 2001.

In 2001-2002, she fulfilled a prestigious residency at the John F. Kennedy Center for the Performing Arts in Washington, D.C., on a Vilar Fellowship in Performing Arts Management. In 2002, she contributed four entries to the *Encyclopedia on Censorship*, edited by Derek Jones. Sesay's entries there underlined an understanding of governmental limitations placed on a nation's writers: she wrote on Chinua Achebe, a Nigerian writer; Kolosa John Kargbo, Sierra Leonean dramatist and journalist, 1954-1989; Sylvester Cheney-Coker, Sierra Leonean poet and novelist, 1945–; and Sierra Leone, a country profile. While writing those essays, she brought her activist work on canonic issues to an academic audience in the United States. She toured several colleges in the U.S. to attend academic conferences and to describe the new literature of Britain, among them the Pacific Coast Conference on British Studies' panel on Black British Literature at Pomona College, California, 2002; Gettysburg College, Philadelphia, 2002; SUNY-Geneseo, New York, 2002, and the D.C. Area Writing Project Invitational Summer Institute held at Howard University in Washington, D.C., 2002. Her activism earned her a place as General Secretary of the PEN Writers Abroad Centre, and she was selected to be on the

Search Committee of International PEN, in addition to The Arvon Foundation's Writer's Residential Programme for 2003.

In 2005, she published her edited collection of scholarly essays on new developments in black British writing, titled *Write Black, Write British: From Post-Colonial to Black British Literature*. The objective of the book, as she discussed in an interview with Maria Helena Lima in *Obsidian III: Literature in the African Diaspora* (2004), was to deepen an understanding of this new development on the British literary scene and to deepen, also, the roots of new black British writing by intellectualizing the discourse on the work itself. The book is divided into three sections: "Writers in Prose-Fiction"; "Writers in Verse"; and "Locating Writers in History, Culture, and Society." Except for a few concluding essays, most of the essays in the text provide an academic perspective on the works of the black British vanguard. The writers would not be considered "worthy," she said, "until there is a body of criticism on them." From 15 through 17 April 2005, as *SABLE Magazine*'s editor in chief, she hosted the magazine's first international literary festival, held in London. Sesay's work as a literary activist has emerged within the context of a more general broadening of the popular perception within in the United Kingdom and abroad of what a British national identity might mean today, and her influence has grown and developed under an Establishment slow to change and in some cases still unwilling to see the people of colour within its borders as British. She is, perhaps, the one individual most often credited with drawing attention to the phenomenon of a new "black" British aesthetic today.

Books Edited by Kadija Sesay

George [Sesay], Kadija. *Six Plays by Black and Asian Women Writers*. London: Aurora Metro, 1993.

Sesay, Kadija *Burning Words, Flaming Images, Poems and stories by Writers of African descent*. London: SAKS Publications, 1996.

Sesay, Kadija and Courttia Newland. *IC3: The Penguin Book of New Black Writing in Britain*. London: Hamish Hamilton, 2000.

Sesay, Kadija *Write Black, Write British: From Post-Colonial to Black British Literature*. London: Hansib, 2005.

Sesay, Kadija and Nii Ayikwei Parkes *Dance the Guns to Silence: 100 Poems for Ken Saro-Wiwa*. London: Flipped Eye Publishing, 2005.

CHAPTER TWENTY-THREE

SUSHEILA NASTA: PUBLIC INTELLECTUAL ON CURRENT BLACK BRITISH AESTHETICS

SANDRA PONZANESI
UTRECHT UNIVERSITY, THE NETHERLANDS

Susheila Nasta is among the most prominent editors and literary critics of postcolonial, migrant, and diasporic writings in the United Kingdom. Her research interests are wide ranging and include postcolonial literatures, particularly literatures of the South Asian diaspora, Caribbean literature, life-writing, women's writing, and Black British writing; the relationship between creative writing and critical practices; and colonial and postcolonial modernities. She is a prominent personality in the media, having acquired a reputation as an outstanding "on air" interviewer of literary personages (e.g., Sam Selvon, Buchi Emecheta, Beryl Gilroy, and many others), and her frequent broadcasts on BBC Radio 4 and BBC Television have brought postcolonial and the new British literatures to a wider world public for over two decades. At the same time, Nasta has established herself as a distinguished and prolific writer and editor of scholarly books, academic and journalistic essays, and chapters in books; and, after a highly productive career as an educator associated with an impressive series of academic posts, she is currently Reader in Literature at the Open University and an Associate Fellow at the Institute of English Studies, School of Advanced Studies, University of London.

Born in Britain in 1953 of an Indian father and a British mother, Nasta spent many years in India, the Netherlands, and Germany before returning to Britain in the 1960s to enrol in British schools. She earned her B.A., with joint honours in English and History, from the University of Kent in 1975. In the following year, she earned a Post-Graduate Certificate in Education from the London University Institute of Education. She returned to the University of Kent to pursue graduate studies in English, where (under the supervision of Professors Lynn Innes and Louis James) she wrote her thesis on *London and the*

Experience of Exile in V.S. Naipaul and Sam Selvon and earned her M.A. degree in 1981.

From 1981 through 1986, Nasta was Deputy Head of English at Blackheath High School in London. It was during this period that she began her comprehensive study of cutting-edge scholarship on Caribbean literature. Beginning in 1982, she contributed annually to *The Year's Work in English Studies* (specifically Vols. 63 [1982] - 68 [1987]), edited by Lauren Brake, by writing the series' chapters on Caribbean literature and criticism. It was during this period also that she conceived of the plan to start a refereed journal for the publication of critical articles, essays, reviews, and original writing related to postcolonial literature. Through her active involvement in this particular area of literary study and with this ambitious editorial project in mind, Nasta began her career-long effort to promote innovative research into contemporary writing "of a British Black and South Asian heritage" and to redefine British literary studies. With eventual encouragement and funding support from the Arts and Humanities Research Council of the United Kingdom, she launched *Wasafiri*, as its Founding Editor, in 1984. In a "Face to Face" interview with *The Hindu*'s Gowri Ramnarayan, Nasta later explained the genesis of the magazine:

> We started with the pedagogic aim of teaching African Caribbean and South Asian literature at a time when the canonical syllabus in schools and universities in Britain did not include writers like V.S. Naipaul, Anita Desai and Derek Walcott. *Wasafiri* came out of a group, which held a conference every year for teachers and academics to become more aware of such writers. We had academic articles in each issue. (24 August 2004)

Over the past two decades, the magazine has increased in prestige and readership and gone from a hobby to a nationally funded periodical with an international reputation for excellence. But the start-up was not without its struggles. "We started off [in 1984 and for the first few years] with little grants, one here, one there, for ethnic minorities, cultural diversities whatever," she told Ramnarayan. "The magazine followed me round my house for seven years, until it eventually got some institutional support." But, in its first twenty years, Nasta added, *Wasafiri* "moved from pocket funding to mainstream Arts Council funding. Now [in 2004] it is alongside *The London Review of Books, The London Magazine* and *Granta*. Not to say it gets as much as those magazines, but at least it is perceived as an Arts Council magazine supported by public funding." In the early period during which she was developing *Wasafiri*, Nasta took on a series of academic teaching positions.

From 1986 to 1989, she taught Cultural and Literary Studies at the University of Portsmouth, full time. In 1988, she edited and wrote the

introduction to *Critical Perspectives on Sam Selvon* (a collection of critical essays by diverse scholars and writers), she published her chapter "Teaching *The Lonely Londoners*" to David Dabydeen's *Handbook for the Teaching of Caribbean Literature*, and she edited and prepared an introduction for *El Dorado West One* by Sam Selvon, a transcribed edition of his radio plays supplemented by scholarly notes. Together with Kenneth Ramchand, she edited *Foreday Morning: Sam Selvon's Prose, 1945-89*, which was published in 1989. In that same year she published her polemic essay "There's no such thing as only literature" in *Dialogue and Difference: English into the Nineties*.

From 1989 to 1991, Nasta held Senior Lectureships (part-time and joint) in Modern Literature at Homerton College, University of Cambridge, and in Literary and Media Studies at the University of North London. Not only a versatile academic but also a dedicated teacher, Nasta constantly demonstrated her interests in pedagogy and tested her ideas about postcolonial literatures within the academy, where she investigated the theoretical relationships between creative writing and critical practices with her students. Most of her critical projects have stemmed, she has said, from her work as a teacher. For example, her next book, *Motherlands*, was the direct result of discussions with her students in an undergraduate course she taught on Black Women's Writing during this period of her career.

In 1991, Nasta published her ground-breaking anthology *Motherlands: Women's Writing from Africa, the Caribbean and South Asia* (which was short-listed for the Fawcett Prize in 1991), an anthology of literary essays by women critics from Africa, the Caribbean, South Asia, Britain, and the United States. It was one of the first works not only to collect writing across the British post-colonies, but also to focus specifically on black women's writing, based on the assumption that women from the former colonies underwent a form of double colonization, both imperial and patriarchal. The result was an innovative and much appreciated collection of essays, with an excellent introduction by Nasta that focused on the tropes of motherhood, motherland, and mothertongue as founding myths for the nation, for identity construction, and for creative expression. Marlene Nourbese Philip expressed the spirit of the volume succinctly in her opening poem to the collection, "An Extract from the Discourse on the Logic of Language":

> English
> Is my mother tongue
> A Mother tongue is not
> not a foreign lan lan lang
> language
> l/anguish
> anguish

—a foreign anguish

English is
My father tongue.
A Father tongue is
a foreign language,
therefore English is
a foreign language
not a mother tongue

This poem implies all the crucial issues at stake for black women's writing from Africa, the Caribbean, and South Asia, for whom language carries a whole history of patriarchal myths whether instituted by the colonial power or by later, as Nasta explains, by the primarily male-dominated movements toward nationalism and independence. Language becomes for them both the source of expression and of oppression, a source of creativity that needs to be liberated from the fetters of racism and male domination by fostering the plurality of tales, stories, and myths that have always been the realm of female transmission, but too often silenced by competing discourses of power struggle between colonizers and colonized. *Motherlands* questions the myth of the nation that has been organized around the female figure, an image that has operated in the public space at a purely iconic level and with no agential power whatsoever. Women and the family, as Anne McClintock and other feminist critics have argued, have been central to the representation of the nation's formation, but are totally excluded from any exercise of power because women remain first and foremost relegated to the private sphere. If women were to participate in the nationalist cause, their role would be hardly recognized. Nasta's collection is, therefore, a response to the problem and an ode to women's voices from across different geopolitical locations, generations, and artistic genres—a tribute to chorality and multiplicity—placing strong emphasis on the collective elements of women's experience, but also on the specificity of each woman's and artist's position, role, aesthetics, and contribution. In line with its political objectives, the collection does not focus on the marginalization or victimization of black women writers, but celebrates the transformations that take place through language, displacement, and rebirth. Grace Nichols, the Guyana-born British poet whom Nasta quoted in the introduction, hit the keynote for the book:

I have crossed an ocean
I have lost my tongue
From the root of the old one
A new one has sprung.[1]

[1] From Grace Nichols, "Epilogue," *Fat BlackWoman's Poems* (London: Virago, 1984).

The established scholars who contributed to the collection focused on the first female writers emerging from the postcolonial world. Their essays proved to be landmark works of contemporary criticism. The volume featured, for instance, Elleke Boehmer on Flora Nwapa; Judies Newman on Ruth Prawer Jhabvala and Anita Desai; Shirley Chew on Anita Desai and Nayantara Sahgal; Abena Busia on Mariama Bâ; Ranjana Ash on Kamala Das, Anita Desai, Shashi Deshpande and Nayantara Sahgal; and other critics exploring issues around other important writers, including Joan Riley, Bessie Head, Olive Senior, and Lorna Goodison. The collection focused on the feminist project of retrieving silenced or neglected female voices, but was not designed merely as a means to recuperate lost voices: its editor sought to add an extra intellectual dimension by focusing on the complex relationships between nation, language, and migration as contributing aspects in cultural processes of empowerment ("becoming"). It therefore stimulated not only the creation of an alternative canon of black women writers, but the formation of a more inclusive and productive cultural field in which the areas of contact, contention, and mutual inspiration could be brought to light and examined aesthetically, as *artistic* expression.

In 1992, with support from the British Council, Nasta published *An Annotated Bibliography of Novelists from Africa, the Caribbean and South Asia*. Following that undertaking, Nasta was appointed Senior Lecturer in English at Queen Mary College, University of London, beginning in the fall of 1992. (She held that position for the next seven years.) In 1992, Nasta also published *Highway in the Sun*, a second scholarly volume of Sam Selvon's (transcribed) radio plays, and she contributed an encyclopaedic article titled "Caribbean Women Writers" to *The Bloomsbury International Guide to Women's Writing*.

In the period from 1992 to 2003, Nasta published prolifically in the areas of Caribbean literature and women's writing, while teaching at Queen Mary College, University of London, and editing *Wasafiri*. She was at the same time pursuing the doctorate at the University of Kent. Much of the work she did during this period concentrated on the works of Sam Selvon, whom she knew personally and had met through her father. As she recounted in the introduction to her book *Home Truths: fictions of the South Asian Diaspora in Britain* (2002), Selvon, to support his writing, was working for a time as a clerk at the India House in London under the supervision of Susheila's father. As a civil servant there, Nasta's father happened also to be acquainted with and be surrounded at the India House by many postcolonial writers who would later be of great importance to his daughter. When Selvon died in 1994, Nasta became his literary executor, wrote his obituaries, and continued her efforts to publish his unpublished writing. In 1995, with Anna Rutherford, Nasta published *Tiger's Triumph: Celebrating Sam Selvon*, for which she wrote the introduction. She also contributed chapters to a wide variety of publications, including *Shades*

of Empire in Colonial and Postcolonial Literatures (1993), *Other Britains: Essays in Contemporary Fiction* (1995), *Images of African and Caribbean Women: Migration, Displacement, Diaspora* (1996).

In 1996, she published her important essay (and a manifesto of sorts) "*Wasafiri*: History, Politics and Post-Colonial Literature" in the collection *A Talent(ed) Digger.*[2] In 2000, she edited *Reading the 'New' Literatures in a Postcolonial Era*, wrote the introduction, and contributed a chapter titled "Stepping Out." That same year, she also contributed a chapter on new South Asian voices to *Shifting Continents/Colliding Cultures: Diaspora Writing of the Indian Subcontinent* (2000),[3] and she published her essay "Black women's writing in Britain" in the refereed scholarly journal *Women: A Cultural Review.*[4] The cumulative effect of her work during this period of her life was that she was making a strong case for the importance of a good number of early postcolonial writers who had worked under very harsh conditions and received very little recognition during their lifetimes. Through Nasta's scholarship, Sam Selvon together with V.S. Naipaul and many other postcolonial writers (including Attia Hossain, G.V. Desani, Homi Bhabha, Abdulrazak Gurnah, Rasheed Areen, George Lamming, Mulk Raj Anand, Earl Lovelace, Romesh Gunesekera, and Aubrey Menen) opened the road to new, younger talents. The writers whom Nasta publicized and the generation following them received recognition and visibility unheard of among their worthy predecessors, who were too easily relegated to oblivion in the absence of scholarly and cultural attention. Postcolonial writing benefited immensely as an area of creative ferment and as a field of scholarly study and critical activity, thanks to Nasta's important work in contributing to the institutionalization of the field of postcolonial writing (*and* to the consequent globalization of literary study, the new market operations dictated by publishers, and the newly created literary prizes).

In 2002, Nasta published her book *Home Truths: Fictions of the South Asian Diaspora in Britain*. It was the result of many years of teaching, but primarily the outcome of a postgraduate course she taught at Queen Mary College as part of its Literature, Culture and Modernity program of studies. Since 2001, Nasta had been centrally involved in the rewriting and restructuring of a new course in postcolonial literatures ("Post-Colonial Literatures in English: Readings and Interpretations"). She was also member of the faculty team responsible for teaching twentieth-century literature, and she contributed

[2] In Hena Maes-Jelinek, Gordon Collier, Geoffrey Davis, editors. *A Talent(ed) Digger* (Amsterdam: Rodopi, 1996). pp.127-134.

[3] "Homes Without Walls: New South Asian Voices in Britain" in Ralph Crane and Radhika Mohanran, editors. *Shifting Continents/Colliding Cultures: Diaspora Writing of the Indian Subcontinent* (Amsterdam: Rodopi Press2000). pp.19-34.

[4] Special issue, Helen Carr & Isobel Armstrong, editors. Vol.11, nos.11/12 (2000):71-77.

to the teaching materials for the program "Literature and Nation: Britain and India 1800-1990," a course of studies designed to encourage students to explore questions of the inter-relationship between literature, empire, nation, and national identities from the early nineteenth century to the present.

With the publication of *Home Truths*, Nasta realized her most ambitious and personal project to date. In this critical work, Nasta explored the figure of the migrant writer, placing the individual works of now world-famous figures such as V.S. Naipaul, Salman Rushdie, and Hanif Kureishi within the tradition of im/migrant writing that has evolved in various directions since the Second World War. It was her object to demonstrate that famous contemporary writers had developed on the shoulders of and next to the work of many lesser known writers—including Attia Hosain, G.V. Desani, Aubrey Menen, Sunetra Gupta, Ravinder Randhawa, and Romesh Gunesekera—who deserved as much attention as the newly established gurus of postcolonial writing. She also discussed the legacies of writers published prior to the decolonization and independence movements, for instance the influence of those first narratives by abolitionist ex-slaves (including Olaudah Equiano and Ottabah Cugoano) as well as of Asian reformers (including the radical lawyer Cornelia Sobraji, who attended university in Britain during the nineteenth century). Nasta's book incorporated discussion of the numerous and differently motivated passages to London made by Asian travellers and writers prior to the large-scale migrations following the Second World War. Nasta was particularly interested in those migrants who travelled to Britain with the object of making it their new home. She noted, too, that the reception of migrants by the "Motherland" had always been a problematic one:

> Moreover, as the example of figures such as Sake Dean Mahomet, J.M. Malabari, Cedric Dover or Aubrey Menen have already shown, the location and reception of Asian writers in Britain had always been an ambiguous one, particularly if the writers were not just representatives of the 'exotic' upper class or oriental traveler passing through, but were instead 'natives' of the country— black and Asian Englishmen and women—with leave to stay. (143)

Sketching a careful genealogy which showed the historical, cultural, and aesthetic roots of postcolonial writing prior to post-war migrations, Nasta revealed long-established indigenous traditions, whether the writers considered themselves at "home" or "abroad." By so doing, Nasta not only broke down the rigid chronological binarism of "before" and "after" empire, but also pointed out and re-addressed the complexity of the aesthetic traditions of black and Asian writing in Britain today. *Home Truths* built on and extended the work of earlier scholars, including Antoinette Burton (*At the Heart of the Empire. Indians and the Colonial Encounter in Late-Victorian Britain* [1998]) and Inderpal Grewal

(*Home and Harem. Nation, Gender, Empire, and the Cultures of Travel* [1996]). Nasta's work, however, made an intervention into the conventional grand narrative of European modernity as something that pertains to the European metropolis. Drawing on the work of her friend and colleague Paul Gilroy (*Black Atlantic* [1993]) and other *Wasafiri* authors, Nasta demonstrated that modernity is not a prerogative of the centre, but part of a wider, shared experience that also happened elsewhere and even managed to challenge, disrupt, and contest European notions of modernity and its aesthetic avant-garde. *Home Truths* brought into question the received notion of a unitary home, along with the interrogation of all "certainties" about belonging, identity, and artistic canonization. What the South Asian literature of the diaspora showed more than any other set of contemporary writing, Nasta argued, was the constant process of transformation and cultural borrowing brought about through layers of migration that have shaped the project of modernity beyond any simple binary notions of home and abroad, mainstream and marginal, or modern and postcolonial. The central focus in twentieth-century literature on the migrant condition (and the way it has been inhabited, narrated, and exploited by numerous writers of the South Asian diaspora) bears testimony to the slippery and rather provisional meaning of the term *diaspora* as a trope for displacement and hybridization. It also suggests a need to qualify the meaning of diaspora by taking into account the material conditions that account for gender, generational, linguistic, and national shifts. If according to Rushdie the "past is a country from which we have all emigrated," the perspective of the migrant writer is heightened by being "out-of the country" and at times "out-of language" (*Home Truths*, 138). The diasporean condition thus involves inevitable transformations and rebirths, renewals and metamorphoses at both physical as well as metaphysical levels.

Nasta is careful enough to account for the shift in terminology from *immigrant* to *migrant*, a shift that has taken place as she claims between Sam Selvon's Black Londoners and Rushdie's transmogrification of the selves in the *Satanic Verses*, a shift that marks the limited space allowed for the reflection concerning the formation of postmodern and postcolonial identities. However, the classifying effects of critical terminologies is not neutral, nor is the interrelationship between the various namings a simple one. The migrant aesthetics of Rushdie is close to the language of Western modernism and post-structuralism. In this case modernity is described as a European or metropolitan experience that fails to account for the operations and consequences of colonialism on the notion of "migration" itself—and is very different from Sam Selvon's attempt at giving voice to the ordinary, black, and unlettered im/migrants. Rushdie's *Satanic Verses*, for example, not only celebrates a sense of migrant hybridity, but also, "through the very attempt to forge new

relationships between previously incompatible positionings and epistemologies, leads [...] to a simultaneous eruption of the repressed dynamics of national 'purities' and 'tradition' voiced through both the 'Black Maria' witch hunters of 'Maggie Torture's' Britain and the potentially essentialist religious narratives of the diaspora itself" (p. 161).

In 2003, Nasta was awarded her D.Litt. degree in English and Postcolonial Literatures from Kent University. In that year, she widened her interest in world literatures and began setting up links between Professor Beate Neumier of the University of Koln and Professor Bryan Cheyette of the University of Southampton to develop an inter-university research project on Jewish/postcolonial/migrant writing in Europe. She was motivated by her interest in writings from the margins and by what she saw as a need to create intellectual alliances in order to test how cultural peripheries communicate and create exchanges with each other, by pointing out their communalities as well as their radical differences. As a team member, she helped design a new creative writing course for the Open University that centres on multiple genres, including autobiography/life-writing. Since 2003, as a trustee for SALIDAA (South Asian Diaspora Literature and Arts Archive), Nasta was involved in major fund-raising for the first South Asian Literature and Arts Archive in Britain and has procured significant funding from the Millennium Lottery Fund to create an interdisciplinary digital archive of South Asian Arts in Britain from 1945 to the present. Along with these activities, Nasta has dedicated time as a member of the executive committee of the Commonwealth Writers Prize and to her role as a judge of a number of other literary prizes. She has served as advisory editor on the boards of several journals, including *Moving Worlds: Journal of Transnational Literatures*, *Atlantis*, and of the *Journal of West Indian Literature*, University of the West Indies. The most important contribution that Nasta has made to both academic and creative circles has been her editorship of *Wasafiri, The International Magazine of Contemporary Writing*.

In 2004, *Wasafiri* celebrated its first twenty years of stimulating issues. To mark the occasion, Nasta edited *Writing across Worlds: Contemporary Writers Talk* (2004). She wrote the introduction and included interviews with many creative writers who had been published in the magazine since its inception, including Sam Selvon, Wole Soyinka, Chinua Achebe, Jamaica Kincaid, V. S. Naipaul, Caryl Phillips, Salman Rushdie, George Lamming, Micheal Ondaatje and more; the interviewers were themselves established critics and writers: Aamer Hussein, Alastair Niven, Maya Jaggi, Caryl Phillips, Harish Trivedi, Robert Fraser, Susheila Nasta herself, and others.

In the introduction to the twentieth-anniversary issue of *Wasafiri* (No.42, Summer 2004), Nasta wrote that the magazine had focused, since its inception, on the figure of the writer as a cultural traveller, moving

words/worlds across cultures and transporting the imagination beyond the maps of narrowly defined borders. The name of the magazine, she explained, derived from the word for *traveller* in the East African language Kiswahili. As a hybrid offshoot itself from the Arabic *safari*, the name was chosen to draw attention to the way in which writing has always been a form of cultural travelling, a means of transporting words into other worlds, of making crossings and forging connections between apparently conflicting cultures (5-6).

Wasafiri has become a highly valued magazine concerned with the publication of critical articles, essays, reviews and contemporary writing in the postcolonial field. It is the particular combination of accessible theoretical discussions combined with original and cutting-edge new creative writing that makes the magazine stand out from others. As Nasta further highlighted, in the introduction to *Writing across Worlds*:

> Since it was founded in 1984 in Britain, *Wasafiri* has given particular prominence to the work of writers whose literary and historical preoccupations do not necessarily fit within the confining national rubrics of any particular movement, tradition or culture, and whose perspectives have been cross-cultural. As one of the few publications to have provided sustained and serious exposure to several generations of African, Caribbean, South Asian and black British writers in Britain, it has not only charted an important cultural and literary history but has also effected curriculum change, signposting new waves and connections in the related literary community world-wide. (6)

The magazine, for many years based at Queen Mary College, moved to the Open University in 2005. It grew from two issues per year in 1984 to a glossy quarterly in 2006, published and distributed by Routledge (Taylor & Francis), but it still focuses primarily on creative and critical writing from Britain and the black and Asian diasporas. The magazine stands out also for its sumptuous and beautifully styled layout and its covers, which testify to the role that artists operating in visual culture, cinema, and photography play in the making of the new British culture. Its special issues have become collectors' items—for instance, Black Writing in Britain, Lusophone Writing, Women's Writing, Migrant Writing in Europe, South African Writing, Mauritian Writing in English, Pacific Writing, Traveller's Tales, the South Asian Diaspora, Frantz Fanon, Global Cinema, Gay and Lesbian Writing. In 2006, Nasta was planning special issues on Arab Literatures, Postcolonial Life-Writing, and Writing in China. *Wasafiri* has sustained a constant campaign against those elements in the mainstream literary establishment who label publications with names like *Wasafiri* unimportant because they assume the producers and readers are more interested in issues of race and culture than in literary aesthetics. Although the opposition to *Wasafiri* is losing the contest, as more and more mainstream support and recognition is bestowed on the magazine, it is important to

remember that the new wave in contemporary world literature is not a presence to be taken for granted in the British cultural arena. Nasta and her magazine are increasingly seen as necessary to the cultural health of the nation.

Nasta's life-long commitment to the arts and education has indeed contributed to changes on the contemporary British literary landscape. She has already been credited with an enormous achievement—by effectively and intelligently putting questions of diaspora, race, and class on the cultural and political agendas of Britain and beyond. Characterized by a crystal clear literary style that never indulges in easy jargon and empty theoretical virtuosity, her writing promises to make a durable contribution to the world's understanding of aesthetics in the twenty-first century.

Books Authored

Nasta, Susheila. *An Annotated Bibliography of Novelists from Africa, the Caribbean and South Asia,* British Council Publications, 1992.

—. *Home Truths: Fictions of the South Asian Diaspora in Britain.*Basingstoke, Palgrave, 2002.

—. *Jamaica Kincaid: Writing a Life.* Northcote, British Council Writers and Their Work Series, forthcoming 2007.

Books Edited

Nasta, Susheila. *Critical Perspectives on Sam Selvon* (and introduction). Washington, D.C.: Three Continents Press, 1988. Rpt. by Lynne Reiner Publications, USA, 1995.

—. *El Dorado West One by Sam Selvon.* Peepal Tree Press, Leeds, 1988. 156pp. Transcribed edition of radio plays with notes.

Nasta, Susheila and Kenneth Ramchand. *Foreday Morning: Sam Selvon's Prose 1945-89.* Longman, 1989. 321pp. Reprinted 1992.

Nasta, Susheila. *Motherlands: Black Women's Writing from the Caribbean, Africa and South Asia* (and introductory essay). Women's Press, 1991; Rpt. by Rutgers University Press, 1992. Shortlisted for Fawcett Society Prize, 1991.

Nasta, Susheila and Anna Rutherford. *Tiger's Triumph: Celebrating Sam Selvon.* Dangaroo Press, 1995.

Nasta, Susheila. *Reading the "New" Literatures in a Postcolonial Era* (and introduction). Cambridge: Boydell & Brewer, 2000.

—. *Writing across Worlds: Contemporary Writers Talk* (and introduction). London: Routledge, 2004.

—. *Making Tracks*: *Wasafiri 1984-2004* (and introduction). London: Wasafiri, 2004.

CONTRIBUTORS

DIRAN ADEBAYO has been hailed as one of the most original young literary talents around. His first book, the acclaimed *Some Kind of Black*, a 1990s coming of age story, broke new ground for the London novel, was longlisted for the Booker Prize and won him the Saga Prize, a Betty Trask Award, the Authors' Club's "Best First Novel" Award, and the Writers Guild's "New Writer of the Year Award" for 1996. His next novel, *My Once Upon A Time*, which continues his chronicling of black British life, has also received rave reviews. It has been called "an exhilarating, magical fairytale for our times" and a novel that "turns the private eye genre on its head." Adebayo has also written stories for BBC TV and radio, has been a columnist for *New Nation* newspaper, and writes frequently on social and cultural issues for national newspapers ranging from *The Guardian* to *The Daily Mail*. In 2003, he co-edited *New Writing 12* (Picador), an anthology that showcases new U.K. and Commonwealth writing. He is currently writing his third novel *The Ballad of Dizzy and Miss P* and a book of essays, *Here is a Protest*. He is a member of the national Council of the Arts Council of England. Of Nigerian parentage, Adebayo grew up and lives in London. He studied law at Oxford University. dizzy@diran.freeserve.co.uk / O.Adebayo@soton.ac.uk

R. VICTORIA ARANA is Professor of English at Howard University, where she teaches British literature, research methods, literary criticism/theory, and travel writing. With Lauri Ramey, she co-edited *Black British Writing* (Palgrave Macmillan 2004); she has published essays on "black" British writers in *Write Black, Write British* (2005, K. Sesay, ed.) and elsewhere. She has edited *Contemporary "Black" British Writers* for the *Dictionary of Literary Biography* series and the *Companion to Twentieth-Century World Poetry* (NY: Facts on File, in press). rvarana@archeform.com

KEVIN ETIENNE-CUMMINGS is a doctoral student of History at the University of Michigan at Ann Arbor (U.S.A.). He has contributed reviews and personal essays to *SABLE Literary Magazine* and written on contemporary Afro-Caribbean philosophy for *Humanitas*, the Journal of the George Bell Institute. His current interests are black philosophies of existence and their relationship to PanAfricanism in the southeast islands of Africa, particularly the Seychelles, his birthplace. ketiennec2@hotmail.com

GEORGE KELLY FOWOKAN is a British artist and educator working in the diasporan tradition. Born in Jamaica of African descent, he moved with his family to Brixton (London) and has lived since childhood in England. He has travelled widely in the Far East, Europe, America, and Africa. It was in Nigeria that he reconnected with the traditions of African representation in the great historic centre of Yoruba culture: the City of Benin. Stuart Hall said, "We can see in this itinerary, not the simplicity of a return to a lost origin, but the more complicated story of all of those who have lived the 'diaspora' experience—who are children of the 'scattering' which slavery, colonialism and the Middle Passage of slavery represented. We see the trace of the slow, painful struggle to connect together again the fragments of a broken and fractured history, and not simply to return to that image and history as if nothing had happened, but to put the parts together again for the future across a disrupted and splintered past." In 1994, the Jamaican High Commission in London hosted an exhibition of his sculptures entitled "Beyond My Grandfathers' Dreams." He is a member of the Society of Portrait Sculptors, U.K., and has been selected for Royal Academy of the Arts exhibitions on several occasions. He sculpted—among many other extraordinary works around the world—the monumental, thirteen-foot-high obelisk of masks representing the multi-cultural peoples of south London, a work in honor of Prominent Black Achievers. fowokan@hotmail.com

ANTHONY JOSEPH is a poet, musician, and lecturer. He was born in Trinidad and moved to the U.K. in 1989. He is the author of two poetry collections: *Desafinado* (1994) and *teragaton* (1997). In 2004, he was selected by the Arts Council of England for the historic "Great Day" photo as one of fifty Black and Asian writers who have made major contributions to contemporary British literature. In 2005, he was the British Council's first Poet-in-Residence, at California State University, Los Angeles. As a spoken-word artist, he has performed internationally, including at The Chicago Humanities Festival, Festa Internacional de la Literatura, Barcelona, Spain; UCLA; Howard University, Washington, D.C.' and London's Queen Elizabeth Hall. He has taught creative writing at London Metropolitan University, University of Surrey, Roehampton; currently he lectures at South Thames College, London. His latest book is *The African Origins of UFOs* (Salt Publishing, 2006). mail@anthonyjoseph.co.uk / www.anthonyjoseph.co.uk

ROSHINI KEMPADOO is a practitioner and lecturer in Media Production. She has exhibited nationally and internationally. Her solo retrospective show *Roshini Kempadoo work: 1990 – 2004* was recently exhibited at the Russell-Cotes Gallery, Bournemouth, U.K., having completed a tour in the U.K. Group shows include *A Place Called Home*, South Africa Art Gallery (SANG), Cape Town;

and *Techno Seduction*, Cooper Union Art Gallery, New York. Publications include *Roshini Kempadoo Work 1990 – 2004*, OVA (2004) and *Roshini Kempadoo – Autograph portfolio* (1997). Kempadoo has presented her work and lectured at numerous events, including *Black Diaspora Artists, Past and Present* at Conway Hall, London; *Visual Culture Colloquium*, at Cornell University, U.S.A. She lectures at the University of East London. Currently completing a Ph.D. at the Fine Arts Department, Goldsmiths College, London, Roshini Kempadoo has been affiliated with the Format Partners Library in London and Napier University in Edinburgh, Scotland. r.kempadoo@btinternet.com

VALERIE KANEKO LUCAS is Assistant Professor and Director of Outreach and Engagement in the Department of Theatre, College of the Arts, at the Ohio State University—Columbus. She has published articles on the reception of East Asian theatre and identity formation in Black British, British Asian, and Asian American performance. Her current research interests are in the areas of hybridity, contemporary British theatre, British Asian and Black British writers from the post-Empire Diaspora, and a comparative study of British Asian and Asian American theatres. She is engaged in archival work at the Theatre Museum London documenting the work of Tara Arts, a pioneer in British Asian theatre. lucas.219@osu.edu

MAGDALENA MACZYNSKA is an Assistant Professor of English and the Writing Seminar Program Director at Marymount Manhattan College in New York City. Her scholarly interests include contemporary fiction, the history of the novel, and urban studies. She has published articles on the work of Martin Amis, Ian McEwan, and David Lodge, and has recently defended a dissertation on visionary satire in the contemporary London novel. Her new project is a study of post-secular urban writing. mmaczynska@mmm.edu

SHEREE MACK graduated with an M.A. in Creative Writing from Northumbria University in 2003 and has started her doctoral study at Newcastle University, researching Black British women poets as well as producing her own poetry. She has been a secondary school teacher and is now a freelance writer. She is the creator and coordinator of *identity on tyne*, the only group in the North East providing a space exclusively for writers of colour. She has presented papers at various universities in Britain and has had her work published in creative and academic journals and anthologies. Sheree.Mack@newcastle.ac.uk

AMNA MALIK is a Lecturer in Art History and Theory at the Slade School of Fine Art, UCL, London. Her doctoral research at the University of Essex was on

surrealism and psychoanalysis; she has extended this interest to diaspora-based artistic practices and the relationship between art, identity politics, and psychoanalysis. In 2004, she organized an international conference on the subject in collaboration with the Freud Museum: *Art, Identity and the Unconscious in the Age of Trans-Nationalism* brought together artists, theorists, and psychoanalysts. She has published articles on Shirin Neshat, Steve McQueen, and Lorna Simpson and written monographs on Alia Syed and Rosalind Nashashibi for Lux. Her recent publications include "Alina Szapocznikow's Abject Objects" in *Stilled: Contemporary Still-life Photography by Women,* edited by Christine Rolphe and Kate Newton, published by IRIS and Ffotogallery in December 2005; & *Abbas Kiarostami's Romantic Conceptualism?* 'Portfolio' April 2004. Forthcoming publications include "Isaac Julien's Black Atlantic: A Reconsideration of 'Looking for Langston' 1989, Through Locational Identity" in *Art History* 2007; "Under the Eyes of Colossus: Zadoc Nava's 'Shadowlands'" in *Portfolio* June 2006; "Kara Walker's black marks, white walls" in *Shame and Sexuality, Psychoanalysis and Visual Culture*, edited by Ivan Ward and Claire Pajaczkowska, to be published by the Freud Museum and Middlesex University, 2007. She was a panel member for the Jerwood Photography Prize in 2004 and is a regular contributor to *Portfolio* and *Art Monthly*. She has been invited to present papers on her research at the British Museum, TrAIN Research Centre at Chelsea College of Art, and Oxford Brookes. She is currently preparing a book on the subject of diaspora-based art practices, cultural politics, and psychoanalysis. amnamalik@mac.com

VALERIE MASON-JOHN (AKA QUEENIE) has a Master's in Creative Writing, Education and the Arts. She is a playwright and the author of the only non-fiction books that document the lives of African and Asian lesbians in Britain: *Making Black Waves* and *Talking Black*. She has published a collection of poetry, plays, and prose: *Brown Girl in the Ring.* Her debut novel *Borrowed Body* (2005) was highly praised and called the British *Color Purple*. She won the Windrush (Arts and Community Pioneer) Achievement Award in 2000. In addition to writing, she works as a trainer in anger management. Her most recent book which explores this theme, *Detox Your Heart* (2006), has won wide acclaim. www.valeriemason-john.co.uk / valerie.masonjohn@gmail.com

COURTNEY J. MARTIN is a doctoral candidate in the History of Art department at Yale University. In 2004, she curated an exhibition of artists' books, *The C Series*, which traveled to the Nathan Cummings Foundation in New York and the Baltic Centre for Contemporary Art in Gateshead, England. Her recent publications include "Post-Post Black: Senam Okudzeto in Basel" in *NKA:*

Journal of Contemporary African Art and "Sight Was Regulated, Shapes Were Continually Re-fashioned: Alia Syed's *Eating Grass*" for the catalog of the 2006 Biennale of Sydney. Prior to entering Yale, she worked in the Media, Arts, and Culture unit of the Ford Foundation in New York City. courtney.martin@yale.edu

MICHAEL MCMILLAN is a writer, playwright, curator, and academic of Vincentian parentage. His plays and performance pieces have been produced and published extensively. He has edited several books, and his essays have appeared in numerous publications, journals, and magazines, both nationally and internationally. He is a Visiting Professor of Creative Writing (London College of Communication–University of the Arts) and doing an M.Phil./Ph.D. at Middlesex University, where he is affiliated as a Research Student/Tutor. He recently curated the very successful *The 'West Indian' front room: Memories and Impressions of Black British Homes*, (The Geffrye Museum October 2005-Feb 2006). m.mcmillan62@btinternet.com

KOBENA MERCER is Reader in Diaspora Studies in the Department of Visual Culture and Media at Middlesex University London—and an inaugural recipient of the 2006 Clark Prize for Excellence in Arts Writing. He has taught at New York University and the University of California at Santa Cruz and received fellowships from Cornell University and the New School University in New York. His first book, *Welcome to the Jungle* (1994), opened new lines of enquiry in art, film, and photography, and his writings feature in several landmark anthologies, including *Out There* (1990), *Cultural Studies* (1992), *Art and Its Histories* (1998) and *Theorizing Diaspora* (2003). He has published monographs on James Van Der Zee, Adrian Piper, Isaac Julien, Rotimi Fani-Kayode, and Keith Piper; and he is editor of *Cosmopolitan Modernisms* (2005) and *Discrepant Abstraction* (2006), in the Annotating Art's Histories series on cross-cultural perspectives in 20th century art co-published by InIVA and MIT. mercerk@clara.co.uk

JUDE CHUDI OKPALA is a theorist and Associate Professor of English Language and Literature at Howard Community College; he also teaches philosophy and English at Howard University. Among his publications are two novels, *The Visible Man* (1995) and *The Uncircumcised* (2006); he has also published scholarly papers on Chinua Achebe, Chris Abani, and Ben Okri in *Callaloo*, *BMa: The Sonia Sanchez Literary Review* and elsewhere. Currently, he is working on Nigerian diasporic writers. jokpala@howardcc.edu

DEIRDRE OSBORNE, Ph.D., lectures in drama at Goldsmiths College, University of London. Her research in Victorian literature focuses upon motherhood, colonial ideology, and nation building. She has published essays on black British dramatists, including Roy Williams, Kwame Kwei-Armah, Dona Daley, and Debbie Tucker Green. Forthcoming is an essay on women spies in occupied France (1942-45) and a monograph, *Inheritors of the Diaspora: Contemporary Black British Poetry, Prose and Drama*. drs01do@gold.ac.uk

KOYE OYEDEJI is a research Ph.D. student in Literatures of the Nigerian Diaspora at the School of Oriental & African Studies (London, U.K.). He has contributed to a number of publications including *New Nation* and the *Nottingham Evening Post*. His short stories, poetry, and essays have appeared in *IC3: The Penguin Book of New Black Writing in Britain* (Penguin 2000), *The Fire People* (Payback Press 1998) and *Write Black, Write British* (Hansib 2005). He a contributing editor for *SABLE LitMag*. koyeoyedeji@gmail.com

MEENAKSHI PONNUSWAMI is Associate Professor of English at Bucknell University, where she teaches dramatic literature and theatre history. Her current research interests have been in black and Asian theatre in Britain. Her essay on British Asian playwrights appeared recently in *Feminist Futures?* (Palgrave Macmillan, 2006), a collection of scholarly essays on feminist theatre. Her essay "'Small Island People,'" published in *A Cambridge Companion to British Women Playwrights* (Cambridge UP: 2000), is a study of nostalgia and identity in several plays by black British women and includes a brief history of postwar black British theatre. She is currently working on Winsome Pinnock's writing of history. mponnus@bucknell.edu

SANDRA PONZANESI is Assistant Professor of gender and postcolonial critique at Utrecht University (The Netherlands), Institute of Media & Re/presentation. She has been visiting professor at the University of California, Los Angeles; and visiting scholar at the University of California, Riverside. Her recent research interests concern the reception of postcolonial literature in relation to the literary award industry and the exploration of digital literacies of migrant youth in transnational contexts. She has published on post-colonial critique, transnational gender theories, Italian colonial history, visual culture and Third World cinema. Among her publications are *Paradoxes of Post-colonial Culture: Contemporary Women Writing of the Indian and Afro-Italian Diaspora* (Albany: SUNY Press, 2004) and *Migrant Cartographies New Cultural and Literary Spaces in Post-colonial Europe* (Lanham, MD: Lexington Books, 2005) with Daniela Merolla. Sandra.Ponzanesi@let.uu.nl

LAURI RAMEY is Director of the Center for Contemporary Poetry and Poetics at California State University, Los Angeles. Her publications include *Black British Writing* (with R. Victoria Arana), *Every Goodbye Ain't Gone: An Anthology of Innovative Poetry by African Americans* (with Aldon Lynn Nielsen), *The Heritage Series of Black Poetry, 1962-1975: A Research Compendium* (in consultation with Paul Breman), *What I Say: Innovative Poetry by Black Writers in America* (with Aldon Lynn Nielsen) and *Slave Songs and the Birth of African American Poetry*. Her recent fellowships include a Huntington Library Research Fellowship (2006) and Joseph A. Bailey II, M.D. Fellowship in the African American Experience (2005). LRamey@calstatela.edu

ROY SOMMER is Professor of English at Wuppertal University (Germany). His publications include a monograph on the Black British novel (*Fictions of Migration. Ein Beitrag zu Theorie und Gattungstypologie des zeitgenössischen interkulturellen Romans in Großbritannien.* Trier: WVT, 2001) as well as several articles on the subject (most of them in German), including "'Simple Survival' in 'Happy Multicultural Land'? Diasporic Identities and Cultural Hybridity in the Contemporary British Novel" in *Diaspora and Multiculturalism: Common Traditions and New Developments.* Monika Fluderni,editor(Amsterdam/New York: Rodopi, 2003; pp. 149-181). rsommer@uni-wuppertal.de

SUANDI is of Nigerian and Liverpool British heritage. A performance poet with three collections of poetry and the critically acclaimed theatre piece *The Story of M* to her credit, she tours nationally and internationally. She has received numerous recognitions and awards, including a NESTA Fellowship, The Big Issue Community Diploma, The Windrush Inspirational Award, a Winston Churchill Fellowship, and an the O.B.E. in the Queen's 1999 New Year Honours List. She has also written two librettos: *The Calling* (BBC Philharmonic 2005) and *Mary Seacole: Opera* (2000). suandi@blackartists.org.uk

ANDRENE M. TAYLOR is a Ph.D. student in English at Howard University. She has presented papers on Gayl Jones at several scholarly conferences. Her areas of specialization are literary criticism and African American, Caribbean, and British literatures. andrenemtaylor3@yahoo.com

SAMERA OWUSU TUTU is a London-based journalist. She has contributed to a number of women's magazines and music publications, including *Straight No Chaser* world music magazine. In 2005, she founded *Junxion.co.uk*, an online magazine and marketplace dedicated to providing a forum for London's Black

progressive creative scene and its independent creatives of African origin. samera.owusututu@gmail.com

TRACEY L. WALTERS is Assistant Professor of Literature at Stony Brook University in the Departments of Africana Studies and English. She has published a number of articles on black British literature, including: "A Black Briton's View of Black British Literature and Scholarship," and "'We're All English Now Mate Like It or Lump It': Zadie Smith's *White Teeth* and the Question of Black/British Fiction." She is currently editing a collection of essays on Zadie Smith and is completing *Writing the Classics Black: Political and Poetic Function of Classical Revision*, an examination of ways black women appropriate classical Greek mythology. walterstracey@hotmail.com

BIBLIOGRAPHY

Background, History, & Criticism

Agamben, Giorgio. *The Man Without Content*. Stanford: Stanford UP, 1999. Original in Italian as *L'uomo senza contenuto*. Quodlibet, 1994.

Arana, R. Victoria, and Lauri Ramey, editors. *Black British Writing*. Palgrave Macmillan, 2004. This collection of essays provides an imaginative international perspective on ways to incorporate black British writing and culture in the study of English literature, and presents theoretically sophisticated and practical strategies for doing so. It offers a pedagogical, pragmatic, and ideological introduction to the field for those without background, and an integrated body of current and stimulating essays for those who are already knowledgeable. 192 pages. ISBN 1403965552

Arana, R. Victoria. "The 1980s: Retheorizing & Refashioning British Identity." In *Write Black, Write British*. London: Hansib, 2005. 230-240.

—. ed. "Introduction." *Contemporary "Black" British Writers/Dictionary of Literary Biography*. Sumter, SC: Bruccoli, Layman, Clark; & Detroit: Gale Research Co., forthcoming.

Armstrong, Isobel. *The Radical Aesthetic*. Oxford: Blackwell Publishers, 2000.

Ashcroft, Bill, Griffiths, Gareth and Tiffin, Helen. *Key Concepts in Post-Colonial Studies*. London: Routledge, 1998.

Baker, Jr., Houston A., Manthia Diawara, and Ruth Lindenborg, eds. *Black Cultural Studies: A Reader*. Chicago and London: University of Chicago Press, 1996.

Bailey, David, Ian Baucom, and Sonia Boyce, editors. *Shades of Black: Assembling Black Arts in 1980s Britain*. Duke University Press, 2005.

Ball, John Clement. *Imagining London: Postcolonial Fiction and the Transnational Metropolis*. University of Toronto Press, 2004. Comparable to John McLeod's book (listed here);on the same topic and published in the same year.

Carroll, Noël. *Beyond Aesthetics: Philosophic Essays*. Cambridge U P, 2001.

Centre for Contemporary Cultural Studies. *The Empire Strikes Back: Race and Racism in 70s Britain*. London: Hutchinson Publishing, 1982. [Stuart Hall, editor.]

Dabydeen, David, and Nana Wilson-Tagoe. *Reader's Guide to West Indian and Black British Literature*. London: Hansib, 1997. Still a good resource on links between Caribbean and black British writing.

Donnell, Alison, editor. *Companion to Contemporary Black British Culture*. Routledge, 2002. This is the first comprehensive reference book to provide multidisciplinary coverage of the field of black cultural production in Britain. The book covers works by people and institutions with roots in African, Caribbean, and South Asian ethnicities while at the same time addressing the debates concerning notions of black Britishness and cultural identity. The format is encyclopedic and covers cultural production since 1970 in writing, music, visual and plastic arts, performance works, film and cinema, fashion and design, and intellectual life. The volume features an index, cross-referencing, and a thematic entry list. Entries include bibliographies. 356 pages. ISBN 0415169895 (Still indispensable as a research resource.)

Elliott, Emory, Louis Freitas Caton, & Jeffrey Rhyne, eds. *Aesthetics in a Multicultural Age*. Oxford: Oxford University Press, 2002.

Farrell, Laurie Ann, editor. *Looking Both Ways: Art of the Contemporary African Diaspora*. Ghent: Snoeck Publishers, 2004. This book considers the work of artists from North, South, East, and West Africa who live and work in Western countries, including Belgium, France, Germany, the Netherlands, Portugal, the United Kingdom, and the United States. As its title indicates, *Looking Both Ways* refers to the artists' practice of looking at the psychic terrain between Africa and the West, a terrain of shifting physical contexts, aesthetic ambitions, and expressions. It examines the relationship between physical contexts, emotional geographies, ambition, and freedom of expression while focusing on the increasing globalization of the African Diaspora. *Looking Both Ways* is not a survey, but rather an intimate consideration of the work of twelve artists: Fernando Alvim, Ghada Amer, Oladélé Bamgboyé, Allan deSouza, Kendell Geers, Moshekwa Langa, Hassan Musa, N'Dilo Mutima, Wangechi Mutu, Ingrid Mwangi, Zineb Sedira, and Yinka Shonibare. Essays by Okwui Enwezor, Laurie Ann Farrell, José António B. Fernandes Dias, Laurie Firstenberg, Steven Nelson, Salah Hassan and John Peffer. 184 pages / 182 color. ISBN 905349443X

Griffin, Gabriele. *Contemporary Black and Asian Women Playwrights in Britain*. Cambridge University Press, 2003. This volume analyzes concerns such as reverse migration (in the form of tourism), sexploitation, arranged marriages, the racialization of sexuality, and

asylum seeking as they emerge in the plays. It argues that Black and
Asian women playwrights have become constitutive subjects of British
theater. The focus is on plays by Tanika Gupta, Winsome Pinnock,
Amrit Wilson, and others. 302 pages. ISBN 0521817250

Himid, Lubaina. "Mapping: A Decade of Black Women Artists, 1980-1990." In
Passion: Discourses on Blackwomen's Creativity. Urban Fox Press,
1990.

Innes, C. L. *A History of Black and Asian Writing in Britain: 1700-2000*.
Cambridge UP, 2002.

Kay, Jackie, and Dorothea Smartt. "Jackie of All Trades, Mistress of Many:
Interview." *Sable: The LitMag for New Writing*, Issue 9 (Autumn
2006): 5-18.

King, Bruce. *The Internationalization of English Literature. The Oxford English
Literary History, Volume 13 (1948-2000)*. Oxford: Oxford UP, 2004.
Controversial thesis, but good overview.

Low, Gail, and Marion Wynne-Davies, eds.. A Black British Canon? NY:
Palgrave Macmillan, 2006.

Madureira, Luís. *Cannibal Modernities: Postcoloniality and the Avant-garde in
Caribbean and Brazilian Literature*. Charlottesvill: U of Virginia P,
2005.

McLeod, John. *Postcolonial London: Rewriting the Metropolis*. London:
Routledge, 2004. This book explores the imaginative transformation of
London by African, Asian, Caribbean and South Pacific writers from
the 1950s to the late twentieth century. Engaging with a range of
writers from Sam Selvon and Doris Lessing to Hanif Kureishi and Fred
D'Aguiar, John McLeod examines a cultural history of resistance to the
prejudice and racism that have at least in part characterized the
postcolonial city. This resistance, he argues, bears witness to the
determination, imagination and creativity of London's migrants and
their descendants. McLeod's study provides historical background on
this older group of writers, for those interested in British or
postcolonial literature or in theorizations of the city and metropolitan
culture. 224 pages ISBN 0415344603

Mercer, Kobena. *Welcome to the Jungle: New Positions in Black Cultural
Studies*. Routledge, 1994. "A passionate and detailed history of the
New Black British Cultural Studies by one of the major players in its
making. In its attention to 'the formal and strategic aesthetics of
hybridity,' and to the differences and alliances between Black US and
Black British, this book is indeed 'intranational and outernational.'"
Gayatri Chakravorty Spivak. 352 pages. ISBN 0415906350

Mullard, Chris. *Black Britain*. London: George Allen and Unwin Ltd., 1973.

Newland, Courttia and Kadija Sesay, eds. *IC3: the Penguin Book of New Black Writing in Britain.* London: Hamish Hamilton, 2000. Anthology. Contains poetry, fiction, essays.

Okpewho, Isidore, Carol Boyce Davies, and Ali Mazrui, editors. *The African Diaspora: African Origins and New World Identities.* Indiana University Press, 2001. These essays contribute to the debate between those who believe that the African origin of blacks in Western society is central to their identity and outlook and those who deny that proposition. The contributors ponder the key questions underlying that controversy. Their 33 essays are divided into five main parts: The Diaspora: Orientation and Determinations; Addressing the Constraints; Race, Gender, and Image; Creativity, Spirituality, and Identity; and Reconnecting with Africa. 899 pages. ISBN 0253214947

Owusu, Kwesi. *Black British Culture and Society: A Text-Reader.* Routledge, 2000. From the Windrush immigration of the 1950s to contemporary multicultural Britain, *Black British Culture and Society* examines the postwar Afro-Caribbean diaspora, tracing the transformations of Black culture as it establishes itself in British society. Combining classic texts on Black British life with eighteen new articles, Kwesi Owusu's collection represents the rich diversity of the Black British experience. Contributors explore key facets of Black experience, charting Black Britons' struggles to carve out their own identity and status in an often hostile society. From performance poetry and the politics of Black hairstyles to problems of health and economics, these articles embrace a range of issues and themes such as popular culture sport, religion, education, carnival, community and race relations, and examine the tense relationship between successful Black public figures and the media. Featuring interviews with noted Black artists and writers such as Caryl Phillips, and including articles from key contemporary thinkers, *Black British Culture and Society* explores the Black community's distinctive contribution to cultural life in Britain today. 576 pages. ISBN 0415178460

Phillips, Caryl. *A New World Order: Essays.* (Cultural critique) New York: Vintage International, 2002.

Phillips, Mike and Trevor Phillips. *Windrush: The Irresistable Rise of Multi-Racial Britain.* London: Harper Collins, 1998.

Procter, James. *Dwelling Places: Postwar Black British Writing.* Manchester UP, 2003. Good background.

Ramey, L., editor; & R. Victoria Arana, associate editor. *Sea Change: Black British Writing,* a special issue of *BMa: The Sonia Sanchez Literary Review* 6:2 (Philadelphia: Drexel University, Spring 2001).

Sampson, Anthony. *The Changing Anatomy of Britain*. New York: Random House, 1982.
Sesay, Kadija, ed. *Write Black, Write British: From Post Colonial to Black British Literature*. Hansib, 2005. This book offers critical essays that examine contemporary black British literature by new black writers born in Britain and writing about Britain from a black British perspective. Various essays explore how the themes of alienation, belonging, gender politics, identity, language, madness, and race take on very different spins from those of the earlier, postcolonial generation. Writers featured in this collection are Diran Adebayo, Patience Agbaby, Bernardine Evaristo, Jackie Kay, Andrea Levy, Courttia Newland, Leone Ross, Dorothea Smartt, Zadie Smith, and Benjamin Zephaniah. 384 pages. ISBN 1870518063
Spencer, Ian. *British Immigration Policy since 1939: The Making of Multi-Racial Britain*. London: Routledge, 1997.
Stein, Mark. *Black British Literature: Novels of Transformation*. Ohio State University Press, 2004. This book concentrates on works of the *Bildunsroman* subgenre, including those by Caryl Phillips, Salman Rushdie, Hanif Kureishi, and others. Stein argues that a postcolonial and interdisciplinary analytical method must be used to understand these products of the African, Caribbean, and South Asian diaspora. ISBN 0814251331
Sulter, Maud, editor. *Passion: Discourses on Blackwomen's Creativity*. West Yorkshire: Urban Fox Press, 1990. This is an eclectic volume comprising historical timelines, essays, news pieces, photography, installations, essays on film, poetry, interviews, and a collection of rare published reviews of women's art exhibitions. The volume provides a wide angle on black women artists and their creative projects in Britain. There is a collective effort in this publication to redraw the map of black aesthetics to include nontraditional women's works and perspectives.
Walder, Dennis. *Post-Colonial Literatures in English: History, Langauge, Theory*. Oxford: Blackwell, 1998.
Wambu, Onyekachi. *Empire Windrush: Fifty Years of Writing about Black Britain*. London: Phoenix, 1998.
Williams, Raymond. *Culture and Society: 1780-1950*. London: Chatto and Windus, 1958.
—. *The Sociology of Culture*. Chicago: University of Chicago Press, 1981.
Wright, Michelle M. *Becoming Black: Creating Identity in the African Diaspora*. Duke University Press, 2004. This book engages a history and analysis of black subjectivity throughout the African diaspora. The

author compares black writers and thinkers from the US, the Caribbean, Africa, France, Great Britain, and Germany and the ways they have responded to white claims about black consciousness. She also discusses the impact of feminist writers and artists in this debate. Among those whose works and ideas are explored in this context are W. E. B. Du Bois, Aimé Césaire, Léopold Sédar Senghor, Frantz Fanon, Carolyn Rodgers, Audre Lorde, Joan Riley, Naomi King, Jo Hodges, Andrea Levy, Simon Njami, Daniel Biyooula, and others. 280 pages. ISBN 0822332884

Young, Robert J.C. *Colonial Desire: Hybridity in Theory, Culture and Race.* London: Routledge, 1995.

Poetry

Caddel, Richard, and Peter Quartermain, editors. *Other: British and Irish Poetry since 1970.* Hanover and London: Wesleyan Press, 1999.

Chatterjee, Debjani, ed. *The Redbeck Anthology of British South Asian Poetry.* Redbeck Press, 2000.

Duffy, Carol Ann. (White poet/black personae) *The Other Country.* London: Anvil Press Poetry, 1990; new ed. 1998.

Evaristo, Bernardine. *The Emperor's Babe.* London: Penguin, 2001.

—. *Lara.* London: TunbridgeWells, Kent: Angela Royal Publishing, 1997.

George [Sesay], Kadija, ed. *Burning Words, Flaming Images: Poems and Short Stories by Writers of African Descent.* London: SAKS Publications, 1996.

Joseph, Anthony. *The African Origins of UFOs.* Salt, 2006.

—. *Teragaton.* Poisonenginepress, 1997.

—. *Desafinado.*Poisonenginepress, 1994.

Kay, Jackie. *The Adoption Papers.* Highgreen, Northumberland: Bloodaxe Books, 1991.

—. *Other Lovers.* Highgreen, Northumberland: Bloodaxe Books, 1993.

—. *Bessie Smith.* Absolute Press, 1997.

—. *Off Colour.* Newcastle upon Tyne: Bloodaxe Books, 1998.

McCarthy, Karen, editor. *Bittersweet: Contemporary Black Women's Poetry.* London: The Women's Press, 1998. Anthology includes American, Caribbean, African, and black British poets.

Newland, Courttia and Kadija Sesay, eds. *IC3: the Penguin Book of New Black Writing in Britain.* London: Hamish Hamilton, 2000. Anthology. Contains poetry, fiction, essays.

Nichols, Grace. *The Fat Black Woman's Poems.* Virago (UK), 1984.

Sissay, Lemn. *Rebel without Applause.* Edinburgh: Bloodaxe 1992; Payback
 Press, 2000.
—. *Morning Breaks in the Elevator.* Edinburgh: Payback Press, 1999.
—, editor. *The Fire People: A Collection of Contemporary Black British Poets.*
 Edinburgh, Scotland: Payback Press, 1998 .
Smartt, Dorothea. *Connecting Medium.* Leeds: Peepal Tree Press, 2001.
Smith, Rommi. *Mornings & Midnights.* Peepal Tree Press, 2006.
—. *Moveable Type.* Pontefract (UK): Route (Publishers), 2000.
SuAndi. *Nearly Forty.* Liverpool: Spike Books, 1994.
—. *There Will Be No Tears.* Manchester: Pankhurst Press, 1995.
—, ed. *4 For More.* artBlacklive, 2002.
—. *Mary Seacole*, opera libretto by SuAndi, music by Richard Chew. Premiered
 at The Watermans Arts Centre in London, July 2000.
Sulter, Maud. *Zabat: Poetics of a Family Tree.* Hebden Bridge: Urban Fox
 Press, 1989.
—. As a Black Woman: Poems 1982-1985. London: Akira Press, 1985; rpt.
 Hebden Bridge: Urban Fox Press,1989.
Zephaniah, Benjamin. *City Psalms.* Newcastle upon Tyne: Bloodaxe Books,
 1992.
—. *Propa Propaganda.* Newcastle upon Tyne: Bloodaxe Books, 1996.
—. Too Black, Too Strong. Newcastle upon Tyne: Bloodaxe Books, 2001.

On Poetry

Arana, R. Victoria. "Black American Bodies in the Neo-Millennial Avant-
 Garde Black British Poetry." *Literature and Psychology* 48, 4 (2002):
 47-80.
Jenkins, Lee M. *The Language of Caribbean Poetry*, University of Florida P,
 2004. Has chapters on David Dabydeen, Kamau Brathwaite and Lorna
 Goodison.
Kay, Jackie. 'Bold Type Interview' April 1999. On-line at
 http://www.randomhouse.com/boldtype/0499/kay/interview.html.
—. 'Transcript—Jackie Kay.' BBC Programmes 1 2 3 4 5 (7-11 May 2001).
 On-line at http://www.bbc.co.uk/radio3/speech/workinp/kay.shtml.
Nasta, Susheila. W*riting Across Worlds: Contemporary Writers Talk.*
 Routledge, 2004.
Ramey, Lauri. "Contemporary Black British Poetry." In *Black British Writing,*
 R. Victoria Arana and Lauri Ramey, eds. NY: Palgrave Macmillan,
 2004. 109-36.

—. "Interview with Mannafest." *BlackWater Review* (Winter 2001), 46-63. Reprinted in revised form, *Writing in Education* 24 (Autumn 2001), i-vi.

—. "Freedom in Form: Patience Agbabi," *Sable Litmag*, Spring 2007 (forthcoming).

—. "Introduction to *Whether Or Not* by Roi Kwabena" (UK: RAKA Publications, 2001), vii-x. Reprinted on Contemporary Postcolonial and Post-Imperial Literature in English Website, ed. George P. Landow, Brown University, with mirror site at National University of Singapore:
http://www.postcolonialweb.org/caribbean/kwabena/ramey1.html
(June 2005).

Sandhu, Sudkhev. *London Calling: How Black and Asian Writers Imagined a City*. London: HarperCollins, 2003.

Sesay, Kadija. *Write Black, Write British: From Post Colonial to Black British Literature*. London: Hansib, 2005.

Severin, Laura. *Poetry off the Page*. Ashgate, 2004. Has two chapters on Jackie Kay.

Fiction

Aboulela, Leila. *The Translator.* Edinburgh: Polygon, (1999) 2001.

Adebayo, Diran. *Some Kind of Black.* London: Virago, 1996.

—. *My Once Upon a Time.* London: Abacus, 2002.

Adichie, Chimamanda Ngozi. *Purple Hibiscus.* London: Fourth Estate, 2004.

Ali, Monica. *Brick Lane.* Scribner, 2003.

Antoine, Patsy, and Courttia Newland, eds. *Afrobeat: New Black British Fiction.* London: Pulp Faction, 1999.

Bryan, Judith. *Bernard and the Cloth Monkey.* London: Flamingo, 1998.

Emecheta, Buchi. *The New Tribe.* Oxford: Heinemann, 2000.

Evaristo, Bernardine. *Lara.* London: Angela Royal Publishing, 1997.

—. *The Emperor's Babe.* London: Hamish Hamilton, 2001.

—. *Soul Tourists.* London: Hamish Hamilton, 2005.

Eze-Anyika, Ike. *Canteen Culture.* London. Faber and Faber, 2000.

George [Sesay], Kadija, ed. *Burning Words, Flaming Images: Poems and Short Stories by Writers of African Descent.* London: SAKS Publications, 1996.

Johnson, Catherine, ed. *Playing Sidney Poitier and Other Stories.* London: SAKS Media Publications, 1999.

Joseph, Anthony. *The African Origin of UFOs.* Cambridge: Salt Publishing, 2006.

Kay, Jackie. *Trumpet.* London: Picador, 1998.

—. *Why Don't You Stop Talking.* (Short stories) London: Picador, 2002.

Kureishi, Hanif. *The Buddha of Suburbia.* Boston: Faber and Faber, 1990.

—. *The Black Album.* New York: Scribner, 1995.

Levy, Andrea. *Every Light in the House Burnin'.* London: Headline Review, 1994.

—. *Never Far from Nowhere.* London: Headline Book Publishing, 1996.

—. *Fruit of the Lemon.* London: Headline Book Publishing, 1999.

—. *Small Island.* Picador, 2004.

Mason-John, Valerie. *Borrowed Body.* London: Serpent's Tail, 2005.

McInnes, Colin. *The London Novels: City of Spades. Absolute Beginners. Mr. Love and Justice.* New York: Farrar, Straus and Girroux, 1969.

Mo, Timothy. *Sour Sweet.* London: Deutsch, 1982.

Newland, Courttia and Kadija Sesay, eds. *IC3: the Penguin Book of New Black Writing in Britain.* London: Hamish Hamilton, 2000. Anthology. Contains poetry, fiction, essays.

Newland, Courttia. *The Scholar.* London: Abacus, 1998.

—. *Society Within.* London: Abacus, 2000.

—. *Snakeskin.* London: Abacus 2002.

—. *Music for the Off Key: Twelve Macabre Stories.* London: Peepal Press, (Aug.) 2006.

Oyeyemi, Helen. *The Icarus Girl.* London: Bloomsbury, 2005.

Nwokedi, David. *Fitzgerald's Wood.* London: Jonathan Cape, 2005.

Rushdie, Salman. *The Satanic Verses.* London: Viking 1988.

Selvon, Sam. *The Lonely Londoners.* London: A. Wingate, 1956.

—. *Moses Ascending.* London : Davis-Poynter, 1975.

—. *Moses Migrating.* Harlow, Essex, England : Longman, 1983.

Smith, Norman. *Bad Friday.* London: New Beacon, 1985.

Smith, Zadie. *The Autograph Man.* New York: Random House, 2002.

—. *White Teeth.* New York: Vintage, 2001.

—. *On Beauty.* New York: Random House, 2005.

Syal, Meera. *Anita and Me.* New York: New Press, 1997.

Wheatle, Alex. *Brixton Rock.* London: BlackAmber Books, 1999.

—. *East of Acre Lane.* London: Fourth Estate, 2001.

—. *The Seven Sisters.* London: Fourth Estate, 2002.

—. *Island Songs.* London: Allison and Busby, 2005.

Wheatle, Alex, and Mark Parham. *Checkers.* London: The X Press, 2003.

On Fiction

Ahearn, Edward. *Visionary Fictions. Apocalyptic Writing From Blake to the Modern Age.* New Haven:Yale University Press, 1996.

Arana, R. Victoria. "Jackie Kay: The Fiction of Liberation." *Sable: The LitMag for New Writing,* Issue 9 (Autumn 2006): 19-31.

Ball, John Clement. *Imagining London: Postcolonial London and the Transitional Metropolis.* Buffalo: University of Toronto Press, 2004.

Bertens, Hans and Douve Fokkema, editors. *International Postmodernism. Theory and Literary Practice.* Philadelphia: John Benjamin's Publishing Company, 1997.

Dawes, Kwame. "Negotiating the Ship in the Head: Black British Fiction." *Wasafiri* (Spring 1999):18-24.

D'haen, Theo. "Postmodernisms: From Fantastic to Magic Realist." *International Postmodernism. Theory and Literary Practice.* Hans Bertens and Douve Fokkema, editors. Philadelphia: John Benjamin's Publishing Company, 1997.

Elias, Amy. "Meta-*mimesis*? The Problem of British Postmodern Realism." *International Postmodernism. Theory and Literary Practice.* Hans Bertens and Douve Fokkema, editors. Philadelphia: John Benjamin's Publishing Company, 1997.

Furst, Lilian. *All is True: The Claims and Strategies of Realist Fiction.* Durham, NC: Duke UP, 1995.

Jackson, Rosemary. *Fantasy:The Literature of Subversion.* New York: Methuen, 1981.

Lee, Allison. *Realism and Power. Postmodern British Fiction.* New York, Routledge, 1990.

Lee, Robert A. *Other Britain, Other British: Contemporary Multicultural Fiction.* London & East Haven, Conn.: Pluto Press, 1995.

McLeod, John. *Postcolonial London. Rewriting the Metropolis.* New York: Routledge, 2004.

Nochlin, Linda. *Realism.* Baltimore: Penguin Books, 1971.

Procter, James. *Dwelling Places: Postwar Black British Writing.* New York: Palgrave Macmillan, 2003.

Reichl, Susanne, & Mark Stein. *Cheeky Fictions: Laughter and the Postcolonial.* Amsterdam: Rodopi, 2005.

Sahdhu, Sudhdev. *London Calling: How Black Asian Writers Imagined a City.* London: Harper Perennial, 2004.

Sesay, Kadija. *Write Black, Write British: From Post Colonial to Black British Literature.* London: Hansib, 2005.

Shaffer, John, editor. *A Companion to the British and Irish Novel.* Malden, MA: Blackwell, 2005.

Skinner, John. "Black British Interventions." In *A Companion to the British and Irish Novel.* Ed. Brian Shaffer. Malden, MA: Blackwell, 2005.

Stein, Mark. *Black British Literature: Novels of Transformation.* Columbus, OH: Ohio State UP, 2004.

Wood, Andy. "Contemporary Black British Urban Fiction: A 'Ghetto Perspective'?" *Wasafiri* (Summer 2002): 18-22.

Travel Writing

Eshun, Ekow. *Black Gold of the Sun: Searching for Home in England and Africa.* London: Hamish Hamilton, 2005.

Phillips, Caryl. *The European Tribe.* NewYork: Vintage, 1987 (expanded, 2000).

Stone, Maureen. *Black Woman Walking: A Different Experience of Travel.* Bournemouth, UK: BeaGay Publications, 2002.

Younge, Gary. *No Place like Home: A Black Briton's Journey through the American South.* London: Picador, 1999.

Drama & Theater

Amos, Valerie, Gail Lewis, Amina Mama, and Pratibha Parmar, eds. 'Many Voices, One Chant: Black Feminist Perspectives.' *Feminist Review* 17 Special Issue (July 1984).

Brewster, Yvonne. 'Drawing the Black and White Line: Defining Black Women's Theatre: the Director of the Talawa Theatre in Interview.' Interview with Lizbeth Goodman. *New Theatre Quarterly*, 28 (May 1991): pp. 361-8.

Bryan, Beverley, Stella Dadzie, and Suzanne Scafe. *The Heart of the Race: Black Women's Lives in Britain.* London: Virago, 1985.

Croft, Susan. *Black and Asian Performance at the Theatre Museum: A User's Guide* London, 2002.

Dahl, Mary Karen. 'Postcolonial British Theatre: Black Voices at the Center.' In J. Ellen Gainor (ed.) *Imperialism and Theatre: Essays on World Theatre, Drama and Performance.* London and New York: Routledge, 1995: pp. 38-55.

Godiwala, Dimple, ed. *Alternatives within the Mainstream: British Black and Asian Theatre.* Cambridge: Cambridge Scholars Press, 2006.

Griffin, Gabriele. *Contemporary Black and Asian Women Playwrights in Britain.* Cambridge: Cambridge University Press, 2003.

Joseph, May. "Bodies Outside the State: Black British Women and the Limits of Citizenship." In Peggy Phelan and Jill Lane (eds.) *Ends of Performance.* New York: New York University Press: 1998, pp. 197-213.

Macmillan, Michael. "Re-baptizing the World in Our Own Terms: Black Theatre and Live Arts in Britain" *Canadian Theatre Review* No.118, Spring 2004. 54-61.

Mama, Amina. *Beyond the Masks: Race, Gender and Subjectivity.* London and New York: Routledge, 1995.

Mirza, Heidi Safia, ed. *Black British Feminism: A Reader.* London and New York: Routledge, 1997.

Nkrumah, Afia. "Introduction" in *Black and Asian Plays Anthology.* Robson, Cheryl, Ed. London: Aurora Metro Press, 2000.

Osborne, Deirdre. "Judging a Book by Its Cover: Race, Reading and the Search for Identity in Kwame Kwei-Armah's *Fix Up.*" In *Teaching Contemporary Literature and Culture Vol.1. .*" Susanne Peters, Klaus Stierstorfer and Laurenz Volkmann, eds. Trier: Wissenschaftlicher Verlag, 2006. (in press)

—. "Writing Black Back: An Overview of Black Theatre and Performance in Britain." *Studies in Theatre and Performance.* Vol. 26. No.1 (Jan. 2006): 13-31.

—. "The State of the Nation: Contemporary Black British Theatre and the Staging of the UK." *Staging Displacement, Exile and Diaspora.* Christoph Houswitschka and Anja Muller-Muth, eds. Trier: Wissenschaftlicher Verlag Trier, 2005. 129-149.

—. "I ain't British though / Yes you are. You're as English as I am": Staging Indigenous Identities in contemporary Black British Drama. *Conference Proceedings of the International Conference on Englishness.* University of Worchester, December 2005.

—. "A Recent Look at Black Women Playwrights." Kadija George, ed.. *Six Black and Asian Women Playwrights* London: Aurora Metro, 1996. Updated and Reprinted 2005.

—. "In Celebration of Dona Daley" in *Sable: Black Literary Mag* Autumn/Fall 2004, Issue 5. 56-9. ISSN 1740-4142.

—. "Una Marson" and "Winsome Pinnock" in *Black Drama Database.* Alexandria, Virginia: Alexander Street Press, 2003.

Pinnock, Winsome. "Breaking Down the Doors." In a *Theatre in a Cool Climate,* eds. Vera Gottlieb and Colin Chambers. Oxford, UK: Amber Lane Press, 1999. 224 pages ISBN: 1 872868 26 6

Ponnuswami, Meenakshi. "Small Island People: Black British Women and the Performance of Retrieval." *A Cambridge Companion to British Women Playwrights,* eds. Janelle Reinelt and Elaine Aston. Cambridge University Press, 2000: 217-234.

River, Sol B.,et al. "Ditch the Mumbling Smackheads" *The Guardian.* Jan. 7, 2004. 12.

Stoby, Michelle. "Black British Drama after *Empire Road.*" *Wasafiri,* Issue no.35, Spring 2002.

Tompsett, Ruth A., ed. *Performing Arts International.* Volume 1, Part 2. Special Issue: *'Black Theatre in Britain'* (1996).

Ugwu, Catherine, ed. *Let's Get It On: The Politics of Black Performance.* London: Institute of Contemporary Arts and Seattle: Bay Press, 1995.

Verma, Jatinder. "'The Challenge of Binglish': Analysing Multi-Cultural Productions." In *Analysing Performance: A Critical Reader.* Patrick Campbell, ed. Manchester: Manchester University Press. 1996. 193-202.

Television and Media

Belson, William A. *The Impact of Television: Methods and Findings in Program Research.* London: Crosby Lockwood and Son, 1967.

Bourne, Stephen. *Black in the British Frame: Black people in British Film and Television 1896-1996.* London: Cassell, 1998.

Boyle, Andrew. *Only the Wind Will Listen: Reith of the BBC.* London: Hutchinson and Company, 1972.

Briggs, Asa. *The History of Broadcasting in the United Kingdom, Volume 4: Sound and Vision.* Oxford: Oxford University Press, 1979.

—. *The History of Broadcasting in the United Kingdom, Volume 5: Competition.* Oxford: Oxford University Press, 1995.

Carpenter, Humphrey. *The Envy of the World: Fifty Years of the BBC Third Programme and Radio Three.* London: Weidenfeld and Nicolson, 1996.

Crisell, Andrew. *An Introductory History of British Broadcasting.* New York: Routledge, 1997:

Dates, Jannette L., and William Barlow. *Split Images-African Americans in the Mass Media.* Washington D.C.: Howard University Press, 1990.

Fiske, John. *Television Culture.* London: Routledge. 1987.

—. *Power Plays, Power Works.* London: Verso. 1993.

—. *Media Matters.* Minneapolis: University of Minnesota. 1994

Geraghty, Christine and Lusted, David, eds. *The Television Studies Book.* London: Arnold, 1998.

Hall, Stuart. "The Whites of their Eyes: Racist Ideologies and the Media." *The Media Reader*. London: BFI. 1990.

Hartmann, Paul and Husband, Charles. *Racism and the Mass Media: A Study of the Role of the Mass Media in the Formation of White Beliefs and Attitudes in Britain.* London: Davis-Poynter, 1974.

Lambert, Stephen. *Channel Four: Television with a Difference?* London: BFI, 1982.

Madge, Tim. *Beyond the BBC: Broadcasting and the Public in the 1980s.* London: Macmillan, 1989.

Paulu, Burton. *British Broadcasting in Transition*. Minneapolis: University of Minnesota Press, 1961.

Pines, Jim, ed. *Black and White in Colour: Black People in British Television since 1936*. London: British Film Institute, 1992.

Pym, John. *Film on Four-1982/1991: A Survey*. London: British Film Institute, 1992.

Richards, Jeffery. *Films and British National Identity: From Dickens to Dad's Army.* Manchester: Manchester Press, 1997.

Scannel, Paddy and Cardiff, David. *A Social History of British Broadcasting: Volume One 1922-1939 Serving the Nation*. Oxford: Basil Blackwell, 1991.

Smith, Anthony. *British Broadcasting*. Plymouth: David and Charles, 1974.

Vahimagi, Tise. *British Television*. Oxford: Oxford University Press, 1994.

R. Victoria Arana, *Washington, D.C.*